HUNGRY PLANET

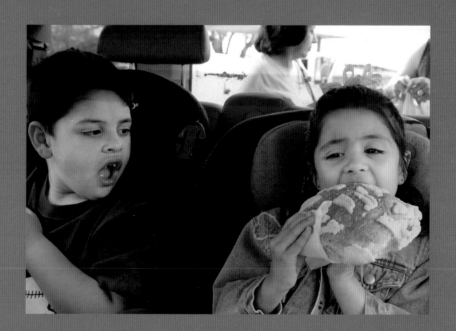

WHAT THE WORLD EATS

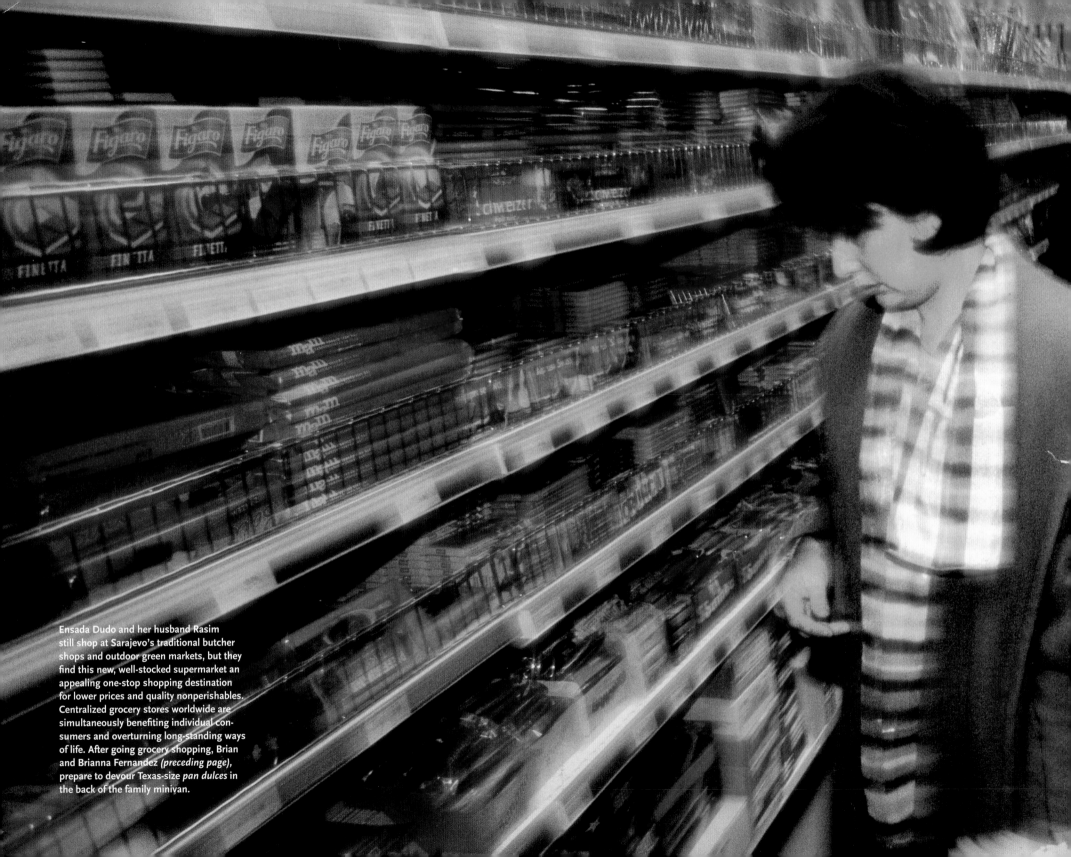

Ensada Dudo and her husband Rasim still shop at Sarajevo's traditional butcher shops and outdoor green markets, but they find this new, well-stocked supermarket an appealing one-stop shopping destination for lower prices and quality nonperishables. Centralized grocery stores worldwide are simultaneously benefiting individual consumers and overturning long-standing ways of life. After going grocery shopping, Brian and Brianna Fernandez *(preceding page)*, prepare to devour Texas-size *pan dulces* in the back of the family minivan.

HUNGRY
PLANET

WHAT THE WORLD EATS

PHOTOGRAPHED BY PETER MENZEL

WRITTEN BY FAITH D'ALUISIO

MATERIAL WORLD BOOKS

AND

TEN SPEED PRESS

22

30

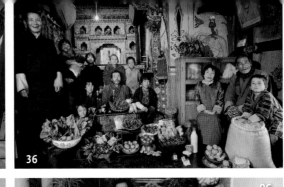36

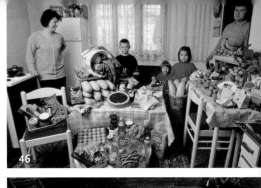46

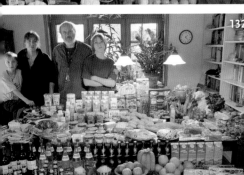74

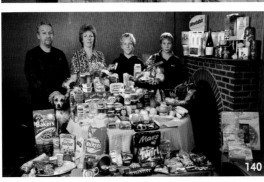82

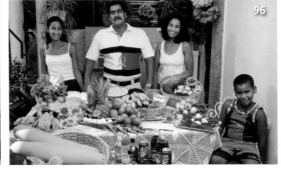96

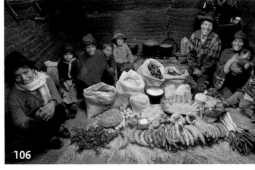106

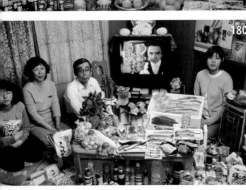132

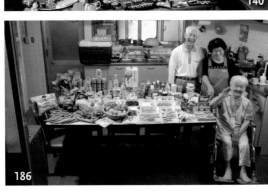140

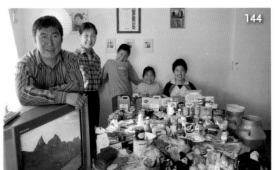144

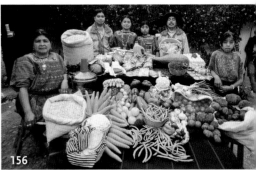156

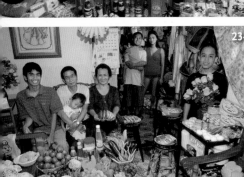180

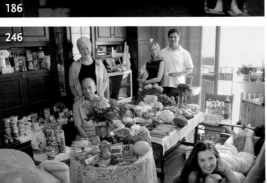186

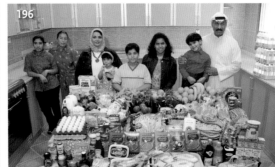196

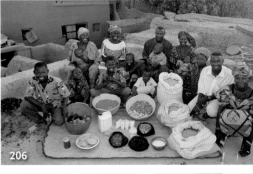206

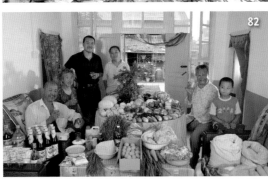234

246

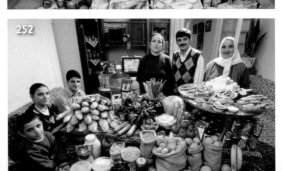252

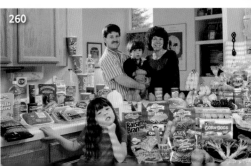260

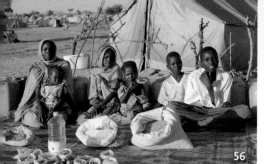
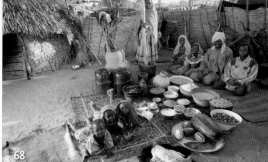
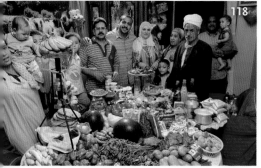
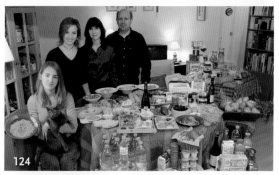
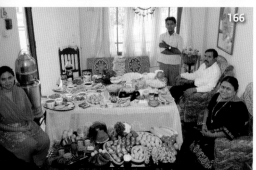
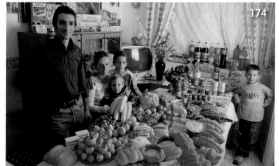
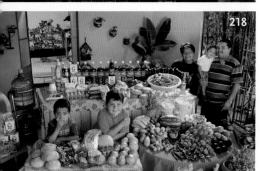
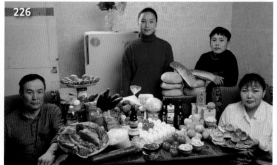
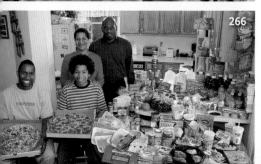
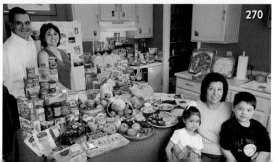

CONTENTS

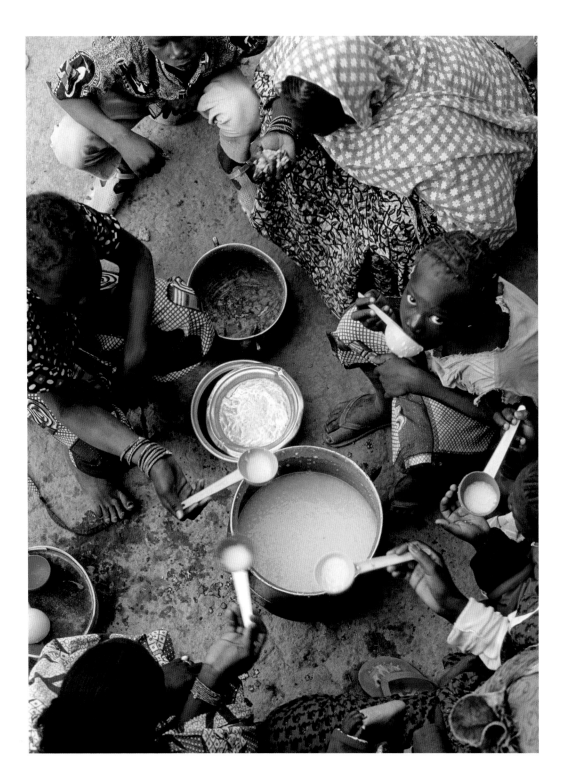

Glancing up at a visitor, Fourou—the twelve-year-old daughter of Soumana Natomo's second wife, Fatoumata—takes a momentary break from the family breakfast of thin rice porridge cooked with sour milk. Like most families in their village in Mali, the Natomos eat outdoors, sitting on low stools around a communal pot in the courtyard of their house.

Dinner for Six Billion

EVERY NOW AND THEN you come across a book so fresh, original, and perceptive that even someone like me, who has researched the subject for years, is surprised all over again by how the study of food can say so much about the human condition. This is one such book. In creating *Hungry Planet: What the World Eats*, Peter Menzel and Faith D'Aluisio did something deceptively simple and utterly brilliant: they photographed families throughout the world posed with a display of all the foods they eat in an entire week. The result is not only a set of wonderful family portraits, but also a stunning commentary on some of the most critical issues facing the world today. The photographs have much to tell us about how people from different countries, cultures, and levels of society feed their families, and the reasons for the similarities and differences. The particular foods purchased or acquired by each family reflect cultural traditions, of course, but they also demonstrate how diet, nutrition, and health depend on less controllable matters, such as poverty, conflict, and globalization. Although the photographs are cross sections—one family, in one place, in one country, at one moment in time—they cannot help but represent the larger issues that affect us all.

Everyone eats. People around the world differ in many ways, but dinner unites us all. Throughout history, we humans have always found nourishing ways to use whatever foods we could get our hands on. The earliest diets were hunted and gathered from the foods that were available as a result of geography and climate. But as soon as people figured out how to trade foods, they did. Resourceful cooks turned the foods at hand into widely varying diets, some so uniquely delicious as to merit the status of cuisines. Beyond that, human survival is proof that just about any diet is sufficiently nutritious to support growth and reproduction. Whether a diet promotes *optimal* adult health is another matter. For the best health and longevity, you need a variety of foods to be available, affordable, and adequately palatable.

As the *Hungry Planet* photographs show, the current diets of most world populations have moved well beyond hunting and gathering. They have evolved in response to changes in food production that began with the Industrial Revolution some 200 years ago. New means of preservation allow foods to be eaten long after they are grown and harvested (hence, ketchup). New means of transportation—railroads, trucks, and airplanes (as well as technologies such as refrigeration)—mean that foods grown in one place can be consumed "fresh" many thousands of miles away. Thus, even in someplace as remote as Bhutan (p. 36), Namgay and Nalim have a few oranges, surely

grown well beyond the Himalayas. New processing techniques allow companies to make shelf-stable food products that can be transported and consumed much later (like pasta in Greenland, p. 144). New technologies have permitted the development of previously unknown food products like instant coffee and Cheez Whiz (p. 234). New marketing methods can create worldwide demand for such products (chief among them, the almost ubiquitous Coca-Cola, p. 218).

In industrialized countries, food supplies have become increasingly independent of geography, climate, or season. Participants in global food economies now expect fresh fruits and vegetables to be available year-round at relatively low cost. As developing economies improve, people have more money and can buy foods for convenience rather than necessity. You can see the rising expectations and the choices they inspire in the foods bought by many of the newly prosperous families pictured here.

The photographs reflect another hugely important historical phenomenon. Until quite recently, the most serious problem related to food was getting enough to eat, and starvation was the most serious health consequence. Famines occurred regularly as a consequence of natural disasters or human conflict, and large numbers of people suffered from malnutrition. Even today, insufficient food is a daily torment for nearly a billion people on earth, half of them young children. This lack is especially disturbing because the world produces more than enough food for everyone; it is just not distributed equitably. Look, for example, at the rations of the Sudanese refugees in Chad (p. 56) and the conditions under which their meager meals must be prepared. Political conflict is the cause of these particular inequities, but you also can see graphic depictions of the effects of poverty on other families who live where food is scarce.

But the photographs have even more to tell us. As conflicts resolve and people in developing countries become better off, they acquire more stable resources and change the way they eat. They inevitably replace the grains and beans in their diets with foods obtained from animal sources. They buy more meat, more sweet foods, and more processed foods; they eat more meals prepared by others. Soon they eat more food in general. They start gaining weight, become overweight, and then develop heart disease, diabetes, and the other chronic diseases so common in industrialized societies. Here we have the great irony of modern nutrition: at a time when hundreds of millions of people do not have enough to eat, hundreds of millions more are eating too much and are overweight or obese. Today, except in the very poorest countries, more people are overweight than underweight. Some socially conscious governments struggling to feed their hungry populations must also contend with the health problems of people who eat too much food.

The phenomenon of going from not having enough food to overeating is now so common that it has been given its own name: the nutrition transition. To see the nutrition transition in action, you need only compare the diets of families from Mali, Mongolia, and the Philippines with those from France, Australia, and the United States. Rates of obesity are rising rapidly in all countries, but are highest in the most industrialized countries. To understand why, just examine the shopping lists and food displays.

As someone whose work links the study of food to nutrition and public health, I view these photographs through my own lens—one focused on the ways in which

"Here we have the great irony of modern nutrition: at a time when hundreds of millions of people do not have enough to eat, hundreds of millions more are eating too much and are overweight or obese. Today . . . more people are overweight than underweight."

food marketing affects dietary choices. In today's fiercely competitive financial environment, food companies are required to expand sales and to demonstrate growth every quarter. Obesity and its health consequences are just collateral damage. Growth-seeking companies cannot imagine a better place to find new buyers than the emerging economies of developing nations. That is why China—with its more than one billion inhabitants—is of such intense interest to the makers of food products and fast food. Compare the diets of the two Chinese families, one urban and one rural. Both are prospering. Both have enough food. Both are in transition from a diet of poverty to one of affluence. The rural family (p. 82) has just started down this road. Its foods are mostly grains, vegetables, and fruits, along with relatively small amounts of meat. The foods on display in the family portrait are mostly raw or minimally processed, and you can easily imagine how they might be cooked in your favorite Chinese dishes. This rural family buys cubes of chicken stock as a luxury; others are beer, cigarettes, and, as is common nearly everywhere, Coca-Cola. In contrast, the urban family (p. 74) can afford—and has access to—a great many more foods of different kinds. It buys many of the same basic foods as the rural family, but adds items that go well beyond the traditionally Chinese: baguettes, sugar-free gum, Häagen-Dazs Vanilla Almond Ice Cream, and takeout from KFC. Such is the global food market in the early 21st century.

Nutritionist that I am, I celebrate the increasing prosperity that removes the threat of starvation, and I hold on to the hope that global marketing will not destroy either the joys of traditional cuisines or the health of the people experiencing the nutrition transition. But when I look at the Greenland photographs, I cannot help but wonder about the new food traditions of this family. Do they use the ketchup to season walrus or polar bear meat? How do Pringles fit into their traditional diet? And how do we interpret the effects of global food marketing when we encounter cigarettes among the purchases of families in Japan, Mongolia, the Philippines, or Turkey? *Hungry Planet* raises such questions and more. It is a gorgeous book, but also a rich and thoughtful commentary on today's human condition. Peter Menzel and Faith D'Aluisio have given us a feast—for the eye, the heart, and the mind. We are privileged to have them among us. Enjoy!

Marion Nestle, Ph.D., M.P.H., is the Paulette Goddard Professor of Nutrition, Food Studies, and Public Health at New York University. Her books include Food Politics: How the Food Industry Influences Nutrition and Health.

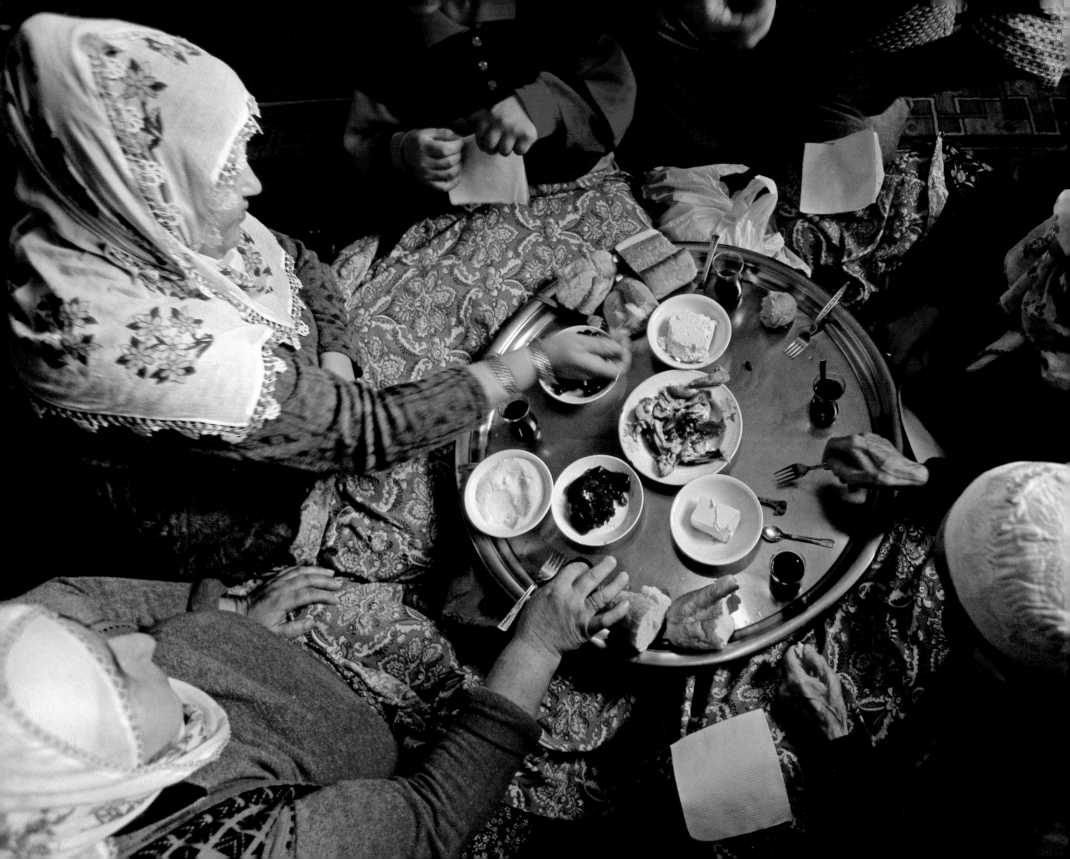

Dinner Is Served

In the Golden Horn area of Istanbul, Turkey, the Çinar family gathers on the floor of their small living room to share their morning meal: feta cheese, olives, leftover chicken, bread, rose jam, and sweet, strong tea.

PETER MENZEL AND I INVITED OURSELVES to dinner with 30 families in 24 countries to explore humankind's oldest social activity: eating. Anyone who remembers grocery shopping 20 years ago knows that the U.S. diet has changed rapidly, but fewer people realize that this transformation is worldwide. Some dietary changes are due to globalization, as largescale capitalism reaches new places. Others are due to rising affluence, as people in formerly impoverished places gain the means to vary their diet—first eating more meat and fish, then pizza and burgers. And some changes are due to the tides of migration, as travelers, immigrants, and refugees bring their own foods to new lands and acquire new tastes in return. To learn more, we watched typical families the world over as they farmed, shopped, cooked, and ate. At the end of each visit, we created a portrait of the family surrounded by a week's worth of their groceries. The sum, we hope, is a culinary atlas of the planet at a time of extraordinary change.

THIS BOOK BEGAN with a single mouthful of noodles. In the mid-1990s, Peter and I found ourselves in a small covered motorboat off the southern coast of the island of New Guinea, speeding through the Arafura Sea. It was early spring—typhoon season was approaching. At this time of year, storms can come up so quickly that the local charter planes suspend operations at the slightest hint of bad weather, and even the illegal fishing trawlers plundering the tropical seas around the island are extra careful. Because our assignment schedule was tight, we couldn't wait for a less stormy day. Instead, we hunted for an experienced boat captain willing to make the seven-hour journey to the Asmat—a heavily forested section of the Indonesian province of Papua—one of the most remote places on earth.

Peter is a photojournalist and I am a writer, and we have worked together in almost 50 countries over the last 12 years. We generally focus on international stories, and that day eight years ago we were headed to the Asmat to document the lives of its hunting and gathering inhabitants.

From the Asmat's ramshackle capital, Agats, we took a 40-foot longboat three hours up the Pomats River to the village of Sawa. It was a small, poor place deep in the rain forest, a collection of wooden huts without running water, electricity, telephones, or roads of any kind. Its people live hand to mouth, felling towering sago palm trees and mashing the pulp to make their staple food, a kind of bread. When they can get them, they eat sago grubs. Occasionally, they get fish from the river. It was the steamiest, swampiest place I'd ever been. And it was there, an hour or two after our arrival, that this book began.

Peter and I were (respectively) photographing and talking with a tall skinny man and his two sons, all three of whom showed the marks of hard living. Like many in the village, the man was blind in one eye from vitamin deficiencies; the children had skin diseases and looked seriously undernourished. As we were talking, the older boy pulled a dry brick of instant ramen noodles out of its wrapper and munched it down. His naked, pot-bellied little brother tipped the ramen's flavoring packet into his own mouth and worked the powder around with his tongue until it dissolved. I was mesmerized. I saw this scene play out again and again during our time in Sawa, a place with next to no connection to the rest of the world—children eating an uncooked convenience food intended to simplify the busy lives of people very far away.

I asked a Catholic priest, a longtime resident missionary, about the noodles. He said that logging money had begun to trickle into the villages of these hunters and gatherers. Accompanying the cash came the first merchant to Sawa, a Sulawesian who sold dried food and snacks. Now there's nothing intrinsically wrong with the occasional quick snack of ramen noodles in processed broth, but you don't have to be a food activist to wonder if it is a good idea for the Asmattans, already struggling to find basic nourishment, to dose themselves with jolts of sugar, salt, and artificial flavors.

Since that visit to the Asmat we've seen similar scenes worldwide, and have noticed that something odd—even revolutionary—is going on in the world of food. Producing and consuming food is one of humankind's oldest and most basic activities, but the signs of change are everywhere. Riding in taxis through Beijing, we'd see scads of Kentucky Fried Chicken outlets springing up. A grandfather in rural China who remembers the pain of hunger railed against the young Chinese he sees

On the way back from Mackas (Aussie slang for McDonald's), 15-year-old Nakayla Samuals (in 50 Cent T-shirt) rips open the *Spy Kids* 3-D comic book that the restaurant awards to purchasers of Happy Meals. Like her half-sister Sinead Smith (drinking) and her friend Amelia Wilson, Nakayla is from an Aboriginal family whose roots lie in the arid outback. But the girls have little interest in outback cuisine; at least for now, Mackas is their culinary mecca.

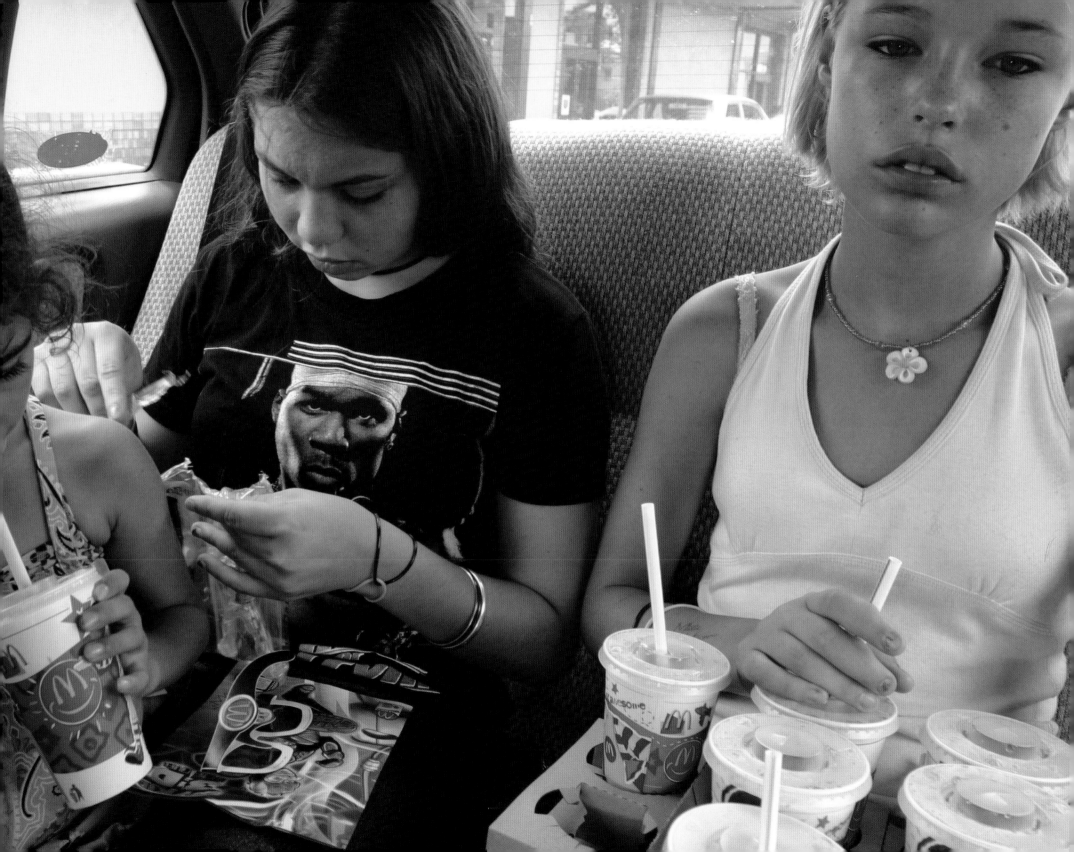

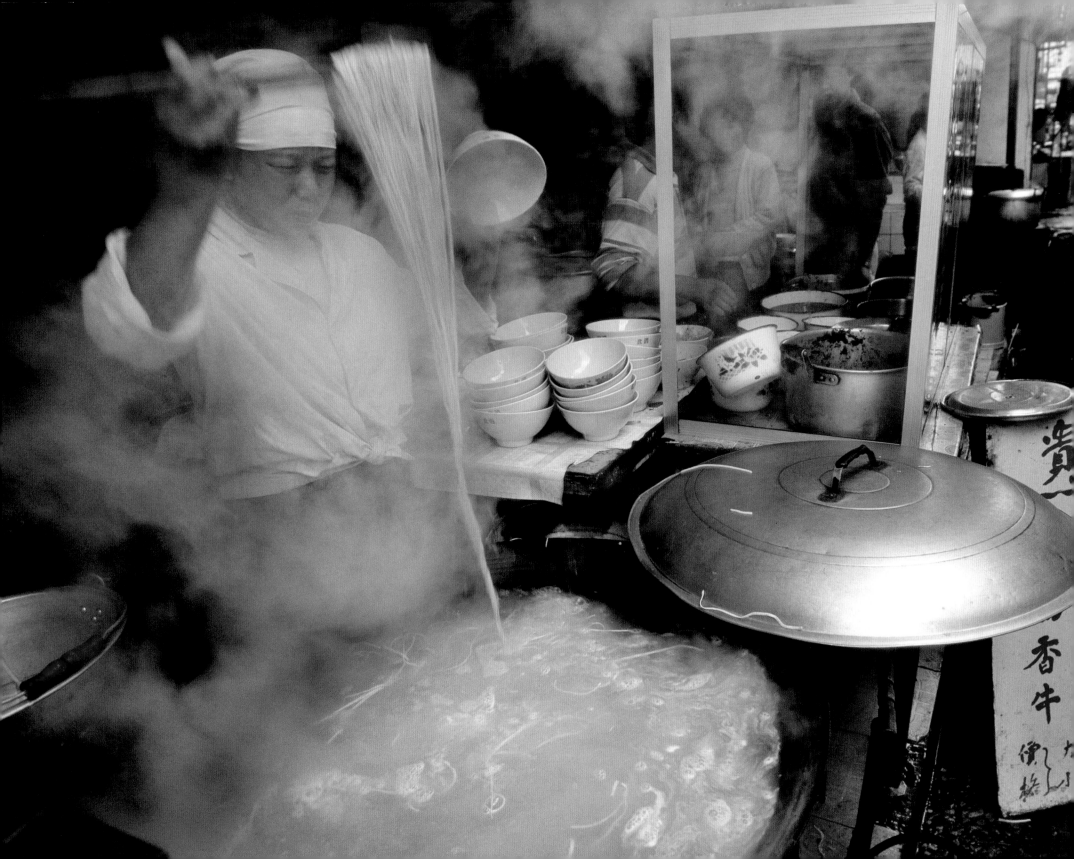

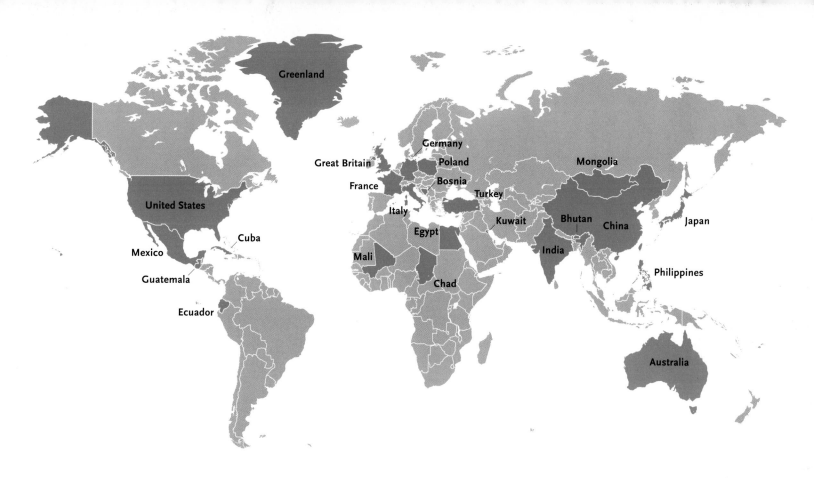

Steam rises in clouds from the huge woks of this noodle vendor in Kunming, in southwest China. Cooked in the celebrated style of the city of Guiyang, 300 miles away, these egg noodles are served in a spicy broth and topped with chicken, beef, shiitake mushrooms, or—most famously—pig intestines and blood.

now, wasting food. Here at home, on assignment in the Midwest, we saw endless rows of corn and soy, and learned that much of it is now genetically modified. (For better or worse, we Americans don't know when we are eating GM foods—and when we aren't.) In the suburbs of Paris, we met French teenagers whose favorite meals were Pad Thai and sushi. A young mother living in Mexico told me that she had no idea what were the ingredients of soft drinks. Her sedentary family of five was drinking six gallons of Coca-Cola a week, to the exclusion of most other beverages, even as she worried about the family's growing weight and dental problems.

The global marketplace has changed the way people are eating. Societies that are becoming less physically active are also increasing their consumption of energy-dense foods. Even without the academic studies, it's easy to spot—just look around. Many affluent countries are overfed. And unfortunately, it seems that in the developing world, even before people attain a level of affluence that helps ensure their adequate nutrition, they are eating in ways almost guaranteed to make them less healthy. As charitable organizations continue their desperately important campaigns against world hunger, others begin equally important campaigns against world obesity. Meanwhile, activists left, right, and center denounce food corporations, food scientists, food conservationists, and food regulators .

To try to make sense of this fascinating, baffling, important muddle, we worked our way around

the world and looked at the everyday food of everyday people everywhere—the heaping plates at middle-class mealtimes, the meager communal bowls shared by families crushed by poverty, the sacks of grain served up by overworked aid organizations, the clamorous aisles in hypermarkets, the jam-packed shelves in mom-and-pops, the foods prescribed by religious doctrine, the foods of celebration, subsidized foods. We met people along the way who helped us illustrate the bewildering diversity of what humankind eats in the 21st century: global food, snack food, fast food, junk food, health food, functional food, complimentary food, fortified food, organic food, processed food.

The result—the book in your hands—is not a diet book. Nor is it a jeremiad about supposedly evil corporations, or the supposed enemies of progress, or any of the other sides in the debate about the politics of food. Rather, it is an attempt at a global portrait at a time of momentous change—a freeze-frame snapshot of a fast-moving target.

PROCESS

Gathering information for any project that spans multiple countries is dauntingly difficult, but this one was particularly hard, not least because I often had to introduce concepts that are taken for granted in the developed world. Take, for instance, the idea of a recipe. At Breidjing Refugee Camp in eastern Chad, I asked our translator, Hassane, about the recipe for *aiysh*, the thick porridge that is the staple food of the Sudanese families in the camp. Hassane looked completely blank. I explained that we wanted to write down the method by which D'jimia, the woman we were speaking with, cooked *aiysh*. "How can we get such a thing?" Hassane asked. "There is no such plan for cooking. She learned it from her mother." "I realize that," I replied, "but I must write down how *aiysh* is made, so that the people who read this book can make sense of the food and the process that D'jimia uses to make it." "They only make it, they don't talk about it," he argued. "I realize that, Hassane," I tried again, "but D'jimia will talk about it if we ask her. Please tell her that I have watched many, many women make *aiysh*, and now I want to ask about the method she uses, so I can write it down for the book."

Peter had exited this conversation, understandably enough, and was photographing at the next tent block, where a group of men were slaughtering a goat for the celebration of the end of Ramadan. D'jimia and the chief of her tent block—who was translating Hassane's Arabic into D'jimia's native Massalit—watched our exchange with interest.

"This is much too difficult," Hassane repeated, shaking his head, as we began anew—from English to Arabic, Arabic to Massalit, and back again. Within a short time, D'jimia had outlined the instructions for making *aiysh*, and we had moved on to talking about the life she and her five children used to lead, and the plentiful food they'd had in Sudan, before being forced into Chad by the Janjawiid. (p. 56).

But the flow of information was not just one-way. Sometimes the project taught our subjects as much as it taught us. After our visit to the British village of Collingbourne Ducis in Wiltshire and the subsequent family food portrait, Deb Bainton e-mailed: "I can't believe that I was honest enough to let you photograph the amount of Mars bars I ate in a week—the average British family will be pleased to see that! I eat hardly any these days, so I suppose I've moved on to something equally unhealthy—scary thought, if I've started to get remotely healthy!" (p. 140).

A hubbub of voices swirls over the main weekly market in Hargesia, the capital of Somaliland, a breakaway section of Somalia, in northeast Africa. Despite the chronically chaotic political situation, people still try to go about their ordinary lives whenever they can—in this case, buying and selling beef, mutton, and camel meat.

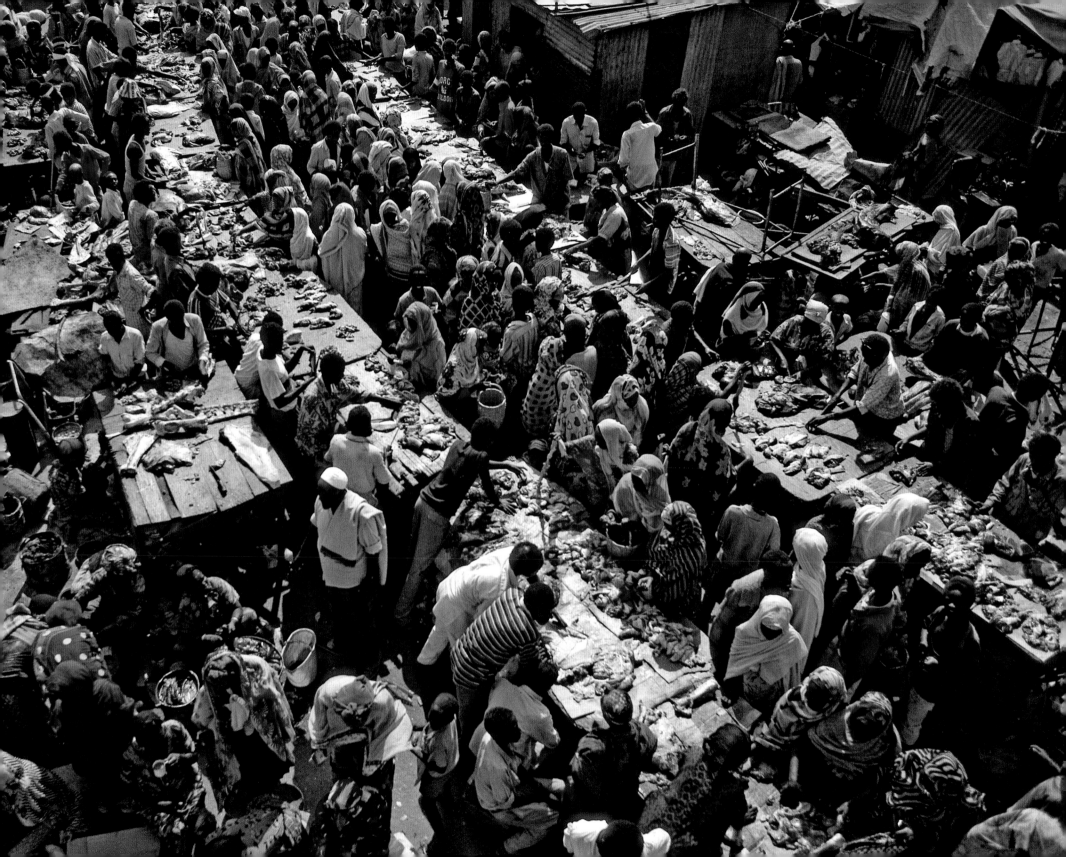

As the message from Deb Bainton and my cross-cultural exchange in Chad suggest, assembling this book was a long, arduous, fascinating, and occasionally charming experience. (For details on the methodology, please see page 278.) Along the way, we asked for additional input from Marion Nestle, Carl Safina, Alfred W. Crosby, Corby Kummer, Francine R. Kaufman, and Charles C. Mann. (Contributors' profiles can be found on page 284.)

As I write this Peter is outside in our garden shoveling compost into a wheelbarrow and getting ready for the spring growing season in Northern California. I've placed my weekly food order with Planet Organics in San Francisco and filled the coffeepot with good clean water from our 250-foot machine-drilled well. All the while, I'm thinking about Amna Mustapha, the winsome 12-year-old girl we got to know in Chad, hauling cooking water out of a temporary hand-dug well in a dry river-bed every day (p. 68). And I'm thinking about D'jimia, the widowed mother of five, on the Chad-Sudan border, thankful for the food rations from the world community, and the United Nations tent over her family's head, but wanting fervently to go back home to Sudan and her mango trees. She's worried about affording the cost of a single handful of dried okra (p. 56).

I'm also reminded of a story told to me by our friend Charles Mann, who is occasionally our editor. More than a decade ago, he says, Peter and he went to Chetumal, on the Mexico-Belize border. "It was a real hole," he explained, "at least back then. The only restaurant open late at night was completely empty except for us. The menu was, shall we say, limited; the service, none too enthusiastic. But we are upbeat and adventurous folks, right? On the menu is *pulpo y hígado*—octopus and liver. I figure it's like *paglia e fieno*, the Italian dish, which isn't actually a platter of straw and hay, but green and yellow pasta. This too must be, you know, a metaphor. So I order it. It comes. It's chunks of octopus in pureed beef liver. Now, I am ordinarily a member of the Clean Plate Club. This is the first time in years that I not only can't finish a dish, I can't start it. Years later, I see a cartoon of a waiter in a tux bellying up to a table with this smoking, charred mass on a platter. 'It's a fried telephone book,' he tells the horrified customer. 'We put it in French, and you ordered it.' That was me," said Charles. Actually, from time to time, that's all of us.

SOME BITES OF THE HUNGRY PLANET

• Nalim, a subsistence farmer, pours us cups of salty butter tea in front of the same cooking hearth where I last saw her, years ago, in her village of Shingkhey, Bhutan. "The children were wondering when you were coming back," she says. She still has the wristwatch I gave her, although it no longer works. She does, however, have a battery-run clock on the wall, and it's running. "Do you follow the clock?" I ask. "What happens at 9:30 in the morning?" "We need to get the cows out," she says. "And when it's 11 a.m.?" I ask. "Lunch." "And what if you don't have batteries for the clock?" I ask. "I look at the sun," says Nalim. "If it's overhead, it's lunchtime." "What if the sun is over there?" I ask, pointing over her shoulder. "Then everyone better get going!" she says. "They're late for work!" (p. 36).

• It was love at first sight for Marge Brown of Riverview, Australia. Tall, handsome, hard working—a brand-new electric refrigerator. She had never had one at home in the outback, only a cranky old kerosene-powered fridge. The Aboriginal Australian has used some of her pension to buy herself the

For this Sunday brunch outside Hamburg, Germany, Jörg Melander rode his bicycle through late-November snow to get rolls and pastries from a bakery near home. His wife Susanne has just finished an all-night nursing shift, and is making the effort to enjoy the family meal, instead of going right to bed. But the bread, cheese, and jam washed down with tea, coffee, and hot chocolate are worth it.

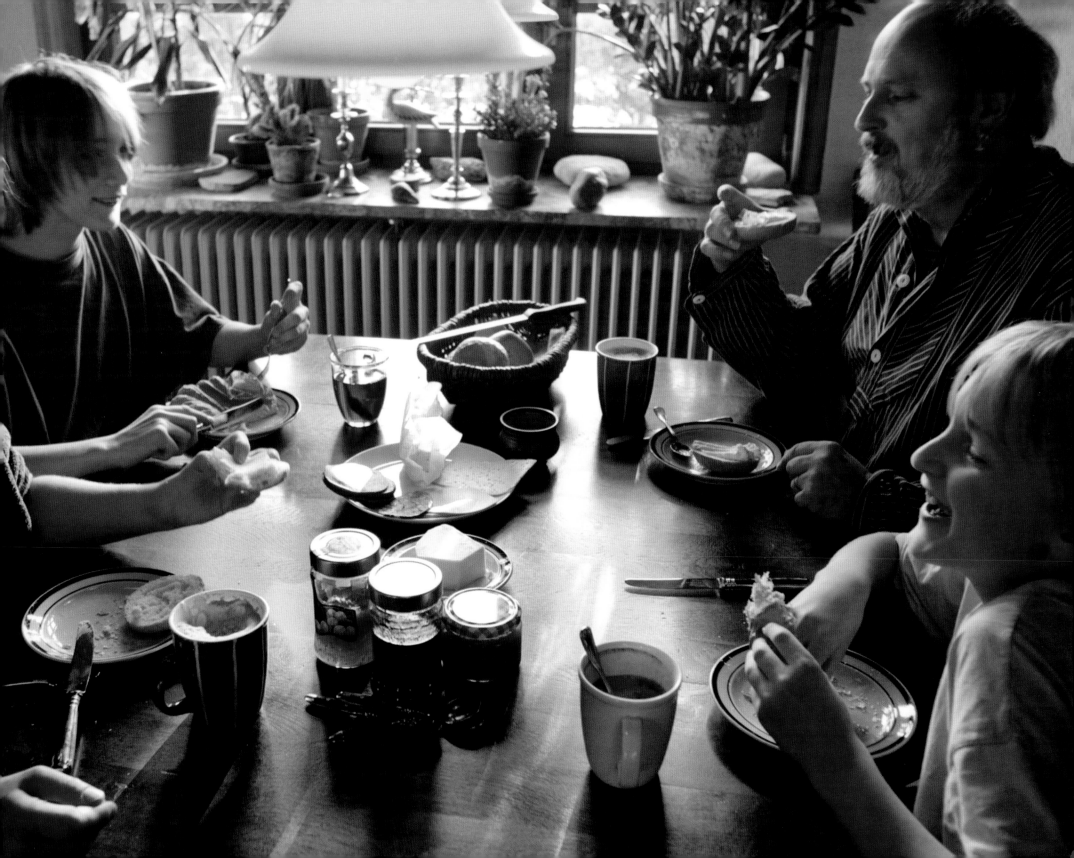

new refrigerator for her family's home near Brisbane. "Since I had my stroke, I can't do much," she says, "but I can sit here and read, and look at my refrigerator!" (p. 22).

• A group of Muslim men are sitting under the lone shade tree near their village outside Abeche, Chad, to escape the sun. I tell them we had been in Greenland, where it doesn't ever get dark during part of the year. The men wrap their heads around that one for a while and then Mustapha Abdallah Ishakh asks, "Are there Muslims there?" "No, probably not too many," I tell him. "We could never live there," he says. "We wouldn't know when to pray." Muslims pray five times a day, at prescribed times, in accordance with the sun. (p. 68).

• The *cuy* that Ermelinda and Orlando Ayme of Tingo, Ecuador, allow to run around loose on the floor of their kitchen house until they're large enough to eat are substantially smaller than the ones that are basted on a spit, roasted to a crispy brown, and served in Ecuador's towns and cities. The city *cuy*, raised by *cuy* ranchers, are fed vitamin supplements and alfalfa, while the country *cuy* eat only grass. *Cuy* is the Spanish word for Guinea pig. (p. 106).

• "I remember when I was a child," says Marzena Sobczynska of Konstancin-Jeziorna, Poland. "We often ate hen broth. I remember clearly that Grandma picked up the hen, and with the axe took its life away. The hen, without its head, was running around for some time, giving me a chill. I cannot imagine that I would allow my children to watch something like this, but Grandma didn't care—the hen was to eat, without any sentiment and fuss. She poured hot water on it, plucked off the feathers, and next she cut it. Some undigested seed came out from the inside of the hen—*brrrr*. It had an awful smell! I'm still not very fond of broth." (p. 246).

• "When I was growing up," says Jörg Melander of Bargteheide, Germany," my parents had ducks and chickens. I think that when you want to eat something, you should be able to kill it yourself. It's not a nice feeling but it has to be done. I was 16 and my father told me to kill some chickens for a meal. "It wasn't good," he says, "but I did it." (p. 132).

• In Cap Hope, Greenland, the edge of the icy Arctic Scoresby Sound is only 300 feet from Emil and Erika Madsens' front window—a breathtaking view marred only by an unfamiliar fragrance that permeates the house. Narwhal oil, Erika's favorite. It's the oil from the great horned whale, and it's never purchased, only shared by someone who kills one. Erika keeps hers in an old powdered milk tin. The children don't like eating it. "But they will when they're older," predicts Emil, as he drenches a small dried fish in the dark oil and eats it. Peter is eating a lot of it too. It smells like roofing tar to me. I'll stick with Emil's flavorful musk ox stew. (p. 144).

• As were many families representing the so-called developed world in this book, the Revises of Raleigh, North Carolina, were shocked to see on display the amount of food their family of four ate in one week. Rosemary Revis says, "Everyone was very unsettled by the sheer amount and kinds of food on the table for the photograph." She tells us they're using their portrait in this book as a catalyst for personal change. (p. 266).

As she arranges her clothes in the chilly desert dawn, D'jimia Ishakh Souleymane, a Sudanese widow at a refugee camp in neighboring Chad, watches the pot of water she is heating to make *aiysh* (porridge). Anticipating the new moon at the end of the month of Ramadan, when Muslims fast, she is preparing a celebratory meal for her five children.

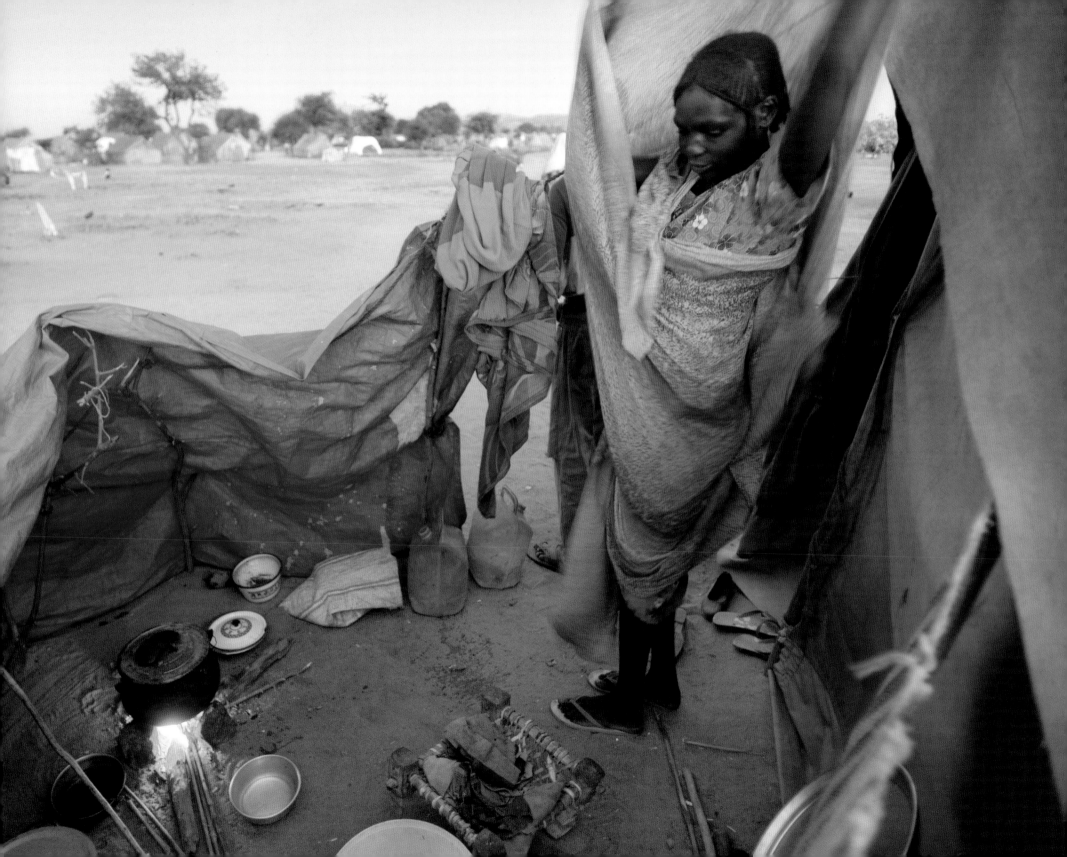

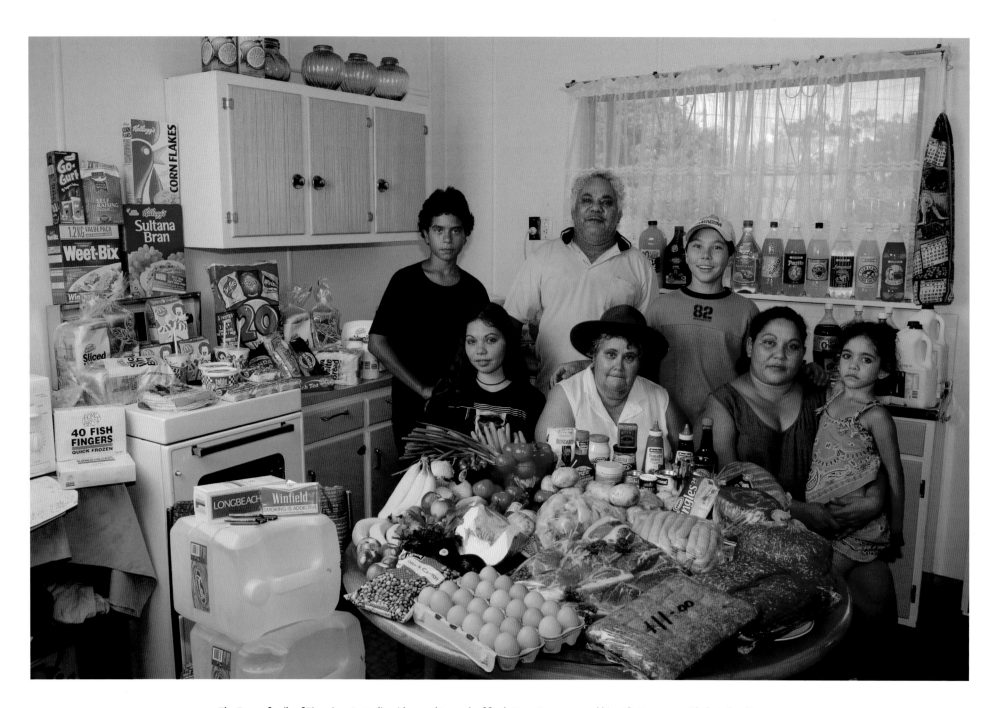

The Brown family of Riverview, Australia with a week's worth of food: Doug Brown, 54, and his wife Marge, 52, with their daughter Vanessa, 32, and her children, Rhy, 12, Kayla, 15, John, 13, and Sinead, 5. The length of the Brown's grocery list changes depending on whether Vanessa and her children are living with them at the moment. Cooking methods: electric stove, microwave, and BBQ. Food preservation: refrigerator-freezer. Favorite foods—Doug: "Anything anyone else cooks." Marge: yogurt. Sinead: Mackas (McDonald's).

Outback In

ONE WEEK'S FOOD IN JANUARY

Grains & Other Starchy Foods: $28.79

Coliban variety potatoes, 8.8 lb; *Home Brand* (store brand) white bread, sliced, 4 loaves; *Home Brand* whole wheat bread, sliced, 2 loaves; *Weet-Bix* breakfast cereal, 2.7 lb; *White Wings* self-raising flour, 2.7 lb; basmati rice, 2.2 lb; *Kellogg's* Sultana Bran cereal, 1.9 lb; *Nanda* spaghetti, 1.1 lb; *Nanda* spirals, 1.1 lb; white pocket bread (pita), 13 oz; *Kellogg's* corn flakes, 10.9 oz.

Dairy: $24.55

Sunshine whole milk, 2.4 gal; *Home Brand* vanilla ice cream, 1.1 gal; *Home Brand* thickened cream, 1.3 qt; margarine, 2.2 lb; *Yoplait* yogurt, nonfat, 1.5 lb; *Yoplait* Gogurt (drinkable yogurt), 1.2 lb; *Kraft* Cheese Singles, 1.1 lb.

Meat, Fish & Eggs: $117.99

Woolworths smoked ham, 11 lb; silverside (corned beef), 9.9 lb; minced meat, 6.6 lb; pork chops, 6.6 lb; sausages, 6.6 lb; steakettes, 6.6 lb; chicken, 4.4 lb; rissoles, 4.4 lb; *Home Brand* eggs, 24; *Home Brand* beef patties, frozen, 2.2 lb; *Home Brand* fish fingers, frozen, 2.2 lb.

Fruits, Vegetables & Nuts: $30.54

Yellow bananas, 2.7 lb; white nectarines, 2.4 lb; Jarrahdale variety pumpkin, 2.4 lb; carrots, 2.2 lb; yellow onions, 2.2 lb; tomatoes, 2.1 lb; avocados, 3; cucumbers, 1.4 lb; *Master Foods* tomato sauce, 16.9 fl oz; zucchini, organic, 1.1 lb; mixed vegetables, frozen, 1.1 lb; red bell peppers, 11.2 oz; celery, 8.8 oz; green bell peppers, 8 oz; shallots, 6.4 oz.

Condiments: $35.44

Cornwell's vinegar, 1.6 qt; *Bundaberg* white sugar, 2.2 lb; *Holbrook's* Worcestershire sauce, 25.4 fl oz; *Kraft* cheese spread, 1.1 lb; *Cornwells* Lancashire relish, 1.1 lb; *Master Foods* BBQ sauce, 16.9 fl oz; *IXL* plum conserve (jam), 10.6 oz; *Kraft* chili & lime dressing, 10.2 fl oz; *Kraft* mayonnaise, 6.7 oz; *Kraft* smooth peanut butter, 6.6 oz; baking powder, 4.4 oz, *used in johnnycakes*; *Mitani* chicken salt, 3.5 oz; *Keen's* curry powder, 2.1 oz; mustard, 1.6 oz; *Splenda* (artificial sweetener), 1 oz; salt, 2.2 oz.

Snacks & Desserts: $4.59

Smiths chips, variety pack, 14.1 oz; rich tea biscuits (traditional English cookies), 7.1 oz.

Prepared Food: $4.28

Maggi instant beef noodles, 1.1 lb; *Gravox* gravy, 4.2 oz.

Fast Food: $28.28

McDonald's: 6 Happy Meals, 3 Mc Oz (burgers), *Coca-Cola*, 6 small, 1 large.

Beverages: $37.92

Frantelle spring water, 7.9 gal; diet *Coca-Cola*, 1.6 gal; *Mildura* fruit drink, 1.1 gal; *Just Juice* orange drink, 2.5 qt; diet *Sprite*, 2.1 qt; *Golden Circle* apple juice, 2.1 qt; *Golden Circle* lime cordial, 2.1 qt; *Golden Circle* orange & mango crush, 2.1 qt; *Kirks* club lemon soda squash, 1.3 qt; *Kirks* creaming soda, 1.3 qt; *Kirks* lemonade, 1.3 qt; *Kirks* pasito (passionfruit-flavored drink), 1.3 qt; *Solo* lemonade, 1.3 qt; *Sunkist* orange drink, 1.3 qt; *Coca-Cola*, 20.3 fl oz; *Tetley* tea, 175 teabags, *this number is not a typo*; *Bushell's* coffee, 1.8 oz.

Miscellaneous: $64.07

Longbeach cigarettes, 10 pks; *Winfield* tobacco, 1.8 oz; *Lion* cigarette papers, 4 pks.

Food Expenditure for One Week:
481.14 Australian dollars/$376.45 USD

Five-year-old Sinead was terrified the first time she saw her mother slaughter a sheep. "She said to me, 'Mommy, I don't love you anymore,'" says Vanessa Stanton, "and I told her, 'Well Sinead, we're not going to eat anymore if I don't.'"

ALTHOUGH THE COUNTRY HAD NO SHEEP until the late 18th century, when European settlers began to import and raise them in large numbers, many of Australia's original inhabitants came to embrace the shepherd's life. Sheep slaughtering is a common chore for people living in the outback—Australia's vast, desolate interior—and Vanessa Stanton learned it from her parents. Vanessa's grandfather—Sinead's great-grandfather—was the shearer's cook at a sheep station in the outback town of Goodooga in the Australian state of New South Wales, and Vanessa's mother, Marge Brown, says living in the outback is "as much a part of me as breathing." As did many young girls in the outback, Marge went to work on a sheep station when she was 13. "I was milking the cows, getting the horses for riders, mustering [rounding up] sheep, and killing some for us to eat," she says. Girls who did this work were called jillaroos; boys were called jackaroos. It was tough work, but she didn't think of it that way, because everyone around her was doing it too.

At age 16, Marge decided to study nursing, and when she graduated, she practiced her chosen profession in the outback. How does she compare her childhood to her grand-childrens'? "My grandchildren have it easy today," she says, but she voices her complaint with a smile that lights up her face, despite the ravages of illness, and makes her grandchildren laugh.

Doug Brown met Marge through a mutual friend. He didn't know she was the daughter of the shearer's cook who picked him up every day and took him to work until his friends—he calls them "mates"—pointed it out after he hung her photograph on the shearing shed wall. They soon married. Marge worked as a nurse in an outback clinic while Doug continued to work as a shearer and played in a band on the weekends. Like their parents before them, the Browns raised their children, and many foster children, on yet another sheep station—this one in Weilmoringle, upriver from Goodooga—with no

running water or electricity. "We cooked on an open fire and washed our clothes in a 44-gallon drum," says Marge. They had a refrigerator that ran on kerosene. Sometimes.

Outback life, as Marge recalls it, perpetually alternated between comedy and catastrophe– "There was always something," says Marge. "Doug would go off with his mates and strange things would happen." Like the chicken coop escapade: "He went down to the pub with his mates," Marge says. "'Where's Dad?' everyone wondered." "The boys dropped me off home after the pub kicked us out," says Doug. "Somewhere along the line I musta taken the wrong door. I'm sleeping and there's a draft, and I'm thinking, someone left a bloody window open. I reach up, and I can feel this railing, and something else—that squawks! It's a bloody chicken, and I jump up. Where am I? I'm in the *chookie* house." "Another time, Dad went out back to freshen up and didn't come in for a while," says Vanessa. "Next we know, here comes a camel with Dad's new Christmas hat between his teeth." He let the camel keep it.

Doug Brown moved to the coastal city of Brisbane, in the state of Queensland, in 1995. "I saw it and I liked it, so I stayed," he says. "It was time for a change." Marge stayed behind because she loved her work as a midwife, and the outback. Then a stroke damaged her motor skills. Suddenly, Doug was cast in the role of caretaker. Today they live on the outskirts of Brisbane, in the small town of Riverview. Family grocery shopping, household chores, and meals are now his domain, with Marge as his guide. "He's a better cook then I was," she says generously. When he's tired of cooking, Vanessa pitches in.

The Browns' tendency to see the world a little differently from most enriches the family narrative—even their recounting of a trip to the local shopping mall when Marge's 90-year-old father came from the outback for a visit. "Her father had never been, and we took him there," says Doug. "He has a walker," adds Marge. "We get to the escalator," says Doug, "and he looks up, and he won't get on. I tell him, 'I'll be right behind you, don't worry.' We go up just fine. Then we have the same argument to go back down. He finally gets on, and we're going down, but he leans backward farther and farther until he goes over! These two guys with their trolleys [carts] and a girl with a baby were all that stopped him. Everything was a tangle. I tell him, 'Next time, we'll take the lift.' He says, 'I'm not getting in that with you either.' 'What are you, some kind of wuss?' I ask. 'You're trying to

kill me!' he says. He never would go in a shopping mall again. "This fear runs in the family—years passed before Marge ever attempted to ride an escalator. After a lifetime spent in the solitary outback, Doug too says he has trouble negotiating the modern world. "My ears start ringing when too many people get to talking around me," he says. "I get weak-kneed."

Their daughter Vanessa, a frequent visitor and sometime houseguest since her mother's series of strokes, is more adept at straddling the two worlds. She and her children meld into and out of the household seamlessly, as many of the children have lived with their grandparents off and on since they were young. John has lived the longest with his grandparents, and he's the one who spars most often with his grandmother. "John and I do clash a lot," says Marge, "every day." "Normally, it's about yogurt," says Vanessa. "The yogurt in the fridge is mine," says Marge. "No one else can eat yogurt unless they put their own in there!"

Morning meals center around Doug's fresh fruit salad, but it's not the type familiar to dieters. "I dice it up and then douse it with cream and sugar," says Doug. "A *lot* of cream and sugar," adds Vanessa. "Pop used to eat Weet-Bix with mango juice and cream," says John. "It sent his sugar [level] through the roof," says Vanessa dryly. "He's not allowed to have mango juice anymore."

All three of the adults have diabetes, though only Marge has to take medication to control it, and all are overweight. Marge is the only one who weighs less now than she used to, due to a change in her diet and the effects of her illnesses. The Browns see being overweight as a pervasive issue for many of their fellow Australians: "Everyone here is looking for a quick way to lose weight," says Vanessa. "Queensland is the fat state. Southern Australians are slimmer. It's hotter up here—everyone runs for the air conditioner, and they lay there in front of the TV." "With Mackas, Sizzlers, and KFC," adds Doug. (Mackas is Aussie slang for McDonald's.)

Food stories figure prominently in the family lore: John remembers a time when the family was still living in the outback and he was sent to catch a porcupine for dinner, after a hard rain. "We got lost," says John. "You should *never* walk into the sand hills on a cloudy day, because they all look the same," scolds Vanessa. "There's no way to pick out the markings on a cloudy day." "We walked and walked," continues John, "and we crossed some water. [My brother]

- Population: **19,913,144**
- Population of Metro Brisbane: **1,508,161**
- Population of Riverview: **4332**
- Area in square miles: **2,967,124 (slightly smaller than the contiguous 48 U.S. states)**
- Population density per square mile: **7**
- Urban population: **92%**
- Land that is desert: **44%**
- Ratio of sheep to people: **5:2**
- Life expectancy, male/female: **78/83 years**
- Indigenous population: **2.4%**
- Indigenous population in 1777: **100%**
- Life expectancy gap between indigenous and nonindigenous population: **−20%**
- Annual alcohol consumption per person (alcohol content only): **10.9 quarts**
- GDP per person in PPP $ (Purchasing Power Parity: an adjustment for what equivalent local goods would cost in the U.S.): **$28,260**
- Total annual health expenditure per person in $ and as a percent of GDP: **$1,741/9.2**
- Caloric intake available daily per person: **3,054 calories**
- Overweight population, male/female: **70/60%**
- Obese population, male/female: **21/23%**
- Cigarette consumption per person per year: **1,907**
- Meat consumption per person per year: **235 pounds**
- McDonald's restaurants: **726**
- Big Mac price: **$2.46**
- Menu items that contain mutton/lamb in McDonald's restaurants: **0**
- Kangaroos killed under commercial harvest for meat and skins (2003): **3,474,483**

Raised in the arid outback, the Browns now find themselves on the outskirts of Brisbane, a tropical city that has heavy thunderstorms almost every afternoon in the summer. Their home is only 20 minutes by parkway from the city center, but they remain almost as far away from it in spirit as if they were still in the outback.

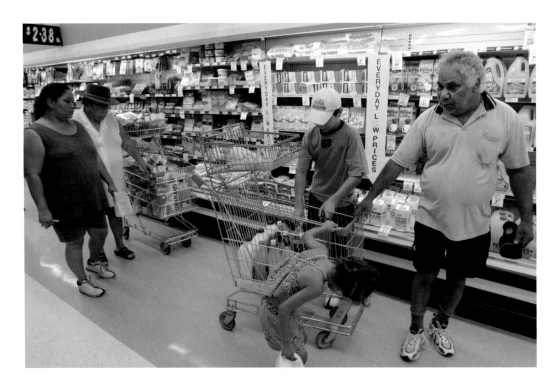

..
FIELD NOTE
..

The last time I was in Australia I spent a week in the outback, camping with three grandmotherly aboriginal artists who showed me how to dig up and eat witchetty grubs and honey ants. We also ate a two-foot goanna lizard that one of them, Bessie Liddle, had killed with a spade, and a kangaroo tail they bought at a Quickstop on the way out from Alice Springs. I learned a lot and admired the women for their ability to walk into the barren red desert and forage meal after meal.

On previous runs up and down the arrow-straight Stuart Highway, a lonely strip of asphalt that bisects the thousand miles of outback, I was impressed with the number of overturned cars and dead animals. On a predawn drive out of Coober Pedy, the steel roo-guard on my Land Cruiser saved the life of the radiator but abruptly ended that of a 100-pound kangaroo who hopped from a ditch into the headlights and the hereafter. Buzzards cleaned up bloated free-range cattle carcasses and flattened smaller rodents and snakes. This road kill was easy to explain—but what about the overturned cars? Had drivers swerved to avoid one of the large animals, or to run over the smaller edible ones? Or fallen asleep on the monotonous road, or gone astray fetching a Fosters from the eskie?

Doug's story about jumping out of a car to chase down a porcupine brought back memories of driving Miss Bessie—who frequently rolled down the window to shoot her .22 rifle at a scampering rabbit from our barreling Toyota. Some people might be put off by aboriginal folks' fondness for a free lunch, but not me. I reveled in sharing game with 20th century hunter-gatherers; and Doug's porcupine tale made me regret not being able to personally report on its taste and texture.
— *Peter*

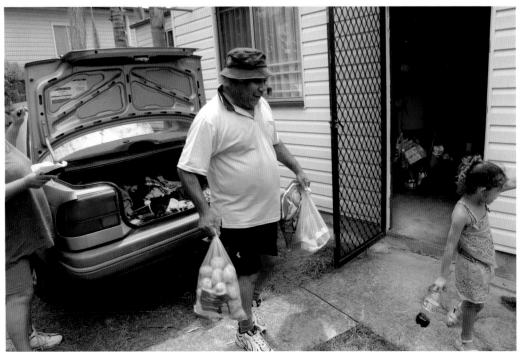

John holds his sister Sinead (at right) as they graze in the nearly-empty refrigerator. But the next day it's full—every two weeks a new check appears and the family goes to the supermarket (above left). Unloading the car, the Browns return (bottom left) to their modest neighborhood.

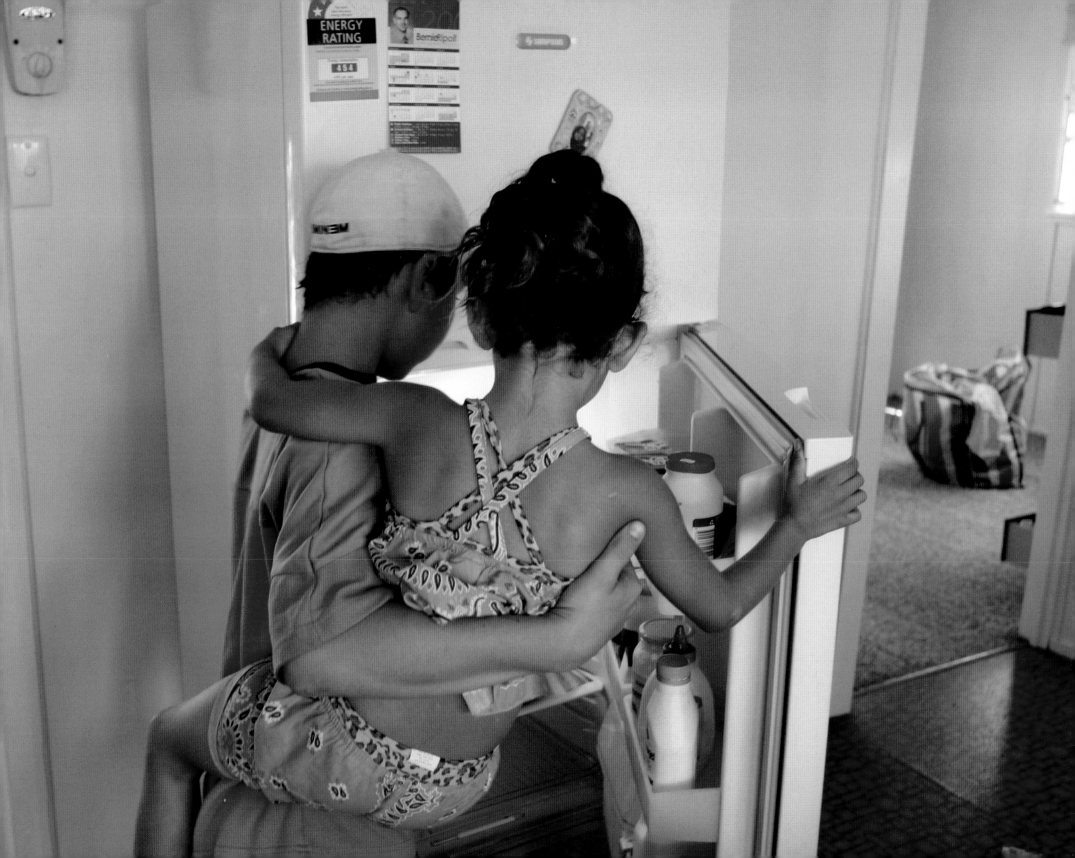

Rhy didn't know how to swim, so I carried him on my back and he almost drowned me. We got to a big tree and slept there, and we was hearing things and all frightened. Then we heard whistling. It was my uncle. We was right near the house," says John. "I cried all night," says Vanessa. "I thought they were gone, and they were right here." "No porcupine, though," says John, mournfully. "A porcupine is a lot of work," says Doug. "Dig after it, run after it, clean it, hang it, cook it for hours. And just when you're ready to eat it, your mates show up, all wanting a leg each. 'Well, there's only four of 'em,' I say. They start eating and soon there's nothing left." Everyone nods in agreement. "Once you have a porcupine in the house," adds Vanessa, "that's a big treat and you've got two or three families showing up for the johnny-cakes [wheat-flour campfire bread] and porcupine."

Porcupine, kangaroo, and lamb were their standard fare in the bush, but play a smaller role in the family diet in suburban Brisbane. Government disability pensions go directly into the adults' bank accounts every two weeks, and this money covers rent, meals, and expenses. "We've got to buy a certain amount of food, and it has to last the fortnight," says Marge. "In the bush, if we ran out of meat, it was easy to go over to the paddock and get a 'roo. Here, if you're out of money, you're out of meat. In the bush, you could get a full sheep for $10 ($7.58 USD)." "Around here," says Vanessa, "I think the butchers charge $80 ($60.60 USD) for a whole sheep, cut up." "I like chicken," interjects John. "Especially Kentucky Fried Chicken," says his mother. "He could eat it every day," says Marge. "We told him he's going to grow breasts if he keeps eating it as much as he does," says Vanessa, laughing.

Doug tries to limit the fast-food trips to only once or twice a month, especially when the grandchildren are home, but Sinead is able to charm him into going more often. "'Pop, do you think you could do something about Mackas?' she asks me," he says, roaring with a belly laugh so infectious that soon everyone in the kitchen has joined in. "It's cheaper to make McMuffins ourselves," says Marge, "and Doug makes beautiful hamburgers out of steakettes [preformed meat patties]." All agree though that a steakette doesn't quite taste the same. "But if you eat it quick," Doug says, "you don't notice the difference. And you can always add barbecue sauce." Doug buys a lot of sauces, trying for that quintessential special blend. He is frankly horrified at the cost of fast food. "At Mackas, $6 ($4.55 USD} feeds one person." John says. "Pops told the waitress one time,

'For that price, I'll buy all the ingredients and make you ten of 'em.'"

Vanessa finds that Sinead will not be swayed by imitations—even the best intentioned. "I'm standing there with the knife and the potatoes, and I cut this way and that way, so they're like the Mackas fries," says Vanessa. "And then Sinead says, 'Do you have the right oil, Mum?' And I ask her, 'What oil do you want, Sinead?' And she says, 'Well, will it cook right, Mum? It has to be the right oil or it won't cook right.' And it never does cook the right way," says Vanessa, who adds that, despite inevitable failure, she will always make the culinary attempt to keep her daughter happy.

Besides the fresh porcupine and kangaroo, did food at the sheep station differ from what they eat now? "Our food came in on the mail truck and there wasn't much of a selection," says Marge. "We had a standing order for rice, flour, some tinned meat, tinned fruit, salt, sugar, and powdered milk. Sometimes jam would come, or something else special." "And then Mom would make boiled lollies," adds Vanessa, "with corn syrup, flour, and jam. And we got nasty ol' black licorice sticks. We had them for about five or six years, until we learned that there were red ones!"

Today, the multitude of food choices overwhelms the Browns. "In the past, decisions were made for us, because there wasn't much to choose from," says Marge. "Now, we stand there in the shop and scratch our heads." "We're still trying to work out what's good for us," says Vanessa. "Twenty years ago, there was one, maybe two, of everything on the shelf. Now, you go to buy a packet of cheese and there are about 30 or 40 different varieties. You got cholesterol-free, salt-free, you got this and that, and you don't know half the time what you're looking for. Finally, I go for everything that says 'original.'" "I do like that salt-free butter," says Marge. "Yeah, it looks real good," says Doug, "just like butter, until you dip your finger in for a taste and *eew*, why bother?"

Vanessa does feel that her children have missed out on some of the most basic experiences she remembers from her own childhood. "We ran out of tea bags recently, and I had some loose tea. I boiled water and the kids were watchin' me. They couldn't believe it when I put the tea leaves in the water. They said, 'Where's the bags?' They were all alarmed. I asked them, 'Haven't you been educated in anything?'" Indeed they have: they are well aware of every branded soft drink, snack, and fast food. And they want them.

Marge Brown's Quandong Pie

1 cup self-raising flour

3 cups all-purpose flour

6 oz butter

1/2 t salt

1 cup milk

1 lb quandongs (bright-red wild Australian peaches), peeled, pitted, and chopped

1 cup sugar

1 T lemon juice

water

- Preheat oven to 350° F.
- Make pastry. With fingers, work flours, butter, and salt together in a bowl (or use metal dough blender).
- Add milk and press into a ball.
- Roll out pastry into 2 rounds big enough to cover deep 8" pie dish.
- Put 1 pastry round into deep pie dish so that it just overlaps edge.
- Put quandongs, sugar, and lemon juice into saucepan and add water to cover. Cook at low boil for 30 minutes. Water will turn red. Remove from heat and drain in colander, catching liquid in separate bowl. Put liquid in refrigerator to cool.
- Fill pie with quandong mixture, adding 3–4 T of reserved quandong liquid to moisten.
- Place second round on top of pie, pinch edges together. With knife, cut small vent holes in top. Decorate with leftover pastry bits (optional).
- Put pie in preheated oven. Immediately lower temperature to 300° F and cook for 30 minutes, or until juices begin to bubble. If edges cook too quickly, cover with foil.
- Let pie rest for 10 minutes, then serve hot with custard, cream, or ice cream topped with some remaining quandong liquid.

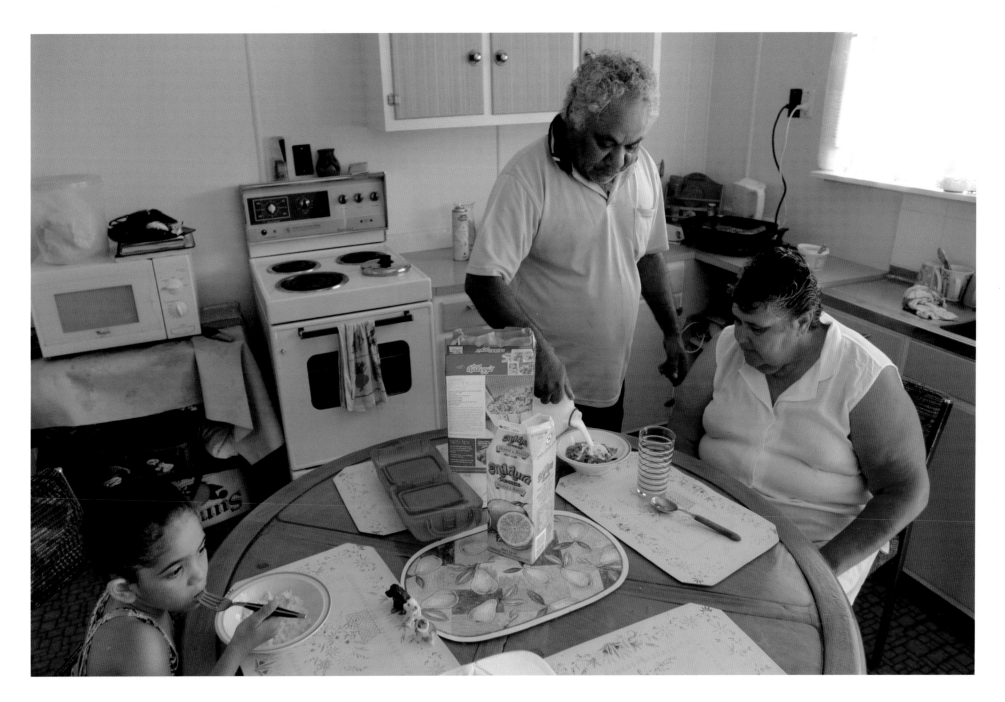

Breakfast during the children's summer vacation is low-key and unstructured. Everyone eats when the mood strikes them. Vanessa bustles about, scrambling eggs for Sinead and herself. The boys help themselves to cereal and sandwiches. Meanwhile, Doug cooks himself a hearty breakfast of fried meat, onions, gravy, and buttered toast, and oversees his wife's meal of cereal and juice—since her stroke, Marge has been trying to eat a more healthy diet.

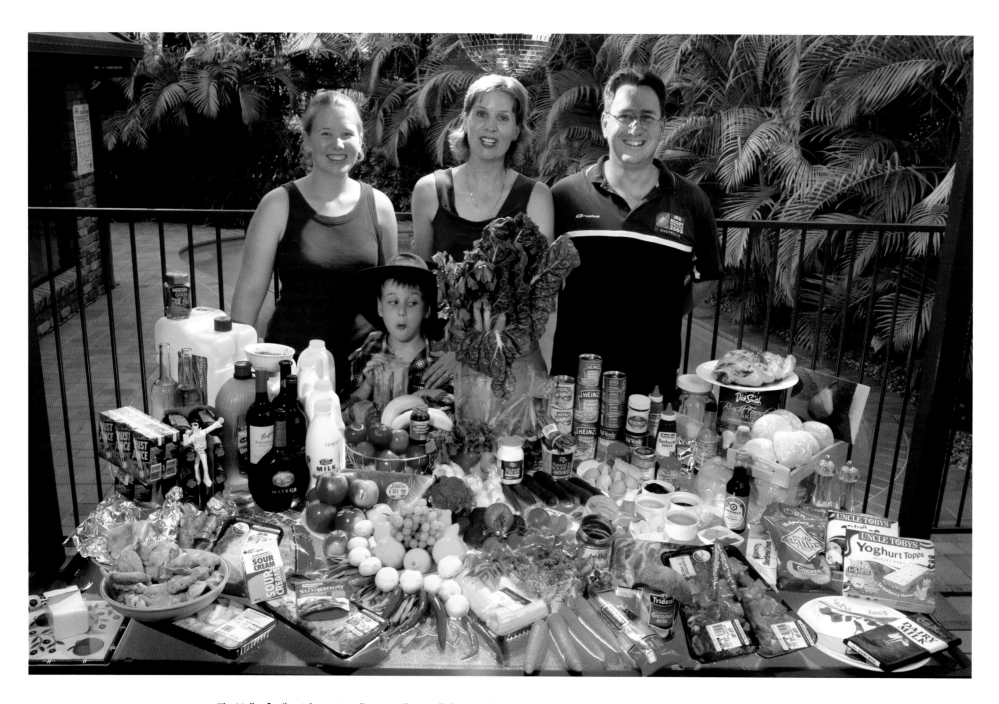

The Molloy family—John, 43, Natalie, 41, Emily, 15 (called Em), and Sean, 5 (wearing his school uniform, including a hat for sun protection)—on the backyard patio by their pool in Brisbane, on Australia's east coast, with one week's worth of food, in January. Cooking methods: stove, microwave, and outdoor BBQ grill. Food preservation: refrigerator-freezer. Favorite foods—John: prawns and chocolate. Natalie: fresh fruits and cheese. Emily: Mexican food and homemade dips. Sean: spaghetti Bolognese and lollies.

Feast of Eden

ONE WEEK'S FOOD IN JANUARY

Grains & Other Starchy Foods: $24.76

White Russet variety potatoes, 4.4 lb; white bread, sliced, 2 loaves; bread rolls, 10; *Dick Smith Bush Foods* breakfast cereal, 2.2 lb; *San Remo* spaghetti, 1.7 lb; *San Remo* penne, 1.1 lb; white rice, 1.1 lb; sweet chili twist (savory bread), 12.4 oz.

Dairy: $19.01

Pura Light Start milk, 1.6 gal; *Pauls* milk, whole, 2.1 qt; cheese, 1.1 lb; *Pauls* Greek yogurt, natural set (fermented in the container in which it is sold), 1.1 lb; *Pauls* thickened cream, 10.2 fl oz; *Woolworths* (store brand) sour cream, 10.2 fl oz; butter, 2.7 oz.

Meat, Fish & Eggs: $84.31

Chicken, whole, 4.4 lb; tuna, canned, 4.4 lb; *Woolworths* beef, 2.2 lb; *Woolworths* chicken breast, 2.2 lb; *Woolworths* lamb, 2.2 lb; *Woolworths* pork, 1.1 lb; sea perch, 2.2 lb; eggs, 6; ham, 10.6 oz; salami, 3.5 oz.

Fruits, Vegetables & Nuts: $66.78

Watermelon, seedless, 3.7 lb; *Sundowner* variety apples, 2.8 lb; oranges, 2.7 lb; yellow bananas, 1.8 lb; plums, 1.7 lb; green grapes, 1.4 lb; lemons, 1.2 lb; nectarines,‡ 1.2 lb; *Heinz* baked beans, 2.3 lb; avocados, 4; iceberg lettuce, 2 heads; cucumbers, 1.9 lb; *Val Verde* peeled tomatoes, canned, 1.8 lb; tomatoes, 1.6 lb; white onions, 1.6 lb; carrots, 1.5 lb; sweet corn, 4 ears; asparagus, 1 lb; silverbeet (spinach-like greens), 1 lb; celery, 8.8 oz; *Master Foods* tomato sauce, 8.5 fl oz; mushrooms, 8.4 oz; broccoli, 8 oz; beetroot, canned, 7.9 oz; Italian flat beans, 7.9 oz; tomato paste, 7.1 oz; snow peas, 6.8 oz; red bell peppers, 6.4 oz; garlic, 2.2 oz.

Condiments: $23.50

Coconut milk, 13.5 fl oz; peanut butter, 8.8 oz; *Kikkoman* less-salt soy sauce, 8.5 fl oz; *Lea & Perrins* Worcestershire sauce, 8.5 fl oz; *Master Foods* BBQ sauce, 8.5 fl oz; *Nutella* chocolate spread 7.1 oz; *Master Foods* seeded mustard sauce, 6.2 oz; *Viva* olive oil 4.4 oz; red chili peppers, 3.6 oz; basil,* 3 oz; ginger, 2.9 oz; *Capilano* honey, 2 oz; parsley,* 1 small bunch; balsamic vinegar, 1.7 fl oz; coriander (cilantro),* 1 small bunch; *Master Foods* horseradish,‡ 1 oz; jam, 1 oz; mayonnaise,‡ 1 oz; *Master Foods* tomato and chili pickle (salsa), 1 oz; mint,* 1 small bunch; oregano,* 1 oz; Tonkatsu sauce, 1 oz; *Vegemite* (salty, vegetable-based spread), 1 oz; cumin, 0.3 oz; mustard seeds, 0.3 oz; rosemary,* 4 sprigs; turmeric, 0.3 oz; black pepper, 0.2 oz; curry,* 20 leaves; salt, 0.2 oz; thyme,* 1 small bunch; bay leaves, 5.

Snacks & Desserts: $17.67

Ice blocks (popsicles), 24-pk; sultana raisins 13.2 oz; *Cadbury* Dairy Milk chocolate bar, 8.8 oz; *Uncle Tobys* strawberry muesli bars, 8.8 oz; *Uncle Tobys* fruit twists, 7.9 oz; *SAKATA* crackers, 7.1 oz; *Arnott's* shortbread cream biscuits, 4.4 oz; *Smith's* chicken-flavored potato crisps, 1.8 oz.

Prepared Food: $3.29

Heinz spaghetti, canned, 1.5 lb; beef Stroganoff mix, 1.4 oz.

Beverages: $63.94

Water, 2.6 gal; fruit juice, 3.2 qt; red wine, 3 25.4-fl-oz bottles; *Just Juice* poppers (juice boxes), 2.6 qt; *Mateus* rosé wine, 25.4 fl oz; *Cascade* light beer, 6 12.7-fl-oz bottles; *Nescafé* gold blend coffee, 1.8 oz; *Nestle* milo (instant chocolate drink), 0.8 oz; *Twinings of London* English breakfast tea, 10 teabags.

Miscellaneous: $0.49

Cenovis multivitamins, 7 pills, *for Natalie.*

* Homegrown; ‡ Not in Photo

Food Expenditure for One Week: 388.22 Australian dollars/$303.75 USD

The Molloys seek out local cuisine when they travel around Asia. Once, in Kuala Lumpur, Malaysia, John and Natalie came upon a narrow street lined with small open-air restaurants—and an all-male clientele. They moved from this gender-segregated Muslim enclave to an area that served both men and women. "We had dosa (rice and lentil pancakes) and curry wrapped in a banana leaf," says Natalie. "I had curry-stained fingers for weeks afterward. It was delicious!"

FIFTEEN-YEAR-OLD EMILY MOLLOY and her mother Natalie are languishing in the steamy heat and dreaming of a cool breeze that's a couple of months away. It's only early January, the height of summer on Australia's central east coast. Both Emily and Natalie are drinking tall glasses of filtered water and watching Sean, 5, career around the house eating his second ice block (frozen juice bar) of the day. Natalie has taken the day off from her job as a finance officer at University of Queensland College to ready Sean for his first day of school. Natalie's husband, John, a banker, has just arrived home. This time of year, their house is suffocating—they'll eat outside.

Tonight is nibbles night. "Once a week, it's just little nibbly things," says Natalie as she and Em carry small plates of ready-cooked supermarket chicken, artichokes, pistachios, olives, pickles, crisps, crackers, Vegemite, and snow peas to the covered poolside patio where they eat most summer meals. Other nights, John fires up the grill to barbeque lamb and grill vegetables, or Natalie and Em make pasta with meat sauce and elaborate salads. Em, a budding chef's apprentice, likes to experiment on her family and friends. Her ambition reaches beyond simply providing a meal. "For me," says Em, "sharing a meal is a great excuse to bring people together." On Friday nights, Sean is treated to McDonald's or Subway fare before his T-ball match.

Although the Molloys love such stereotypically Australian fare as grilled meat and "nibbles," the proximity to Asia gives Australians a thoroughly contemporary awareness of—and experience with—genuine Asian culture and food. The Molloys—and Australians, generally—are inveterate travelers, but John can often find his favorite international food right at home. Sean's Sri Lankan daycare provider has an outside kitchen as well as a modern indoor one. "She cooks for her church," says John, "and there's always the chance of a little taste of Samosas, or some sort of curry. Some mornings, I walk up to the house with Sean and sniff the air and there it is—oh boy, something good for tea this morning."

Nibbles night begins: Emily smears a thin film of Vegemite across a slice of white toast. "It tastes really good," she enthuses about the yeasty, vegetable-based spread that to the newly initiated might seem kind of a tongue-curling experience. "When I get bored with just Vegemite on toast, I'll eat it with avocado on toast. Yummy!"

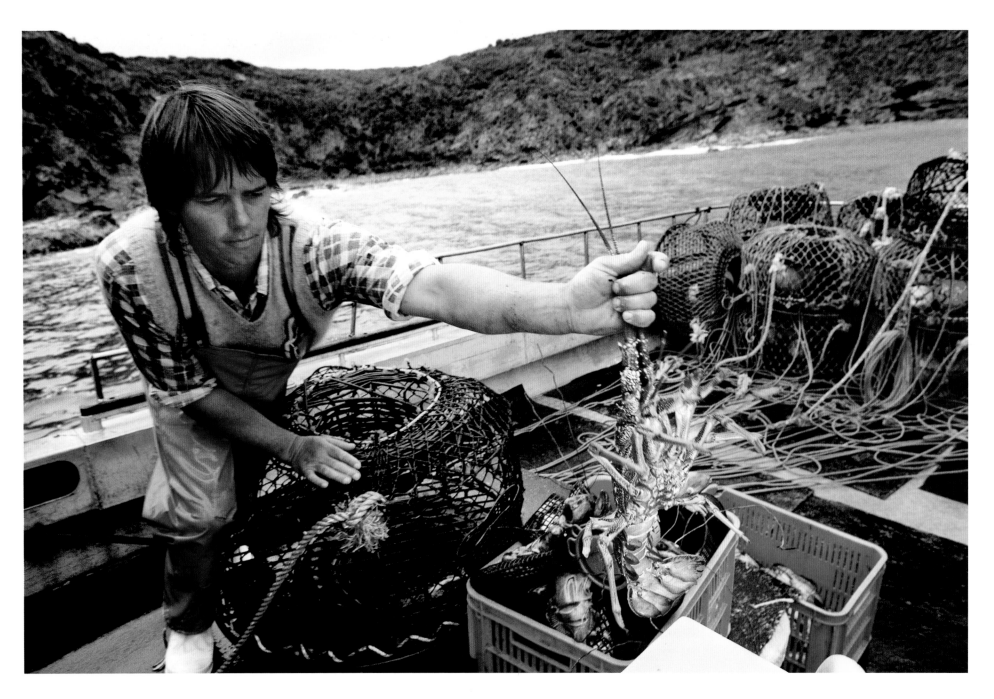

Australia's population is concentrated on the coasts, which means that seafood is a major part of most people's diets—especially shrimp and spiny lobster (shown here being harvested off Cape Otway, near Melbourne). The Molloys are an exception. Although John and Sean love seafood, Em is skeptical and Natalie can't abide it—she was forced to eat it as a child. Because Natalie does the shopping, the family doesn't eat seafood a lot.

Whether the name refers to the fine sand on its beaches or the money pouring in from commercialization, Brisbane's famed Gold Coast has become Australia's biggest tourist development. Every summer, throngs of just-graduated high school students invade Surfers Paradise, as this beach 30 miles southeast of the city is known—their arrival kicks off what is sardonically called "schoolies week."

I hadn't been in Brisbane in a dozen years and was pleasantly surprised to see how nicely the city had redeveloped its downtown and riverfront, with botanical gardens, bike paths, and riverside restaurants. I was surprised again by the suburbs: with their neat ranch houses, trim lawns, palm trees, strip malls, and fast food, they looked strangely like the suburbs of Los Angeles. The heat during our January visit built to a tropical crescendo—each afternoon around five it usually rained and thundered and blew. If it didn't, you felt like you'd go mad from the heat.

The afternoon we shot the Molloy family's portrait on their patio was no exception. A torrential rain and set-trashing wind hammered us right before we were ready to shoot, forcing us to take down our lights and cover up the food. It knocked out the electricity in the whole neighborhood. An hour later, when the storm had passed, the ambient light on the pool and the plants was pristine but there was still no electricity, and I was glad that I had all-battery-powered flash units. By 8 p.m., we had put all the food and equipment away and were drinking beer by lantern light—there was still no power—beneath the disco ball on the patio. The Molloys' daughter Emily emerged from the house with an assortment of cold appetizers. I grazed along the row of bowls and plates, sampling all of them. In this way I was rudely reminded that Vegemite, a yeasty paste best suited as roach bait, is an acquired taste.
— Peter

Much Australian food is similar to the foods found in Europe or the U.S. (*above right, local variants of the cereal known to Americans as Rice Krispies*). **But some are distinctly Australian, including, notoriously, the yeast-extract spreads** (*bottom right*). **The most famous of these is Vegemite, the Molloys' favorite, bought by Kraft from its Australian creators. Other brands include the locally manufactured Mightymite and Promite (a sweeter version). Some Australians still hold out for Marmite, the British original.**

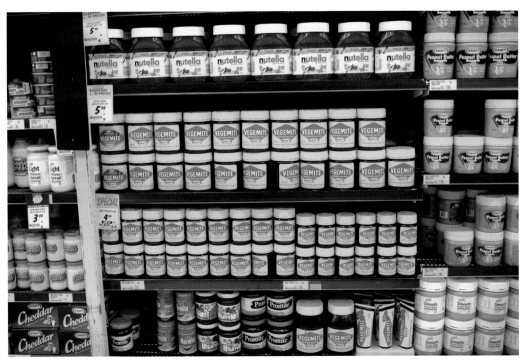

Molloy Family's Barbecued Prawns with Chilies, Coriander Leaves (Cilantro), and Lime Butter

16 large green king prawns

4 oz butter

2 fresh Thai chilies, seeded and finely chopped

2 T freshly squeezed lime juice

2 T fresh coriander leaves (cilantro), finely chopped

- Shell and clean prawns, leaving tails intact. Cut prawns halfway through from the back, then spread and press flat.
- Cook prawns on very hot, lightly oiled BBQ grill for approx. 1 minute (watch carefully so as not to overcook).
- Melt butter and mix in chilies, lime juice, and coriander leaves.
- To serve, drizzle sauce over prawns.

Natalie Molloy's Avocado and Mango Salad

Salad:

Mixed salad greens (arugula, watercress, cos [romaine], minuette, and/or other varieties), washed and dried

2 ripe avocados, thinly sliced

2 ripe mangos, thinly sliced

3 rashers (slices) bacon, cooked till crisp and coarsely chopped

1 cup pecans, whole

Dressing:

1/3 cup extra-virgin olive oil

2 T fresh lemon juice

1 T thickened cream

1 t whole-grain mustard

- Place salad greens on a flat dish and top with avocado, mango, bacon, and pecans.
- Combine dressing ingredients and drizzle over salad.

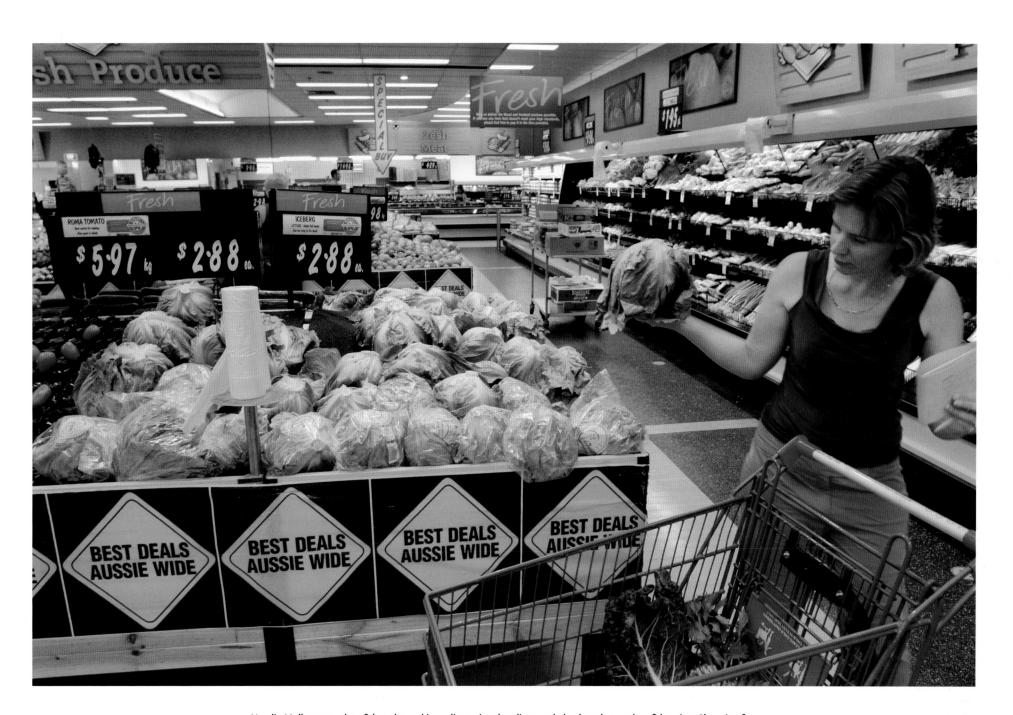

Natalie Molloy puts a lot of thought, and ingredients, into her dinner salads, though not a lot of dressing. Shopping for the evening's meal, she buys English spinach, tomatoes, carrots, cucumber, avocado, mung beans, capsicum (peppers), snap peas, and corn—though decides against the iceberg lettuce in her hand.

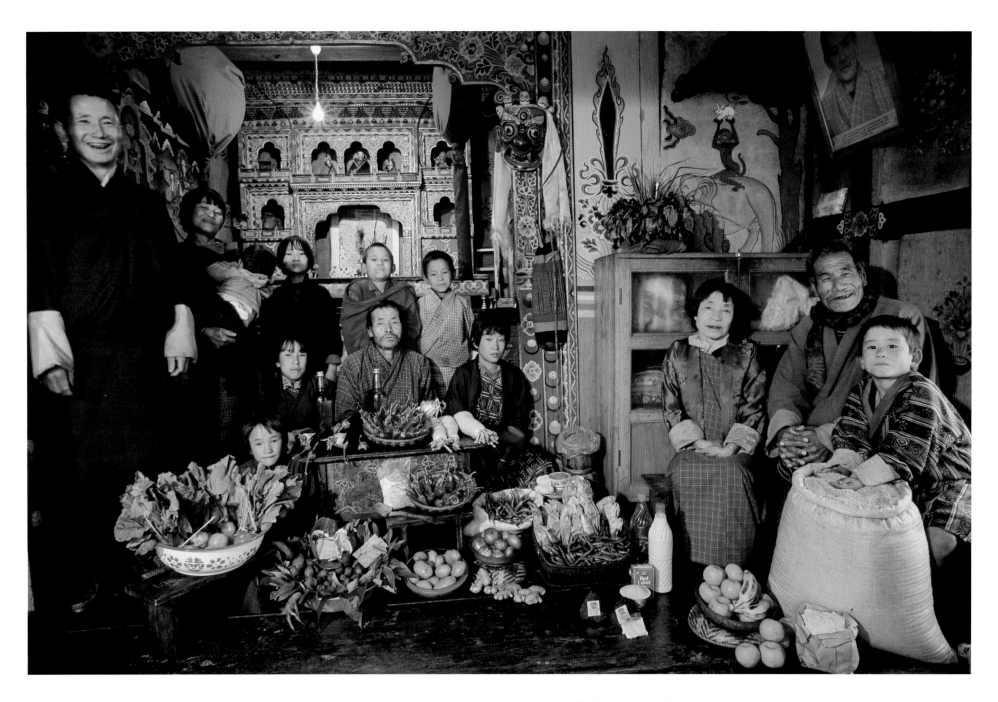

In Shingkhey, a remote hillside village of a dozen homes, Nalim and Namgay's family assembles in the prayer room of their three-story rammed-earth house with one week's worth of food for their extended family of thirteen. Cooking method: clay stove fueled by wood fire. Food preservation: natural drying. *(See opposite page for list of family members.)*

Power to the People

Family members (left to right, standing): Sangay Kandu (39, husband of Sangay), Sangay, 35, holding Tandin Wangchuk (7 months), Sangay Zam (12, daughter of Sangay Kandu and Sangay), Chato Namgay (14, monk, son of Sangay Kandu and Sangay), Chato Geltshin (12, son of Sangay Kandu and Sangay), (left to right, seated): Zekom (9, daughter of Nalim and Namgay), Bangam (also called Kinley, 21, daughter of Nalim and Namgay), Drup Chu (56, brother of Nalim), Choeden (16, daughter of Sangay Kandu and Sangay), Nalim (53, family matriarch and wife of Namgay), Namgay (57, family patriarch and husband of Nalim), Geltshin (9, son of Sangay Kandu and Sangay).

In Bhutan, the chili pepper is a vegetable, not a condiment, and is eaten at almost every meal. "This has been a bad year for chilies," says Nalim. "Insects attacked them, and they shriveled and died." Luckily, neighboring India can fill the void at the market, but it's hard for subsistence farmers like Nalim to afford to pay for a staple that they can usually grow themselves.

ON THIS EARLY WINTER MORNING in the Himalayan village of Shingkhey a potful of red rice simmers atop the low earthen stove in Nalim's kitchen. Nalim's daughter Sangay, a pleasant-faced woman with a ready smile, pushes another stick of wood into the fire hole to regulate the heat under the rice. Sangay's five other children and her two younger sisters are still asleep on the floor of the next room, but baby Tandin Wangchuk watches from his perch on her back as she mixes up whole chilies, cheese, onion, chili powder, and salt, and grinds it into a paste to eat with the rice. Meanwhile, Nalim has churned the morning milk into butter and is now preparing butter tea, which is—butter, with a few tea leaves, in hot milky water. Her husband Namgay extricates himself from the arms and legs of his slumbering children and grandchildren and limps over to the kitchen fire, where Nalim pours him a steaming cup of the salty liquid. He sits by the glassless window of their house, sips deeply, and looks out over their small sleeping village. The quiet will end abruptly when the children awaken.

Nalim, who like most people in Bhutan has no family name, is a subsistence farmer in the central part of the small kingdom of Bhutan, just northeast of India. Her husband Namgay is the village seer; he spends his days reading holy Buddhist texts for the sick, the unlucky, and the hopeful. He also mills grain for other villagers, using a small fuel-powered machine that he got through a government loan program. Because he is disabled, Namgay can't do the heavy labor that most men in farming families do. That work is left to Nalim's son-in-law, Sangay Kandu, and her brother, Drup Chu, who do the plowing with a pair of ornery bulls and a wooden plowshare. When they need extra help, others in the village pitch in—and Sangay Kandu returns the favor when asked: cooperation is often the key to survival in poor places.

Sangay and Nalim take turns tackling the inevitable tasks of parenthood and farming. One feeds breakfast to their family of 13, gets the kids ready for school, slops the pigs, and

sends the cows off to graze, while the other heads to the fields for the day's work—sowing, hoeing, and harvest. These days, though, Nalim is usually the designated field-worker because Sangay is nursing Tandin Wangchuk. It was different with their last babies; Nalim's youngest daughter, Zekom, now 9, is the same age as Sangay's son Geltshin, and either mother could stay home and nurse both babies while the other worked in the fields.

Like many Himalayan villages, Shingkhey has narrow, terraced fields, with trails between them that lead to pounded-earth houses. The houses are all three stories tall and have hand-carved windows—some with glass, most without—and an elaborately decorated prayer room. Painted by monks in traditional motifs and containing an ornate carved altar, the prayer room is used during the yearly *puja* (ritual family blessing) and for daily Buddhist offerings. Families live on the second story of the house; they store dried meat, grain, and straw in the large top-story loft; their animals are corralled on the ground floor. For years, the government has been trying to stop families from keeping animals so close to their living quarters, because it encourages the spread of insects and disease, but it's still a common practice.

Namgay's moment of peaceful reflection with his cup of butter tea ends when the children begin to stir. Sangay's son Geltshin comes into the smoky kitchen and is handed a cup of watery whey left over from yesterday's cheese making. Namgay and Nalim's grandson Chato Namgay, a 14-year-old Tantric Buddhist monk who is studying in the district capital, Wangdi Phodrang, is home for a visit. He wraps his maroon robes over his Western-style undershirt and carries a flame from the kitchen to light the butter lamps on the altar in the prayer room. "I'm studying Buddhist teachings," he tells me, "and I'm learning stitching [religious embroidery]." He's currently working on a rendition of the triple jewels, the Buddha, the Dharma, and the Sangha—the three central concepts of Buddhism. He likes the school a lot, he says, and laughs when I ask him whether he misses day-to-day village life. "Studying is much better than working in the fields or [tending] the cows," he replies. Still, he plugs right back into life here when he returns, as if he'd never left.

The children fold up the bedding without being asked and Zekom distributes bowls in a circle on the wooden floor. It has developed a handsome, waxy, hand-rubbed sheen after decades of being cleaned after meals of red rice, chilies, and cheese. Everyone accepts a dollop of curry in a bowl, then rolls the rice into little balls and dips them into the curry. The conversation is brisk until the last scrap of food is eaten. Inevitably, it disappears in less time than it took Sangay to make it. This and the butter tea constitute breakfast, which closely resembles lunch and dinner. Almost all the family's meals consist of cheese, vegetables, and red rice. (Mostly rice—in the course of a week, they will eat almost 70 pounds of it. In eastern Bhutan, though, corn, rather than rice, is the staple grain.) As Buddhists, they don't kill animals for food, but if a cow dies by accident, then they'll eat it. "When we have meat, we'll eat it until it's gone. It's morning, afternoon, and evening, meat," says Nalim, laughing. Otherwise, they have meat only during the *puja*, when a group of visiting monks cleanses the house of evil spirits. Every house in a village has a *puja* once a year and shares the meat of a pig, which has been killed by a special butcher. In Nalim's village of 12 houses, that's a taste of pig 12 times a year.

Not So Chili

Nalim is unhappy that she has to buy chilies this year. She's used to growing or raising almost everything herself, and if she doesn't have something she needs, she borrows it from a neighbor. The problem is that no one has had a good chili year. For subsistence farmers like Nalim, money didn't much figure into the economic equation in the past, but now they have expenses that require an outlay of cash. She sells cheese and homemade *ara*, a potent grain-alcohol drink, in Gaselo, where her children go to school, an hour's walk away. The extra money, which should be used to purchase school uniforms and supplies, now must be used to purchase food.

While the children clean up—again without being asked—Namgay dips into the hidden pouch in his *gho*, the traditional robe worn by Bhutanese men, and pulls out a betel nut and some lime paste for his first morning chew. It's easy to tell when someone is chewing betel nut, the mildly addictive, mildly narcotic fruit of the areca palm tree. They look like they're bleeding from the mouth. All four adults in the family chew it regularly, as does almost everyone in Shingkhey.

Matrilineal, Inc

Nalim and Sangay's mother-daughter partnership gets a real workout in the early summer when the rice plants are tender. "It takes too

- Population: **2,185,569**
- Populaton of Shingkhey village: **96 (est.)**
- Area in square miles: **18,142 (half the size of Indiana)**
- Population density per square mile: **121**
- Urban population: **9%**
- Percent of population that are subsistence farmers: **85**
- Land that is above 10,000 feet in elevation: **44.5%**
- Population with access to electricity: **30%**
- Life expectancy, male/female: **60/62 years**
- Fertility rate (births per woman): **5**
- Literacy rate, male/female, 15 years and older: **56/28%**
- Annual alcohol consumption per person (alcohol content only): **0.6 quarts**
- GDP per person in PPP $ (Purchasing Power Parity: an adjustment for what equivalent local goods would cost in the U.S.): **$1,969**
- Total annual health expenditure per person in $ and as a percent of GDP: **$9/3.9**
- Overweight population, male/female: **34/45%**
- Obese population, male/female: **5/13%**
- Meat consumption per person per year: **6.6 pounds**
- McDonald's, Burger King, KFC, Pizza Hut restaurants: **0**
- TV stations in 1998/2005: **0/1**
- Government tariff for individual foreign visitors per day: **$205 to $240**

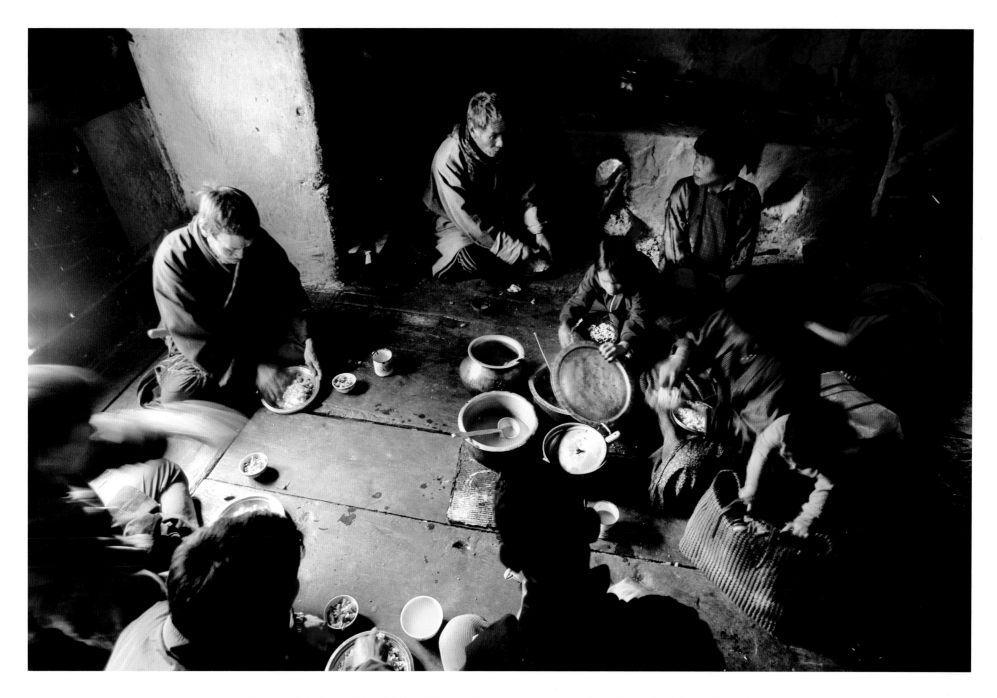

Namgay (left, by fire) and his wife Nalim (right, by fire) eat a lunch of red rice and a small cup of cooked vegetables with their family and friends in the kitchen area of their earth-walled house. The kitchen and adjoining rooms are often smoky because the cookstove/fireplace is inside the house and doesn't vent to the outside. Nalim says that she would like to build a kitchen in a different building but can't afford it.

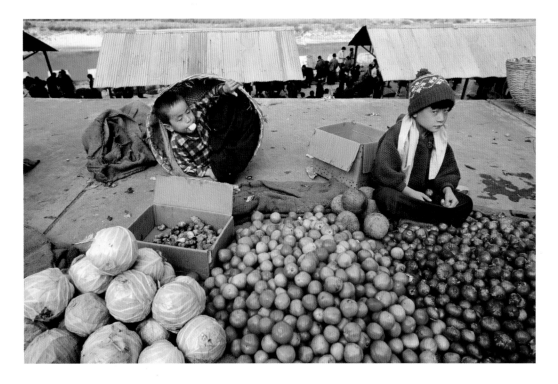

Bhutanese *Shamu Datshi* with Pork (Mushroom, Cheese, and Pork)

4 lb dried pork (if unavailable, use bacon, not fresh pork), chopped into tiny pieces

3–4 lb fresh or dried mushrooms, sliced *(collected in the forests of Bhutan during June, July, and August)*

12 fresh red chilies (use dried if unavailable), sliced

2 balls (tennis-ball-size) crushed cow cheese

1 T mustard oil, vegetable oil, or soybean oil

salt, to taste

4 green onions, shredded

- Cook chopped pork in a pot until tender.
- Add mushrooms and chilies to meat, followed by cheese.
- Pour oil and salt on top. Cover and cook.
- When mixture starts to boil and cheese starts to melt, stir well.
- Sprinkle onions on top. Serve with red rice.

Bhutanese Red Rice

6 oz red rice per person

- Rinse rice and place in a large pot. Add water to cover rice by 3 inches.
- Cook over high flame until boiling.
- Stir occasionally, until rice turns semisoft.
- Drain off water by placing lid over pot and tilting pot sideways.
- Place pot back on stove; spread cooked rice until level in pot.
- Cook on low flame for 5 minutes. Stir once and serve.

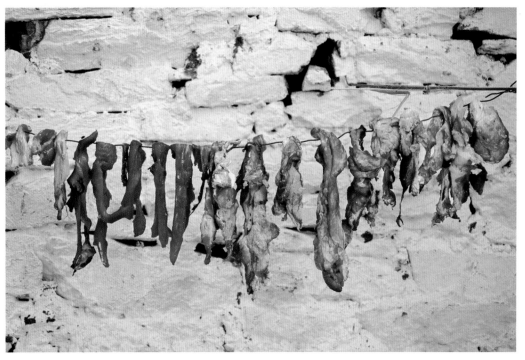

Young market vendors tend their family's cabbage, tomatoes, and onions in the Sunday market in Wangdi Phodrang *(above left)* a two-hour walk from Shingkhey village. Above the municipal market, a shopkeeper's TV satellite dish doubles as a dehydration rack for red chili peppers *(at right),* while back in the village, meat is preserved by drying it in the sun.

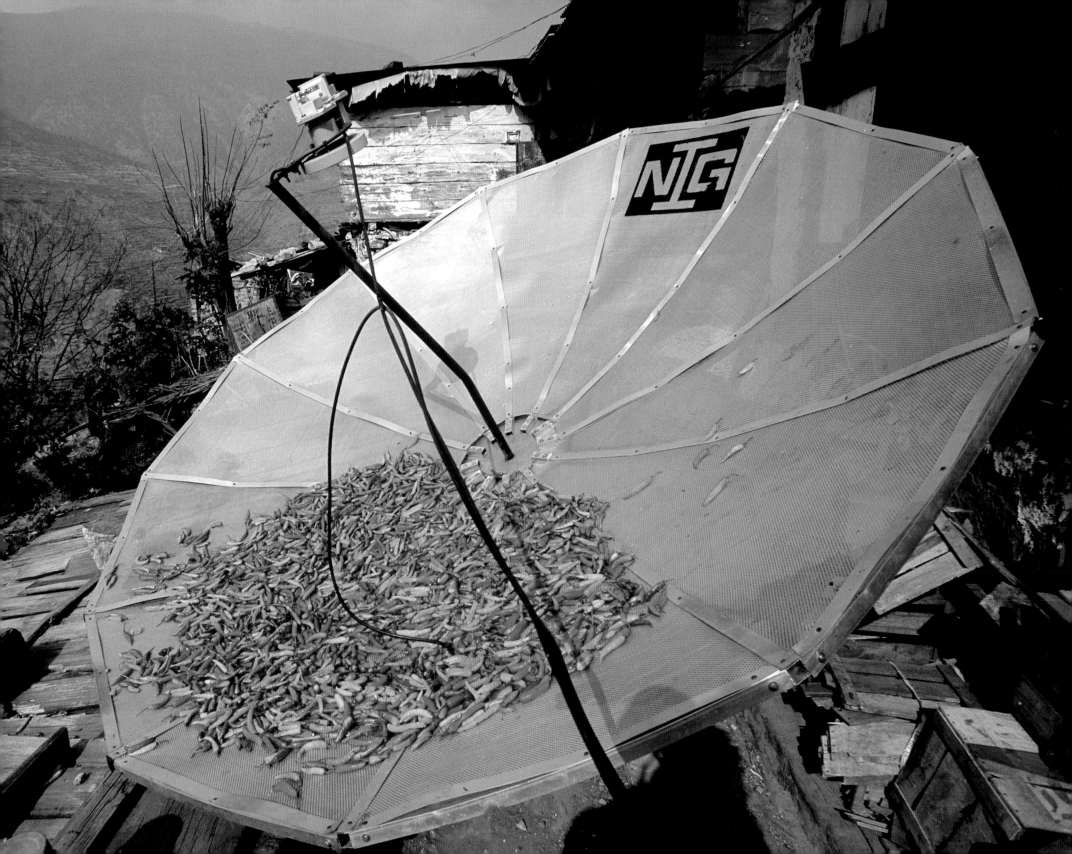

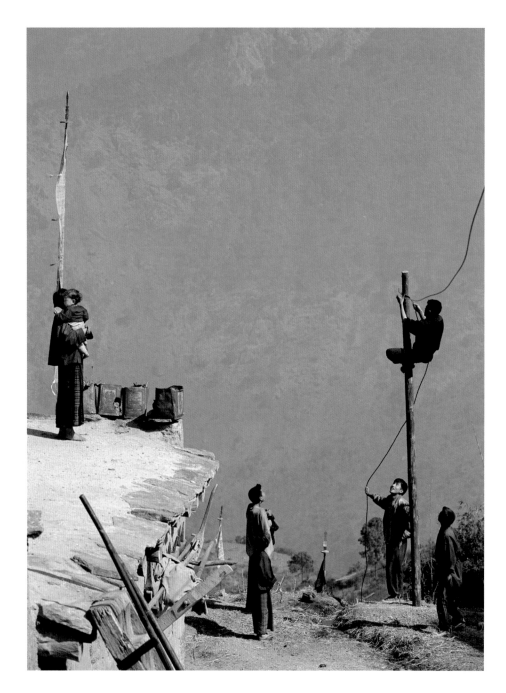

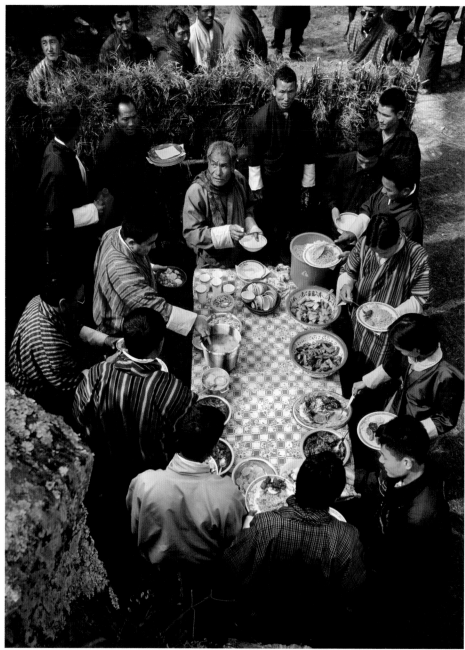

On the ledge of their house, Sangay, holding Tandin Wangchuk, watches government workers complete the electrical connections from a new small hydroelectric dam in a neighboring valley. The next day, during a celebration of the electrification, visiting dignitaries join Namgay (at the head of the table) at a buffet of red rice, potatoes, tomatoes, cucumbers, beef, chicken, and a spicy cheese and chili pepper soup. The villagers have been stockpiling food for the event.

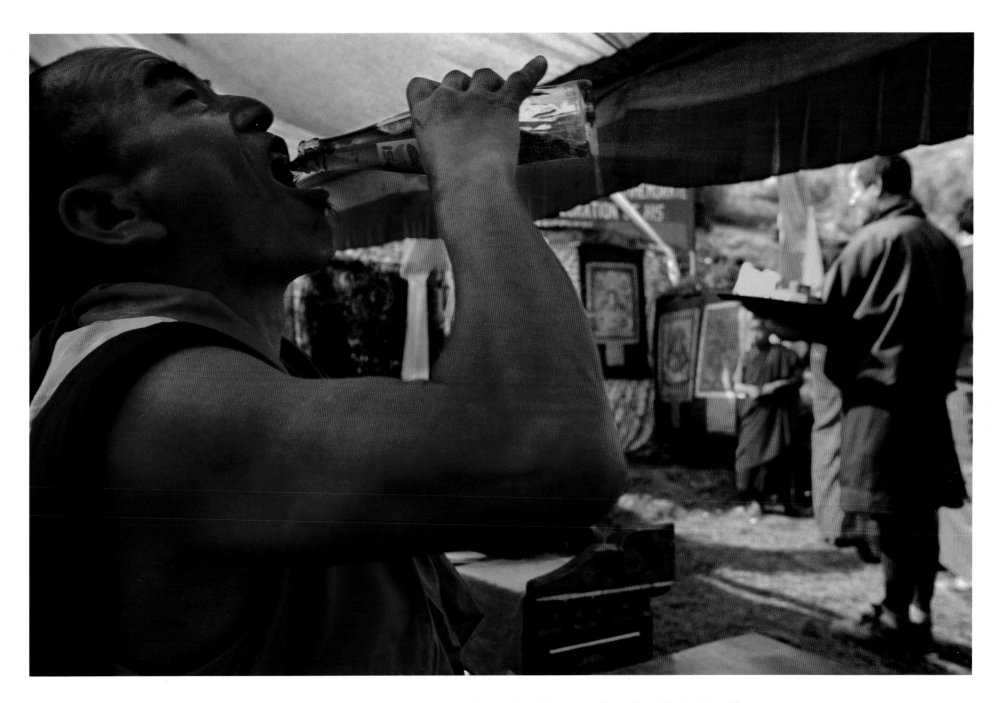

Sitting in lawn chairs under a tent with other guests of honor, a lama takes a swig of Pepsi during the electricity celebration. Chato Namgay (in red robe) has just lighted the ritual butter lamps on an altar below the transformer on the power pole. Above a photo of the king, a sign reads: "Release of Power Supply to Rural Households Under Wangdi Phodrang Dzon Khag to Commemorate Coronation Silver Jubilee Celebration of His Majesty, King Jigme Singye Wangchuk."

much time to go down to my house and then back up to the fields," Nalim says. "If it's raining, I just eat in the rain." Many of the fields they farm don't belong to the family. Nalim rents them from other villagers, and gives the owners half of the harvest in return.

Farming the scattered, steeply pitched plots is hard work: sometimes she must stay in the terraces overnight, especially just before a harvest, when grains are looking especially succulent to the roaming cattle and horses with inattentive owners. One hungry cow or two can ruin an entire harvest, but the animal's owner must pay back what has been eaten or damaged. If there's no one around to see what happened, then there's big trouble until blame can be assessed. "If my cows go into other fields, I have to pay," Nalim says.

In addition to rice, Nalim's family grows wheat, barley, and mustard. In snatched moments of spare time, she winnows harvested mustard seed on a ledge outside the house and then presses it for oil, which they use for cooking. Next to the house they raise tomatoes, carrots, spinach, chilies, green onions, beans, squash, and turnips. When they're not in school, the younger children are responsible for keeping animals out of the vegetable garden.

Sangay's daughter Choeden, 16, is the only child in the family who doesn't go to school. The chief animal-tender and field assistant, she is being groomed to take over the household and the farming. Originally, it was to have been Nalim's middle daughter, Bangam, but the girls decided the matter themselves: Choeden didn't want to go to school and Bangam did, so they switched roles. It was best, Nalim says, because Bangam is not as strong as Choeden. Bangam, like her father, is a hunchback. When someone from the family has to work on a village construction project, Choeden is always the designated worker. Just yesterday, after tending the cows all day, she spent a companionable evening singing with her girlfriends and pounding a rammed-earth wall with a wooden tamper, as part of a home-building construction crew. "Yes, Choeden is a big help," says Nalim. "Bangam sometimes has to stay home from school to help take care of the younger children, if we're working in the fields and Choeden is away helping someone else, but Choeden has a lot of responsibilities now."

Nalim is interested to hear from me that Bangam's English—a required course in Bhutan's schools—is getting quite good. But she's quick to point out that education itself doesn't put food on the table. In fact, with school uniforms and supplies to buy, it costs her money.

"Well," says Nalim, "at least she's good at one thing. When I take Bangam with me [to the market town of Wangdi Phodrang] she can read the signs and tell me what they say, so that helps." Echoing a lament of mothers everywhere, Nalim adds, "Sometimes I get angry with Bangam when she doesn't do housework. I tell her, 'You're the one who gets to go to school and have the new clothes—you have to clean the house when you're home.'" Nalim expects her daughter to use her education to get a job and help support the family. "There are so many people to feed, but so few people to do the work," says Nalim. "I hope that this will change as they get older."

LET THERE BE LIGHT BULBS

A switch will be flipped tomorrow afternoon, and the dark corners of Nalim's earthen house, and the houses of her neighbors, will all spring into the light for the first time ever. That such a remote village can get electricity is a testament to the vigor with which the government is harnessing the power of Bhutan's rivers to modernize the countryside. Nonetheless, it's hard not to wonder whether Nalim will be able to afford light bulbs and lamps, much less the electricity to power them. The government, we learn, is subsidizing the rural communities' power and fixtures, but Nalim will have to buy her own light bulbs. Yesterday, Sangay went to the ledge outside their house, where she and her mother have winnowed mustard seed for decades, and watched government electricians raise the last power pole. And Nalim and the children gathered at the back of the house by the kitchen garden as another worker attached power lines to the meter outside their door—above the landing where generations of Nalim's kin have washed their faces, brushed their teeth, and bathed their babies.

In the evening before their dinner of red rice, chilies, and spinach curry, lit only by the kitchen fire, the family stood in the smoky room as a bare, dangling light bulb—the first in their home—came to life in the middle of the ceiling. The grins on their faces, bathed in this new, day-prolonging, artificial light, were wondrous. The lights won't be turned on permanently until tomorrow, when government workers, lamas, and monks come for the official celebration, but Nalim has waited this long—she doesn't mind waiting a little longer. Dinnertime in semidarkness will be a thing of the past. And even the cows on the ground floor will have a light to eat by.

FIELD NOTE

Friends, neighbors, relatives, wandering photographers—visitors are always welcome at the rammed-earth house of Namgay and Nalim. Anyone who shows up at the door is offered toasted rice and tea with milk or butter tea (butter boiled in slightly salty water and maybe a little tea). Most visitors seem to wander in at mealtime and stay for the huge pot of steaming red rice. On top of the rice prepared by Nalim and her daughter Sangay, guests ladle chilies, cheese, vegetables (tomatoes, turnips, onions), and sometimes pieces of dried beef or fish. I like the spicy Bhutanese food, even the dried meat that taxes your jaw muscles. Sitting cross-legged in front of the hearth, everyone chats and shares stories, tossing and spitting inedible pieces of meat or bone onto the floor, which is patrolled by cats and chickens.

During my first visit, it was May, springtime in Bhutan, when everything wakes up from the winter—including the insects. The flies during the day were as numerous and ferocious as the fleas at night. I ate rural Bhutanese style, dipping into the food with my right hand (no utensils) while waving off the flies with my left. Faith says that when she came here in June one year, there were no flies at all.

This time, we came in February, when it was too cold for the flies to breed in the dung that collects under the living quarters (the animals are stabled on the ground floor of the house). The only problem with eating indoors during the winter is the smoke. Namgay and Nalim have a very inefficient flue over the open-hearth stove and the smoky no-breathe zone starts at about five feet above the floor—okay if you are five feet tall, like most Bhutanese, but a real pulmonary problem for six-footers like me. When you're seated, the smoke is tolerable.

— Peter

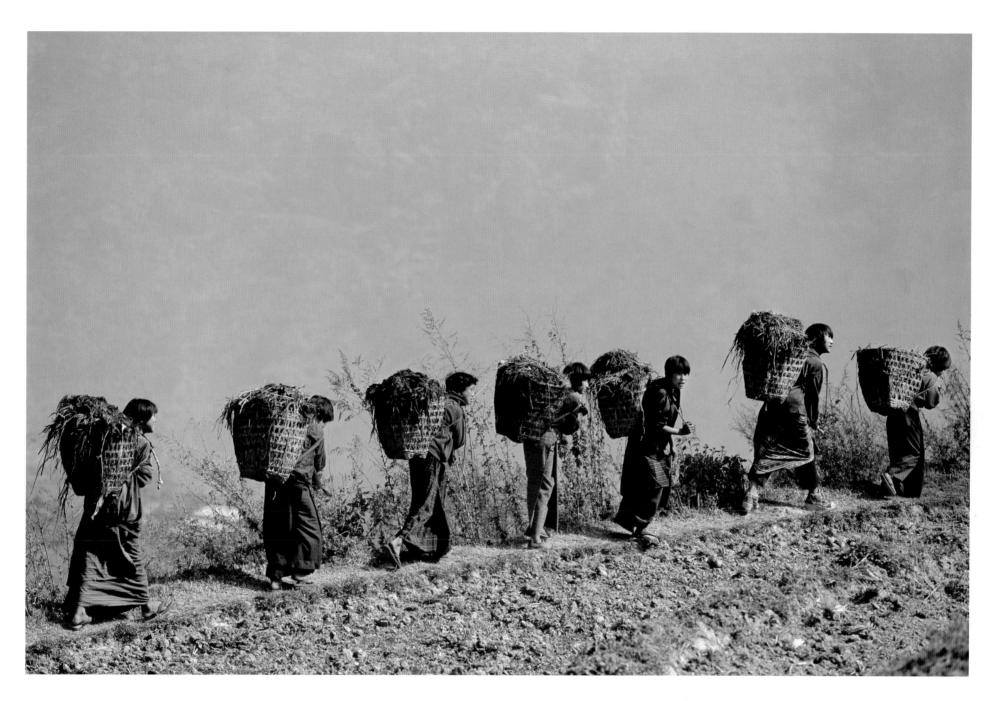

The day after the electrifying celebration in the village, life returns to normal. Singing as they walk, Bangam (third from the right) joins other village girls in collective women's work: cleaning out the manure from the animal stalls under the houses and spreading it on the fallow fields before the men plow. All wear the traditional *kira* worn by all Bhutanese women—a rather complicated woven wool wrap dress. Men wear a robelike wrap called a *gho*.

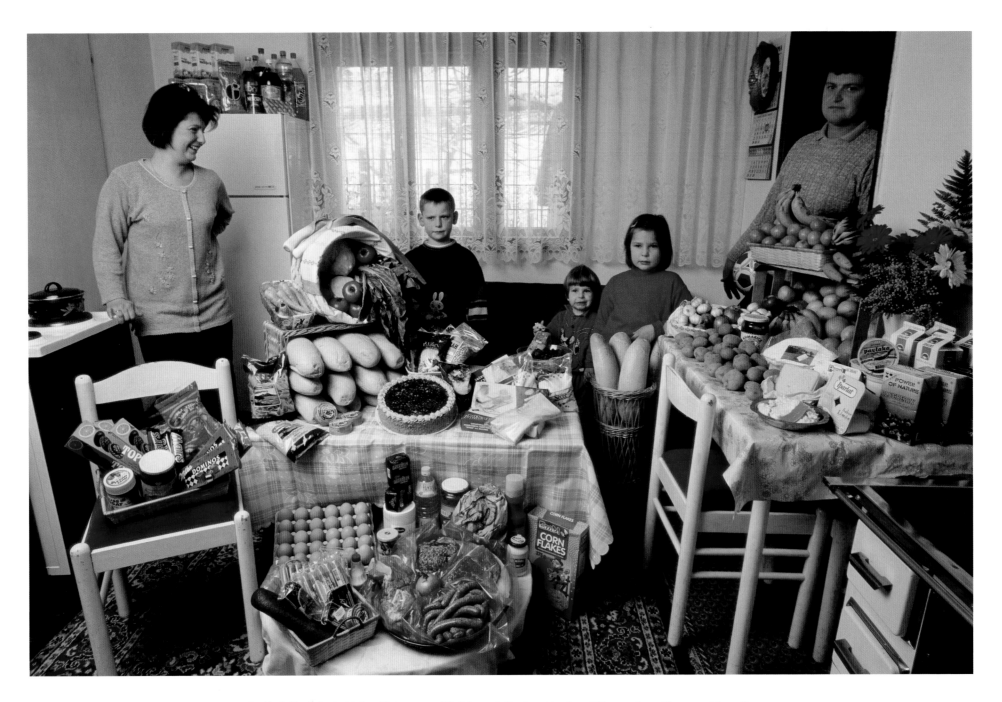

The Dudo family in the kitchen/dining room of their home in Sarajevo, Bosnia and Herzegovina, with one week's worth of food. Standing between Ensada Dudo, 32, and Rasim Dudo, 36, are their children (left to right): Ibrahim, 8, Emina, 3, and Amila, 6. Cooking methods: electric stove, coal/wood stove. Food preservation: refrigerator-freezer.

Postwar Fare

Grains & Other Starchy Foods: $17.40

Bread, 15.5 lb; flour, 4.4 lb; potatoes, 4.4 lb; white rice, 2.2 lb; jufka (thin pastry sheets), 1.1 lb; *Fiamma Vesuviana* penne, 1.1 lb; *Fiamma Vesuviana* riso (pasta), 1.1 lb; pastry sheets, 1.1 lb; *Embi* corn flakes, 13.2 oz.

Dairy: $17.77

Milk, 1.9 gal; yogurt, drinkable, 1.1 gal; cream, 1.6 qt, *used on bread or with eggs; Zvijezda* ghee (butter clarified by boiling, and converted into an oil), 2.2 lb; gouda cheese, 1.3 lb; travnicki cheese (white Bosnian cheese), 1.3 lb; butter, 1.1 lb; *Iparlat* lemon yogurt, 14.1 oz; *Paschal* pineapple yogurt, 14.1 oz.

Meat, Fish & Eggs: $54.22

Ground beef, 4.4 lb; eggs, 30; hot dogs, 4 lb; chicken, baked, 2.2 lb; beef sausage, 2.2 lb; mutton, 2.2 lb; steak, 2.2 lb; veal, 2.2 lb; *Argeta* chicken pâté, canned, 1.1 lb; hard sausage, 1.1 lb; Sarajevo keep-long sausage, dried, 1.1 lb; sardines, canned, 8.8 oz.

Fruits, Vegetables & Nuts: $28.18

Tangerines, 8.8 lb; apples, 6.6 lb; oranges, 6.6 lb; yellow bananas, 3.3 lb; lemons, 1.1 lb; figs, dried, 7 oz; cabbage, 2 heads; carrots, 2.2 lb; garlic, 2.2 lb; kidney beans, 2.2 lb; leeks, 2.2 lb; lentils, 2.2 lb; yellow onions, 2.2 lb; spinach, 2.2 lb; tomatoes, 2.2 lb; mushrooms, 1.1 lb; pickles, 1.1 lb; red peppers,‡ 1.1 lb; peanuts, 2.2 lb.

Condiments: $8.75

Sugar, 4.4 lb; sunflower oil, 1.1 qt; fruit compote,‡ 1.1 lb; cream, 8.5 fl oz, *for coffee; Hellmann's* mayonnaise, 8.3 oz;

peach marmalade, 7.8 oz; mustard, 7.1 oz; sea salt, 7.1 oz; white sugar cubes, 3.5 oz; salt, 1.1 oz.

Snacks & Desserts: $21.74

Raisins, 4.4 lb; hard candy, 2.2 lb; *Dominos* milk chocolate candy, 1 lb; *Tops* orange and chocolate cookies, 1 lb; *Nussenia* nut cream (chocolate spread like *Nutella*), 14.1 oz; *Mars* candy bars, 5.9 oz; *Gold Flips* corn puffs, 4.2 oz.

Prepared Food: $2.47

Chicken soup mix, 5.5 oz; chicken bouillon, 4.7 oz.

Homemade Food:

Cake, whole, *made with ingredients listed above.*

Beverages: $16.90

Fanta orange soda, 2 2.1-qt bottles; *Coca-Cola*, 2.1 qt; *Dijamant* mineral water, 2.1 qt; *Frutti* blueberry juice concentrate, 2.1 qt; *Power of Nature* blueberry and grape juice, concentrate, 2 1.1-qt cartons; *Sunset* orange juice, 2.1 qt; *Mljevena* coffee beans, 1.1 lb; cocoa, 8.8 oz; *Dona* pineapple juice concentrate, 8.5 fl oz; orange juice drinks, powdered, 5.3 oz; *Nescafe* instant coffee, 3.5 oz; tea, 3.5 oz.

‡ Not in Photo

Food Expenditure for One Week: 334.82 Konvertibilna Marka/$167.43

Sarajevo has had its share of strife, and therefore it is not surprising that large tracts of land have been given over to highly visible, and in some cases quite beautiful, cemeteries. Nedzad Eminagic, a lawyer in Sarajevo, explains that the graveyards are seen as a natural part of Sarajevan life: "People here do not look at the graveyards as something so black. These are our neighbors, our sons, and our families, and as Muslims we do not see them as dead. I grew up playing at an old Ottoman graveyard as a kid. My house was just near it; maybe built on it. But none of us, my family or neighbors, ever felt uncomfortable."

ENSADA DUDO SETS TINY COFFEE CUPS on a tray as her husband Rasim gives the crank on his small brass coffee grinder a final brisk turn. They are preparing strong, sugary, Turkish-style coffee for guests on this snowy Saturday afternoon in Sarajevo. She serves the coffee with two Turkish treats: *Rahat lokum*, nutty jellied chews (Turkish delight), and *halva*, a confection traditionally made from honey and ground sesame seeds. The Turkish influence is no surprise: the Ottomans ruled southeastern Europe from the 1400s until late in the 19th century. The goodies attract Emina, 3, and Amila, 6, until they discover they aren't chocolate. The girls return to the window to watch their brother Ibrahim, 8, sledding with friends on new-fallen snow. "They love desserts," says Ensada, "so I bake on the weekends." Women who work outside their homes tend to try to make up for their absence by cooking special treats on the weekends, but Ensada has found that her children are "just as happy, or more so" with a store-bought chocolate Kinder egg and the tiny plastic toy that's hidden inside.

Despite their love of the long Sarajevan coffee break, which can last an hour or more, neither Ensada nor Rasim has much leisure time. Ensada works long hours for the Muslim humanitarian organization Merhamet, and Rasim is a private taxi driver in a city with too many taxi drivers trolling about for fares. The two return home at lunchtime for what is typically the main meal of the day. When they arrive, Rasim's mother, Fatima, who cares for the children while their parents are at work, retreats to a quiet lunch in her apartment upstairs. Despite Ensada's busy schedule, she does not rely on prepared foods or take-out for the lunchtime meal. She makes stewed chicken, or *bosanski lonac*—a meat and vegetable stew usually made with mutton. The Dudos are Muslim and therefore eat no pork. Their evening meal is light and might include leftovers along with *ajvar*, a preserved eggplant and red pepper spread, on crusty slices of bread.

Although Ensada and Rasim buy most of their nonperishables at a bright new supermarket, they still prefer to buy eggs, seasonal fruits, and vegetables at the outdoor Green Market Ciglane. Its surrounding area is a daily reminder of the recent civil war—the site of the 1984 Winter Olympics, with its great athletic feats, has become, in part, a graveyard full of the war dead.

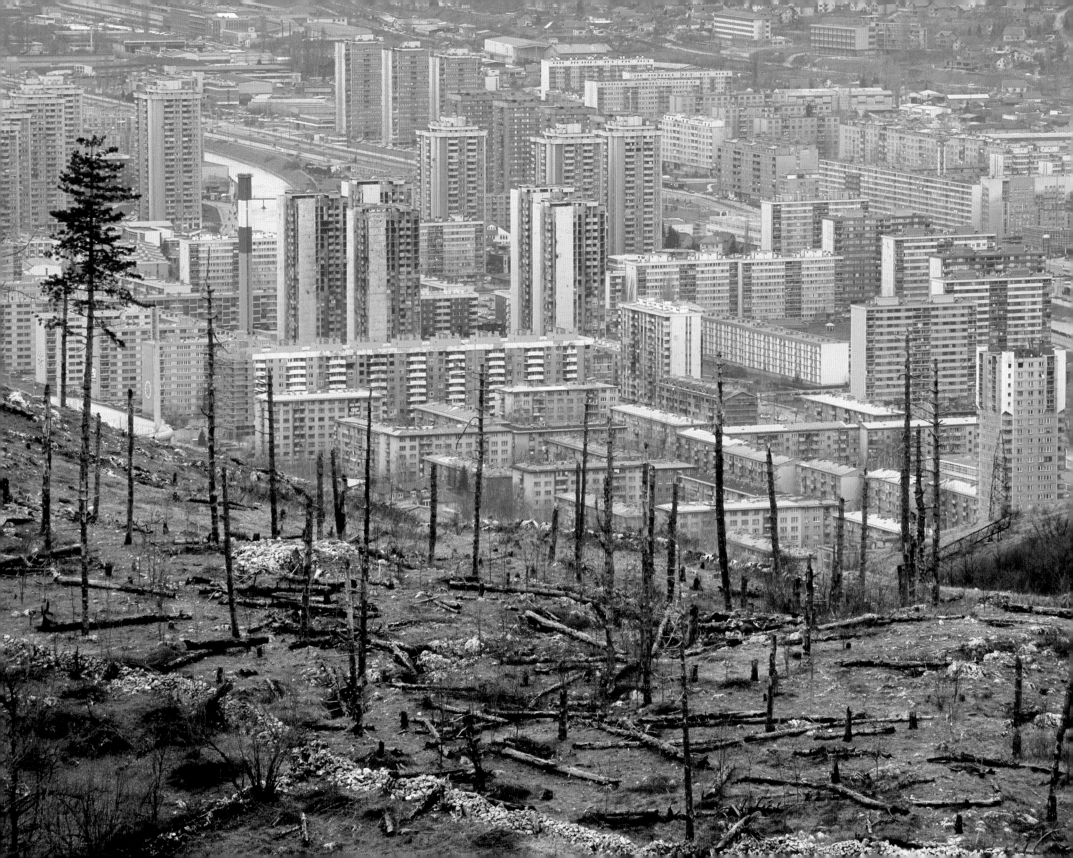

UNCIVIL WAR

Throughout Bosnia's violent civil war of the early 1990s, Ensada and Rasim Dudo and their family struggled to put food on the table. Even so, they were better off than most Sarajevans. Living in the foothills above the city, they had their own well (thus their own water supply), fruit trees, a vegetable garden, and a milk cow. They shared their water and any extra food with their neighbors.

Before the war, Sarajevans in the old city, nestled in their homes and apartments on the valley floor along the river Miljacka, lived a generally comfortable life. Under siege, they were sitting ducks for the paramilitary forces looking down on them from the hills. The task of survival wholly consumed daily life. Women, children, and the elderly braved sniper's bullets to stand in line for water rations and to find food, while able-bodied men went to the front lines to fight. Public utilities and services were nonexistent. The city's ragtag soldiers carried firewood home to their families, as there was no electricity or gas to run their modern stoves.

Thousands died in the war and in the city, among them Rasim's father, who died of a stroke at the front, his sons at his side. Although most of the Dudo family spread across the globe as refugees during the war, Rasim and Ensada remained in Sarajevo with Rasim's mother, Fatima, and Rasim's younger sister, Senada. Today they still live in the same two-family house Rasim's father built before the war. Physically, they say, the city is being revitalized, both by donor countries and by the return of commerce. Emotional scars, however, are slow to heal in this city whose relatively cohesive multi-ethnic population was torn apart by clashing nationalist ideologies.

Signs of the four-year siege of Sarajevo *(at left, former Serb gun emplacements overlooking the city)* are still obvious today. Although food stalls have returned to the Ciglane market *(bottom right)*, parts of the Olympic park behind it *(above right)* have become a burial ground for siege victims.

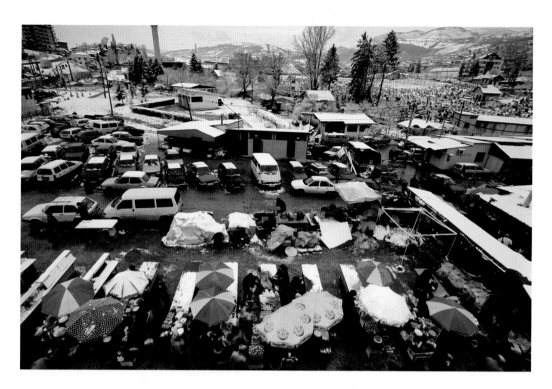

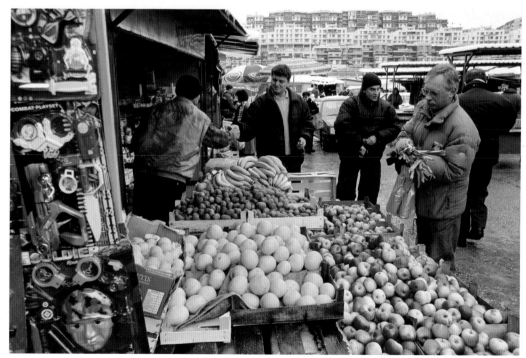

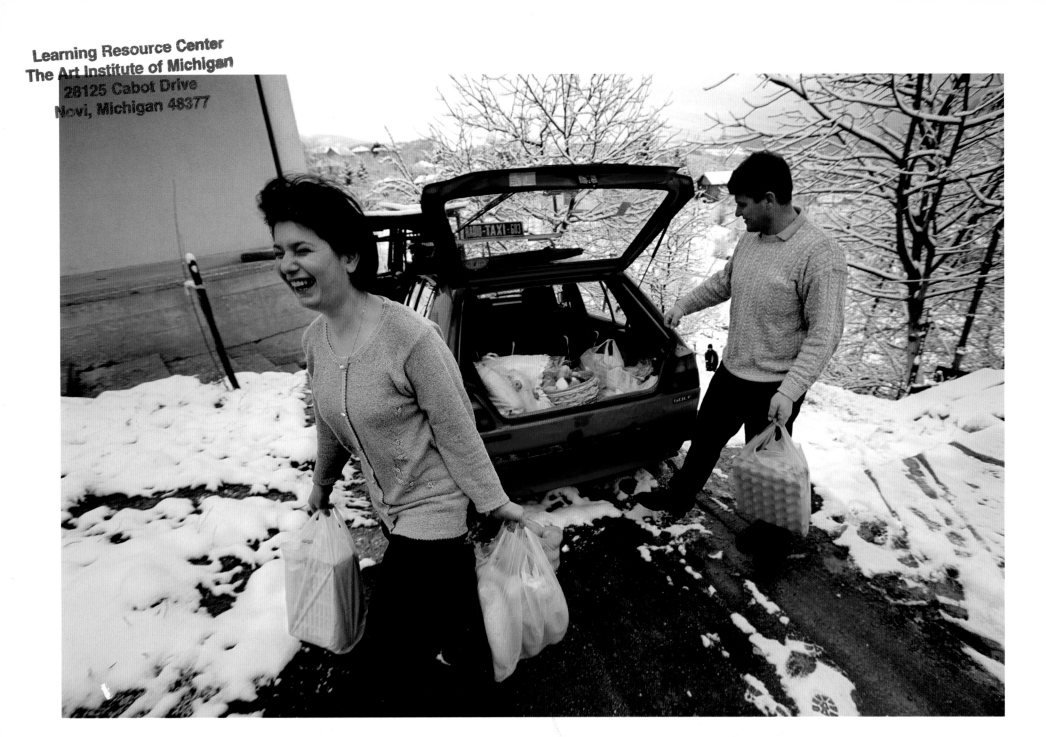

Although their complicated schedules put pressure on their lives, the couple still tries to preserve the rituals and pleasures of eating. Remembering all too well when the city was starving, they are grateful that they can now fill Rasim's taxi with the weekly grocery shopping. Ensada graciously welcomes visitors with Turkish sweets and cups of Turkish-style coffee (far right) on a handcrafted tray—metalwork is a Sarajevan specialty.

BOSNIA & HERZEGOVINA

- Population: **4,007,608**
- Population of Sarajevo: **380,000 (est.)**
- Area in square miles: **19,736 (slightly smaller than West Virginia)**
- Population density per square mile: **203**
- Urban population: **45%**
- Life expectancy, male/female: **69/76 years**
- Fertility rate (births per woman): **1.3**
- Caloric intake available daily per person: **2,894 calories**
- Undernourished population: **8%**
- Annual alcohol consumption per person (alcohol content only): **6.7 quarts**
- GDP per person in PPP $ (Purchasing Power Parity: an adjustment for what equivalent local goods would cost in the U.S.): **$5,970**
- Total annual health expenditure per person in $ and as a percent of GDP: **$85/7.5**
- Overweight population, male/female: **57/51%**
- Obese population, male/female: **14/22%**
- Meat consumption per person per year: **47 pounds**
- Available supply of sugar and sweeteners per person per year: **73 pounds**
- McDonald's restaurants: **0**
- Percent of population, male/female, age 18 and older, that smokes: **55/32**
- Deaths during siege of Sarajevo, 1992–1996: **15,000**
- Unemployment rate (2002): **40%**
- Suicide rate per 100,000 people, prewar and postwar (1992/2003): **11/20**

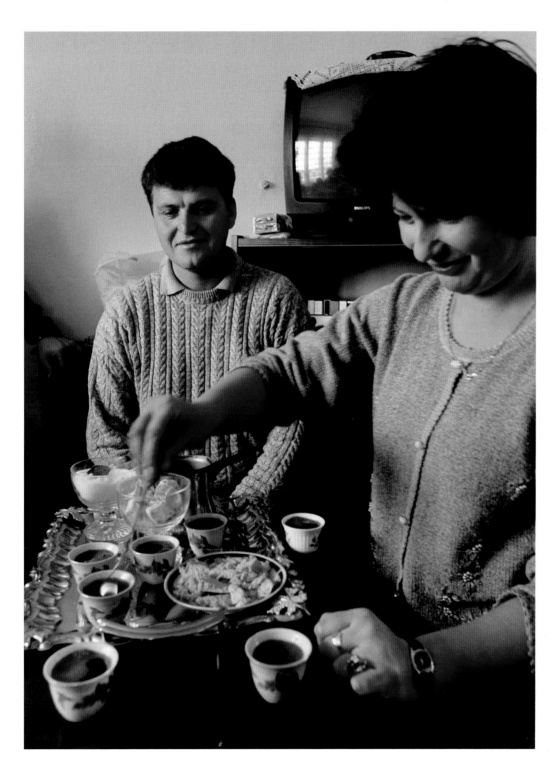

FAMILY RECIPE

Ensada Dudo's *Sitni Cevap* (Small Kebabs)

7 oz butter

4 oz onions, chopped

2 cloves garlic, chopped

1-1/3 lb *junetina* (heifer meat), cut into 1/2–1" pieces

parsley leaves, chopped

celery leaves, chopped

salt

pepper

1–2 T tomato puree

cayenne pepper

- Melt butter in a frying pan over medium-high heat and add onion and garlic; cook until onion turns translucent.
- Add meat, making sure that pieces are separate and don't overlap in pan.
- After 1 minute, add parsley leaves, celery leaves, salt, pepper, all to taste. Sauté until juices are completely evaporated, then decrease temperature and stir in tomato puree and cayenne.
- When meat is finished, add water to cover and bring to a boil. Skim off fat before serving.

Baked, Boiled, Roasted, and Fried

LOOKING AT THE CENTERPIECE of this book—the photographs of families from all over the world with the foods they normally eat in a week—it is hard not to identify with them, no matter how much they differ from us in appearance. The context of the photographs—food—tells us everything we need to know. Nothing is more basic to the maintenance of all our lives than food. Nothing is more important to the continuance of our customs, crafts, religions, institutions—to our cultures and civilizations—than family. Mealtime is when we take on fuel and lay the foundations of our societies.

More than likely, the apes who were ancestors of both the chimpanzees and ourselves did not dine at preselected times and locations. They probably operated in bands much of the time, as chimps do today, and when they discovered food, ate it immediately, on the spot, and only incidentally together. The experience surely promoted some bonding, but by our standards it was scarcely communal. There was little to remind us of the gathering of family and friends around the turkey-laden table on Thanksgiving.

Then, over the epochs there came a monumentally important change. We began to collect food and to carry it back to some location known to all where successful kin with food and kin who were having an unlucky day gathered to share it. The family evolved to be more than relationships dictated by DNA. The germ cell of what today we call community eased into history.

The phenomenon accelerated mightily as our ancestors learned how to increase the proportion of available organic matter that they could digest by inventing cooking. Cooking is universal among our species. Cooking is even more uniquely characteristic of our species than language. Animals do at least bark, roar, chirp,

do at least signal by sound; only we bake, boil, roast, and fry.

Treating food, plant or animal, with high heat changes it, simplifies it, so to speak, so our teeth and gut can deal with it more effectively. In general, it transforms organic matter that, when raw, is unpleasant to eat, difficult or impossible to digest, and unhealthy or even deadly into nourishing and palatable food. On average, chimps spend six hours a day chewing, and people (that is to say, members of the cooking species) only one.

Cooking reinforced the trend toward community. Kindling had to be collected beforehand and carried to the central location to which the food collectors would return. Planning for the future, albeit the near future, became necessary. Cooking made us smarter and, at the same time, it enormously increased the range of organic matter that we could tap for nourishment, and thereby the kinds of places and climates in which we could live. Harvard anthropologist Richard Wrangham proposes that humanity was launched when a kind of ape learned how to cook. In his view, we are not herbivores or carnivores but "cookivores."

Our population increased and we trekked out of our African homeland, reached Australia as early as 50,000 years ago, and dispersed to and through the Americas no later than 12,000 years ago, and probably much earlier than that. We became, before agriculture, before metallurgy, before writing, before supermarkets, the most widely settled large land animal on the planet. We were well on our way to becoming the people whose pictures appear in this book.

Few advances comparable in importance to cooking have happened since. The most important have been more quantitative than qualitative. We began not simply to harvest but to adopt certain palatable plants and animals as aides and conspirators. By 3,000 to 4,000

years ago, we had domesticated all those that have been central to our diets ever since—barley, wheat, rice, maize, potatoes, sheep, goats, cattle, horses, and so on—examples of which can be found in most of the family photographs in this book. We have domesticated nothing more significant than strawberries and reindeer since.

We have shared our plants and animals all across the globe, a phenomenon that has been much more important than any new domestications. Consider, for instance, the grasses. Rice, a Southeast Asian grass, has for many centuries been the most important cereal in that continent and is now raised in enormous quantities in Europe and the Americas. Sugarcane, a grass that originated in New Guinea, has spread throughout the tropics. Middle Eastern wheat is grown throughout both temperate zones and is now the most important grain traded internationally.

We have transported our domesticated livestock to all the regions that the animals could tolerate. The horse, for instance (valued for its meat as well as for its strength and speed), is living nearly everywhere suitable climatically. Five hundred years ago, European sailing ships returned the animal, which had died out in the Americas thousands of years ago, to its Western Hemisphere homeland, where it now lives in the millions.

We have increased the output of food by deft use of fertilizers, pesticides, and careful breeding (and, lately, genetic modification). But the old staples are no less central in our diets than they were 3,000 to 4,000 thousand years ago.

The most important advances in the last two centuries or so in assuring ourselves of the next meal may have been in food preservation. The cereal grains, if kept dry, might last for years, even decades, but most of the other foods rotted fast. We had preserved some by drying and salting, which allowed us to dine in Rome on Atlantic codfish every Friday for centuries, but the variety of preservation techniques and of the foods that could be so preserved was limited. A technological revolution—refrigeration, chemical preservatives, cans, bottles, cardboard and plastic packaging—has swept away many of those limitations. In the same decades, mechanized transportation has enabled us to easily transport our preserved foods from regions of excess supply to regions of excess demand. Norwegians eat apples from New Zealand, New Zealanders eat Baltic herring.

Thus defended from seasonal shortages and regional droughts and blights, we have increased vastly in numbers, so the ancient problem of hunger has not been solved for millions of us. At the same time and ironically, we are confronted with the problems of excessive consumption. We retain the genes of our chimpish ancestors, which command us to eat and eat because tomorrow there may be nothing; and to choose sugared foods because these ancestors preferred ripe fruits, their quickest sources of calories. Ergo back pains, diabetes, obesity, arteries jammed with cholesterol, and heart attacks.

The number of us who suffer from the diseases of overeating may be, for the first time in history, approaching that of those suffering from undereating. It may be that we will suffer the former problems to the extent that we cure the latter. Food was, is, and will always be central to the story of *Homo sapiens*.

Alfred W. Crosby, Ph.D., is a professor emeritus at the University of Texas. He is the author of The Columbian Exchange *and* Ecological Imperialism, *has received the Medical Writers' Association Award, and is a member of the American Academy of Arts and Sciences.*

"Cooking is even more uniquely characteristic of our species than language. Animals do at least bark, roar, chirp, do at least signal by sound; only we bake, boil, roast, and fry."

DUBAI, UNITED ARAB EMIRATES

BARGTEHEIDE, GERMANY

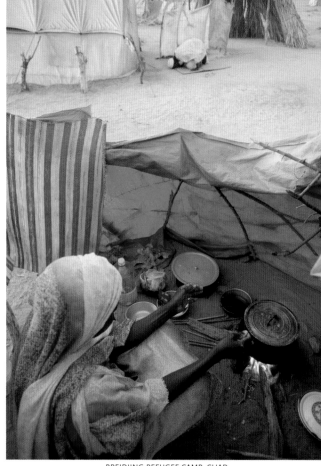

BREIDJING REFUGEE CAMP, CHAD

BUAH MERAH (RED FRUIT) COOKED WITH HOT ROCKS • BALIEM VALLEY, PAPUA

MONTREUIL, FRANCE

TINGO, ECUADOR

KOUAKOUROU, MALI

COPENHAGEN, DENMARK

MANILA, PHILIPPINES

Kitchens

Chemically altering plant and animal tissue by exposing it to heat is one of the oldest and certainly the most distinctive practices in human culture—*Homo sapiens*, as Alfred W. Crosby points out in his accompanying essay, is the only species that cooks. Although the kitchens in these images are wildly different in location and appearance, all of them form the center of a home, even if only temporarily. Kitchens are where families take care of themselves. Cooking is a fundamental task that women, throughout the ages, have undertaken.

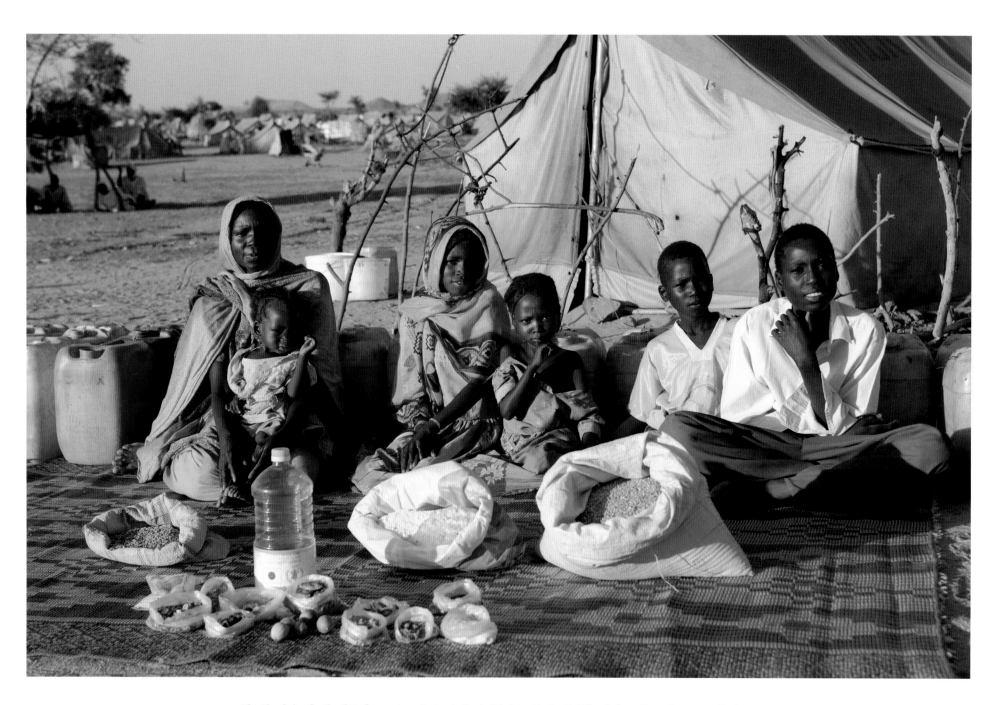

The Aboubakar family of Darfur province, Sudan, in front of their tent in the Breidjing Refugee Camp, in eastern Chad, with a week's worth of food. D'jimia Ishakh Souleymane, 40, holds her daughter Hawa, 2; the other children are (left to right) Acha, 12, Mariam, 5, Youssouf, 8, and Abdel Kerim, 16. Cooking method: wood fire. Food preservation: natural drying. Favorite food—D'jimia: soup with fresh sheep meat.

Refuge

Grains & Other Starchy Foods: ✳✳

Sorghum ration, unmilled, 39.3 lb; corn-soy blend ration (CSB), 4.6 lb.

Dairy:

Not available to them.

Meat, Fish & Eggs: $0.58✳✳

Goat meat, dried and on bone, 9 oz; fish, dried, 7 oz. *Note: Periodically, such as at the end of Ramadan, several families collectively purchase a live animal to slaughter and share. Some of its meat is eaten fresh in soup and the rest is dried.*

Fruits, Vegetables & Nuts: $0.51✳✳

Limes, small, 5; pulses ration, 4.6 lb, *the seeds of legumes such as peas, beans, lentils, chickpeas, and fava beans.* Red onions, 1 lb; garlic, 8 oz; okra, dried, 5 oz; red peppers, dried, 5 oz; tomatoes, dried, 5 oz.

Condiments: $0.13✳✳

Sunflower oil ration, 2.1 qt; white sugar ration, 1.4 lb; dried pepper, 12 oz; salt ration, 7.4 oz; ginger, 4 oz.

Beverages:

Water, 77.7 gal, *provided by Oxfam, and includes water for all purposes.*

Rations organized by the United Nations with the World Food Programme.

Food Expenditure for One Week: 685 CFA francs (Communauté Financiére Africaine)/$1.23

✳✳Market value of food rations, if purchased locally: $24.37

D'JIMIA ISHAKH SOULEYMANE AWAKENS before dawn on this hot November morning. She pulls on a fold of bright purple fabric to cover her head and shoulders, in accordance with Muslim custom, then readies her kitchen for the first meal of the day. Three rocks set in a triangle prop the family pot above a tiny wood fire. Tilting forward on a low, rickety stool, she scoops handfuls of milled sorghum from a small sack and stirs it into a pot of boiling water. When the mixture is a thick porridge, she dumps the cooked grain into an oiled bowl and swirls its surface flat. Next, she makes soup from a handful of dried tomatoes, some salt, and water. She turns the now-congealed cereal—called *aiysh*—onto a plate, takes the soup pot off the fire, and breakfast for six is ready outside her tent in the dusty, sprawling Breidjing Refugee Camp.

Across this camp and dozens of others in Chad and Sudan, tens of thousands of Sudanese refugee women just like D'jimia, are stooped over their pots in front of their tents, cooking virtually the same food for their own families—a thin soup and *aiysh* for breakfast, lunch, and dinner. All are living in the same situation—in a country not their own, and far from where they ever imagined they'd be.

Civil war in Sudan, Africa's largest country, is nothing new. The government-backed Muslims of the north have fought the animists and Christians of the south since Sudan gained its independence from the British in 1956. When this war finally showed signs of ending, in 2003, another flashpoint erupted—this time pitting Arab Muslims and the government against non-Arab black African Muslims (the indigenous Masalit, Fur, and Zaghawa ethnic groups, among others) in the country's western region of Darfur.

Rebel groups organized from among the region's economically and politically marginalized non-Arabs demanded a share of the country's economic-development resources for Darfur. The rebel groups attacked government installations, and government forces struck back. The progovernment Arab militia—called Janjawiid (in Arabic, "man with a horse and a gun")—struck as well, plundering and burning Darfurian villages over a series of months, killing thousands. Those who weren't killed survived only by fleeing southward, or westward into neighboring Chad, creating an instant humanitarian crisis.

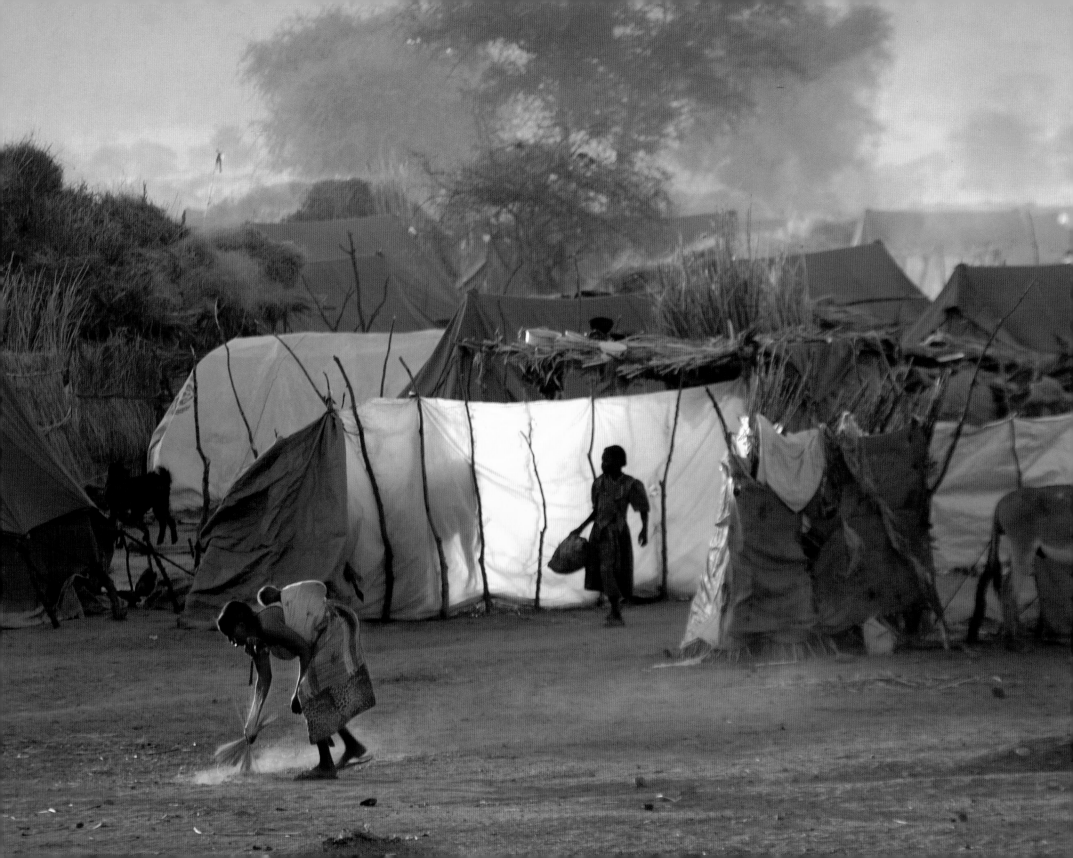

"This was happening to other people, in other areas," says D'jimia, "but not to us. We thought our village [Andrigne] was safe." D'jimia, whose husband had died in an accident in 2003, continued to plant the family's food and care for their sheep, with the help of her older children and extended family. Then, in mid-2004, the Janjawiid attacked their neighboring villages. D'jimia's village chief, Dahia Idriss Khamis, told his people they must escape. The entire village fled into Chad, bringing only what they could carry or squeeze onto a neighbor's donkey cart. D'jimia was confused and frightened; her only comfort, she says, was knowing that there were so many of her neighbors alongside her.

Instant City

Operating a refugee camp—a kind of instant city of impoverished victims—requires vast amounts of coordinated effort amidst chaotic conditions. The camps in Chad are thwarted at every turn by weather, logistics, donor fatigue, host country fatigue, health epidemics, sanitation problems, water shortages, and the idiosyncrasies of human nature. Living arrangements are strictly dictated by the relief agencies—they must be, with so many displaced people to be fed, housed, and cared for. Registered families get a tent, a blanket, a bucket, soap, and a food allocation. They are then organized into blocks and elect a leader, who represents them at the camp council. This council interacts with the lead relief agency. Cultural and religious practices can sometimes conflict with the dictates of the relief agencies, such as when a man asks for an extra tent annex to house his second wife, but generally, the system works—if anything, because it has to.

Because of the haste with which it was established, Breidjing Camp, spread over more than two square miles, is the most over-crowded and least site-planned of the refugee encampments. The burden was eased somewhat when another camp was built nearby, but there are still hundreds of unregistered Darfurians—called spontaneous refugees—living on the camp perimeter and hoping to obtain full refugee status from the United Nations High Commission for Refugees. They get little or none of the benefits that registered refugees get—supplies are finite, even if the need is not.

Meals on Wheels

Food rations arrive at D'jimia's tent block on a donkey cart driven by assistant block chief Ishakh Mahamat Youssouf, who was the chief of a village near D'jimia's in Sudan. This morning, he has waited in the blistering heat to receive the rations at the camp's distribution center, and then driven the two miles back to their tent block, and then traveled countless dusty paths between rows and rows of sand-colored tents with his son to the one speck of shade in his tent block where families were arriving with their own containers to receive rations.

Per person per day the rations are: 15 ounces of cereal, such as sorghum or millet; 1 tablespoon of sugar; 1 teaspoon of salt; and slightly less than ¼ cup each of pulses (such as lentils), CSB (a corn-soy blend—either sweet or salty), and vegetable oil. The total equals about 2,100 calories, less than the recommended daily minimum for an active 16-year-old, but more than enough for a toddler still drinking breast milk. Rations are the same for each individual; decisions about who eats more or less are made within each family. But as one block chief said, and many repeated, "We're still hungry every day." The hunger may be as much for home as it is for fresh vegetables, fruit, milk, and meat.

As the midday heat builds, D'jimia's son Abdel Karim gathers their rations—a 15-day supply for six—and hauls it back to the tent. Like most of the camp dwellers, Abdel Karim and D'jimia are fasting, because it is the Muslim holy month of Ramadan. But the smaller children are not expected to fast, so D'jimia cooks them lunch—*aiysh* again, with okra soup. Afterward, to get out of the relentless sun, she heads for the shade of the few nearby trees, where 80 or 90 men and women sit segregated by gender, according to custom. They're not allowed to quench their thirst, even with water, until after sunset.

When evening comes, D'jimia cooks again. Abdel Kerim carries his soup and *aiysh* to the tent of the assistant chief, and eats with him and his sons. According to Masalit custom, a boy of 16 is

Sunrise at the refugee camp. Another day of waiting begins. It's November, two months after the rainy season but not yet the hot season. Smoke from cookfires chimneys up into the sky; women sweep the dirt in front of their tents; children walk to the water depot with empty plastic containers; roosters crow and donkeys bray into the desert air, which is beginning to lose its nighttime chill.

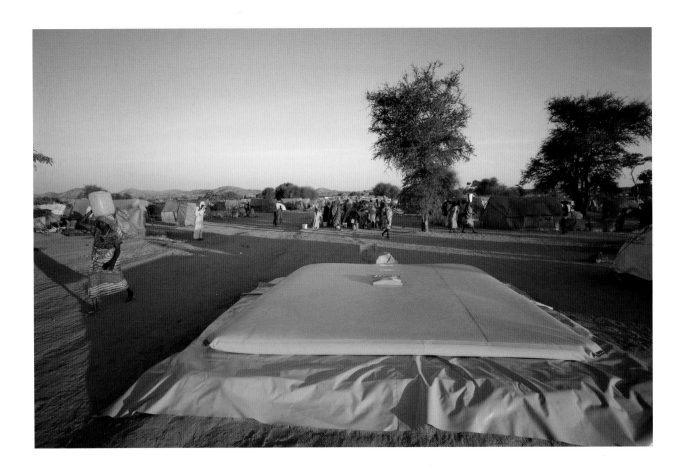 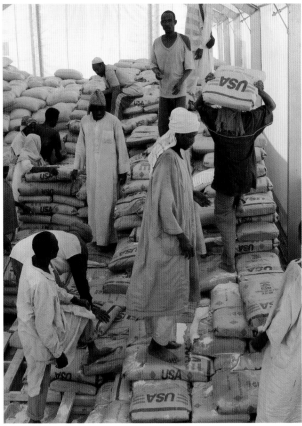

The arrival of an Oxfam water truck is an instant call for everyone in the camp to show up with a container. The trucks fill yellow waterbed-like bladders *(above left)*, which rest on low platforms. The water flows through buried pipes to watering centers, where half a dozen people can fill up at once without wasting any precious liquid. Food distribution, run by the U.N. World Food Programme, is equally systematic. Following a precise schedule, workers distribute food, including bags of corn-soy mixture and sorghum *(above right)*, to block leaders, who then parcel it out to families.

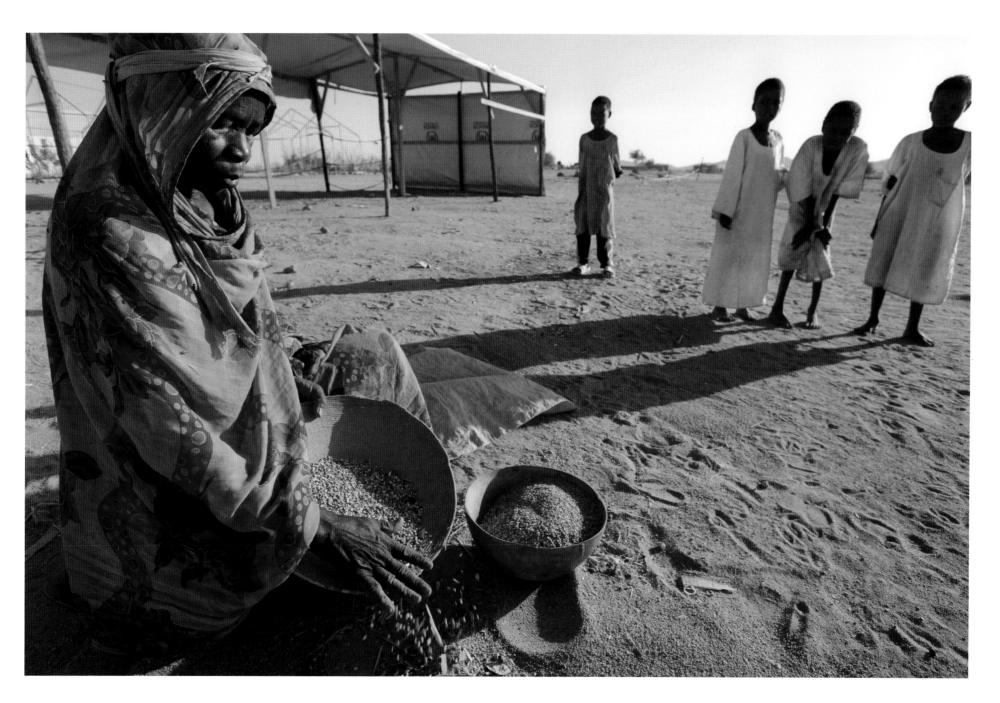

Sitting near the food distribution center right after sunrise, a refugee woman patiently sifts through the sand to pluck out any bits of grain that might have dropped to the ground during the previous day's ration disbursement. The bowl on the ground is a standard-size, two-quart *coro* used to measure grain.

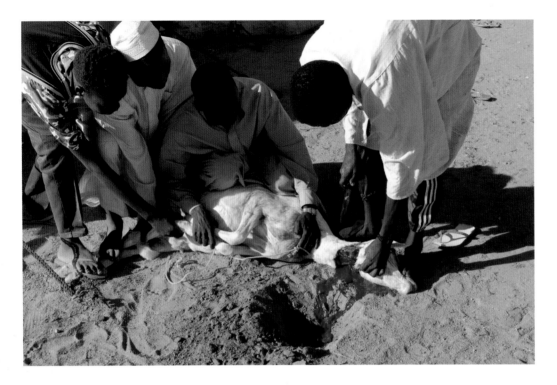

FIELD NOTE

Housing and feeding 30,000 people in an impossibly harsh landscape hundreds of miles from the nearest paved road is no small matter. In 1991, I saw refugee crises building up in Somalia, but when we visited Chad in late 2004, the catastrophe—a by-product of the horrendous ethnic cleansing in neighboring Sudan—was full-blown. I had never witnessed the international aid machine in high gear before: a dozen agencies coordinating tents, latrines, water, food, transportation, communication, medicine, and security for a string of instant small cities that stretched for more than 300 miles along the border with Sudan—impressive, to say the least.

Battered by circumstance, these refugees were stuck in a *Groundhog Day* existence—without choice or change. They couldn't go home, couldn't leave, and weren't supposed to stay. Nor could they farm, herd cattle, or build a permanent house. Every day was an improvisation and every day was exactly the same. In their outdoor prisons, the refugees were not outrageously worse off, materially, than they were in their former lives, but their future prospects were dismaying.

I watched a number of women prepare the same meal from the steady stream of donated international aid over and over again: *aiysh* porridge with soup. No one was malnourished, but no one was well-fed, either. I shook hands with hundreds of boys and young men—six months of inactive camp life and repetitious food had already left many of them bony and fragile. — *Peter*

At the end of the month of Ramadan, the Muslim fasting period, some of the families in D'jimia's block celebrated the festival of Eid al-Fitr by banding together to buy a goat, which they then slaughtered *(above left)*. While the meat simmered in a soup, many refugees went to services at an improvised mosque; afterward, the imam led a procession *(at right)* around the camp, singing songs and delivering periodic homilies. Later that day, the refugee families split up into groups of men and women who feasted, separately, on *aiysh* and goat-meat soup *(bottom left)*.

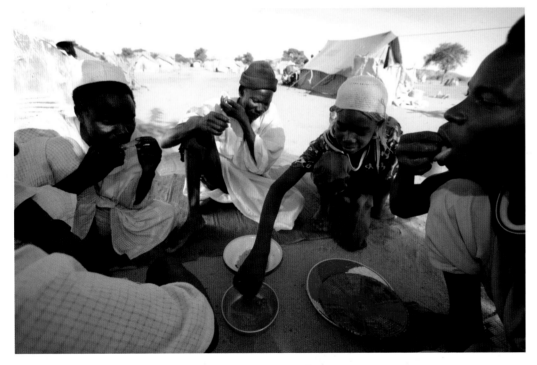

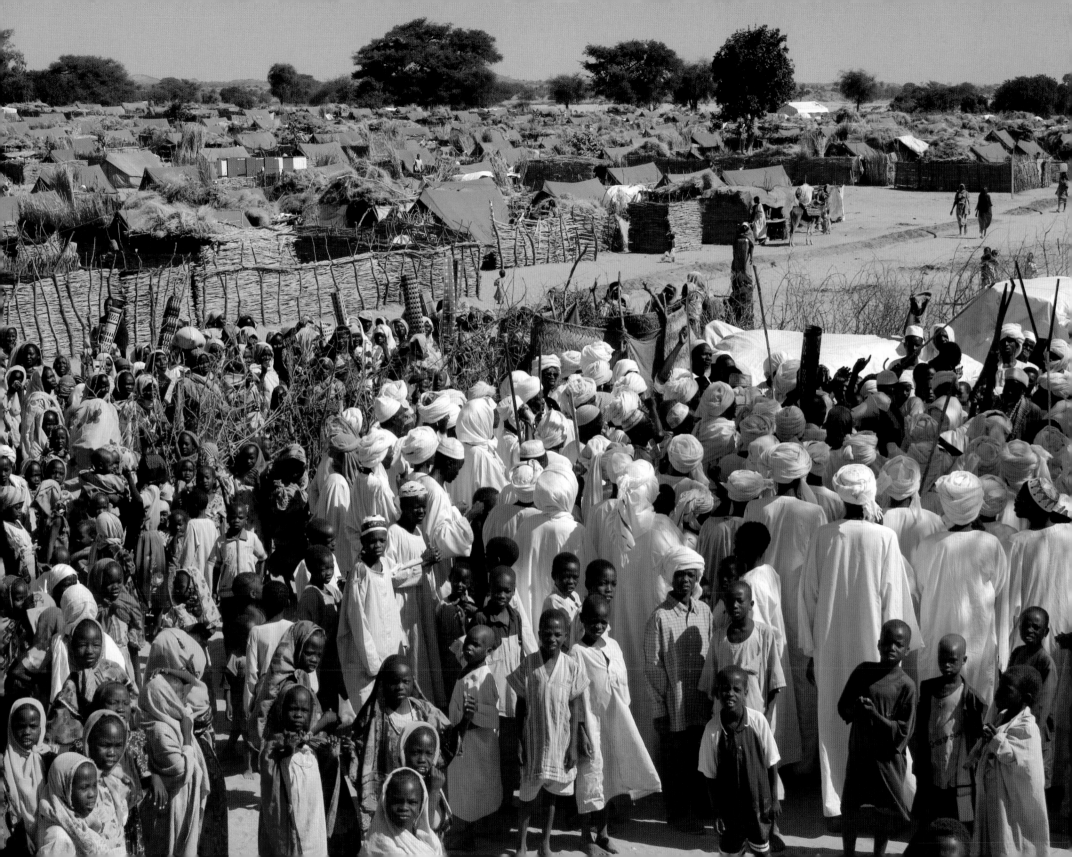

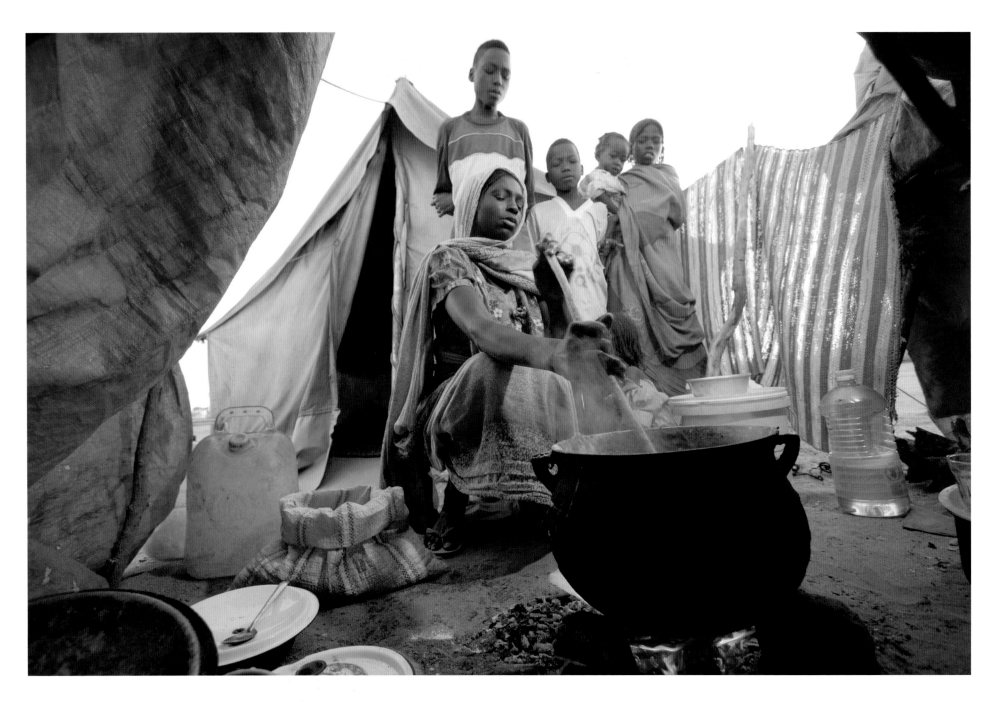

Squatting before the fire with her children, D'jimia Souleymane *(far right, portrait)* stirs a pot of *aiysh,* the thick porridge that this refugee family eats three times a day. Despite losing almost everything in their flight from militia attacks, D'jimia keeps her improvised household as orderly as possible. To cover the ground inside, the family hauled in clean sand from the dry riverbed. D'jimia and the children sleep on two blankets, which she constantly airs out and washes.

D'jimia Ishakh Souleymane's Dried Goat Meat Soup

1 *coro* (approx. 2 qt) water

1 handful (approx. 3 oz) dried goat meat, pounded on rock

1 small handful (approx. 5 oz) dried tomatoes

1 handful (approx. 5 oz) dried okra, pounded on rock

1 teacup (approx. 5 fl oz) vegetable oil

1 small spoonful (approx. 1 t) salt

• Put a pot of water over a freshly lit fire. When water boils, add goat meat, tomatoes, okra, oil, and salt. Simmer about 20 minutes.

Aiysh **(Congealed Porridge)**

1/2 *coro* (approx. 1 lb) millet flour

1 *coro* (approx. 2 qt) water

vegetable oil (enough to coat *aiysh*)

• Bring millet flour to mill to grind.
• After obtaining ground millet flour, light fire and bring water to a boil in a pot.
• Add millet flour in small amounts until it begins to thicken and bubble. Stir constantly, pulling mixture toward you in the pot until it holds together in a gelatinous mass.
• Press mixture into an oiled bowl to make a round shape. Invert onto serving plate or tray.

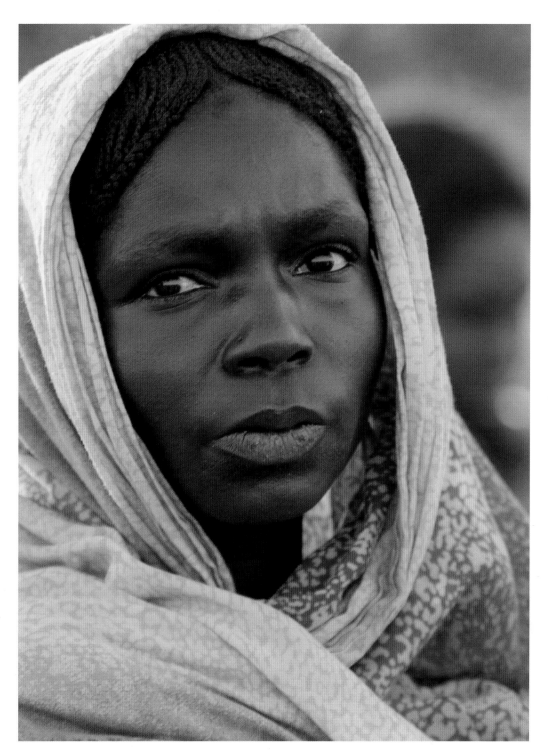

• Population of Darfur Province, western Sudan (adjacent to Chad): **6,000,000**

• Percent of Darfur's population that are refugees within Darfur: **30**

• Area of Darfur in square miles: **170,000 (slightly larger than California)**

• Sudanese refugee population in Chad: **193,000**

• Population of Breidjing Refugee Camp in Chad: **30,000+**

• Refugee camp interviewees who reported witnessing the killing of a family member: **61%**

• Death toll from 2004 Indian Ocean tsunami: **295,000**

• Death toll from Darfur genocide since 2003: **380,000**

• U.S. Government aid to Darfur region since 2003: **$615,598,548**

• U.S. Government aid to tsunami-affected regions: **$950,000,000**

• Number of refugee camps in eastern Chad: **11**

• Number of refugee camps in Darfur: **160+**

• Camels exported from Sudan to Egypt annually for meat: **160,000+**

a man, and therefore too old to eat with his mother and the other children. D'jimia watches the remaining four children dip pieces of *aiysh* into the thin okra soup and reminisces about home. "We were in perfect peace and had plenty of food," she says. "We had everything sufficient in our village—very different from here. We had animals, and we were farming. Every day we had fresh meat." She also had a cow for milk and ten big mango trees. D'jimia would sell her extra fruit and root vegetables at her village market and could afford to buy the children clothes, candies, and school supplies. Staying busy was part of the joy of living—now, living in a refugee camp as a guest, it is impossible.

A DOLLAR A DAY

D'jimia's neighbor Miriam, who fled from a different part of Darfur, lives in the tent next door and has become her closest friend. They help each other with their children, especially when D'jimia hires herself out to plant or harvest for local villagers. "I go to ask for work three or four times a week," she says. "Sometimes there are so many people looking for work, I just come back." When she does find a job, D'jimia can earn about 750 CFA francs ($1.35 USD) per day. She doesn't get any extra money if the older children come to help, but the work gets done faster. She did the same work at home, she says, but in Sudan she was harvesting her own food. "I help the farmers in their fields, cutting millet or collecting peanuts. Then I use the money to buy extra food, like fresh tomatoes, or okra, or dried fish." She can't afford to buy much in the small, refugee-run "convenience" huts sprinkled around the camp. "There's powdered orange-drink mix—the children love sweet things," she says, but usually she sticks to the necessities.

D'jimia's favorite food is *aiysh* with fresh mutton, but meat, fresh or dried, doesn't come with the rations. She says it makes her sad to remember raising her sheep and farming her own okra and peppers. "It was not just a little bit, but a whole field." At the end of Ramadan, she will share the meat from a slaughtered animal with several other families in her block. Even if she can't afford to buy a portion, her block chief will not let them go without.

The food D'jimia prepares here is the same food she prepared at home, and she prepares it in the same way—just in smaller amounts. Daughter Acha, a quiet, smiling 12-year-old, knows how to cook this traditional fare. "She watched me and learned, as I learned to make it from my mother," says D'jimia. The girl's primary tasks, though, are to help with the younger children, especially 2-year-old Hawa, and to gather firewood and fetch water. She's also the one to stand in line to have the family's grain ration milled. A Chadian miller from the nearby village has brought a simple, fuel-powered grinding mill to the camp, to process grain for refugees who don't hand-process their own. The refugees pay him part of their rations in exchange for the service.

WEARING OUT A WELCOME

The Chadians have been remarkably solicitous to the refugees, despite the hardships of having so many uninvited guests, partly because both groups share a cultural heritage. Still, the allocation of natural resources weighs heavily on both host and guest. Firewood is especially hard to come by on the barren plain, and the thousands of refugees are rapidly using up the local supply.

No part of this is easy. Sometimes, say aid workers, some villagers in the host country have less to eat than the refugees. This means that aid agencies have to work out a supplemental feeding program for them as well—an additional drain on relief budgets. Still, it's only fair. Through all the turmoil and tumult, a bright spot for D'jimia is the camp school, organized by the aid organizations. The children are in school here, just as they were in her village. "Education will help the children find work and be secure," she says, though she's not exactly sure how. A man has come around to her tent today to collect 200 CFA francs (36 cents, USD) per child for school supplies. She gives it to him, but it's all the money she has until she finds another day of work—an investment in the future.

Water is a constant preoccupation in the refugee camp. Every day, lines of women and children carry jugs and pots of drinking and cooking water from distribution points to their tents. To get extra water to wash clothes, families dig pits in nearby wadis (seasonal river beds), creating shallow pools from which they scoop out water. In November, the camp wadi had water three feet below the surface. As the dry season advances, the sand pits get deeper and deeper.

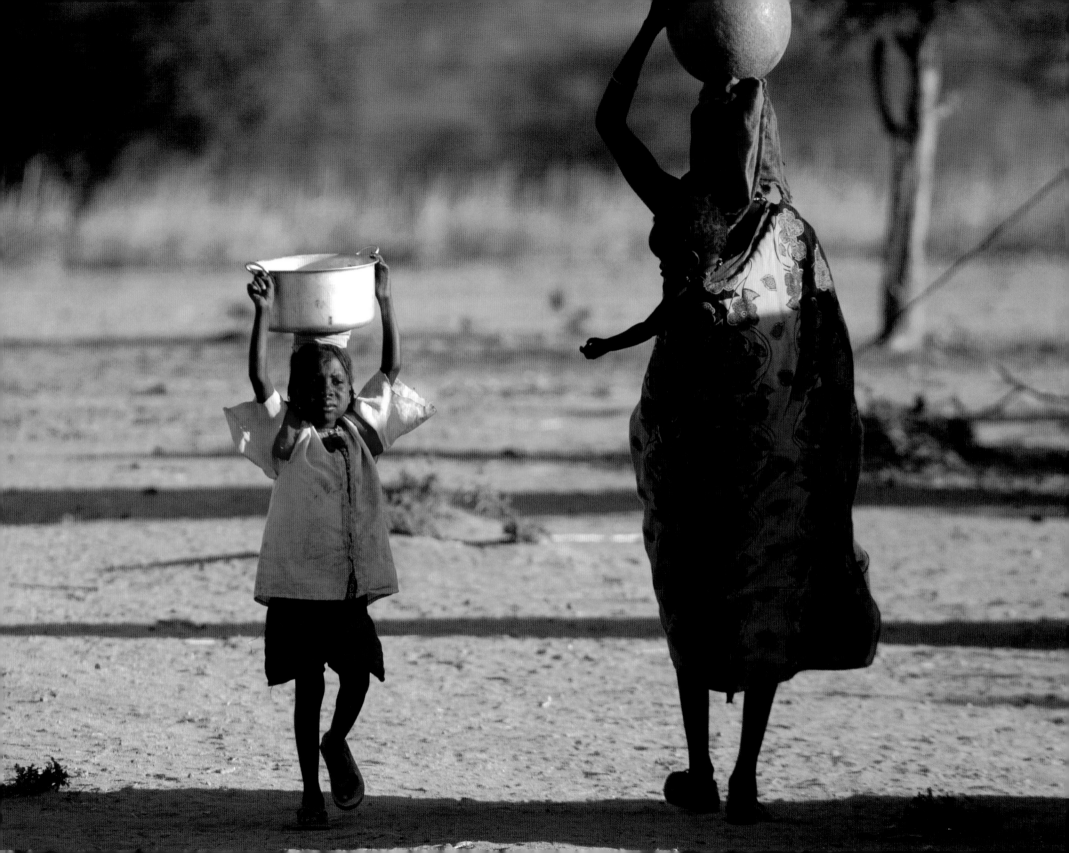

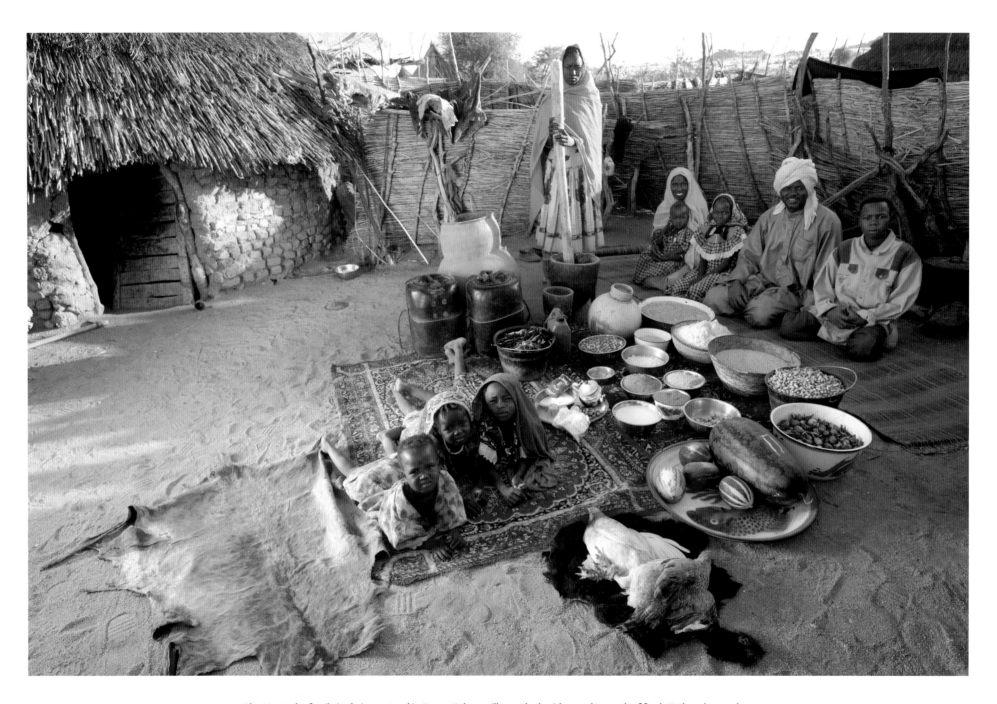

The Mustapha family in their courtyard in Dar es Salaam village, Chad, with a week's worth of food. Gathered around Mustapha Abdallah Ishakh, 46 (turban), and Khadidja Baradine, 42 (orange scarf), are Abdel Kerim, 14, Amna, 12 (standing), Nafissa, 6, and Halima, 18 months. Lying on a rug are (left to right) Fatna, 3, granddaughter Amna Ishakh (standing in for Abdallah, 9, who is herding), and Rawda, 5. Cooking method: wood fire. Food preservation: natural drying.

Water at the Wadi

ONE WEEK'S FOOD IN NOVEMBER

Grains & Other Starchy Foods: **

Millet,* 4 coro—*a "coro" is a Chadian unit of volume approximately equal to 2.1 qt;* millet flour,* 3 coro; sorghum,* 3 coro.

Dairy: **

Milk,* 7 coro, *from family cows.*

Meat, Fish & Eggs: $2.16**

Chickens,* 8.8 lb meat, *after cleaning;* goat meat, dried on the bone, 6.6 lb.

Fruits, Vegetables & Nuts: $7.19**

Watermelons, 22 lb; harar (squash), 17.6 lb; dates, 1 coro; okra,* dried, 1 coro; red onions,* 1 coro; garlic,* 0.5 coro; tomatoes,* dried and milled, 0.5 coro; red peppers,* dried and milled, 0.3 coro; peanuts,* 3 coro.

Condiments: $8.54

Peanut oil, 1.1 gal; sugar, 0.5 coro; salt, 0.5 coro.

Beverages: $0.44

Tea, 3.5 oz; water, hand- or animal-carried half a mile from the wadi, for both drinking and cooking.

* Homegrown

Food Expenditure for One Week: 10,200 CFA francs (Communauté Financiére Africaine)/$18.33

**Market value of homegrown foods, if purchased locally: $25.44

Mustapha Abdallah Ishakh, Amna's father, has cows and goats—co-owned with his large extended family—but you wouldn't call him a herder. His many children do the actual herding, along with the six children of his eldest daughter, Mariam, 25. "We need many kids to do the work," explains Mariam's husband Ishakh, who's readying his horse to drive two bulls across the scrubland to the market town of Abeche, 40 miles away. Another reason not to refer to Chadians like Ishakh and Mustapha as herders is that they also grow vegetables and grain, because self-sufficiency is the best guard against hunger when there is no government safety net. What they don't eat, they share, trade or sell.

TWELVE-YEAR-OLD AMNA MUSTAPHA and her cousin Fatna tie gourds and plastic jugs to the wooden saddles on their fathers' donkeys, then hoist themselves up for the morning ride across the plain of east central Chad to fetch the day's water. There are no family arguments about whose turn it is to go, or who herded the cattle yesterday and twice last week. Children here learn at a young age what's expected of them, and there's no room for argument if everyone wants to eat.

When Amna and Fatna join 20 or 30 other chattering children, mostly girls, for the 20-minute ride to the wadi, a seasonal riverbed that's dry this time of year, they're on donkey-autopilot. Not even the boys on horse- and camelback, galloping up, then stopping in a cloud of dust to tease the girls, can deter their forward motion. When they arrive at the wadi, the socializing doesn't stop but the nonsense does; the boys back off and the girls begin to repair the shallow earthen watering troughs. They must be rebuilt each day before the herds arrive. The sun beats down on their covered heads, but they're used to the daily sauna that is the dry season. The girls pull buckets of water from the narrow wells that have been dug into the wadi, then dump the water into the troughs for the small herds of cows and goats that will be brought here to drink. When the girls finish their work, they fill their jugs with the day's drinking and cooking water. Within minutes, Amna's brothers and cousins arrive with the family's herd. The girls then splash water on their hot faces and head home with the cooking water; the cows and goats, left behind with their herders, begin the daily struggle to find something green to eat.

Although surrounded by livestock, Amna's father, Mustapha, and his family eat red meat infrequently. When they do eat it, they rarely slaughter an animal from their herd because that would deplete their assets. Instead, they split the cost of an animal with several families and butcher it for feasts like the celebration at the end of Ramadan. When the family has meat, Mustapha's wife Khadidja dries some, and reconstitutes it in the soup that family members eat with their thrice-daily porridge, called *aiysh*. Milk, too, is scarce; Mustapha's cows aren't big milk producers because there isn't much around for them to eat. Khadidja is able to extract only about a cup of curds a day after the scrawny calves have suckled; she adds it to the soup, effectively splitting the milk among nine people.

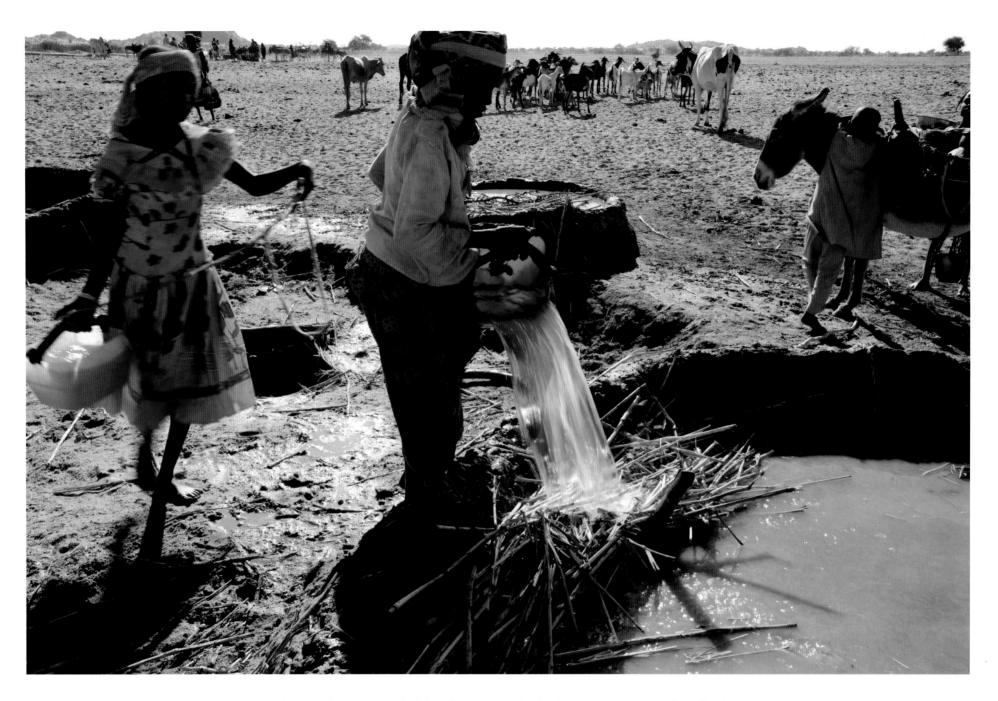

To water their animals, Amna Mustapha (left) and a cousin must first dip plastic containers into a six-foot well (behind Amna). They then pour the water into a low earthen-walled pool from which the animals drink (the millet stalks at the edge of the trough keep the cascading water from breaking down the wall). Families take turns using the pools, which must be rebuilt often and will ultimately wash away during the rainy season.

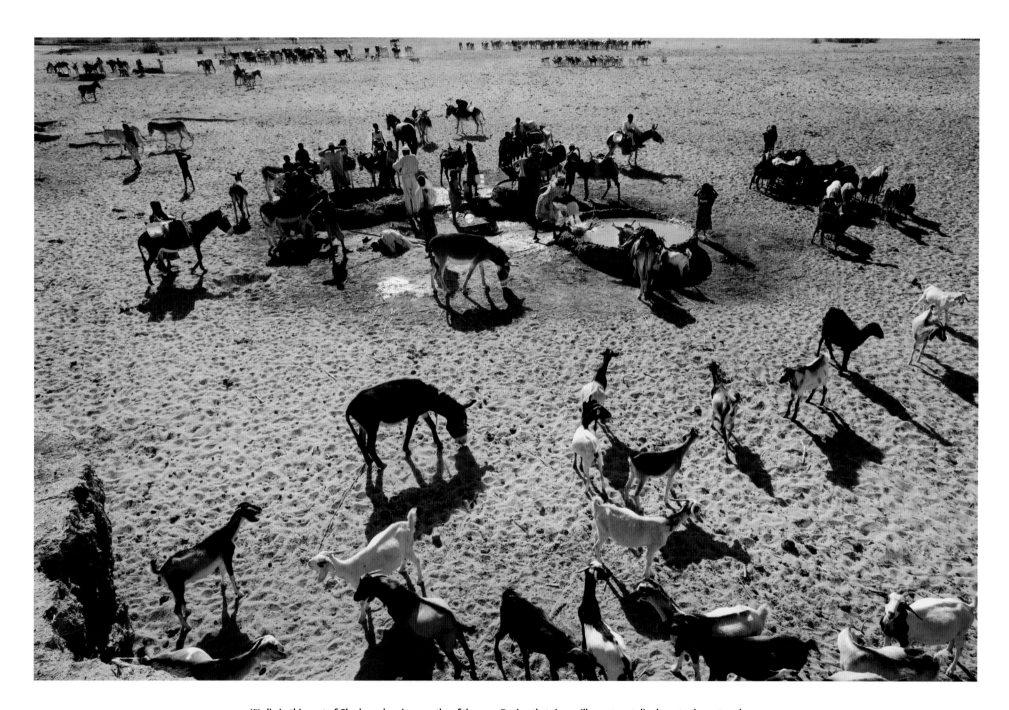

Wadis in this part of Chad are dry nine months of the year. During that time, villagers must dig down to the water, shoring up the wells with millet stalks to keep them from collapsing. In the morning, the wadis are furiously active. One after another, teams of two or three girls fill the pools as wave after wave of animals come to drink. It's hard work: the water rapidly evaporates, sinks into the sand, and vanishes down the animals, and the girls have to keep refilling the pools.

Anyone bouncing along in a four-wheel-drive vehicle on the dirt track that is the highway through eastern Chad would think that the land was too inhospitable for human habitation. An occasional tree, the thorny bushes, and the dry, sandy riverbeds liken this landscape to the center of Australia, where indigenous aboriginals have hunted and gathered for millennia. Here in Africa, people living in widely scattered villages rely on agriculture. They raise goats, cows, donkeys, and camels, and during the rainy season coax some grain and vegetables to grow in the sandy soil. The key is water.

In many parts of this desertlike landscape, water runs fairly close to the surface. Twenty-five miles outside of Abeche, in the village of Dar Es Salaam, children scamper each and every morning to reconstruct the mud drinking troughs at the wadi (they need to be maintained every day because the cattle step on them). Meanwhile, other children fan out to herd the animals to the wadi for their once-daily drink. (There is no school near Dar Es Salaam, so parents do not need to decide whether their children should attend classes or stay home and work.) I couldn't help noticing that the girls did almost all the work; the boys mainly sat around on horses, camels, and donkeys, trying to look important. Girls hauled plastic containers on ropes out of the six-foot-deep wells. Girls carried the water to the troughs and dumped it in. Girls controlled the animal traffic at the wells—the animals have to drink the water quickly, before it evaporates or seeps back into the sand. Observing this labor-intensive daily ritual made it clear to me why families in this part of Africa have so many children: they need them to survive. — *Peter*

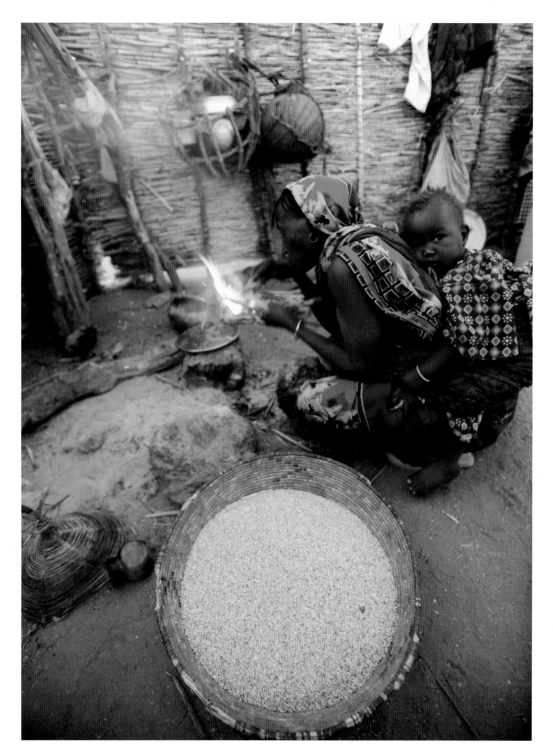

- Population: **9,538,544**
- Population of Dar Es Salaam: **210**
- Area in square miles: **495,624 (slightly more than 3 times the size of California)**
- Population density per square mile: **19**
- Urban population: **25%**
- Percent of population that are subsistence farmers and cattle herders: **>80**
- Land planted in permanent crops: **0.02%**
- Population with access to safe water: **27%**
- Years of ethnic warfare endured since gaining independence from France in 1960: **35**
- GDP per person in PPP $ (Purchasing Power Parity: an adjustment for what equivalent local goods would cost in the U.S.): **$1,020**
- Total annual health expenditure per person in $ and as a percent of GDP: **$5/2.6**
- Physicians per 100,000 people: **3**
- Life expectancy, male/female: **46/49 years**
- Fertility rate (births per woman): **6.7**
- Literacy rate, male/female, 15 years and older: **56/39%**
- Caloric intake available daily per person: **2,114 calories**
- Undernourished population: **34%**
- Oil reserves in southern Chad: **1 billion barrels**
- Number of years oil reserves would supply Chad if used at current rate and not exported: **4,110**
- Oil that is exported: **100%**
- Households with access to electricity: **2%**
- Paved highways, percent of total: **0.8**
- Annual alcohol consumption per person (pure alcohol content only): **0.2 quart**
- Overweight population, male/female: **10/17%**
- Obese population, male/female: **0.3/1%**
- Meat consumption per person per year: **31 pounds**
- McDonald's, Burger King, KFC, Pizza Hut restaurants: **0**

As the sun rises, two men perform their morning prayers beneath a tree in the village of Dar es Salaam in central Chad. Meanwhile, behind a courtyard wall of stacked and dried millet stalks, Khadidja Baradine *(far left)* begins her morning by scooping an ember from the previous night's fire onto a handful of straw. When the straw begins to smoulder, she blows on it to start a cooking fire.

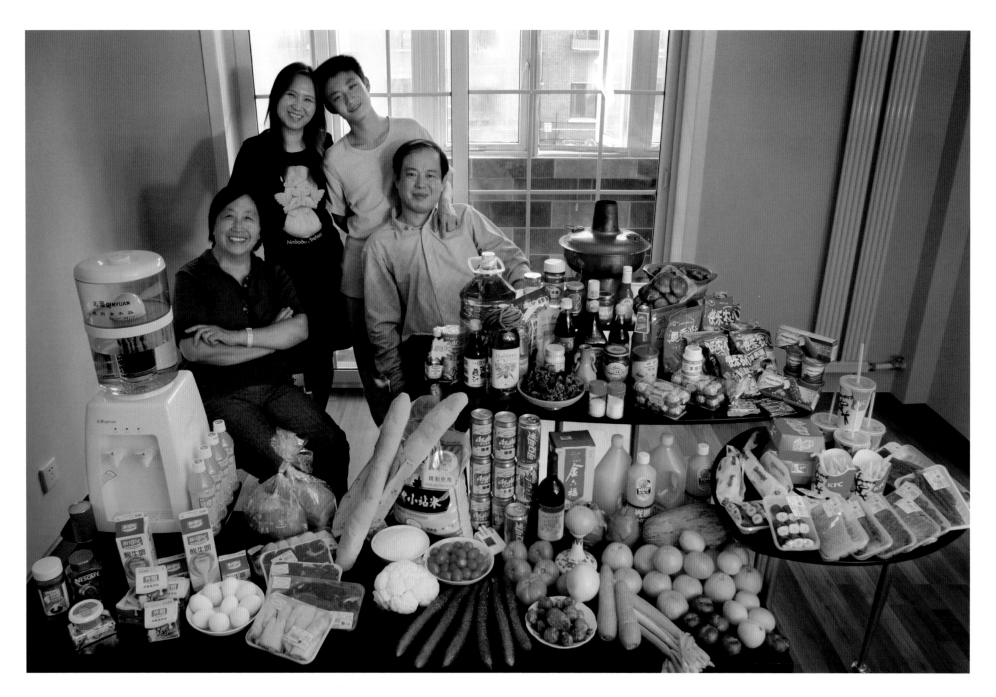

The Dong family in the living room of their one-bedroom apartment in Beijing, China, with a week's worth of food. Seated by the table are Dong Li, 39, and his mother, Zhang Liying, 58, who eats with them a few times a week. Behind them stand Li's wife, Guo Yongmei, 38, and their son, Dong Yan, 13. Cooking method: gas stove. Food preservation: refrigerator-freezer. Favorite food—Dong Yan: *yuxiang rousi*—fried shredded pork with sweet and sour sauce.

On the Cusp

When Dong Li hears that teenagers are eating deep-fried starfish whole at Beijing's newly hip downtown street stalls, the onetime seaside resident howls with disbelief. "Really?" he says. "All of it—not just the inside? That's funny!" That there are trendy downtown street stalls at all is a telling sign of just how much—and how fast— China's capital city has changed. Travelers who last visited Beijing as recently as the late 1990s wouldn't recognize the place.

S TEPPING FROM THE BLEAK CONCRETE STAIRWELL of a nondescript, government-issue lowrise into the Dong family's apartment is a bit of a cultural jolt. As is the custom, we take our shoes off at the door, but traditional China ends there. Using magazine photographs, cheap labor, and an artistic flair, Guo Yongmei has transformed her family's small one-bedroom apartment in ways that might make her old Chinese great-grandmothers fall off their *dengzi* [stools]: creamy lavender walls, built-in closets and cupboards, a parquet floor, modern furniture—and a tricked-out galley kitchen where Xiaozhan rice from outside Tianjin coexists peacefully with French baguettes and Maxwell House coffee creamer.

When he was a child on the Bohai Sea, near the port city of Yantai in Shandong Province, Dong Li explains, "We ate starfish at the seaside. My aunt would scoop out the inside and cook it with fish." "If you saw it being sold on the street whole, and deep-fried, would you eat it?" I ask. "No, no" he says, laughing. I tell him about the teenage girls we'd seen eating deep-fried scorpions-on-a-stick for the first time, on West Dongsi Street, within a few blocks of Tiananmen Square. They said they had read in a fashion magazine that eating this was good for their complexion. The saying goes that the Chinese will eat "everything with four legs except a table and everything with two wings except an airplane." Although the Chinese in the North would say this is only true of people in the South, those in the South would say with good humor that it's pretty much true of themselves. Anyone from outside China would say it seems to be true of everyone.

Dong Li and Guo Yongmei are part of the new breed of Beijinger, moving into China's upwardly mobile and aspiring-to-be middle class. Although the increase in disposable income available to each individual is certainly a factor in upward mobility, there is also

Grains & Other Starchy Foods: $6.52

Xiaozhan rice (a type of rice grown in China), 11 lb; white bread, 2 loaves; French bread, 2 baguettes.

Dairy: $26.29

Bright yogurt, plain, 2.1 qt; *Bright* milk, whole, 1.1 qt; *Häagan-Dazs* ice cream, assorted flavors, 11.4 oz; butter, unsalted, 7.1 oz; *Häagan-Dazs* vanilla ice cream, 5.5 oz; *Häagan-Dazs* vanilla almond ice cream, 3 oz.

Meat, Fish & Eggs: $26.97

Flatfish, 3 lb; beef flank, 2.4 lb; pigs feet, 1.8 lb; beef shank, 1.3 lb; chicken wings, 1.3 lb; eggs, 9; beef, marinated in soy sauce, 1 lb; salmon, fresh, 9.8 oz; pigs elbows, 8.6 oz; sausage links, 7 oz; sirloin steak, 5.3 oz.

Fruits, Vegetables & Nuts: $16.45

Cantaloupe, 6 lb; oranges, 4.2 lb; firedrake fruit (sweet-flavored cactus fruit), 2.3 lb; lemons, 1.5 lb; plums, 1.1 lb; tomatoes, 2.4 lb; cucumbers, 2.3 lb; cauliflower, 1 head; celery, 1.4 lb; carrots, 1 lb; taro, 13.8 oz; cherry tomatoes, 13.4 oz; long beans, 10.6 oz; white onions, 10.6 oz; shiitake mushrooms, dried, 8.8 oz; shiitake mushrooms, fresh, 5.6 oz; black fungus (agaric), 3.5 oz.

Condiments: $17.26

Luhua peanut oil, 1.1 qt; *Hijoblanca* olive oil, 16.9 fl oz; soy bean juice, 16.9 fl oz; orange jam, 12 oz; hot pepper sauce, 9.7 oz; salad dressing, 7.1 oz; white sugar, 7.1 oz; *Maxwell House* coffee creamer, 6.7 oz; sesame oil, 6.8 fl oz; *BB* sweet hot sauce, 5.6 oz; citron day lily, 5.3 oz, *dried flower bud is used for flavoring;* honey, 5.3 oz; vinegar, 5.3 fl oz, *eaten with*

boiled dumplings; pepper paste, 3.5 oz; sour cowpea (black-eyed peas), preserved, 3.5 oz; seafood sauce, 3.4 fl oz; *Knorr* chicken-flavored MSG, 1.8 oz; MSG, 1.8 oz; salt, 1.8 oz; curry powder, 0.4 oz.

Snacks & Desserts: $17.70

Snack chips, 7 bags; *Ferrero Rocher* chocolates, 14.1 oz; *Xylitol* gum, 1 bottle; *Dove* chocolate, 8.5 oz lb; *Xylitol* blueberry gum, 3 pk; *Xylitol* gum, 3 pk.

Prepared Food: $6.12

Sushi rolls, packaged, 1.1 lb; eel strips, baked, 8.2 oz; *Knorr* chicken bouillon, 0.7 oz.

Fast Food: $9.17

KFC: 2 chicken hamburgers, 2 chicken burritos; 4 Coca-Cola; 2 pkgs french fries.

Beverages: $27.95

Grapefruit juice, 2.1 gal; *Asahi* beer, 6 12-fl-oz cans; *Bright* orange juice, 2.1 qt; *Tongyi* orange juice drink, 2.1 qt; *Coca-Cola,* 3 12-fl-oz cans; *Great Wall* dry red wine, 25.4 fl oz; diet *Coca-Cola,* 12 fl oz; *Jinliufu* rice wine, 8.5 fl oz; *Nescafe* instant coffee, 3.5 oz; tap water, boiled for drinking and cooking.

Miscellaneous: $0.63

Zhongnanhai cigarettes, 1 pk.

Food Expenditure for One Week: 1,233.76 yuan/$155.06 USD

a palpable desire to express that individuality as well—and a desire to mold one's life oneself, rather than live a life prescribed by centuries of culture and tradition. (Within certain parameters, of course. The central government has loosened its grip on the daily lives of its people, but still watches them carefully.)

The Dongs' last apartment could more adequately be described as a compartment. They lived in a *hutong*—one of the many centuries-old warrens of family rooms that are arranged around a quadrangle and linked by a tangle of narrow alleyways. Today, they're being systematically razed to make room for shiny new office buildings and skyscrapers to accommodate the growing population that lives and works in Beijing. "I was looking forward to a change," says Guo Yongmei about her new digs. She and Dong Li were interested in creating a spacious environment of the sort that wasn't available when they were living in their small *hutong*. Dong Li, who works for the Beijing municipal government in the basement of the city's tallest skyscraper—the Jing Guang Center—and Guo Yongmei, who is a bookkeeper, live in Beijing's Chaoyang District with their only child, Dong Yan, 13, a quiet, studious boy. Like most children born after China initiated its one-child policy, he gets the undivided attention of his parents and grandparents (just as 6-year-old Cui Yuqi does, in rural Beijing Province [p. 90]).

Hyperspace Chinois

The Dongs, like most urban Chinese, enjoy a combination of Western fast food, international cuisine, and traditional Chinese food. "We like to shop at Carrefour," says Guo Yongmei, referring to the French hypermarket chain. "It's close to us, but too crowded on the weekends." So today they're shopping at the Japanese hypermarket Ito Yokado. "It's just the same," Guo Yongmei says, "but normally not as crowded." She doesn't shop much at the smaller markets anymore because they lack variety, but also, because she likes to see the international brands that are now flowing into the country, and stocking the shelves like never before. Although regional markets still serve the bulk of the country, the multinationals like Carrefour and Walmart (and the Chinese conglomerates like WuMart) have edged out the smaller markets in the cities, where individuals' purchasing power is greatest. They are the urban shopper's choice in China's biggest cities.

Ito Yokado is jammed when we go there with the Dongs. "This isn't crowded?" I ask our translator, Angela Yu, who asks Guo Yongmei. Guo Yongmei shrugs and laughs. "Not really," she says. The noise level calls to mind a football stadium in overtime. We walk behind Dong Li, who has his shopping cart to carve a path through the masses to the seafood counter. To a foreign visitor, it's immediately apparent that the multinational hypermarkets have tailored their stores to Chinese tastes. The seafood counter turns out to be an aquarium-like fish and seafood emporium much like those found in the outdoor markets in many Chinese cities. There are swimming fish, shellfish, slithery eels, fish on ice, cases of live crabs, and frozen fish pieces. Guo Yongmei and Dong Li make their choices together, and send Dong Yan for this and that among the 1,000-year-old eggs, tea eggs, rows and rows of chips, extruded shrimp-and-vegetable puffs, frozen dumplings, fresh dumplings, vegetables, fruits, and sample tastings in every aisle. The enormous number of people working in the store almost equals the enormous number of people shopping there.

Tradition Transition

"Thirty years ago," says Dong Li, there was very little food. "Now there is a lot, and it tastes better." He and Guo Yongmei eat out at restaurants once a week or so, but even then they mostly go to Chinese restaurants. Dong Yan is more apt to want Western fast food. "There is a McDonald's near my school," he says. "I go with my friends." He eats there a couple of times a week—more often if he can. Does he eat differently than his parents? "I like more sweet foods that my parents don't really like." "He's growing up differently than I did," says his father. And it's clear from his voice that Dong Li's happy about it. He's hoping that his son grows up to be a linguist, so that he can travel and study in different countries. At 13, Dong Yan is not inclined to commit to his future.

When Dong Li's mother, Zhang Liying, stops by for a visit, we ask her what she thinks about her son's modern apartment. "It's not really to my taste," she says. "There is nothing here that is familiar." But she smiles as she says this. Zhang Liying, who retired ten years ago from an electronics factory, has cared for her only grandson since he was a baby and she will be in the photograph with her son's family. Is there anything traditional that she would like to bring over, to put in the picture? She brings a Chinese *huoguo* (a hotpot), which she uses to cook thinly sliced meats, fish balls, and fresh vegetables. Her modern daughter-in-law doesn't have one.

CHINA

- Population: **1,298,847,624**
- Population of Metro Beijing: **14,230,000**
- Area in square miles: **3,704,427 (slightly smaller than entire US)**
- Population density per square mile: **351**
- Urban population: **38%**
- Life expectancy, male/female: **70/73 years**
- Fertility rate (births per woman): **1.8**
- Literacy rate, male/female, 15 years and older: **95/87%**
- Caloric intake available daily per person: **2,951 calories**
- Annual alcohol consumption per person (alcohol content only): **5.5 quarts**
- GDP per person in PPP $ (Purchasing Power Parity: an adjustment for what equivalent local goods would cost in the U.S.): **$4,580**
- Total annual health expenditure per person in $ and as a percent of GDP: **$49/5.5**
- Overweight population, male/female: **28/23%**
- Obese population, male/female: **1/1.5%**
- Percent of population, age 20 and older, with diabetes: **2.4**
- Available supply of sugar and sweeteners per person per year: **16 pounds**
- Meat consumption per person per year: **115 pounds**
- Number of McDonald's / KFC restaurants in 2004: **600+/1200**
- Big Mac price: **$1.26**
- Cigarette consumption per person per year: **1,791**
- Percent of population, male/female, 18 and older that smokes: **59/4**
- Percent of population living on less than $2 a day: **47**
- Number of days of curing, after which a "1000-year-old egg" is most delectable: **100**

Chinese cities are among the world capitals of street food, with stands selling an extraordinary variety of treats. In central Beijing, the Enrong Roasted Meat Store offers "Brazilian roasted meat" (left foreground, the vertical, rotating stack of meat), "fresh-boiled" and "honey-roasted" corn on the cob, "Mongolian grasslands roasted meat," dry, tire-black "stinky tofu," and a rack of skewered scorpions (under salesman's outstretched arm).

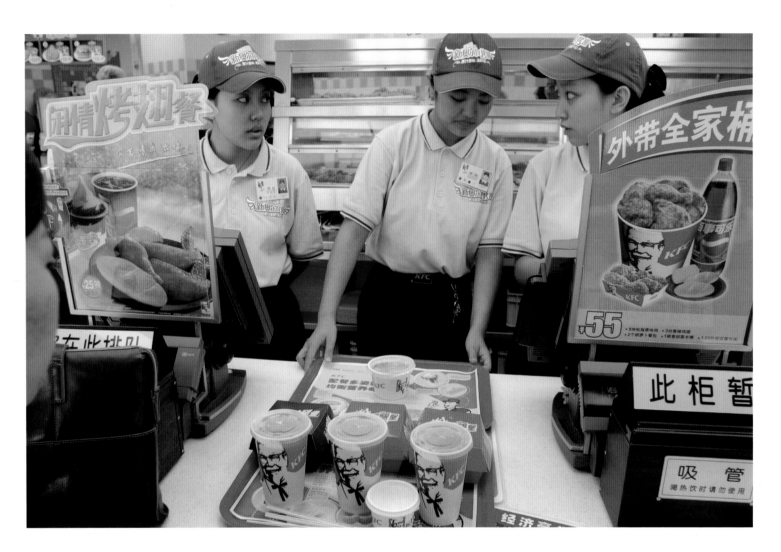

With Beijing's Forbidden City glowing mistily in the background, a group of middle-aged women in Zhongshan Park *(at right)* practices the long-standing tradition of morning group dance and exercise. A newer common sight is the long line of younger or newly affluent urbanites ending at the cash register of the biggest Western fast-food chain in China *(above);* their choice, on the left, is the "Leisurely Fried Wings Meal." More than a hundred KFC outlets operate in Beijing alone.

One day, our son Josh, who is fluent in Mandarin, accompanied me on a gastronomic tour to the east of Tiananmen Square. Bypassing the more aggressive food vendors of Wangfujing Street, we headed for a mellow line of stalls with an incredible variety of food: sea horses, snakes, and live scorpions on skewers; deep-fried silkworm pupae, crickets, and scorpions; fledgling quail, chicken hearts, goat kidneys, and private parts labeled "goat cock and testicles"; clam's feet, frog's legs, and several kinds of squid; fish balls and meat balls; shiitake mushroom caps and hot potato-starch cubes; goat-head and goat-organ soup (both smelled delicious). We opted for potato-starch cubes (gluey and dull), chopped lamb sandwiches (terrific), Sichuan gelatinous dessert (Jello-like cubes made from rice starch, served with sweet syrup), and—most interesting—deep-fried starfish on a stick.

We barraged the stall workers with questions about how to eat the starfish. Should we eat the whole thing? Just the insides? With hot sauce? They pled ignorance—incredibly, the cooks didn't know how to eat their own food, because it came from a different region. So we copied the way everyone else was eating the six-inch creatures: the whole thing, from star tips to center, with a splash of hot sauce. It was crunchy and tasteless—I could only get down two limbs and a bit of the body. All the other customers seemed to be enjoying their deep-fried echinoderms on a stick, but most of ours ended up in the trash. Rating: less than half a star (p. 287).

On our last night in Beijing, we ate with the Dongs. Mr. Dong told us about his childhood visits to the coast in the summer, where he roamed the beaches. "Did you eat starfish?" I asked. "Of course," he replied. "But the only edible part is the center underside. You scoop it out—the rest is terrible." — Peter

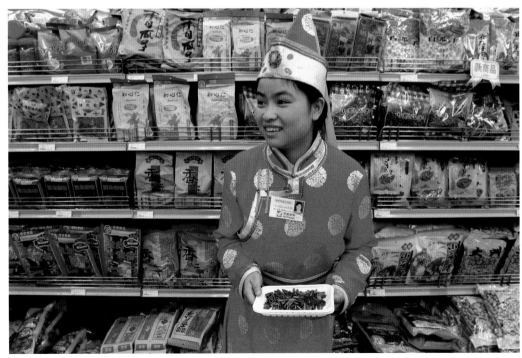

Dong Family's Pigskin Jelly

1 lb fresh pigskin, hair scraped off

1 scallion, cut into 6–7 pieces

1 oz ginger, peeled, cut into 3–4 pieces

3–4 cloves garlic, whole

1/2 oz Sichuan peppercorns (Asian prickly ash), whole

1 whole star anise, broken into 4–5 pieces

2 t Chinese cooking wine

1 t vinegar

salt

soy sauce

- Put pigskin in water to cover and bring to boil for short time to soften.

- Remove pigskin and cut into 1–2" strips to facilitate handling. Combine pigskin, scallion, ginger, 2 cloves garlic, Sichuan peppercorns, star anise, and Chinese cooking wine. Add water to cover and bring to medium boil.

- When water boils, add salt and soy sauce to taste. Continue to boil until pigskin is extremely tender.

- Remove all condiments and spices with chopsticks, but leave pigskin in water. Remove from heat; when cool, store in refrigerator.

- When ready to eat, take cooled pigskin from water and cut into bite-size pieces. Serve mixed with vinegar, 2 cloves mashed garlic, and salt and soy sauce to taste.

The Dongs haul their groceries up the dingy stairwell *(above)* to their newly redecorated fourth-floor flat. During their expedition to Ito Yokado, a Japanese supermarket chain, they inspect a tray of live crabs *(above left)*. In many restaurants and markets in China, much of the seafood is sold live as a guarantee of freshness. In other ways, the supermarket hews closely to Western models, right down to the workers offering samples *(bottom left, a worker in a faux-Mongolian outfit)*.

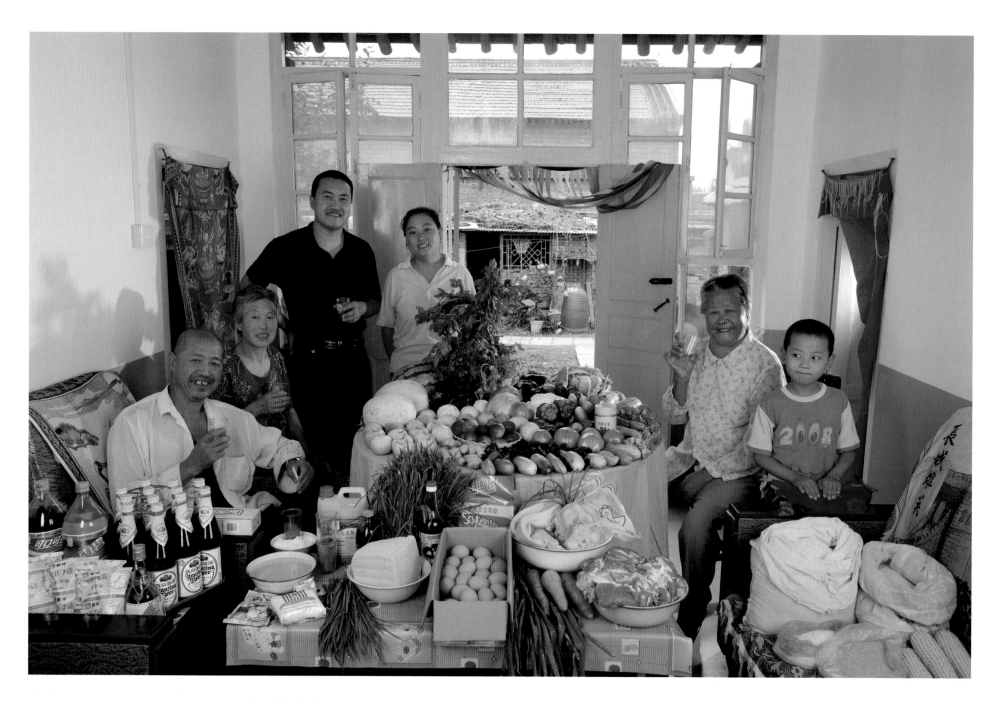

The Cui family of Weitaiwu village, Beijing Province, in their living room with a week's worth of food. Cui Haiwang, 33, and Li Jinxian, 31, stand with their son, Cui Yuqi, 6, Haiwang's mother, Wu Xianglian, 61, and father, Cui Lianyou, 59, and Haiwang's grandmother, Cui Wu, 79. Cooking methods: gas burner, coal stove. Food preservation: refrigerator-freezer. Favorite foods—Cui Yuqi: fish. Li Jinxian: vegetables. Wu Xianglian: "anything." Cui Wu: "everything."

Winds of Change

Grains & Other Starchy Foods: $3.98**

Wheat flour, 23.2 lb; white rice, 6.6 lb; cornmeal, 2.2 lb; millet, 2.2 lb; potatoes,* 2.2 lb.

Dairy: $1.26

Milk, whole, 2.1 qt.

Meat, Fish & Eggs: $23.27

Lamb, 11 lb; eggs, 44; pork, 6.7 lb; chicken, 4.4 lb.

Fruits, Vegetables & Nuts: $11.84**

Watermelons, 18.3 lb; muskmelons (cantaloupe), 12 lb; white peaches, 6.6 lb; black grapes, 3.3 lb; green apples, 3.3 lb; plums, 3.3 lb; pears, 1.1 lb; cucumbers,* 15.5 lb; green beans, 5.5 lb; eggplant, 4.4 lb; tofu, 4.4 lb; cabbage, 2 heads; cauliflower, 1 head; chives,* 3.3 lb; tomatoes, 3.3 lb; zucchini,* 3.3 lb; celery, 2.2 lb; garlic, 2.2 lb; green peppers, 2.2 lb; corn,* 5 ears; *Weiwei* soymilk powder, 1.2 lb; carrots, 1.1 lb; black fungus (agaric), 8.8 oz; green onions,* 8.8 oz.

Condiments: $5.57

Peanut oil, 2.8 lb; soy sauce, 21 fl oz; sesame oil, 11.8 fl oz; ginger, 1.1 lb; *Longfei* vinegar, 1.1 lb; salt, 1.1 lb; white sugar,

8.8 oz; cilantro (also called Chinese parsley), 1 bunch; white pepper, 1.8 oz; yeast, 1.4 oz; five-spice powder, 0.4 oz; MSG, 0.4 oz; Sichuan peppercorns (Asian prickly ash), 0.4 oz; star anise, 0.2 oz.

Prepared Food: $0.09

Chicken bouillon, 1.8 oz.

Beverages: $6.73

Yanjing beer, 12 21.3-fl-oz bottles; Coca-Cola, 2.1 qt; *Sprite,* 2.1 qt; rice wine, 1.1 lb; jasmine tea, 5.3 oz; water for drinking and cooking, *pumped from family well.*

Miscellaneous: $4.53

Hongmei cigarettes, 10 pks.

* Homegrown

Food Expenditure for One Week: 455.25 yuan/$57.27

**Total value of homegrown foods, if purchased locally: $1.96

"Chi fan le ma?" One farmer might say to another when they meet on the street. "Have you eaten?" "Chi bao le," his friend replies. "I'm full." Food has traditionally played such a central role in Chinese life that it is often invoked even in day-to-day greetings.

ON THE HALF-MILE WALK FROM HOME to his cornfield, Cui Lianyou greets neighbors who are working, lounging, eating, and visiting along the single concrete road in Weitaiwu, a rural village 60 miles east of Beijing. He turns down a small path, past the new chemical fertilizer plant, and hops onto one of the narrow, raised ridges of earth that separate the villagers' fields from one another. After a short distance, he steps into his own densely planted cornfield—tall now with plump yellow ears that will soon be ready for picking—and professes surprise that his neighbor's corn is just as tall. "They didn't plant until six or seven days after I did," he says. Grandfather Cui also grows barley, wheat, soybeans, and peanuts, depending on the season. Land assignments—made at the local government level—are temporary. In the government's most recent allocation, the six members of the Cui family were awarded half a *mu* each, for a total of three *mu* (slightly more than half an acre). Private ownership of land by Chinese citizens is still a foreign concept, though the government appears to realize that its citizens might invest more in improving the land if they had more than tenuous ties to it. The Cuis and their fellow villagers have been assigned more land at other times, but now large peach orchards blanket the area that Grandfather Cui and his neighbors used to farm collectively. The local government benefits financially, and some of that money trickles down into public works. Even five years ago all the roads near the Cui's home were dirt, and that's no longer true.

Grandfather Cui's wife, Wu Xianglian, and their daughter-in-law Li Jinxian grow tomatoes, cabbage, squash, and cucumbers in their courtyard kitchen garden, and grapes on a trellis, but despite the family's plots of land, they manage to grow only about 10 percent of what they need all year. The rest of their food is purchased with money earned by Li Jinxian's husband, Cui Haiwang, who is a printing press repairman working out of Beijing. He would prefer to stay with his family in the village, but there are no jobs at

which he can earn enough to support them. He comes home on the weekends. Li Jinxian sometimes works at a nearby factory that makes clothing for Japan and the United States. She is paid 20 yuan ($2.50 USD) for a ten-hour workday and dislikes the job.

The family considers itself poor in comparison with the rest of their village, but they still have some of the amenities that disposable income brings—a TV, a stereo system, a phone—and their family compound has been refurbished within the last two years.

The Cuis, like most of the Chinese population, let nothing go to waste. Cornhusks are put to good use and fed to the three sheep in their shed. They're also fed a portion of the corn crop. The trio was purchased as lambs, and when full grown will be sold to the local butcher to provide the family with extra income. Grandfather Cui's wife will also occasionally weave corn leaves into cushiony seats for the ground outside—each cushion takes two hours to complete and lasts through a couple of rainy seasons. Her chickens in the courtyard will be eaten during the Chinese New Year celebration, or sooner if they stop producing eggs. But they don't raise pigs. Grandfather Cui says, "Pigs are too expensive to raise, because they require scraps and grain, not just garden greens." They have no scraps, he says, except for what they feed to Little White, the cat napping near the bedroom his 6-year-old grandson, Cui Yuqi, shares with his parents. "That's a real country cat," says Grandfather Cui. "It gets a lot of mice. If you go to Beijing, those cats don't know anything about catching mice."

Though more and more urban Chinese are embracing the cash economy, the traditional style of bartering goods and services still prevails in China's rural villages. The Cuis trade a portion of their harvested peanuts for peanut oil. When they dry some of their corn and have it milled into cornmeal, the local miller takes part of it as payment. They bring their wheat to a noodle maker in the village who gives them noodles in trade. It costs them 110 pounds of wheat and five yuan (62 cents, USD) to get 88 pounds of noodles back. They don't climb their five persimmon trees to pick the ripened fruit; instead, men come to do the harvesting, in exchange for a percentage of the fruit. "My grandson and I like to watch them jump from one treetop to the other," says Grandfather Cui. The entertainment is free of charge.

Does Grandfather Cui have a favorite food? "Pork," he says. Then, "No, pork and lamb. And beef." Finally, he summarizes:

"Meat! I like meat!" His wife laughs at him as she passes by on her way to another of her many household tasks—"There's nothing we won't eat," she retorts, and he agrees. "Back in the Cultural Revolution, we ate anything we could find. We dug up everything," says Grandfather Cui, "even wild grass. And if food fell on the ground, it didn't matter—just pick it up, brush it off, and eat it. We didn't waste *anything!*"

Grandfather Cui is concerned with what he sees as the wasteful ways of China's youngest generation. "Kids today who go and order giant tables of food and don't finish it all—that really upsets me. And little kids going to school, for breakfast they buy *you tiao* [a strip of fried dough]. They take a few bites and then throw the rest away. It's just not right. Our grandson doesn't do that," he says. Grandfather Cui thinks he knows where that habit comes from. "They have a lot of money," he says, "and they're not being taught well. In their minds a little waste is nothing."

The desire of typical rural Chinese to eat only traditional foods is changing with Cui Yuqi's generation. "For his birthday, we buy him foods he wants [but] we don't eat, like butter and cake," says Grandfather Cui, who has never eaten anything but food prepared in the Chinese manner by his mother and his wife. No one in the family has ever tasted cheese. Cui Yuqi likes packaged snacks and candy, and although he has never had Western fast food, he's looking forward to trying some. His mother says that she too would try it, but says so apprehensively. His grandparents want no part of it, even if it were affordable. They never eat food outside their home. "It's very expensive," says Li Jinxian. "We aren't in that kind of circumstance."

Though her husband works out of Beijing, the rest of the family has visited the massive city only once—it's geographically close, but beyond their reach financially. The big city overwhelmed the older folks, but "Cui Yuqi was fascinated," says his mother. She's sure he'll go there again. Grandfather Cui doesn't care to ever go back.

Wu Xianglian harvested the last of her tomatoes this morning and is chopping them up for her family's lunch. She cooks *lao bing*, a wheat-flour dough that flakes and puffs when dropped into hot peanut oil, and stir-fries tender bok choy. As she moves between the small detached and semi-detached rooms that form her family compound—the traditional living arrangement in many Chinese villages—daughter-in-law Li Jinxian sets out white rice and *baozi*,

- Rural population (people/households): **800,000,000/245,000,000**
- Population of Weitaiwu village: **450 (est.)**
- Percent of laborers in China engaged in agricultural work: **50**
- Population with access to safe water in rural/urban areas: **68/92%**
- Population with access to safe sanitation in rural/urban areas: **29/69%**
- Ratio of percentage of rural to urban population that is overweight: **1:2.3**
- Ratio of rural to urban electricity use per person: **1:3.3**
- Ratio of rural to urban household consumption: **1:3.5**
- Ratio of suicide rates in rural to urban areas: **4:1**
- Number of casualties in rural China resulting from 420 protests of angry farmers who surrounded local government buildings in the first half of 1998: **7,400**
- Average per person income, rural/urban (in US $): **434/1,029**
- Number of refrigerators per 100 families (rural/urban): **12/80**
- Percent of rural residential energy consumption that comes from noncommercial sources like straw, paper, dung: **57**
- Ratio of Internet users in rural/urban areas: **1:100**
- Rank of rat poison as murder weapon of choice in rural areas: **No. 1**

Li Jinxian always likes to buy fruit from the same vendor, a woman whom she has built a rapport with over time. This week her husband, Cui Haiwang, has come shopping with her—usually he's away working in Beijing. Both husband and wife are discriminating fruit and vegetable shoppers. Sniffing and pinching each item before deciding on a purchase is standard operating procedure.

Li Jinxian's Braised Lamb Meatballs

1 oz onion, chopped

1 oz ginger, coarsely chopped

2 pinches Asian five-spice powder

salt, to taste

2 lb lamb, minced or ground

1 egg

6 cups water

2 oz cilantro (also called Chinese parsley), cut in approx. 1/2" pieces

2 pinches chicken bouillon powder

1/2 t white pepper

sesame oil and vinegar, to taste

- With chopsticks, work chopped onion, ginger, five-spice powder, and salt into lamb; then add egg and knead until ingredients are thoroughly mixed.
- Boil water. Form lamb mixture into 1" balls, then place into boiling water; keep lamb balls as separate as possible so they don't stick together. Return water to simmer and cook for 15 minutes.
- Add cilantro, bouillon, white pepper, sesame oil, and vinegar. Mix and serve.

Shopping for the week's worth of food in the family portrait, Li Jinxian and Cui Haiwang buy chicken, lamb, and pork at the Luckybird Meat Store No. E0001 *(above right)* in the market town nearest their small village. Visiting a fruit vendor in another nearby town, they sniff the plums *(bottom right)* to find the ripest, sweetest fruit.

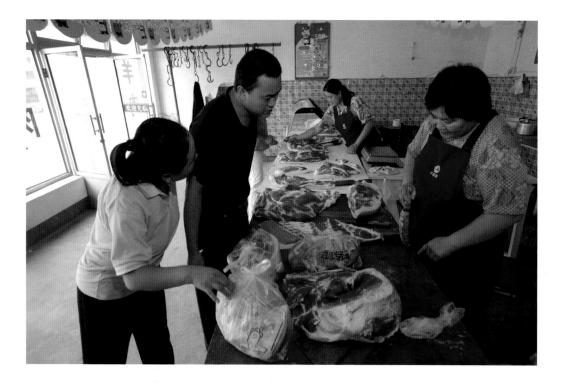

In contrast to the Dongs in central Beijing (p. 74), who did all their grocery shopping at a huge supermarket, the Cuis, outside the city's periphery—two hours east and within sight of the Great Wall—bought their food from stalls in a traditional outdoor market. The sole exception was a big butcher shop, where the butcher totaled their purchase by scratching out the math with her knife on the well-worn wooden counter.

On the way to the market with the Cuis, we passed an improvised stand from which a neighboring family sold soybean milk, *youbing* (puffy, deep-fried dough), and a few other inexpensive fried or steamed foods to early-morning workers. The Cuis passed it by: too pricey. Instead, they stocked up at the market with melons, grapes, and bananas from a vendor whom they knew well. Sniffing and closely examining everything they purchased, they got apples, plums, tomatoes, green onions, black fungus, and other fresh food at several other stands. Three hours later, when we lugged back all the food, the neighbors had brought the benches inside—their makeshift breakfast stand was closed for the day.

The Cuis were doing well in their newly refurbished house, but they remembered hard times past. Later that day, over a sumptuous lunch of homemade steamed pork buns, steamed chicken, tomatoes, green pepper–beef, beef with cauliflower, and rice, we listened to their stories about living and eating during the Cultural Revolution. Like so many other families, the Cuis had been hungry for years and now were thankful for their relative prosperity. — *Peter*

Loaded down with groceries for the family portrait, Li Jinxian and Cui Haiwang are met by Grandfather Cui with his
sanlun che (three-wheeled cart) at the entrance to the narrow lane leading to their home. The Cui family—indeed, most
rural Chinese—would never buy this quantity of food at one time, but would buy smaller quantities every day.

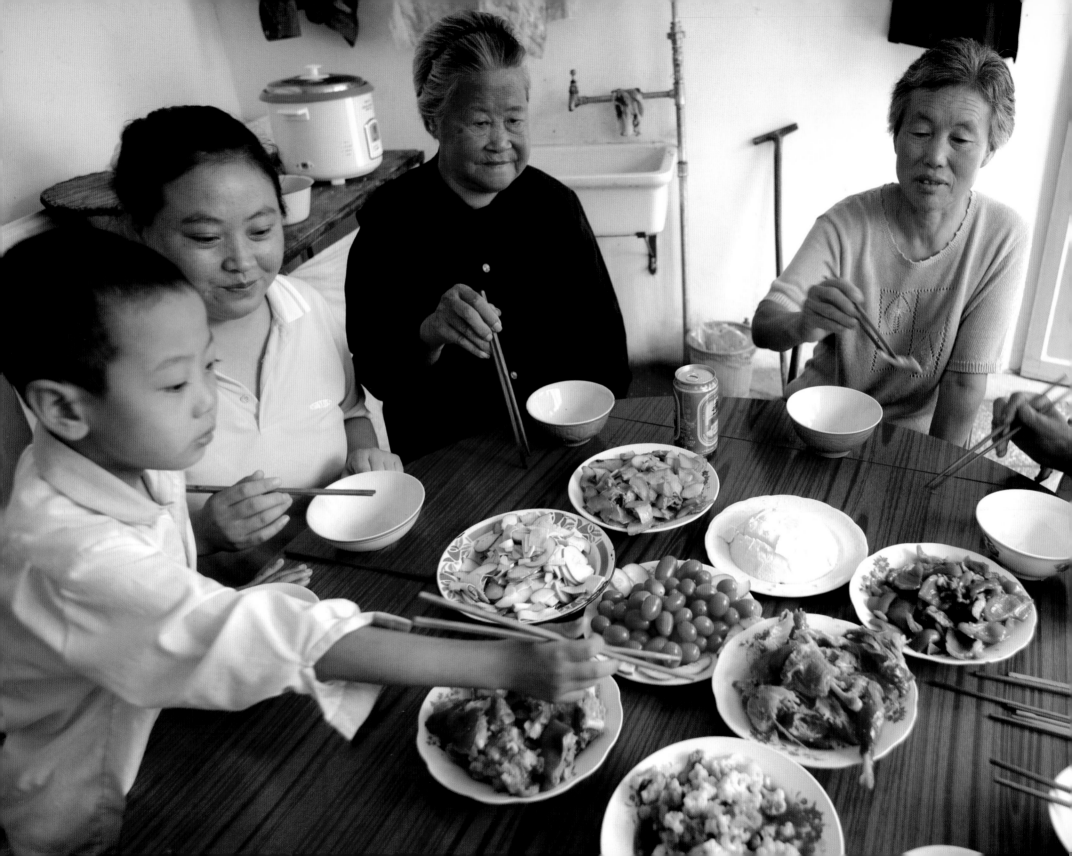

THE CHINA STUDY

Until recently, the rural Chinese diet consisted mainly of a wide variety of low-fat, plant-based foods that are rich in antioxidant micronutrients, complex carbohydrates, and dietary fiber. Land-animal meats, mostly pork and chicken, were mainly eaten on holidays. During the early 1980s, researchers surveyed diets and diseases in 130 representative rural villages and found that the consumption of plant-based foods was associated with fewer Western-culture diseases (heart disease, diabetes, certain cancers).

By contrast, a relatively small increase in the consumption of animal-based foods led to a gradual rise in the clinical conditions that characterize Western-culture diseases. In conjunction with other research, studies of the unique diet and health associations in rural China strongly support the idea that the most profound and comprehensive health benefits of food are obtained by consuming many different types of whole vegetables, fruits, and cereal grains.

— *T. Colin Campbell, Cornell University, author of The China Study*

Breakfast at the Cuis' includes fresh eggs from the family hens *(bottom right)* and hot *mian tiao* (noodles) with a little cooked spinach and MSG. The round chopping block is made from a slice of tree trunk, a common practice in China. In the courtyard that morning, Li Jinxian husks corn *(above right)* from their cornfield under the watchful eye of Great-grandmother Cui Wu. The family will eat some of the corn and trade the rest; the husks go to the sheep. Two hours later, lunch is ready. Six-year-old Cui Yuqi *(left)* reaches for a piece of smoked chicken in the family's kitchen house. Other foods on the table include (clockwise from bottom) cauliflower and beef; pig's feet; dried tofu curd and cucumber; cucumber and beef; steamed egg-white custard; stir-fried green peppers and beef. The tomatoes in the center were picked from their kitchen garden that morning.

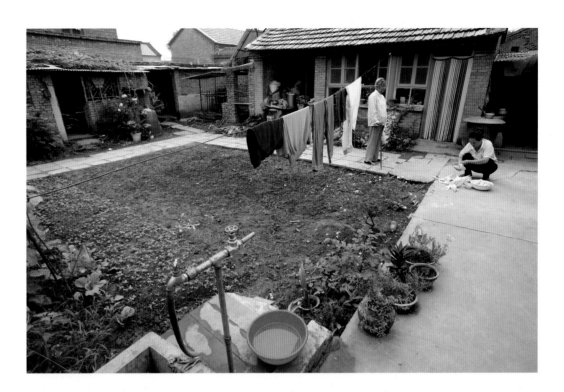

fist-size pork-and-vegetable-stuffed steamed buns. Her son is holed up in the bedroom, practicing basic Chinese character-writing for homework and producing drawings that he carries around from time to time to show the older Cuis. When Cui Yuqi approaches anyone in the family to explain the animals in one of his works of art or the color of the sky over the distant mountains in another, everyone stops their work to take a look.

Children in Cui Yuqi's generation, one of single-child families created by the Chinese government's adoption of a one-child-per-couple policy 25 years ago, are guaranteed the undivided attention of at least two family members—the parents—and four other highly interested parties—the grandparents. The policy has been around long enough that the latest generation of grandparents, who had only one child, now has only one grandchild. These Chinese families pay much attention to their sole descendant, channeling whatever resources they have toward the child's happiness and well-being. Although it's apparent that some of these only children have learned to take advantage of the situation they find themselves in by government decree, Cui Yuqi doesn't seem to be trying to profit from his position in the catbird seat. It will be interesting, though, to see what happens in another generation or two, when this formerly collectivized country is swarming with what the Chinese commonly call *xiao huangdi*—little emperors.

Great-grandmother Cui Wu leans heavily on her cane and steps carefully from her room at the back of the compound, moving toward the dining room through the light mist of rain that has begun to fall. Her husband died many years ago, and she has always lived with her son's family—customary in rural China. She's a bit deaf and had a mild stroke four years ago, but has a droll sense of humor that surfaces when we talk about her childhood. She says of her traditional Chinese clothing of that time, "It was hard to make, and even harder to wear." When she married, she says, like others her age she dropped her given name—called her *gui ming*, or "inner chamber name"—the name young girls were called only within their home, before they were married. Today she's known only by her husband's family name, Cui, and her family name, Wu, and no longer remembers what she was called as a girl.

Grandmother Wu puts the chopsticks on the table and four generations of the family sit down to eat—except that Cui Yuqi says he isn't hungry. "Too much soy milk," suggests his grand-father. "He doesn't like vegetables," says his grandmother.

China has been called a vegetable civilization. Wu Xianglian sees the boy's refusal to eat vegetables as a bit of a warning shot across the bow of Chinese culture. His mother coaxes him to the table, and the boy decides that he is hungry after all. He reaches for the smoked chicken. His grandmother offers him the bok choy.

The Price of Big Rice

"Never could we have imagined that we would ever have this much to eat," says Grandfather Cui, thinking back to his childhood, here in this same rural village. "Back then, we ate cornmeal and mixed grains. Now we have pure grains, and they're affordable." "When I was young," says his mother—Great-grandmother Cui Wu—"we had potatoes—and potatoes." "We relied completely on the land," says Grandfather Cui. "If there was no rain, we were hungry. There was no water at the fields. We had to carry water where it was needed."

Cornmeal figures prominently in many rural Chinese families' early modern history. Corn came to Asia after it was discovered in the Americas, and this was the Cuis' most important grain, along with millet, known locally as *small rice*—which is drought tolerant. It wasn't until after the end of the Cultural Revolution that white rice—colloquially called *big rice*—became an affordable staple for most Chinese families. Today, half the country's white rice is grown along central China's middle and lower Yangtze River basin.

How long have the Cuis been eating big rice? "In the 1960s, it was too expensive," says Grandmother Wu. "We had very little." "Some people could buy big rice then," says Grandfather Cui, "but that was during a difficult time—some people had money to buy it, but no one dared." During the Cultural Revolution, private enterprise was extinguished, farming became collectivized, and the Chinese people were swept up into regional groups of workers under state control. Grandfather Cui's memory of the food during that time is one largely shared by his and his mother's generation: "There wasn't much difference between the quality of food before and during the Cultural Revolution. Both were bad. It has gotten much better."

The Cui family bears no responsibility for the text in this chapter. It is based solely on observation. All information about the government was supplied by other sources.

WOK THIS WAY

I've spent several years traveling this massive country, and almost every mile of the way was, among other things, a foodie's dream. Street foods and cheap eats are my favorite. There's savory Xinjiang lamb shashlik, Shaanxi seasoned pork in a steamed bun (so good that the first time I had one, I walked a mile back to have a second), spicy Sichuan wontons in red oil, thick Shanxi knife-shaved noodles with a tad of aged vinegar...okay, I should stop before I get any hungrier. These treats are all quite well known (in country), but everywhere from the largest city to the smallest town has its own specialties, finding them just takes the patience to eat your way through the millions of restaurants, stands, and vendors China has to offer.

Here are the rules: 1) Forget about cleanliness, since pretty much any food outlet that doesn't cost a fortune will have substandard sanitation. Find comfort in the fact that a billion people eat at places like this every day, but it isn't solving the problem of overpopulation. 2) Don't spend a lot of money, because a day of palatal bliss shouldn't cost more than $3 USD. 3) Look for the universal indicator of good chow—that is, if it's feeding time, search for places where throngs of people are scarfing it up; otherwise, you really need someone familiar with the local area. If you're lucky enough to know/meet someone who can speak more than a single word of English (that word being "hello"), ask them.

Truthfully, some things (read: dog meat) are difficult to get used to, but with enough curiosity and persistence, you, too, will develop cravings for the likes of stinky tofu and pig's blood soup. They're just so... delicious. So head for China with an open mind and an empty stomach, and take with you one more rule: 4) Don't cower in the corner of one of China's growing number of McDonald's.

— *Josh D'Aluisio-Guerreri, Beijing*

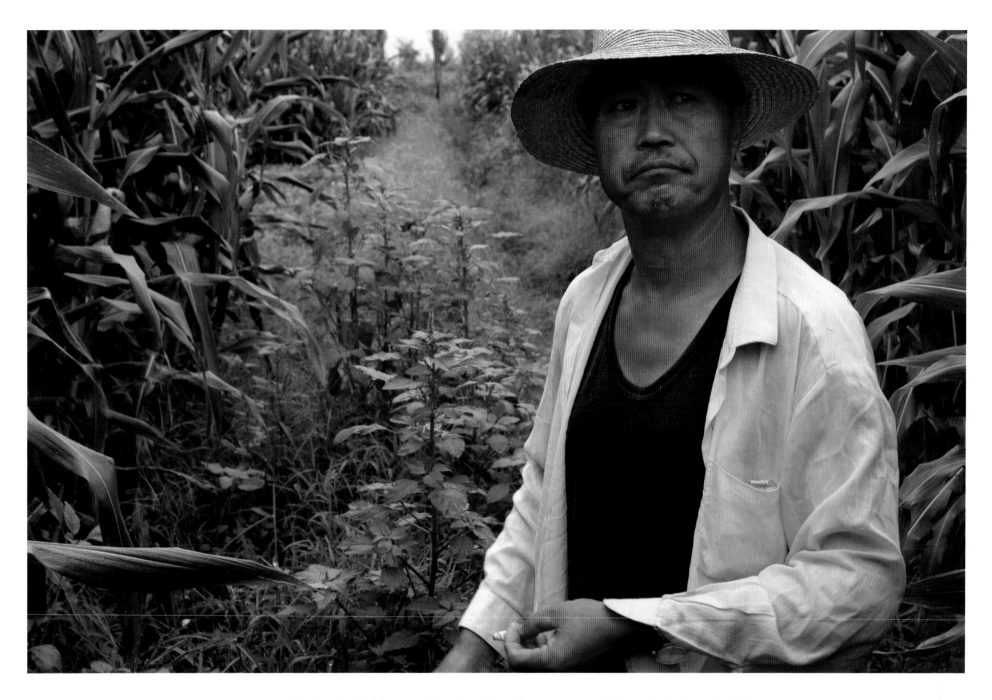

"Never could we have imagined that we would ever have this much to eat," says Grandfather Cui, reflecting on his childhood in the village as he has a smoke in his cornfield.

McSlow

IT TURNED OUT TO BE A HOAX, but the finger a woman claimed to have found in a bowl of chili at a California Wendy's may have been pointing in the right direction: suspicion of the sources and safety of fast food bordering on outright disgust.

Fast food has countless enemies—almost as many, it seems, as the billions and billions served. But few sworn enemies stop to think seriously about just why it is so appealing to those billions, and about its social utility beyond filling up bellies with processed grease. (Like so many scandals closely or distantly related to fast food, the finger story briefly stirred anger and headlines and soon vanished.) They might do well to remember the injunction to know thine enemy. And the equally important one to be wily.

Fast-food restaurants have redefined the American family meal, yes, but they have by no means destroyed it. These restaurants offer safety, or the illusion of it, and comfort and familiarity. They also offer a sense of belonging—even if not to the community that fast-food's critics want. Fast-food communality is the opposite of local. It is communality with people all over the world, eating identical food that betrays no connection to community or place. Families everywhere have pleasant associations with what most right-minded people consider a desecration of real food. And they keep going back, pointing finger or no.

Yet even as fast food remains popular, its costs to the planet—and to the people who produce as well as consume it—are becoming more and more widely known. Since it appeared in 2001, Eric Schlosser's *Fast Food Nation* has been the master text for anyone who ever wondered what life is like for the cooks, servers, and cleaners in fast-food chains and the slaughterhouse workers who process the factory-farmed animals served in them. Degrading, remorseless, and maiming is often the answer.

Schlosser's scathing portrait may not have brought the fast-food industry to its knees, but it did deal a serious blow to its image. Soon after his book was published, several giants began making the kind of policy and purchasing decisions that can change how food is raised and produced in this country. McDonald's implemented slaughterhouse design and procedures suggested by the animal-welfare authority Temple Grandin and demanded that its chicken and egg suppliers use fewer antibiotics and give animals more cage room. It announced that it would not buy genetically altered potatoes for its French fries, hurling a roadblock in the path of GMO-making corporations. More recently, after a months-long boycott, Taco Bell gave in to a farm worker group and agreed to pay migrant workers higher wages.

These decisions, prompted by consumer demand, are what actually make a difference in global agriculture. The power to improve the environment, worker safety, and animal and human rights lies not so much in the hands of governments and unions as in the hands of McDonald's and the other fast-food chains.

THE BEST WAY TO FIGHT FAST FOOD may be to subvert it. Those who wish for a return to regionalism, to a more equitable farming system, and to a safer environment need to be more inventive than simply deciding to declare war on fast food. They could join the Slow Food movement, which in the 20 years of its existence has shown the effectiveness of uniting many small groups that share similar (though not identical) goals. Slow Food, active in 50 countries and now shifting its focus to the developing world, has done more than any single group to bring attention to endangered livestock and fruit and vegetable varieties, and to

vanishing traditions for making foods like cheeses and sausages and jams. Its secret weapon? Promulgating pleasure in eating.

Mano a mano battle, though, will mean making a more responsible, *but not necessarily better-tasting*, version of fast food for those billions who rely on it for quick, cheap meals every day. Yes, there have been tentative tries at "healthy fast food." O'Naturals, owned by the organic yogurt giant Stonyfield Farms, is a small but growing New England chain that sells fresh and appealing organic food in family-friendly restaurants. But the food is too good, and, even worse, looks good for you. It resembles the prepared foods at an upscale organic supermarket chain, with various stir-fries and borrowings from the most fashionable cuisines: Asian, Mexican, Mediterranean. It features posters showing the people who raise the animals and the vegetables that the chain serves. It is designed for people who already know that you should base your diet on grains and fresh vegetables, and that if you want a burger it should be made from grass-fed organic beef.

Subverting fast food involves an outright compromise with ideals, and designing menus filled with items that anyone who loves the world's regional foods will find repugnant. It can also involve great profit.

A serious new rival should start with streamlined, bland recipes that make spurious claims of Mexican and Wild West connections. Aim for anonymity and consistency. Spend a fortune promoting an image of young people having fun. Design brightly lit, plastic restaurants that have the cold, unwelcoming cheer of chains. Be sure they are family-friendly, have clean bathrooms and play areas for children, and offer wireless connectivity.

Then claim that your business is responsible to the environment and to workers, and that a specified percentage of the food it buys is locally raised—and back up those claims.

Most of this food will be far too high in fat and low in fiber to be healthful. It will have no actual regional identity or distinctiveness.

It *shouldn't* be good, in fact. It should be familiar—a reformulation of all the items McDonald's, Burger King, and Wendy's serve. The difference is in the new restaurant's claim to care about workers, customers, animals, and the environment; and putting into systematic practice what the big chains have done only in response to global outrage.

Price, as always, is the leveler. The businesses that produce healthy fast food have so far not been careful enough about compromising quality to achieve lower prices; nor have they been careful enough about investing more heavily in cynical, semideceptive marketing than in good food.

Some optimists say that eating something decent and slightly genuine in a fast-food restaurant will lead consumers who know nothing else to search for ever-better food. But perhaps, after eating enough salads with all-natural Newman's Own dressings at McDonald's, some customers will go to O'Naturals and discover how much better organic chicken and vegetables taste. These thrilled new converts will take note of the O'Naturals bulletin board flyers for community-supported agriculture programs, and start visiting the local farmers' markets, perhaps paying with government-subsidized food stamps (Massachusetts farmers, for example, accept them). At the market they will take lunchtime cooking lessons, and taste tomatoes and local cheeses at an event sponsored by Slow Food, or join the movement and start cooking at home. One glorious day, fast food will be a distant memory.

This is, of course, an unlikely scenario. The best fight is on two tracks. On one road, one is the purity of Slow Food and the stubborn defense of local food and the people who make it. The other, quicker track is frank, creative compromise to subvert the tools and appeal of fast food. This can give fast fast-food relief.

Corby Kummer, a senior editor at the Atlantic Monthly, *is the author of* The Pleasures of Slow Food: Celebrating Authentic Traditions, Flavors, and Recipes. *His work has appeared in* Gourmet *magazine and in the* New York Times.

"One glorious day, fast food will be a distant memory . . .
This is, of course, an unlikely scenario."

BEIJING, CHINA

SAN ANTONIO, TEXAS, USA

WARSAW, POLAND

TOKYO, JAPAN

MANILA, PHILIPPINES

BEIJING, CHINA

SUBWAY • RALEIGH, NORTH CAROLINA, USA

MOSCOW, RUSSIA

Fast Food

Has any human invention ever been as loved and loathed as fast food? Feelings run deep about the huge U.S. fast-food chains, especially McDonald's and KFC. Internationally recognized as symbols of Americanization, globalization, and overflowing schedules, they are also symbols of convenience, reliability, and (usually) cleanliness. Food activists from Paris to Pretoria like to denounce fast food, but, as Corby Kummer suggests in his accompanying essay, the pressures that give rise to it won't go away with a manifesto. Perhaps a backlash movement will arise, prompting equally convenient yet healthier alternatives.

SHANGHAI, CHINA

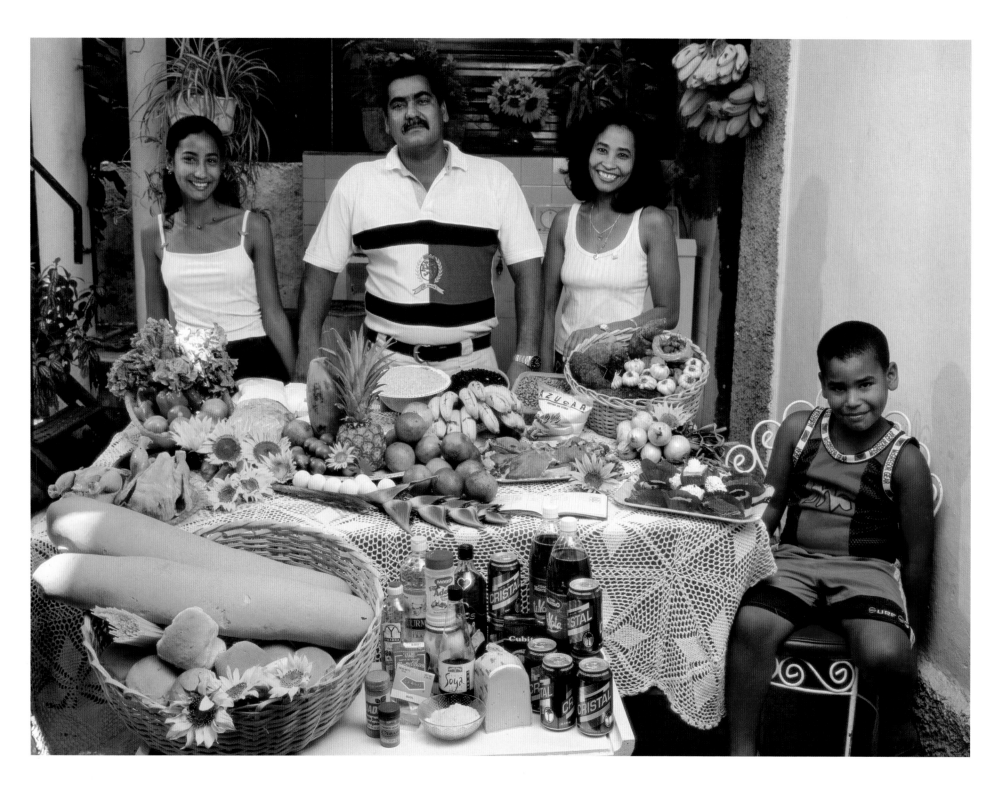

Still Afloat

Grains & Other Starchy Foods: $1.08**

Malanga (potatolike vegetable), 9.9 lb; bread ration, 8.8 lb; potato ration, 6.6 lb; white rice ration, 6.6 lb; pasta ration, spaghetti, 2.2 lb; cornmeal, 1 lb.

Dairy: $6.05**

Yogurt ration,‡ 1.9 gal; cheese, 2.2 lb.

Meat, Fish & Eggs: $15.71**

Chicken, 3.3 lb; pork chops, 2.2 lb; egg ration, 12; fish,‡ 1.1 lb, *caught by Ramon;* pork leg, frozen, 1 lb.

Fruits, Vegetables & Nuts: $4.19

Watermelons,‡ 26.5 lb; yellow bananas, 6.8 lb; oranges, 4.4 lb; pineapple, 2.6 lb; limes, 2.2 lb, *for drinks and preparation of fish;* papayas, 2.2 lb; guava, 1.1 lb; white onions, 4.2 lb; green cabbage, 1 head; black beans, 1.7 lb; red beans, 1.7 lb; lettuce, 1.4 lb; cucumbers, 1.1 lb; garlic, 1.1 lb; tomatoes, 1.1 lb; *Doña Tina* tomato sauce, 1 box; red pepper, 8 oz; green pepper, 8 oz.

Condiments: $4.08**

Vegetable oil ration, 1.1 qt; white sugar, 2.2 lb; salsa, 12 oz; red and green chili peppers, 8.8 oz; salt, 8.8 oz; *Ybarra* vinegar, 4 fl oz; mayonnaise, 2.5 fl oz; black pepper, 2 oz; *Maggi* allspice, 2 oz; oregano, 2 oz; *Wong Wing* soy sauce, 0.9 fl oz; *La Anita* bijol (seasoning made from annotto seeds), 0.3 oz.

Snacks & Desserts: $5.00

Cakes, small, 10.

Prepared Food: $3.05

Spaghetti sauce,‡ 1.1 qt; *during the week Lisandra has lunch at school or joins her brother Mario at her aunt's apartment for rice, beans, eggs, and/or fish. Ramon and Sandra eat the same foods for lunch at their places of employment.*

Restaurants: $10.00

Once a week, Sandra likes to go for Chinese food with the whole family; she likes fried rice.

Beverages: $7.60

Ciego Montero TuKola cola, 2 1.6-qt bottles; *Cristal* beer, 7 12-fl-oz cans; coffee ration, 1.1 lb; *Amor* liquor, 8.5 fl oz; tap water, for drinking and cooking.

Miscellaneous: **

Cerelac ration,‡ *fed to dog.*

‡ Not in Photo

Food Expenditure for One Week: 1,475.88 Cuban pesos/$56.76

**Total value of food rations, if purchased locally: $13.16

In a rare moment, when not surrounded by the in-laws and cousins with whom they share a Colonial-era house, the Costa family—Ramon Costa Allouis, 39, Sandra Raymond Mundi, 38, and their children Lisandra, 16, and Fabio, 6—in the courtyard of their extended family's home in Havana with one week's worth of food. Cooking methods: indoor gas stove, outdoor homemade BBQ grill. Food preservation: refrigerator, grandfather's freezer chest in the courtyard.

First-time visitors to Cuba often say that it looks like time stopped around 1960. With old-fashioned cars, crumbling historic architecture—and amazingly polite, respectful children—Havana exudes a charm reminiscent of Miami Beach, and America, before it became the land of corporate-owned hotels and fast-food joints. But time hasn't stopped in Cuba. Life continues—births, deaths, marriages, divorces, schooling, employment, and retirement.

ANGELINA AND EURIPIDES COSTA'S HAVANA HOME is both gathering spot and thoroughfare for the entire extended family and its circle of friends. Teenage boys headed for the bay tramp through the old Spanish Colonial with snorkels and spearfishing gear, then pass back through hours later, sandy-footed, proudly toting a sea fish or two. "Only a mouthful," observes the Costas' daughter Eulina, her smile softening the words. A troop of 6-year-olds zips in looking for the youngest Costa—Fabio, who tears off with them. Euripides, the family patriarch, just back from a government ration depot, walks through the house pulling the family's monthly food ration on a rickety cart. He's headed to the back courtyard, where bread goes into the deep freeze—food insurance—and rice is added to the family crock. Other times, he can be found in his rocking chair, bare feet straddling its rockers, watching TV in the living room, but keeping an eye out the window for friends who often stop by. He's retired from Cuba's nationalized cigar industry.

Euripides and Angelina partitioned off their small two-story house in Havana's Marianao District when their children began to marry. Eulina, now divorced, lives here with her children, Iris, 15, and Javier, 16. Her brother Orlando lived here as well, until he moved his family up the street. The Costas carved out a living space for Eulina's brother Ramon and his family off the courtyard—a concrete-block apartment, amazingly skinny for its height. Ramon and his wife, Sandra, have to pass through Euripides' or Eulina's part of the house to get to their apartment from the street—luckily, no one minds the interruptions.

Sandra says a quick hello to her father-in-law as she hurries through his house to hers

to prepare dinner. She's a courthouse secretary and always seems to be running late. Daughter Lisandra, 16, is washing vegetables at the sink outside her family's apartment. Her mother changes quickly into shorts and a striped top—even this early in April the weather is steamy—then pares and slices the potatolike *malanga* into wedges to make French fries in her small outdoor kitchen. She'll serve them with a spicy lime-juice-and-garlic *mojo* sauce and also make *congrí* (rice and beans), a standard Cuban accompaniment.

Sandra's son Fabio, 6, has arrived back home to weigh his dinner options. He checks out his mother's kitchen, then doubles back to see what is on his grandmother's menu, hoping for spaghetti. *"Arroz con pollo,"* Fabio reports back. "I'll eat here." "His favorite food is spaghetti with cheese and sugar," says Sandra as she cooks the *malanga* fries. "He would eat it every night, if he could." What would he want to eat otherwise? Hot dogs, all day, every day.

Meanwhile, Ramon arrives home from work, sets the small table in their kitchen with mismatched plates and utensils, then opens a beer and hangs out with his father until dinner's ready. Christina Aguilera is blasting forth from the stereo in Eulina's part of the house, so the teenagers up on the roof can hear it. Christina's holding her own against a Spanish rapper enthusing from another stereo, and cheering football crowds on the TV in Euripides' living room.

Lisandra sits on the steep steps that lead to the "weight room"—a covered rooftop spot with a pigeon coop, bar bells, and a breeze—where two of her male cousins are working out and looking at their muscles in a small hand mirror. The rooftop served as the location of Eulina's beauty parlor until she moved the business down to the front room, facing the street, when the rules against private enterprise began to loosen.

Like most Cubans, Sandra and Ramon, who works at the port for the government-owned import company *Cubalse*, earn nearly the same government-paid salary per month—roughly the equivalent of $15 U.S. More than half the population, including the Costas, also gets some kind of financial assistance from relatives living outside the country. The government takes 10 percent of that money as a tax. Utilities, transportation, and housing are heavily subsidized, and education and health care are free. All Cubans receive subsidized food, which is distributed monthly via a ration card. They pay a token amount for the food. Unfortunately, the

rations don't last the entire month, forcing Cubans to buy higher-priced food from farmers' markets and state stores, often with money sent by their émigré relatives.

In the early '90s, like many people living in Havana, the Costas used to raise pigs in their courtyard, one at a time, then slaughter and eat them. Virtually no one does this any more, because keeping a pigpen in the city is dirty and smelly. "It was too much trouble," says Euripides. And besides, meat is more readily available now.

Food rations vary, depending on what the government has available each month. There's always a pound or two of protein—some months, a little chicken; others, a soy and meat blend; sometimes even fish. Additional items might include coffee, sugar, salt, bread, beans, rice, and oil. Younger children get yogurt. Older adults might get Cerelac—an instant cereal. There might also be nonfood items such as soap, toothpaste, detergent, and tobacco. Nothing goes to waste. No one in the family likes to eat the Cerelac, so they feed it to their guard dog, who spends his days leaning off the roof, barking at passersby.

El bloqueo

El bloqueo (the blockade, as it is called), imposed by the United States during a dangerous game of superpower brinksmanship that has endured to this day, has, in the opinion of critics, both created hardships for the general populace and helped to make Fidel Castro a living icon—the proverbial David struggling against the U.S. Goliath. The economic embargo had less effect on the island nation when the Soviet bloc was still united and was Cuba's chief financial backer and military guardian. With the demise of the Soviet Union, Cuba's financial woes increased a hundredfold and Castro grudgingly allowed a market economy to emerge.

The Costa family bears no responsibility for the text in this chapter. It is based solely on observation. All information about the government was supplied by other sources.

CUBA

- Population: **11,308,764**
- Population of Havana: **2,411,100**
- Area in square miles: **42,792 (slightly smaller than Pennsylvania)**
- Population density per square mile: **264**
- Urban population: **76%**
- Population born after Castro became head of state: **70%**
- Life expectancy, male/female: **75/79 years**
- Fertility rate (births per woman): **1.6**
- Literacy rate, male/female, 15 years and older: **97/97%**
- Caloric intake available daily per person: **3,152 calories**
- Undernourished population: **11%**
- Annual alcohol consumption per person (alcohol content only): **3.6 quarts**
- GDP per person in PPP $ (Purchasing Power Parity: an adjustment for what equivalent local goods would cost in the U.S.): **$5,259**
- Total annual health expenditure per person in $ and as a percent of GDP: **$185/7.2**
- Physicians per 100,000 people: **596**
- Overweight population, male/female: **55/57%**
- Obese population, male/female: **12/21%**
- Percent of population age 20 years and older with diabetes: **6**
- Available supply of sugar and sweeteners per person per year: **137 pounds**
- Meat consumption per person per year: **71 pounds**
- McDonald's restaurants: **1 (on US base at Guantanamo)**
- Cigarette consumption per person per year: **1,343**

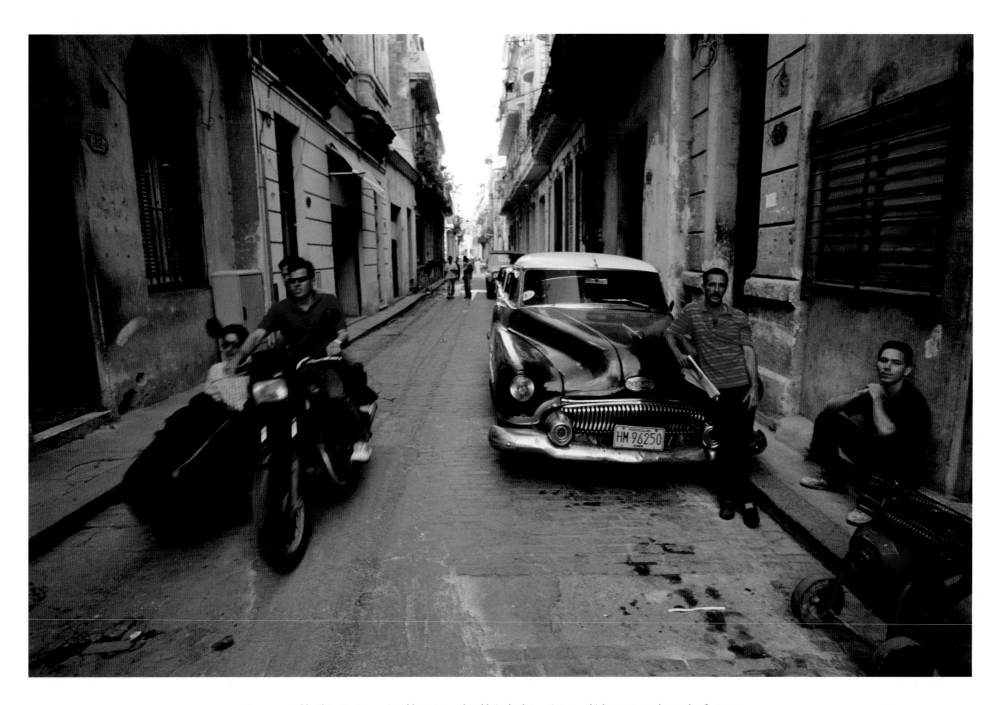

As suggested by this streetscape in Old Havana—the old city harbor—vintage vehicles are a regular mode of transportation throughout Cuba. Since 1962, the U.S. trade blockade has effectively prevented any new cars from arriving. But even though a few auto dealers in Europe and Russia are willing to defy the blockade and the attendant U.S. sanctions, not many Cubans have the money to buy new vehicles.

Sandra's *Congrí* (rice and beans)

1/2 lb red beans

2 *aji* (yellow hot peppers)

5 cups water

1/4 t cumin, ground

1/4 t oregano, ground

1/2 lb pork, cut into 1" pieces

2–4 T lard

1/2 lb onion, diced

3 cloves garlic

4 T salt (or to taste)

1 lb rice

2 oz bacon

- Rinse and soak beans with 1 hot pepper for a few hours or overnight.

- Cook beans over medium-low heat in soaking water until soft. Drain beans, saving 3 cups of the liquid.

- Lightly toast cumin and oregano in a pan, stirring constantly, until fragrant .

- Starting with 2 T lard, sauté pork over medium heat until it releases liquid. Add onion, garlic, and remaining pepper and sauté until onion is translucent; if pan gets dry, add 1–2 T more lard.

- Add beans, saved cooking liquid, oregano, cumin, and salt; bring mixture to a boil.

- Meanwhile, wash rice and fry uncooked over medium heat with 1 oz bacon.

- When bean mixture begins to boil, add rice and bacon. Cover and cook over medium heat until rice is soft.

- Sauté remaining bacon; coarsely chop and use for garnish.

- Variation: prepare as above, substituting black beans and fried crumbled pork rinds for red beans and bacon.

Looking forward to the night's party, Sandra *(left)* sorts through rice, looking for debris before making *congrí*. After sunset, her niece Iris *(right)* celebrates her *Quinceañera*, the traditional coming-of-age party for girls.

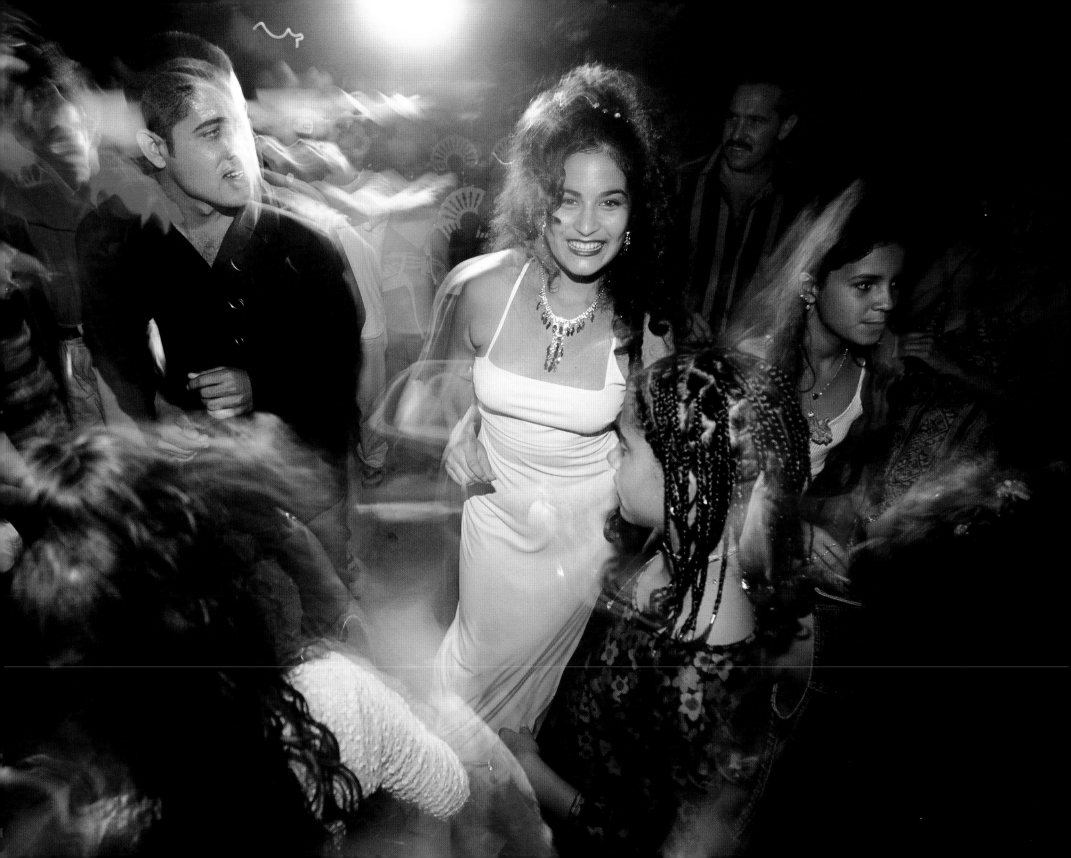

RATION RATIONALE

Since 1962, the Cuban government has issued every household a *libreta*, a ration book that entitles the family to purchase set quantities of food for next to nothing in the nation's thousands of state-run *bodegas* (grocery stores) and *placitas* (fruit and vegetable kiosks). In early 2005, for instance, half a kilogram (about a pound) of rice cost just 18 Cuban cents—six-tenths of a U.S. cent. In addition to their *libreta* food, children get free school lunches; many adults' offices also provide lunch; and the elderly eat in special subsidized restaurants.

Rice, dried beans, cooking oil, eggs, beef, soap, milk, bread, sugar, cigars, and coffee— all are available in the *bodegas* and *placitas*, although sometimes only in tiny quantities.

Until the collapse of the Soviet Union, Moscow subsidized the system with generous shipments of low-priced fuel and food. Afterward, things got tight. Cubans responded by planting urban gardens, which now produce more than a third of the country's vegetables. Still, there is often not quite enough; the monthly per-person beef ration is often equivalent to the meat in two Big Macs.

Today the *libreta* provides a third to a half of a typical family's food; Cubans must obtain the rest from the open agricultural markets, which Castro legalized in 1994 in another response to the fall of Communism worldwide. To Cubans, who typically make 200–300 pesos ($8–$12 USD) a month, these are ruinously expensive. On the open market in 2005, half a kilo of rice cost four pesos (15 cents, USD), twenty-two times the subsidized price.

Despite the flaws in the system, very few people go hungry—in stark contrast, as Cuban officials like to point out, to the situation in many other Latin American nations. Fidel Castro's many critics are unimpressed. In their view, the only reason food is rationed at all is because of the decline in agricultural productivity associated with the Communist system, which collectivized farms. As proof, they point out that many rationed substances, such as sugar, coffee, chicken, and cigars, were abundant in Cuba before the revolution.

The best food in Cuba, my friend Alberto told me, is found in *paladares*—small government-licensed restaurants in private homes. I had been telling him how much I liked the typical Cuban combination *congrí* (rice and black beans mixed together), fried bananas, and *malanga*, a root that tastes a bit like potatoes and is prepared like French fries. My friend responded by leading the way to an alley in a neighborhood nearby. Between a crumbling Colonial-style house and an old garage we found ourselves in the arboreal courtyard of a *paladar*: a modest home outfitted with tables, chairs, and a TV suspended under a canopy behind the bar. A large middle-aged woman in an apron greeted us. Beside her stood the proud owner of the *paladar*, her husband, Ricardo Alfonso Rodrigues, who moonlights on weekends as the drummer in a rock band called the Taksons. After a warm welcome and a cold beer, I made the mistake of inquiring about his band. To make a long story short, in goes a videotape and on goes the TV, full blast. His band does not play the lyrical Cuban music celebrated in films like the *Buena Vista Social Club*. Half an hour later, steaming plates of pork and rice and beans arrived, accompanied by more beer, the latter being a surprisingly effective antidote to aural heavy metal poisoning. Oh, did I forget to mention the owner/drummer was a real short order cook? He was three feet tall.
— *Peter*

Cuban families receive ration cards *(above left)* that in theory let them obtain all their food staples at astonishingly low, state-sub-sidized prices. In practice, the cards don't quite cover everything, so Cubans must venture into the vastly more expensive *agro-mercados*, open markets that sell products from the few government-sanctioned private farms and surpluses from cooperative farms that have fulfilled their state quotas. With Sandra Costa carefully watching, a vendor *(bottom left)* measures out cornmeal mush in the Agromercado 19 y 78 open market in Havana's Marianao district.

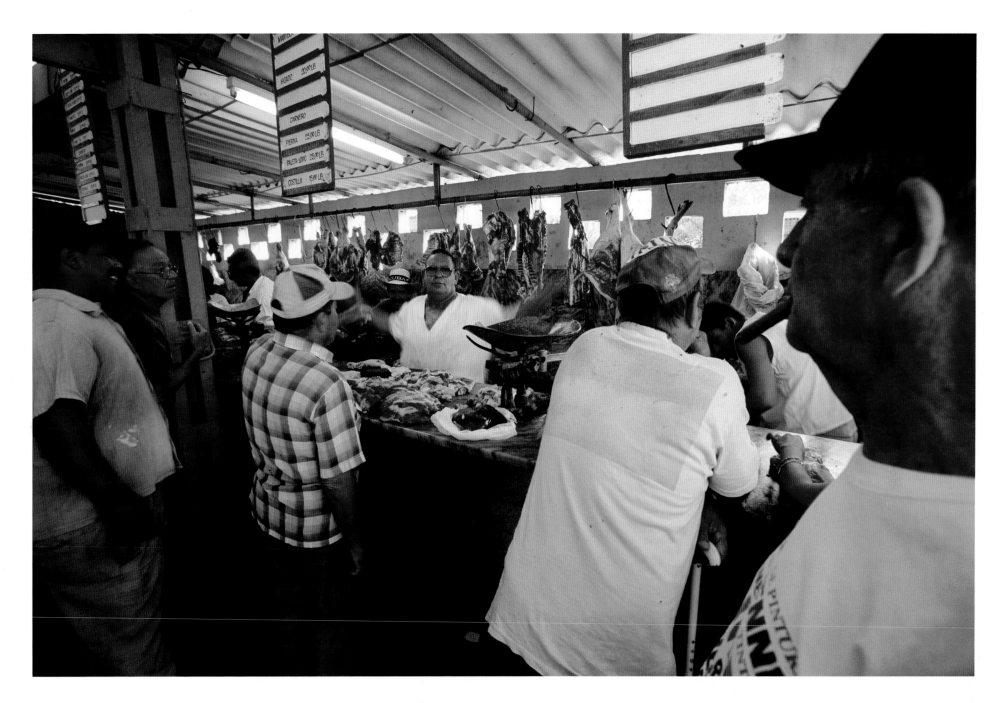

Buyers wait for their meat purchases in the Agromercado open agricultural market. A sign of the government's willing-
ness to experiment with modest levels of free enterprise in the 1990s, the markets may not exist for much longer—in
2004 and 2005, Castro reined back the number of farmers allowed to work for themselves, stopped issuing many types
of licenses for self-employment, and eliminated all traffic in U.S. dollars.

With a friend, the Costa grandsons, Javier (with snorkel) and Ariel (prone), spend the day fishing with snorkels and spear guns at the Havana shore, ten minutes by bike from home. Ariel cleans the catch while cousin Javier and a friend put their gear down on the rocks. All along the city beach, Cubans—like these men *(far right)* on the Malecon, the Old Havana seawall—spend their off hours fishing, both for fun and to supplement their meager food rations.

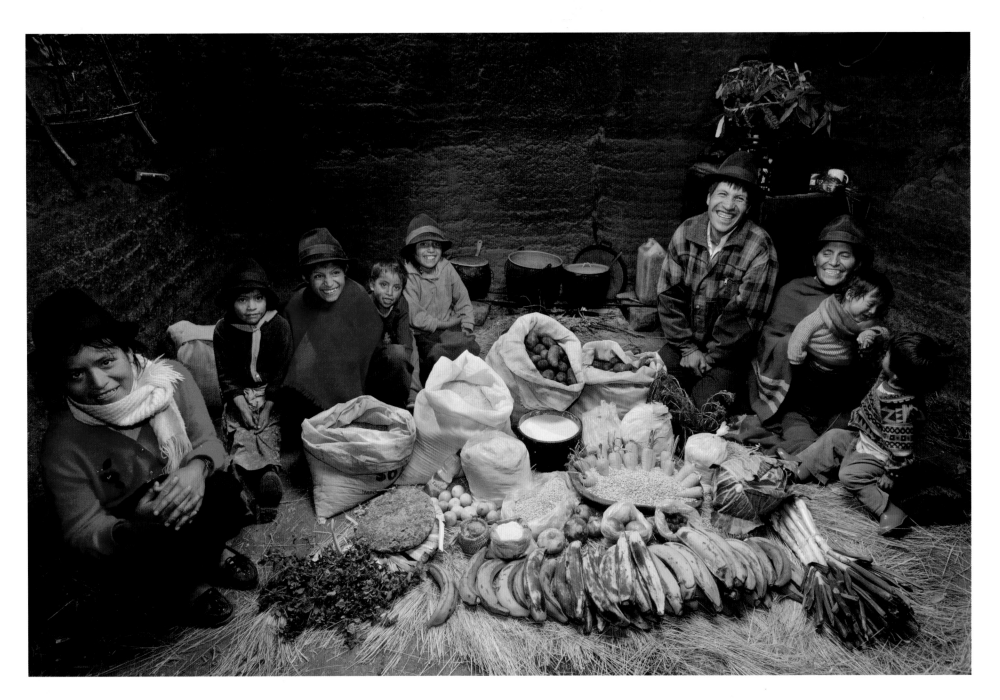

The Ayme family in their kitchen house in Tingo, Ecuador, a village in the central Andes, with one week's worth of food. Ermelinda Ayme Sichigalo, 37, and Orlando Ayme, 35, sit flanked by their children (left to right): Livia, 15, Natalie, 8, Moises, 11, Alvarito, 4, Jessica, 10, Orlando *hijo* (Junior, held by Ermelinda), 9 months, and Mauricio, 30 months. Not in photograph: Lucia, 5, who lives with her grandparents to help them out. Cooking method: wood fire. Food preservation: natural drying.

Pobre Pero Sana

ONE WEEK'S FOOD IN SEPTEMBER

Grains & Other Starchy Foods: $17.40✴✴

White potatoes, 100 lb; white rice, broken, 50 lb, *cheaper than whole rice*; ground wheat,* 15 lb; corn flour, 10 lb; white flour, fine, 10 lb; green pea flour, 8 lb; white flour, coarse, 6 lb.

Note: The Aymes normally grow their own potatoes and corn, but have none to harvest at this time of year. They have eaten the last of their homegrown barley.

Dairy: ✴✴

Milk, 1.8 gal, *from family cows; only part of the week's supply is shown in the photograph.*

Meat, Fish & Eggs:

none.

Fruits, Vegetables & Nuts: $11.25

Plantains, 13.4 lb; yellow bananas, 6.2 lb, *purchased over-ripe as they are cheaper that way*; oranges, 3.6 lb; lemons, 2.5 lb;

Andean blackberries, 1 lb; lentils, 10 lb; carrots, 3.6 lb; red onions, 3 lb; leeks, 2 lb; lettuce, 1 head.

Condiments: $2.90

Brown sugar, 11 lb, *purchased as a cake, used for sweetening coffee and eaten as candy*; salt, 1.5 lb; vegetable oil, 16.9 fl oz; cilantro, 1 bunch.

Beverages: ✴✴

Stinging nettle, 1 small bunch, *gathered wild for tea*; corn silk, 1 handful, *boiled in water for both tea and medicine*; water from a nearby spring, carried by hand, for drinking and cooking.

* Homegrown

Food Expenditure for One Week: $31.55

✴✴Market value of homegrown foods, if purchased: $3.20

I T'S NO SURPRISE THAT ERMELINDA AYME SICHIGALO would rather leave her children at home in Tingo, their small village in the central Andean highlands, than bring them down the mountain to the weekly market in the much bigger town of Simiatug. Her youngest children, especially, want everything they see and she has little money for extras. The 4-year-old, Alvarito, "is the most troublesome," she says, "but he can't be left behind without an argument." It's difficult to imagine any-one arguing with the authoritarian Ermelinda—until we meet Alvarito.

With eight children to raise—including the baby riding in a sling on her back—plus doing field work, tending a flock of sheep, cooking, doing the laundry and the marketing, as well as practicing midwifery and medicinal healing, Ermelinda doesn't have much time to indulge the children. Her husband, Orlando Ayme, who also goes to market, turns out to be the go-to guy for parental largesse—usually Alvarito gets to go shopping. Even without the patter of little feet, the Aymes' food forays aren't easy. There are no shops or markets in Tingo—only neighbors and family to borrow from and share with. The hike down the mountain from Tingo to Simiatug is three miles long; then there's the vertical walk back.

Although Ecuador is situated on the equator and the growing season is long, the Ayme family's fields are 11,000 feet up in the mountains, far removed from the rich tropical lowlands. "Our land is dry, and the wind is harsh," says Orlando, "so it's not that good for planting. The land farther down is much more fertile, but it's too expensive." Despite the difficult climate, they manage to live through most of the year on what they grow in their fields: potatoes, *oca* (a root vegetable), corn, wheat, broad beans, and onions. The only animal protein they eat is guinea pig and chicken, and that only a few times a year. They have a milk cow that produces about one quart a day.

Food security comes in the form of their other enterprise—their flock of 50 sheep, which the Aymes own jointly with their extended family. They raise the animals not for food, but to sell in the market—to tide them over during the dry season, when there's little or nothing to harvest. In addition, Orlando is the Tingo representative to *Pachakutik*, a national political party named after a legendary Inca emperor. He makes $50 a month for

the work, but $15 of that pays the rent on the small room in Simiatug where he stays when he's doing community business. The remaining $35 helps, but it doesn't go very far with a family of ten. Money has been especially tight since the year 2000, when Ecuador, trying to hold back exploding inflation, adopted the U.S. dollar as the national currency. The move slowed inflation, but prices escalated as vendors took advantage of the switch—and the ensuing confusion—to round off prices to the nearest dollar. Suddenly, many small purchases cost at least $1—not a trifling amount considering that more than four out of ten Ecuadorians live on less than $2 a day.

The Aymes spend most of their time in Tingo, farming and raising the children. They lead a physically demanding life—Ermelinda more so than her husband, as Orlando himself admits. In addition to farming, she is the village healer, gathering nettles, corn silk, horsetail, mint, chamomile, plantain seeds, and *paico* (a relative of goosefoot) to make tonics and healthful teas. "It's difficult to keep all these children healthy," she says. "We have no money for doctors and medicine." But Orlando thinks she's selling her efforts short. "We are *pobre pero sana*," he says—poor but healthy.

During our September visit, the last of the potatoes—their staple crop—have been eaten and there's nothing else growing. They're selling two sheep this week to buy food—some for this week and some for later. Orlando thinks he can get $40 for the two at the Simiatug market, if middlemen from the bigger town of Ambato come to the market with their pickup trucks to buy animals.

Cash Cows—and Sheep

The valley town of Simiatug, accessible only by means of a long, winding dirt road and hillside trails, is the sole food-shopping destination for everyone within a 30-mile radius. The descending bright-red ponchos dotting the mountains foretell the arrival of market-bound Ecuadorians, the Aymes included, with Alvarito in tow. Indigenous sellers arrive early to arrange their tables of produce: onions, peppers, carrots, and tomatoes. Potato and rice dealers sell their 100-pound bags from the backs of their trucks. A trader from the tropical lowlands lays out avocados, oranges, papayas, and bananas on fresh banana leaves. One woman has a selection of hats for sale.

The animal market—really just a clearing—is below the schoolhouse, on the edge of town. The Aymes stop here first, to sell their sheep. Many of their fellow villagers are doing the same, except that, in addition to selling sheep they are selling alpacas, llamas, cows, bulls, and piglets. There are no hogs for sale—"People buy piglets and keep them until they're big enough to eat," Orlando says. "No one sells a hog." The animal market is a social gathering spot—mostly for the men, who catch up on the week's events while hoping to sell their animals. An ice cream vendor walks among them, hawking cones, and another man stands around waiting to collect sales tax for the local government.

The wholesalers from Ambato try to press dollars into the sellers' palms to close the deals, but they bid less than anyone wants to take. Finally though, someone takes an offer, jump-starting the morning. Orlando accepts $35 for his sheep—not as much as he wanted but enough to go shopping. The wholesalers throw the sheep down and tie their legs together, "to keep them from breaking in the truck," says Orlando. Money in hand, it's time to go shopping, and Alvarito is obviously sensing an approaching opportunity.

The Aymes always buy their most important staple foods first, and then they keep spending until the money is gone. Orlando and Ermelinda buy 100 pounds of potatoes for $3 and ten pounds of lentils for $4. Next they buy about 50 pounds of flour—corn flour, white flour, green pea flour, coarse white flour, and ground wheat—at the indigenous food cooperative. "They give us good prices," says Ermelinda. She also buys what she calls "broken rice," which is cheaper than whole white rice, though of poorer quality. They can get 50 pounds for about $6—less than half the price of whole white rice. Momentarily, everyone stops to enjoy the show when Alvarito, who has spied a cake in the glass-fronted case at the co-op, causes a commotion when told he can't have it.

Back on the street, plantains are next—13 pounds for $1.80. An 11-pound wheel of *panela*—brown sugar—tightly wrapped in cane leaves—is another $1.80. At home, everyone will chip off chunks throughout the week and eat it like candy, or dissolve it in hot water for a sugary drink. The entire cake of sugar will be gone before next market day. Fresh fruits and vegetables, last on the shopping list, are only purchased if there's extra money. They buy carrots, leeks, onions, and some fruit today, because they sold the sheep. Then the money is gone, so the shopping is over. Orlando lashes as much food as he can onto the horse he borrowed from his father-in-law, and they carry the rest up the mountain themselves. Alvarito carries nothing but disappointment.

- Population: **13,212,742**
- Population of Tingo village: **80 (est.)**
- Area in square miles: **109,454 (slightly smaller than Nevada)**
- Population density per square mile: **121**
- Urban population: **62%**
- Life expectancy, male/female: **68/74 years**
- Indigenous population: **38%**
- Fertility rate (births per woman): **2.8**
- Literacy rate, male/female, 15 years and older: **94/91%**
- Caloric intake available daily per person: **2,754 calories**
- Undernourished population: **4%**
- Annual alcohol consumption per person (alcohol content only): **1.7 quarts**
- GDP per person in PPP $ (Purchasing Power Parity: an adjustment for what equivalent local goods would cost in the U.S.): **$3,580**
- Year in which Ecuador formally adopted the US dollar as legal tender: **2000**
- Total annual health expenditure per person in $, and as a percent of GDP: **$76/4.5**
- Overweight population, male/female: **40/51%**
- Obese population, male/female: **6/15%**
- Meat consumption per person per year: **99 pounds**
- McDonald's restaurants: **10**
- Number of volcanoes: **17**
- Cigarette consumption per person per year: **232**
- Available supply of sugar and sweeteners per person per year: **106 pounds**
- Population living on less than $2 a day: **41%**

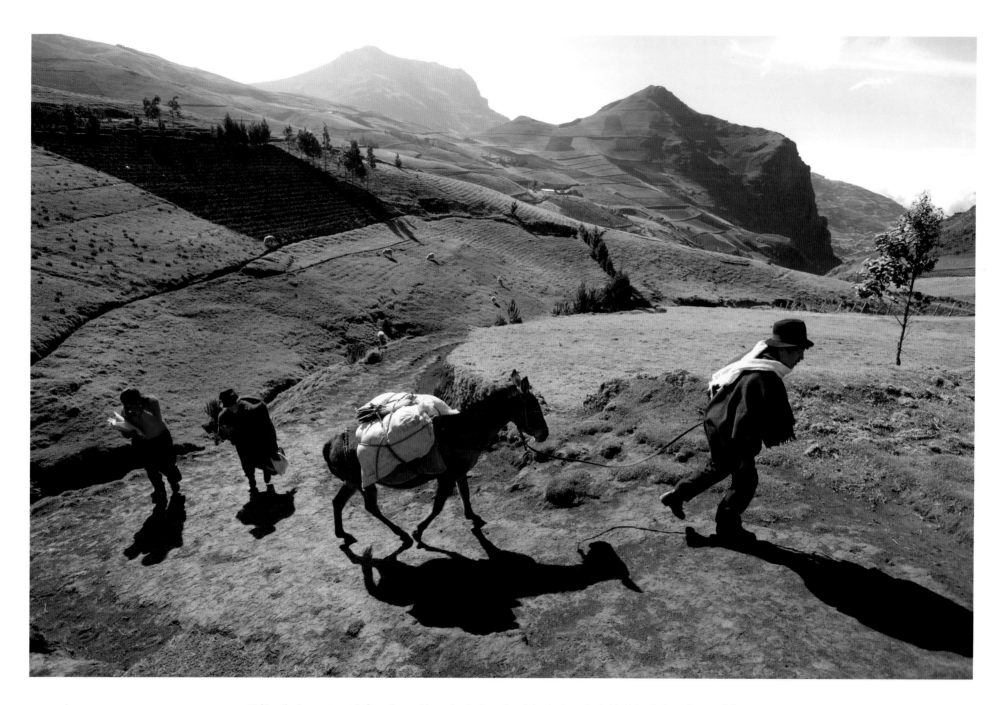

Making the long return trip from the weekly market in the valley, Orlando Ayme leads his father-in-law's horse, while Ermelinda (center) carries the bundled-up baby and some of the groceries and Livia trudges along with her schoolbooks. Alvarito has literally run up the steep path ahead; like 4-year-old boys everywhere, he is a tiny ball of pure energy.

Ermelinda Ayme Sichigalo's
Locro de Papas **(Potato Soup)**

1/2 pail (approx. 5 lbs) potatoes, small, peeled (if potatoes are big, halve them)

6 cabbage leaves, whole

1 scallion, whole

1/2 t lemon juice

2 medium carrots, thinly sliced

1/2 cup milk (if cow is producing)

4 t salt

1 cup string beans

2 t vegetable oil

Lamb, 1 bite-size piece per person (if available)

- Bring potatoes to a boil in water to cover.
- When potatoes reach low boil, add cabbage and scallion. Cook at high simmer for 5 minutes, then add remaining ingredients. If there is meat, add one small chunk per person to flavor.
- Cook at high simmer for 30 minutes.
- Accompany with rice, cooked with finely chopped onions, or fried potatoes and onions.

Barley Porridge

1/2 pail (approx. 3 qt) water

1 handful (approx. 4 oz) barley, toasted

1 oz hard brown sugar

Naranjilla fruit, halved and squeezed

- Combine ingredients and cook 30 minutes.

In Simiatug, Ermelinda *(above left)* buys food at the coop—"the best prices for indigenous [people]," she says. Market day is bustling as families from all over the hills stock up on food *(bottom left, a man ties a 100-lb. bag of potatoes onto his wife's back)*. Taking advantage of their visit to town, men (and a few women) throng the taverns *(far right)*, to drink Andean beer.

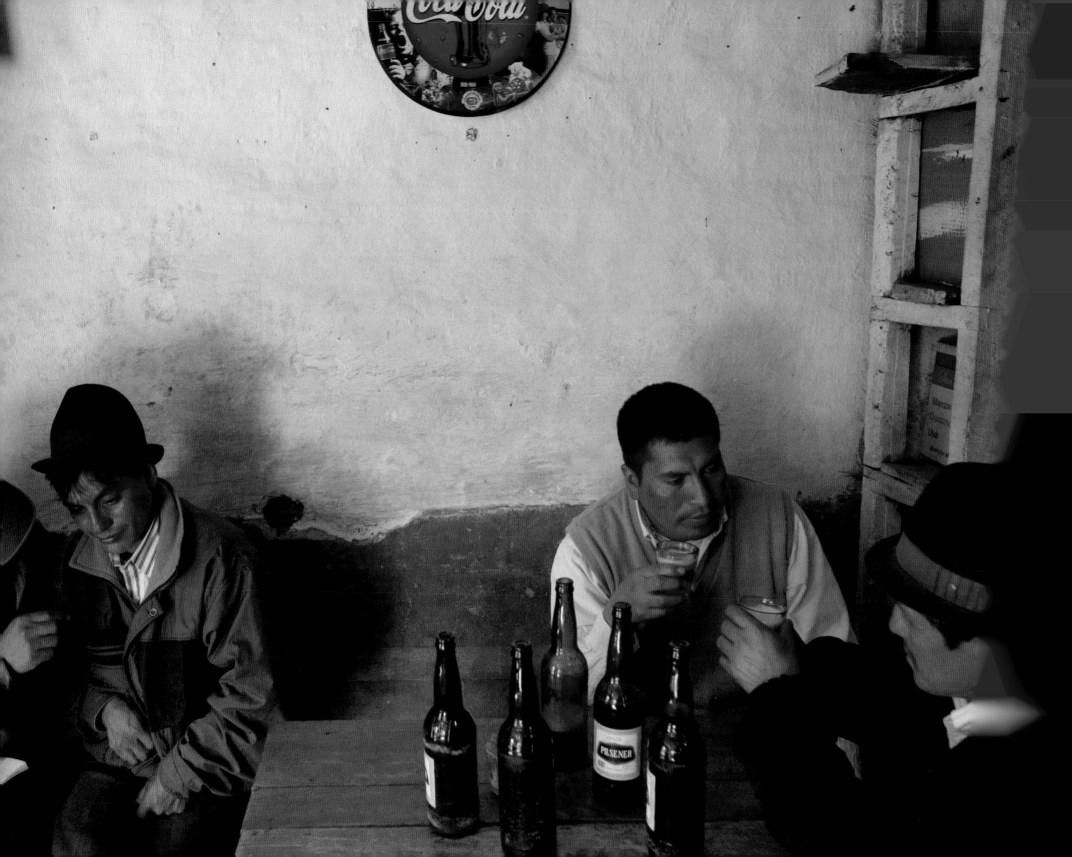

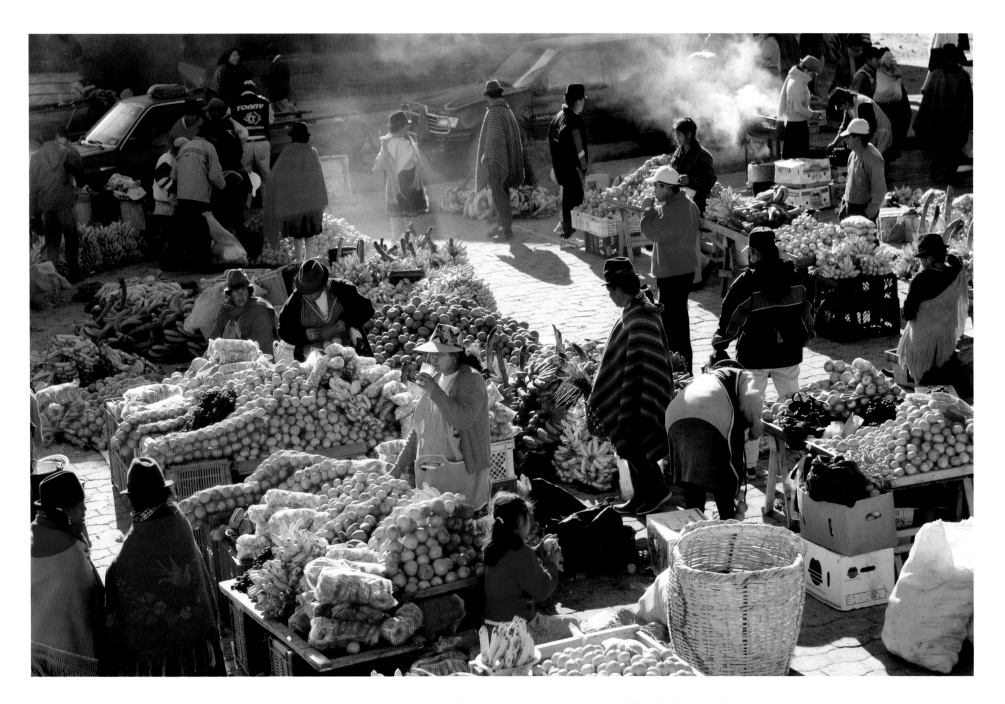

A three-hour drive over dirt roads from the Aymes' house in Tingo, Zumbagua has a vegetable market big enough to attract a few tourists. The town even has a small hotel or two. Zumbagua is midway between the high Andes and the coastal lowlands; its market, supplied by both climatic zones, creates a kind of ecological collision, with purple mountain potatoes and bumpy red *oca* tubers vying for space with tropical pineapples and blocks of coarse brown sugar.

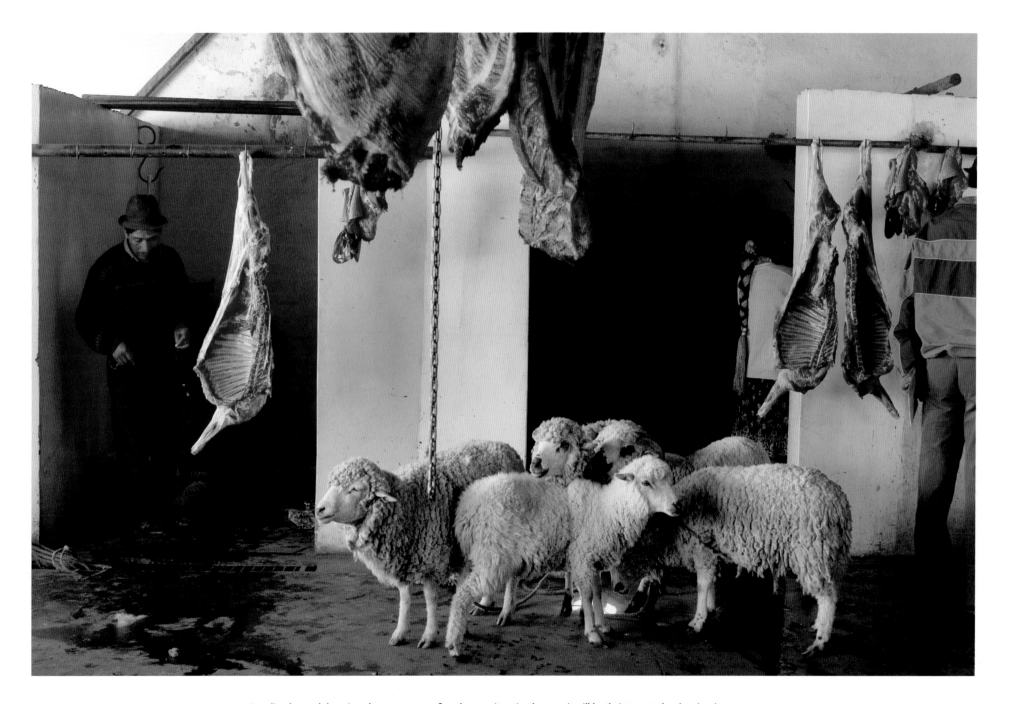

Standing beneath hanging sheep carcasses, five sheep wait patiently; soon it will be their turn at the slaughterhouse, which is attached to the Zumbagua market. At the live-animal market a quarter mile away, shoppers can pick out the animals they want, then have them killed, skinned, and cleaned. The entire process, including the time it takes to walk the sheep from the market to the slaughterhouse, takes less than an hour.

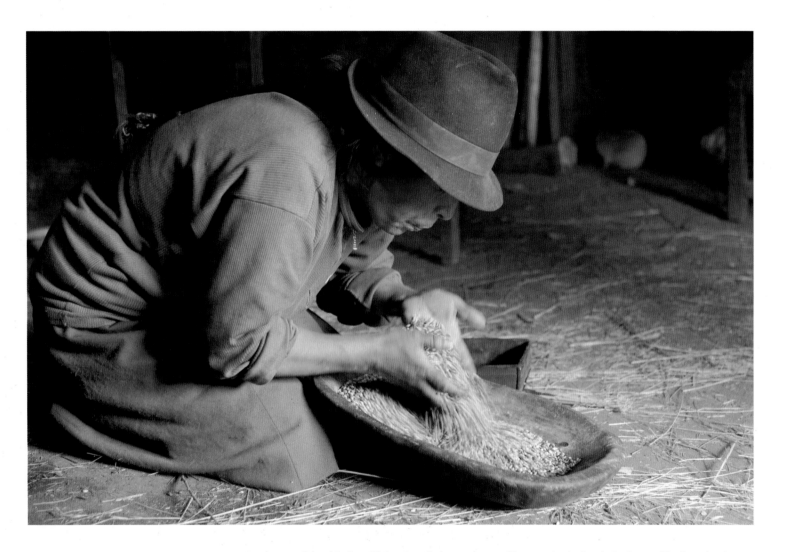

Wearing a traditional Andean felt hat, Ermelinda spends part of her morning in the windowless cooking hut, cleaning barley in the light from the doorway. After she blows away the dust and chaff, the grain is ready to be ground for break-fast porridge. In the afternoon, after the women work in the fields, Ermelinda's sisters often come to visit. The women *(at right)* gossip, and nurse their babies, snacking on small potatoes and corn that has been parched and roasted.

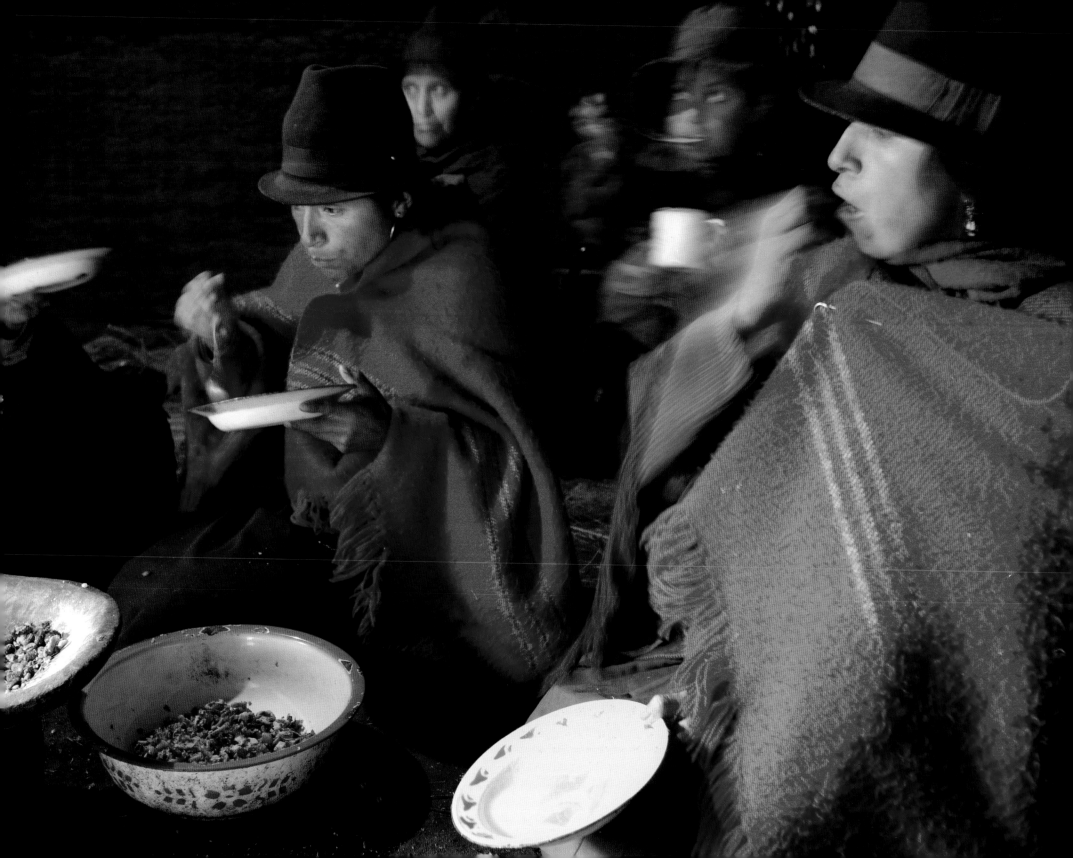

He wanted a red wool poncho like the ones his brothers and sisters wear, but there wasn't the money for it. He stomps up the trail.

By the time they get home, the wind is howling outside and it's almost dark. Ten-year-old Jessica, who has been out on her own with the sheep all day, has corralled them for the night in their makeshift pen and left the dog there to scare off marauding wild animals. In the kitchen house (the family has two small adobe huts, one for the kitchen, the other for sleeping), Ermelinda kindles the embers to bring the fire to life. Chickens scurry through the doorway and scratch around until Ermelinda tells Alvarito to shoo them out, which he and 30-month-old Mauricio do gleefully. The chickens race back inside each time someone opens the door, so the boys are kept busy throughout the dinner preparations. Natalie, 8, takes the baby from her mother without complaint. He doesn't like his feet to touch the dirt floor and cries when they do. Finally, Natalie bounces him on her knee until he falls asleep.

Ermelinda adjusts the wood so that the embers remain at a constant temperature for cooking—much like a modern stove, except without the knobs. There's no ventilation in the cooking house, so the ceiling beams and walls are black with soot. The room is warm but smoky. Orlando is one of the few husbands we've met in the developing world who helps in the kitchen. He peels onions for Ermelinda's potato soup, which is simmering on the fire, and doesn't appear to be doing it for the first time.

Cuy (guinea pigs) have the run of the room but generally stay near the warmth of the fire, and away from the chickens. When the little rodents grow big enough, they will be eaten—probably at Easter time. The Aymes' scrawny, rat-size cuy bear no resemblance to the cuy for sale in Ecuador's bigger cities. City cuy are fed alfalfa and vitamin supplements and grow as large as small dogs.

No one has to be called for dinner. Even the eldest daughter, Livia, who has been doing schoolwork in the family's sleeping house, has appeared. Everyone sits on the dirt floor or on little benches and eats their fill of the starchy soup they have most nights. There's enough for visitors as well—a taste of the culture of sharing that still predominates in the rural Andes.

When asked about favorite foods, the couple is a bit stumped. After some thought, Orlando chooses pea-flour porridge with potatoes. "I really love that," he says. "He loves lollipops," teases Erme-

linda's sister Zulema, who has stopped by for a visit. She and Ermelinda's other sisters often drop by for a meal and to talk, all the while working on colorful handiwork for Simiatug Samai—the artisan's cooperative based in the town. Ermelinda says she likes everything they eat and can't choose a favorite food.

The Aymes generally call all packaged and processed food "Swiss," a sure sign that Nestlé, the giant Swiss multinational, has successfully muscled its way onto the rickety shelves of the developing world's markets. Is there anything they like to eat but don't, because it's too expensive? "Yes," says Orlando, "canned sardines and packaged cheese." Has anyone in the family ever eaten fast food? "One time, when I was at a course of study in Ambato," says Orlando. "It was meat on bread [a hamburger]. It was okay, but a bit strange. And I wasn't able to see how it was made."

There are no appliances, no clocks, no furniture, no running water, and no modern kitchen utensils. Earlier, Ermelinda watched Peter open our cases to extract the equipment he needed for the photographs. "I never thought I'd ever see anything so expensive here," she said. There was really nothing we could say in response.

The wind has picked up, and family members begin drifting over to the sleeping house a few yards away. Although it's 10 o'clock at night, it's not time for bed yet. The radio blasts Ecuadorian music, and the children bound back and forth from one bed to another as Livia works again on her schoolwork at a makeshift desk in the earthen room. She attends high school in Simiatug only a few days a week, because of the distance. There is a grammar school in Tingo, which the younger children attend, unless it's their turn to tend the sheep. Ermelinda attended high school for two years but had to quit when the babies started coming. She wants all her children to finish school.

When they do finally sleep, the children are head to head, five or six to a bed. We sleep on the floor next to everyone, on fresh straw and in warm sleeping bags. The fierce wind peppers the corrugated metal roof with sand and gravel throughout the night.

Breakfast time comes all too quickly. Ermelinda's up early with the baby and feeds him while she grinds barley with the large hand grinder. She combines the barley and wheat in a basket on the floor and then stirs it into boiling water on the fire to make morning porridge. She adds brown sugar and waits for the children to awaken.

On five previous trips to Andean countries in South America I had failed to partake of the biggest delicacy the Andes has to offer: cuy, guinea pig. I had seen the creatures in the kitchens of rural highland dwellings, where they have the run of the house and yard. On several occasions I had tried to order cuy, only to discover that at many restaurants it must be ordered in advance—cuy is often reserved for special occasions, such as the courtship negotiations that precede a wedding, the wedding itself, christenings, and a boy's first haircut.

On this trip I was determined to try cuy. So I asked Oswaldo Muñoz about it right at the beginning of our visit, as we were driving out of Quito. "I'm glad you asked me about that," he said. "I've got a great place for you."

Two hours later we hit the small city of Ambato, where we pulled up to a storefront restaurant that Oswaldo swore was the best in Ecuador: Salon Los Cuyes II (loosely translated, "Guinea Pig Hall II"). Despite my long interest in cuy, I was startled by the sheer size of the beasts. They were the biggest guinea pigs I'd ever seen—the size of small dogs. Cooked whole on the rotisserie, they were like big dachshunds with fat rat heads, complete with protruding incisors and crispy rodentlike ears.

The light-pink cuy meat, served with a traditional potato, onion, and peanut-sauce stew, was delicious. It tasted like a cross between suckling pig and rabbit and was just as rich; three of us split half a cuy and still couldn't finish it (Faith didn't try very hard). Cuy for 3 was only $20, including tip and soft drinks.
— Peter

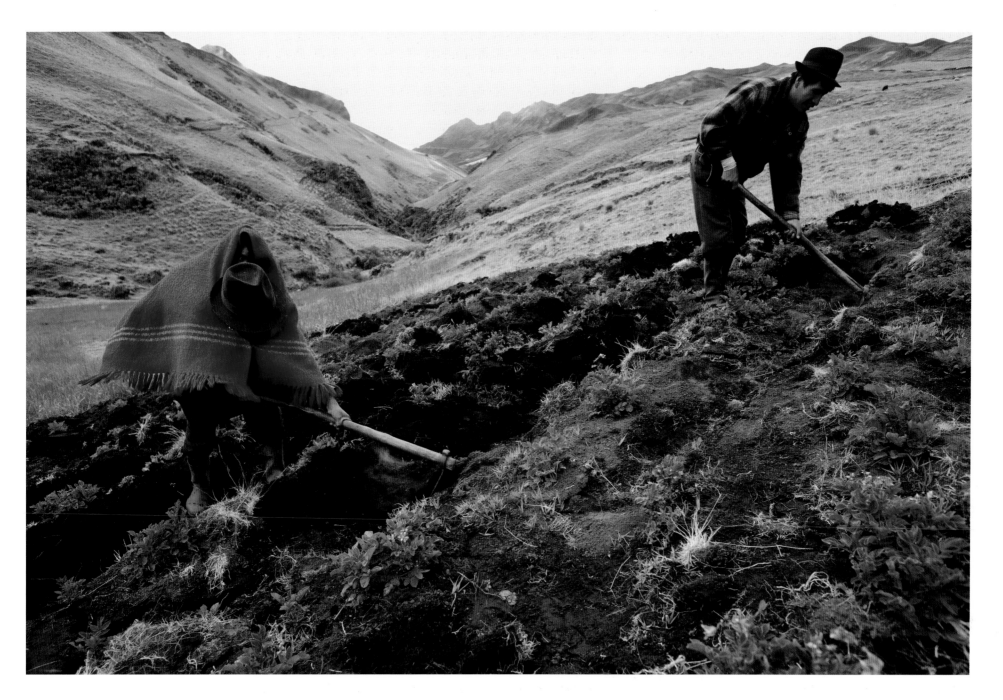

Cultivating potatoes on a windy afternoon, Ermelinda wraps her baby in two shawls tied in different directions. When she and Orlando arrived at the field, a ten-minute walk from their home, they said a quick prayer to *Pacha Mamma* (Mother Earth) before working the land. Occasionally, Ermelinda has to adjust the baby's position, but generally she has no problem carrying her tiny passenger.

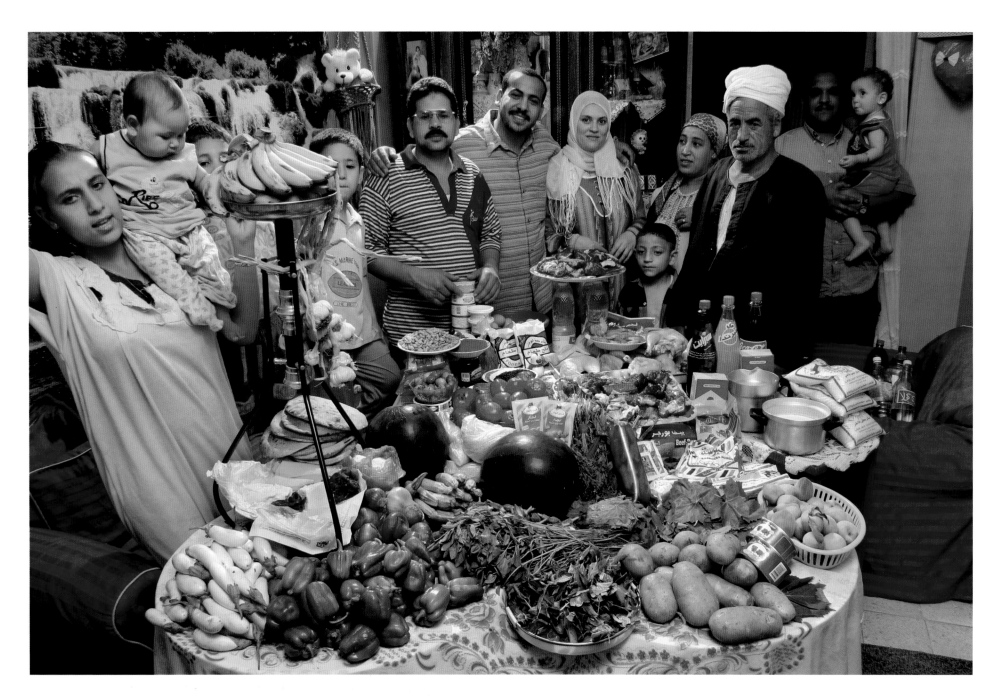

The Ahmeds' extended family in the Cairo apartment of Mamdouh Ahmed, 35 (glasses), and Nadia Mohamed Ahmed, 36 (brown headscarf), with a week's worth of food. With them are their children, Donya, 14 (far left, holding baby Nancy, 8 months), and Karim, 9 (behind bananas), Nadia's father (turban), Nadia's nephew Islaam, 8 (football shirt), Nadia's brother Rabie, 34 (gray-blue shirt), his wife, Abadeer, 25, and their children, Hussein, 4, and Israa, 18 months (held by family friend).

Cairene Cuisine

ONE WEEK'S FOOD IN MAY

Grains & Other Starchy Foods: $2.73
Potatoes, 8.8 lb; white rice, 6.6 lb; basbousa powder (semolina flour and ground nut mix), 2.2 lb, *used to make a dense, Egyptian cake saturated with syrup;* macaroni, 2.2 lb; pita bread, 2.2 lb; gullash (paper-thin dough), 1.1 lb.

Dairy: $11.11
Milk powder, 6.6 lb; butter, 4.4 lb; white cheese, salted, 2.2 lb; white cheese, unsalted, 2.2 lb; Italian cheese, sliced, 1.1 lb, *not a weekly purchase;* President cheese, 1 lb; yogurt, 8.8 oz.

Meat, Fish & Eggs: $33.22
Farm chickens, 16.5 lb; lamb meat, 8.8 lb, *meat and meals are often shared with Nadia's brother, his wife, and their two small children. Extended Egyptian families often live together, or nearby, and eat together frequently, especially during holiday times;* eggs, 25; tuna, canned, 3 lb; beef burger patties, 1.1 lb; beef, frozen, 1.1 lb; *Bordon* corned beef, canned, 14 oz; meat, pickled, 8.8 oz.

Fruits, Vegetables & Nuts: $10.53
Watermelons, 30.9 lb; yellow bananas, 5.5 lb; peaches, 4.4 lb; white eggplants, 7.7 lb; red onions, 6.6 lb; tomatoes, 6.6 lb; green olives, mixed with lemons, 4.4 lb; green peppers, 4.4 lb; squash, 4.4 lb; black olives, 2.2 lb; cucumbers, 2.2 lb; garlic, 2.2 lb; grape leaves, 2.2 lb; Jew's mallow (a traditional Egyptian vegetable used in soup), 2.2 lb; okra, 2.2 lb; beans, 1.1 lb; pickled vegetables, 1 qt.

Condiments: $7.05
Yasmeena sunflower oil, 1.1 gal; sugar, 2.2 lb; *Vigitar* ready-made filé spices, 1.8 lb; honey, 1.1 lb; coriander leaves (cilantro), 3 bunches; parsley, 3 bunches; black pepper, 7.9 oz; chili powder, 7.9 oz; coriander seed, 7.9 oz; cumin, 7.9 oz; mixed spices, powdered, 7.9 oz; salt, 7.1 oz, *used as a seasoning, and to salt pickles, and clean meat.*

Snacks: $1.33
Halawa (sweet sesame cake), 2.2 lb.

Prepared Food: $0.09
Beans, cooked, 1 dish.

Beverages: $2.47
Coca-Cola, 1.1 qt; *Mirinda* orange soda, 1.1 qt; *Sprite,* 1.1 qt; *Al-Arousa* tea, 1.1 lb; tap water for drinking and cooking.

Food Expenditure for One Week:
387.85 Egyptian pounds/$68.53

THERE IS NOTHING FAST about Egyptian food, and on this steamy spring day in Cairo, it's probably just as well. Nadia Mohamed Ahmed and her sister-in-law Abadeer sit barefoot and cross-legged on the floor of Nadia's apartment, companionably coring baby eggplants and stuffing them with spicy chopped lamb for the evening meal. Eight-month-old Nancy calmly straddles one of her mother's shoulders; one arm wrapped around Nadia's scarved head. When the baby gets tired, Nadia slides her down from her perch and breastfeeds but never stops stuffing. Nancy soon falls asleep and is tumbled onto a nearby bed, adjacent to the kitchen, her arms outstretched, surrounded by pots and pans and food. The two mothers are unfazed by the noise of their other children, who are playing on the small, laundry-filled balcony overlooking a narrow street. Gold bracelets tinkling, the women finish preparing the eggplant and begin wrapping steamed grape leaves around a lemony mixture of rice, garlic, and lamb—stacking the tiny packages on a plate and talking all the while. The dishes are *mahshi,* which in Arabic means "stuffed."

Nadia's daughter Donya, 14, sits down to help them. Donya does not yet cover her hair with a scarf, but Nadia and Abadeer live as many women do in traditional Muslim cultures, cloistered from society, their hair covered in the presence of visitors, their husbands negotiating their contact with the outside world. The two families live a floor apart in a crumbling old building above Islamic Cairo. This urban amalgam of medieval and modern life—buses, donkey carts, new cars, boys hauling goods, women covered and not—is unified by the call to prayer that issues from mosques throughout the city five times a day.

Abadeer's husband Rabie enters the apartment, flops into a chair, and announces "My back hurts, and my knee." He's a tour guide in old Cairo and spends much of his time on the streets, trying to get hired. As he talks, he beckons to Abadeer with a flip of his hand; she jumps up to fetch him a glass of water, which he sips as she returns to work. Nadia's husband Mamdouh, a plumber, arrives home tired and quiet. A slightly unbalanced overhead fan chops erratically into the fluorescent light, causing a visual effect not unlike a film missing every third or fourth frame. The breeze is comforting in this oppressive heat. The sun starts to set and everyone perks up, just in time for *mahshi.*

EGYPT

- Population: **76,117,421**
- Population of Cairo: **7,629,900**
- Area in square miles: **386,560 (slightly more than 3 times the size of New Mexico)**
- Population density per square mile: **197**
- Urban population: **42%**
- Population with access to electricity: **96%**
- Life expectancy, male/female: **65/69 years**
- Fertility rate (births per woman): **3.3**
- Literacy rate, male/female, 15 years and older: **68/47%**
- Caloric intake available daily per person: **3,338 calories**
- Undernourished population: **3%**
- Annual alcohol consumption per person (alcohol content only): **0.5 quarts**
- GDP per person in PPP $ (Purchasing Power Parity: an adjustment for what equivalent local goods would cost in the U.S.): **$3,810**
- Total annual health expenditure per person in $ and as a percent of GDP: **$46/3.9**
- Overweight population, male/female: **65/70%**
- Obese population, male/female: **22/39%**
- Population age 20 and older with diabetes: **7.2%**
- Available supply of sugar and sweeteners per person per year: **66 pounds**
- Meat consumption per person per year: **49.5 pounds**
- McDonald's restaurants: **40**
- Big Mac price: **$1.67**
- Cigarette consumption per person per year: **1,275**
- Population living on less than $2 a day: **44%**
- Percent of camels imported into Egypt that are used for food: **90%**

Muslims gather to pray at Al Fath Mosque *(at left)* **in central Cairo. Seen from the minaret of another mosque, a teenage boy** *(at right)* **delivers bread.**

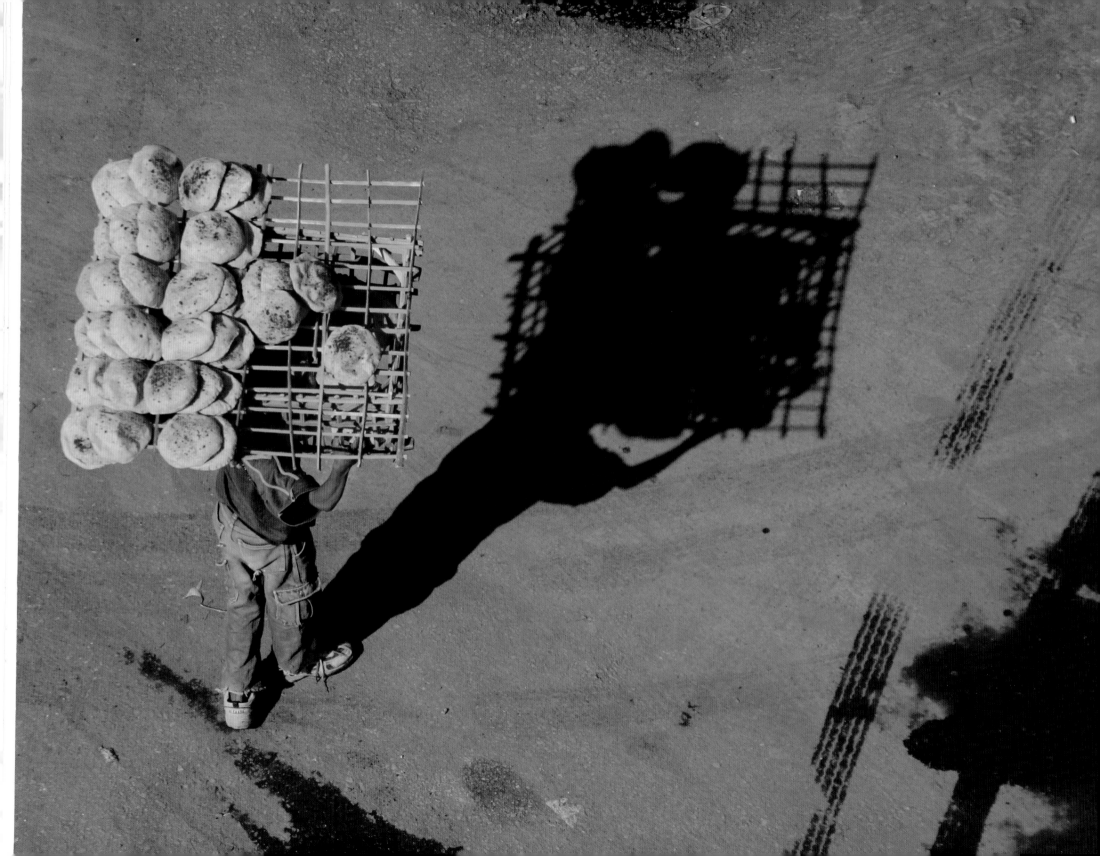

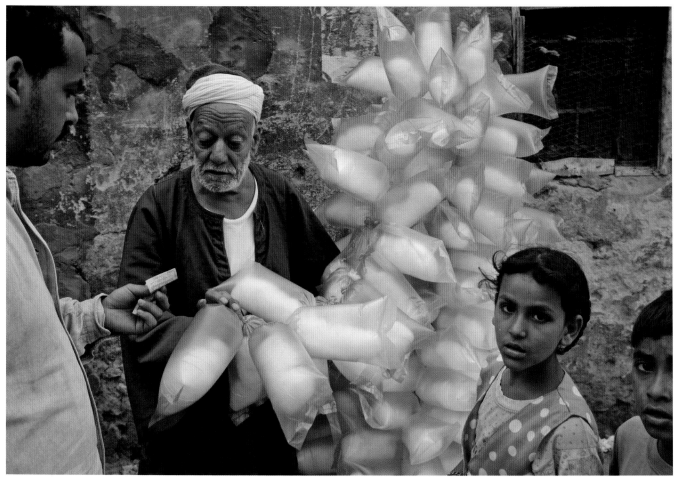

COTTON CANDY • CAIRO, EGYPT

HOT PRETZELS NEAR THE BLUE MOSQUE • ISTANBUL, TURKEY

SPIT-ROASTED *CUI* (GUINEA PIG) • AMBATO, ECUADOR

CHICKEN VENDORS • PHNOM PENH, CAMBODIA

SEA HORSES, CICADAS, SILKWORM PUPAE • BEIJING, CHINA

PINEAPPLE AND MANGO CHUNKS • COLOMBO, SRI LANKA

PIG AND CHICKEN INTESTINES, FATTY PORK • MANILA, PHILIPPINES

RED SALTY EGGS • MANILA, PHILIPPINES

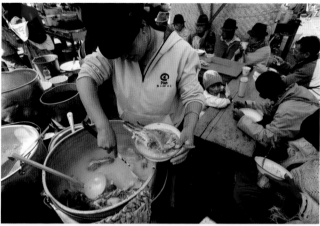

SHEEP'S HEAD SOUP • ZUMBAGUA, ECUADOR

BETEL NUT VENDOR • VARANASI, INDIA

Street Food

Street food is easy take-away food: Chinese teenagers choose a skewer of deep-fried scorpions; Middle Eastern vendors sell spicy kebabs and shwarma, and glasses of tea are carried overhead on trays from teashops to area businesses. For vendors, the street is a cheap place to cook, especially in cities like Manila, where unemployment is rampant, and Mexico City, where merchants toss together custom tacos and quesadillas. Street cooking began as a way to provide cheap food for the poor, as Charles Mann explains in his accompanying essay. Yet, as societies become more mobile and affluent, this quick and convenient food goes upscale.

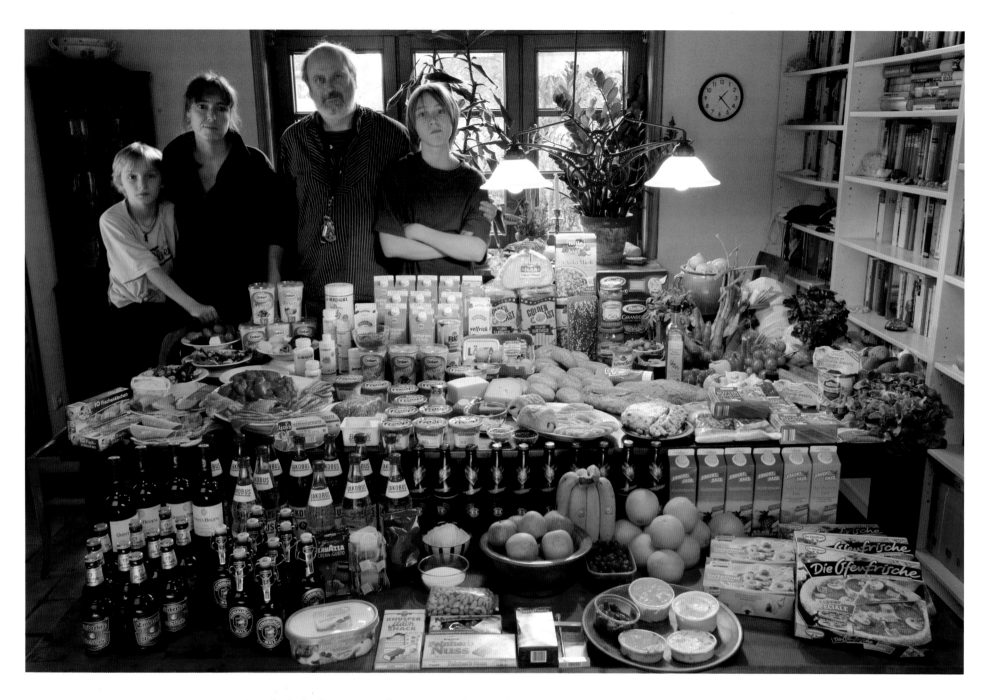

The Melander family—Jörg, 45, and Susanne, 43, with sons Kjell, 10, and Finn, 14—in the dining room of their home in Bargteheide, Germany, with a week's worth of food. Cooking methods: electric stove, microwave, and outdoor BBQ grill. Food preservation: refrigerator-freezer, freezer chest. Favorite foods—Jörg: fried potatoes with onions, bacon, herring. Finn: fried noodles with eggs, cheese. Kjell: pizza, vanilla pudding. Susanne: "anything that's fresh and good".

Bio Logic

ONE WEEK'S FOOD IN NOVEMBER

Grains & Other Starchy Foods: $31.98

Kölln muesli, 3.3 lb; *Golden Toast* whole grain bread, 3.3 lb; potatoes, 2.8 lb; brown bread, 2.2 lb; white bread (Italian style), 2.2 lb; bakery buns, 1.3 lb; *Barilla* linguini, 1.1 lb; *Barilla* rotini, 1.1 lb; *Harry* rye bread, 1.1 lb; wheat flour, 10.6 oz; croissants, with chocolate, 9 oz.

Dairy: $64.33

Milk, low fat, 3.2 gal; *Onken* yogurt, low fat, 9.9 lb; *Velfrisk* Danish fruit yogurt, 2.1 qt; *Froop* fruit yogurt, 3.6 lb; *Langnese* banana split ice cream, 2.2 lb; hard cheeses, assorted, 1.8 lb; Greek yogurt spreads, assorted, 1.1 lb; whipping cream, bio (organic), 14.1 oz; sour cream, 10.6 oz; *Milsani* butter, 8.8 oz.

Meat, Fish & Eggs: $51.31

Beef, 2.6 lb; goulash beef, 2.5 lb; eggs, 12; cold cuts, 1.4 lb; beef, ground, 1.3 lb; *Iglo* fish sticks, frozen, 1.3 lb; pork, thinly sliced, 1.1 lb; *Lloyd* herring fillets, canned, 14.1 oz; bacon, 4.6 oz.

Fruits, Vegetables & Nuts: $78.10

Oranges, 9 lb; apples,* 3.9 lb, *from family apple tree;* yellow bananas, bio, 2.6 lb; red grapes, 10.6 oz; white cabbage, 1 large head, 11 lb; cherry tomatoes, 3.3 lb; green peas, frozen, 2.2 lb; yellow onions, 2.2 lb; cucumbers, 2.1 lb; kohlrabi (turniplike vegetable), 2.1 lb; butter lettuce, 2 heads; iceberg lettuce, 2 heads; fennel root, 1.8 lb; sour pickles, 24.4 fl oz; arugula, 1.2 lb; carrots, 1.1 lb; leeks, 1.1 lb; mushrooms, 10.6 oz; radishes, 9.8 oz; red bell peppers, 8.6 oz; yellow bell peppers, 8.6 oz; pickled peppers, 7.2 oz; green onions, 6.4 oz; garlic, 0.2 oz.

Condiments: $31.83

Extra-virgin olive oil, 16.9 fl oz; *Homann* 1,000 Islands salad dressing, 10.6 oz; *Kühne* mustard, 8.8 oz; sugar, 8.8 oz; *Heinz* tomato ketchup, 8.5 fl oz; sea salt, 7.1 oz; lard, 4.4 oz, *for frying;* powdered sugar, 4.4 oz; *LÄTTA* margarine, low fat, 4.4 oz; paprika, 3.5 oz; black peppercorns, 1.8 oz; balsamic vinegar, 1.7 fl oz; oregano, 0.2 oz; Bourbon vanilla bean, 1.

Snacks & Desserts: $14.56

Chocolate, assorted, 1.1 lb; stollen (a buttery German cake), 1.1 lb; pistachios, 10.6 oz; bakery cinnamon rolls, 2.

Prepared Food: $66.78

Dr. Oetker pizza, frozen, 2.5 lb; *Knorr* tortelloni, frozen, 2 lb; vegetables in butter, frozen, 2 lb; *Erbsen-Eintopf* pea soup, canned, 27.1 fl oz; *Bertolli* tomato, garlic, and pecorino cheese pasta sauce, 13.5 fl oz; olives with almonds, 10 oz; dried tomatoes in olive oil, 8.6 oz; instant soup, 7.1 oz; vegetable stock, 6 tablespoons. Cafeteria meals, five days a week: *Finn at school, pizza or spaghetti; Kjell eats lunch at home (already listed); Jörg at work, green salad, meat salad, rouladen with potatoes and vegetables, spinach with potatoes and sausage, chili con carne. Susanne eats yogurt at work.*

Beverages: $70.17

Jakobus soda water, 12 25.4-fl-oz bottles; *Erdinger* beer, alcohol-free, 10 16.9-fl-oz bottles; *Frucht-Oase* multi vitamin fruit juice, 4 1.1-qt cartons; *Einbecker Ur-Bock* beer, 10 11.1-fl-oz bottles; *Quinta Hinojal* red wine, 4 25.4-fl-oz bottles; *Flensburger* malt beer, 8 11.2-fl-oz bottles; *Frucht-Oase* multi vitamin orange juice, 2 1.1-qt cartons; cocoa powder, 14.1 oz; *Lavazza* espresso, 8.8 oz; fruit tea, 7.1 oz; black tea, 25 teabags; tap water, for cooking and drinking.

Miscellaneous: $91.01

Centrum vitamins, 7 pills, *taken by Susanne daily. Vitamins and supplements taken by Susanne and children: Herbalife* products: Formula 1, powder, 7.3 oz; AloeMAX, 2 fl oz; Formula 2, 45 pills; vitamin B, 45 pills; Formula 3, 23 pills; Formula 4, 23 pills; Herba-Lifeline, 23 pills; Coenzyme Q10 Plus, 8 pills.

* Homegrown

Food Expenditure for One Week:
375.39 euros/$500.07

Moving directly from the blazing African furnace of Chad into a bone-chilling German blizzard is an amazing jolt to body and brain, but as we rush inside Jörg and Susanne Melander's home in the town of Bargteheide, north of Hamburg, we are enveloped immediately in nourishing warmth. Gemütlich. Language purists say this German word can't be accurately translated into English, but its effects can be felt in every cozy corner of the Melanders' welcoming home. The lights are low; candles are burning. The wind is blowing outside, but it doesn't touch us by their fire.

WHEN WE COMPLIMENT THE MELANDERS on their beautiful home, we discover that Jörg's penchant for weekend projects and Susanne's creative eye have produced a multiyear cycle of renovation and renewal. The house belonged to Jörg's beloved great-aunt Emmy. The Melanders moved in with her before their sons were born. "She was a grandmother to Kjell and Finn," Susanne explains, in her soft, throaty voice as she pours us spiced tea. Jörg and his father, an accomplished carpenter, reworked the house to fit the conjoined households, then did it again after Emmy's death in 1997, and have been fine-tuning it ever since.

The utilitarian cooking space, with its compact, precise drawers and cupboards, is a work of art reminiscent of the Frankfurt Kitchen designed by Margarete Schutte-Lihotzky in the 1920s, but is more charmingly approachable. The high, peaked roof of this early '20s house, so common in snow country, is echoed inside, above the upstairs bedrooms and home office, where we find one of Jörg's other weekend projects—the networked family computers—and where there are also boxes of maps to be found, and shelves stuffed with books and classical music. "The boys read more than their friends do," says Susanne, "but not as much as we used to." Jörg, a biologist who works in Hamburg, in the editorial department of Germany's GEO magazine, says, "The only time I am at home is on the weekends, and I have many projects to accomplish." Now, though, his self-assigned projects have grown to include more kitchen duties and grocery shopping, as Susanne has ramped up her nursing career, and her schedule flies all over the clock. For the first time, Jörg must regularly brave their super-size supermarket, called Famila—solo.

WITHOUT A NET

The range of food choices in a modern super-supermarket is a thousand-fold more than in the little shops and markets that have long populated the village squares of Germany. And to Jörg, a careful and precise man, those thousands of choices mean thousands of additional chances for error. He approaches Famila with what might be described as abject fear, telling me that Susanne shops with such expert efficiency that he's afraid he won't do as well. Had any other man said this, I'd be tempted to haul out the imaginary violin, to accompany a suspected feeble attempt at work avoidance, but Jörg's angst is genuine. "It's easy to make a wrong decision," he says. He says he likes the no-frills discount chain Aldi, which is something of a cult favorite in Germany, but the Aldi inventory is hit-or-miss. There's a lot of some things, and none of others.

Although they are big and busy, the Famila stores, based in northwest Germany—don't resemble the standard-issue overlit boxes that one associates with multinational food conglomerates. "You would probably faint dead away in one of those really big hypermarkets," I tell him. "It would just not be possible for me," says Jörg, and there is laughter aplenty while all of us contemplate his supposed befuddlement.

Jörg is more comfortable in small shops and at their town's weekly outdoor market, which is only a short walk away, through a vintage Lutheran churchyard. "Economically, it makes sense to shop for some things at the big stores," Susanne says, "but I prefer the fresh food in the outdoor markets. I like to know how long [it] was in transport, where it comes from, how long it was in the sun, [and whether] it was picked ripe or unripe." And the outdoor market's produce sellers are a perfect fit for her desires, as they often have grown their own produce or have gone to a farm themselves to get it in the morning of the day it is sold. Susanne works hard to ensure that her family is eating the most nutritious food possible, and then supplements it with fish-oil capsules and Herbalife products. She would like to buy only organic foods, but they're more expensive to produce, and therefore cost more. Only a modest percentage of the foods they buy are organic, but they're easy to spot: Germany's organic certification program uses a standardized bright-green logo stamped with the word "Bio."

THE TOWN MARKET

Germans treasure their outdoor markets and will brave even the bitterest, coldest days of the year to buy all manner of wholesome local produce, condiments, teas, cheeses, meats, and fish. Susanne and Jörg frequent the same sellers each week, wicker baskets in hand, rolling grocery cart at the ready.

"The potatoes are from [near] the Elbe River, southeast of Hamburg," one vendor tells us. "A place called Vierlanden, where there are lots of greenhouses." The traveling merchants work out of small trailers, with curtains to keep out the wind, rain, and snow. Some have heat lamps. The meat and vegetables seem to like the weather more than the people do. Men in heavy winter coats and caps toss vegetables into bags. A Turkish tea seller with scores of varieties is doing a brisk business. Susanne purchases a fragrant herbal tea and so do I.

"We use lots of onions," says Susanne as she views the offerings of one vendor—Mr. Puttfarken—who has kohlrabi, black-radish, garlic, spinach, mushrooms, green beans, and peppers for sale. He owns a truck farm with his family, he says, and also sells produce from other people's farms. Mr. Puttfarken sells both organic and nonorganic produce at two different weekly markets, and works the remainder of the week on the farm with his family. He likes selling in the outdoor markets, he says, but when the price of the trailer and fuel are factored in, it is no less expensive than running a shop. "But it's better for the vegetables," he says. Little tastes are offered at each stand—vegetables, cheeses, yogurt spreads, bread. After noshing at the market, Peter won't need to eat tonight.

FAMILA ENDING

Jörg's weekend mornings begin with a bike ride to get fresh-baked *Zimtbrötchen* (cinnamon rolls) or *Schoko-Croissants* (chocolate croissants) for Kjell, 10, and Finn, 14, and plain rolls for himself and Susanne to eat with cheeses and sliced meat. When he returns, he directs a wake-up call up the stairs toward the bedrooms. Kjell, the first one down, sits with his eyes half-closed, his chin barely an inch above his cup of cocoa and cinnamon bun. Finn takes a little longer, but soon Jörg and his sons are sitting at the beautiful slab table, built by Jörg's father. Susanne is working at the nursing home until this afternoon—or maybe later. "There's a lot of paperwork," she says. "People aren't like pencils you can just drop somewhere and pick up later." Jörg did the big-box-store grocery shopping yesterday, so he can rest easy today and tackle another home project.

CARPE DIEM reads a sign posted in every room of the house—"seize the day." I don't think Jörg and Susanne need the reminder.

Lined up like a row of epaulets from Beefeaters' dress uniforms, the Melanders' *rouladen*-in-progress dominate the family's narrow kitchen counter space. That night, Jörg and Susanne will entertain four dinner guests in the old but comfortable house he inherited from his great aunt. The *rouladen*, a traditional German entrée, is a Melander favorite.

Germany has always been culturally familiar to me. My grandparents on both sides came to the U.S. from Germany just before World War I. My uncle Otto owned a small grocery and German deli. We ate a lot of German food.

My father's clean-your-plate policy was especially troublesome every Tuesday night when we had canned sauerkraut with kielbasa and boiled potatoes. I later came to love pickled herring with sour cream and onions and heavy dark bread; and now whenever I am in Germany it is hard to pass a stand selling freshly grilled bratwurst or knockwurst without partaking. But as a kid I didn't eat a lot of it cheerfully.

One of my least favorite culinary memories was the "special" dish my mom made by rolling a pounded piece of beef around an onion, a pickle, and some other ingredients that I regarded as kid-unfriendly. Called *rouladen*, this concoction was toothpicked together and then cooked in a big cast-iron skillet. The meat exuded some brown goop that became thick gravy, which was supposed to soften the dry meat. It ranked one notch above sauerkraut and kielbasa.

So when Jörg and Susanne announced with some fanfare that Jörg was preparing his special *rouladen* for a dinner party that night, I was interested—but solely from a photographic point of view. Painstakingly prepared over several hours in the Melanders' galley-size kitchen, the beef bombs, slathered in a gooey brown sauce, elicited oohs and aahs from the dinner guests and family—everyone except me. They were a huge hit. Even Faith, who doesn't like meat, polished hers off. Jörg ate two. Though I finished mine, some childhood memories are hard to dispel.

— *Peter*

- Population: **82,424,609**
- Population of Bargteheide: **13,680**
- Area in square miles: **137,810 (slightly smaller than Montana)**
- Population density per square mile: **598**
- Urban population: **88%**
- Life expectancy, male/female: **76/82 years**
- Fertility rate (births per woman): **1.4**
- Caloric intake available daily per person: **3,496 calories**
- Annual alcohol consumption per person (alcohol content only): **13.1 quarts**
- Annual consumption of beer/soft drinks per person: **103/76 quarts**
- GDP per person in PPP $ (Purchasing Power Parity: an adjustment for what equivalent local goods would cost in the U.S.): **$27,100**
- Total annual health expenditure per person in $ and as a percent of GDP: **$2,412/10.8**
- Overweight population, male/female: **64/54%**
- Obese population, male/female: **20/19%**
- Population age 20 and older with diabetes: **4.1%**
- Meat consumption per person per year: **181 pounds**
- Sausage consumption per person per year: **67 pounds**
- McDonald's restaurants: **1,211**
- Big Mac price: **$3.75**
- Cigarette consumption per person per year: **1,702**

At the outdoor Friday market in their tidy community of Bargteheide, Susanne steadies her shopping list on Jörg's chest *(above left)* as she checks off purchases. An hour later, they walk home *(above)* with their produce, cutting through the town square, past a 13th century church. The next day, Saturday, it snows. Because Susanne is at her nursing job, Jörg lines up outside *(bottom left)* to buy meat at the Saturday market in neighboring Ahrensburg.

After making the chilly walk back from the Friday market, Jörg lights a fire and Susanne brings out yogurt spreads, cheese, stuffed olives, peppers, fresh bread, and a Dresden stollen and pours a cup of tea for a friend, Venita Kaleps *(above)*. The next morning, Susanne leaves early for her nursing job. Kjell *(right)* sits patiently with his hot chocolate, waiting for his father to join him at the dining-room table for a breakfast of fresh rolls, meat, and cheese.

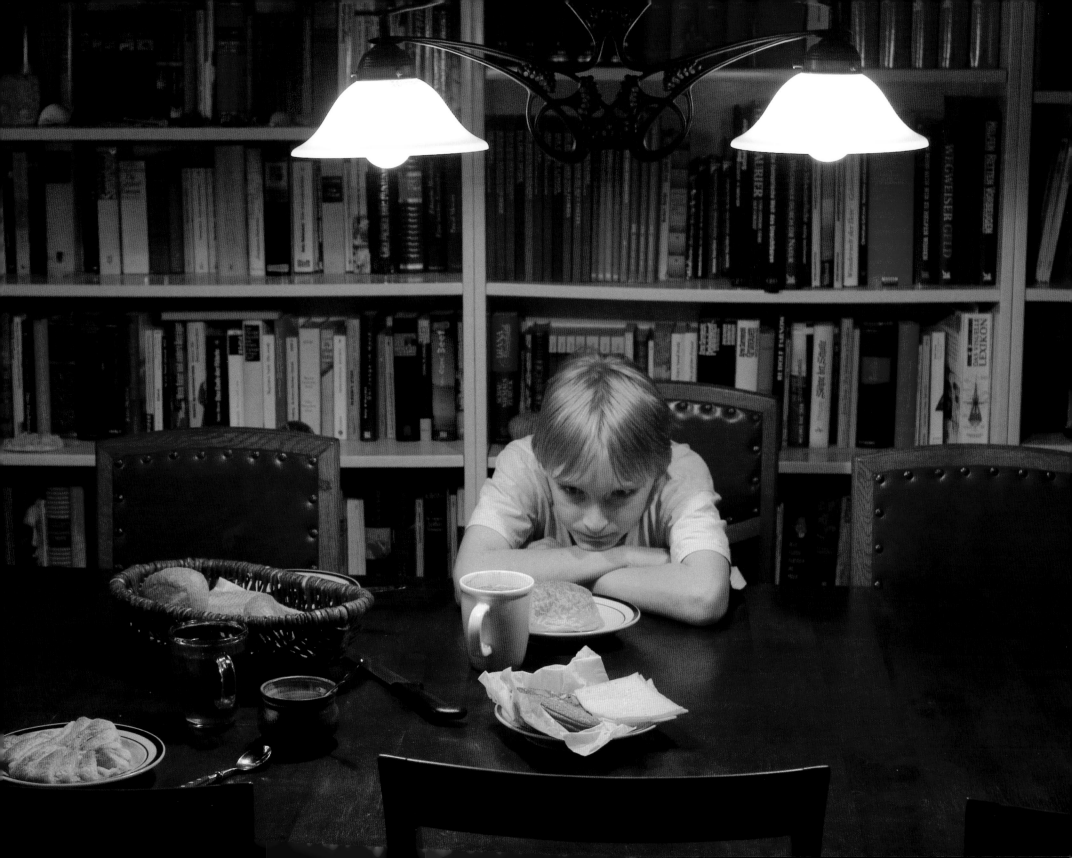

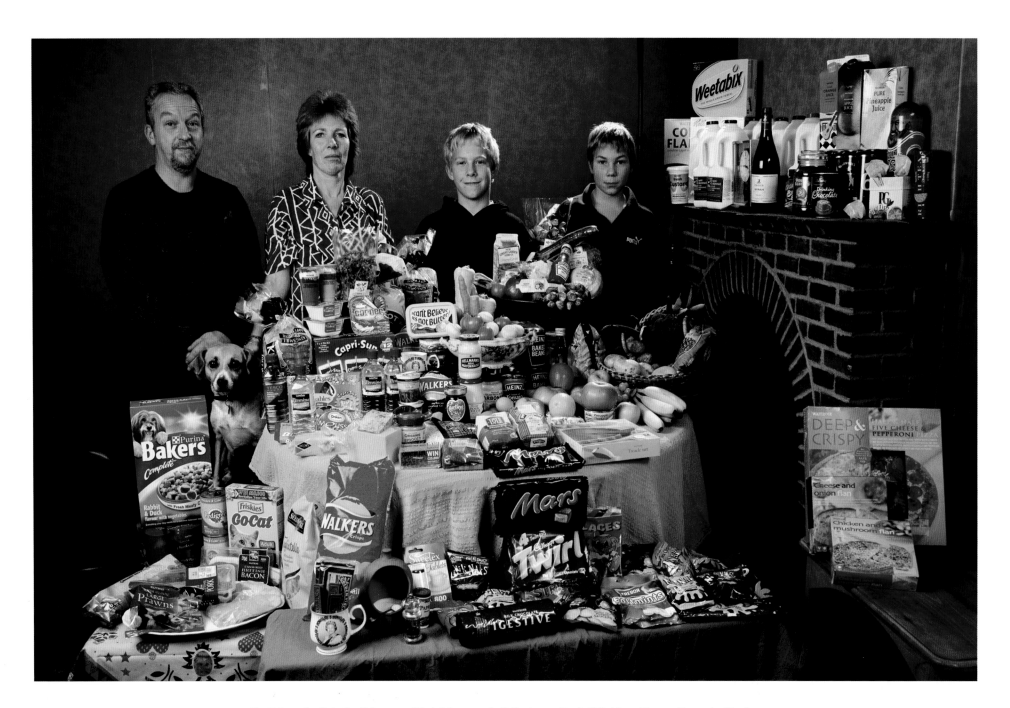

The Bainton family in the dining area of their living room in Collingbourne Ducis, Wiltshire, with a week's worth of food.
Left to right: Mark Bainton, 44, Deb Bainton, 45 (petting Polo the dog), and sons Josh, 14, and Tadd, 12. Cooking methods:
electric stove, microwave oven. Food preservation: refrigerator-freezer, a second small freezer. Favorite foods—Mark:
avocado. Deb: prawn-mayonnaise sandwich. Josh: prawn cocktail. Tadd: chocolate fudge cake with cream.

Bacon at the Bees'

Grains & Other Starchy Foods: $20.41

White potatoes, 3.9 lb; *Kingsmill Gold* soft white bread, sliced, 2 loaves; *Hovis* crusty white bread, 1.8 lb, *Weetabix* whole-grain cereal, 1.5 lb; new (young) potatoes,1.3 lb; *McDougall's* self-raising flour, 1.1 lb; *Saxby* puff pastry, 1.1 lb; *Seeds of Change* tagliatelle, 1.1 lb; *Waitrose* (store brand) porridge oats, 1.1 lb; *Kellogg's* Coco Pops,13 oz; *Waitrose* corn flakes, 12 oz; *Waitrose* garlic baguette, organic, 6 oz; *Jacob's* TUC crackers, 5.3 oz.

Dairy: $27.93

Semi-skim milk, 3.5 gal; full-cream milk (whole), 2 qt; *Waitrose* strawberry yogurt, 1.5 lb; *Müller Corner* strawberry yogurt, 1.2 lb; *Waitrose* custard, 1.1 lb; mild English Cheddar, 11.5 oz; *Philadelphia* cream cheese, 8 oz; *Waitrose* rhubarb yogurt, 6 oz; *Waitrose* toffee yogurt, 6 oz; *Country Life* butter, 4.4 oz; *Cropwell Bishop* cheese, 3.5 oz.

Meat, Fish & Eggs: $28.34

Waitrose British pork, 2.2 lb; *Waitrose* eggs, 12; *Waitrose* pork escalopes,‡ 1.1 lb; *Waitrose* tuna, canned in brine, 1.1 lb; honey-roasted ham, 11.8 oz; *Waitrose* unsmoked British bacon, 5.5 oz; *Waitrose* large prawns, frozen, 5.3 oz.

Fruits, Vegetables & Nuts: $35.27

Coxes variety apples, 2.8 lb; Braeburn variety apples, 1.8 lb; yellow bananas, 1.5 lb; oranges, 1.4 lb; Granny Smith variety apples, 1.3 lb; green grapes, seedless, 14.4 oz; *Del Monte* pineapple chunks, canned, 8 oz; *Heinz* baked beans, canned, 2.8 lb; *Waitrose* brussel sprouts, fresh 2.2 lb; *Birds Eye* garden peas, frozen, 2 lb; white cabbage, organic, 1 head; white mushrooms, 1.6 lb; cauliflower, 1 head; carrots, 1.5 lb; parsnips, 1.2 lb; iceberg lettuce, 1 head; tomatoes, 1 lb; broccoli, 13.9 oz; cucumber, 11.2 oz; red onion, 10.6 oz; runner beans, 10.2 oz; mange tout peas (snow peas), 5.3 oz; sugar snap peas, 5.3 oz.

Condiments: $20.34

I Can't Believe It's Not Butter spread, 15 oz; *Heinz* ketchup, 14 oz; *Hartley's* Best raspberry jam, 12 oz; *Heinz* salad cream, 10 oz; *Hellmann's* Real mayonnaise, 10 oz; *Waitrose* smooth peanut butter, organic, 8 oz; *Waitrose* blend olive oil, 5.1 fl oz; *Tate Lyle* white sugar, 4.4 oz; *Waitrose* dark-brown muscovado sugar, 3.5 oz; waldorf salad topping, 1.8 oz; paprika, 1.7 oz; black pepper, 1.4 oz; *Maldon* sea salt, 1 oz; *Saxa* table salt, 1 oz; basil,* 1 bunch; parsley,* 1 bunch; *Sweetex* sweetener, 80 tablets, *these are very small.*

Snacks & Desserts: $28.74

McCain oven chips, (French fries), frozen, 2 lb; *Mars* candy bars, multipacks, 1.7 lb; *Waitrose* savory wedges,‡ frozen, 1.7 lb; *Waitrose* milk chocolate digestive biscuits, 14.1 oz; *Waitrose* treacle tart, 13.4 oz; *Cadbury* twirls, 8.9 oz; *Trebor* Softmints, 7.9 oz; *Haribo* Maoam Stripes, 7.1 oz; *Waitrose* rich tea biscuits, 7.1 oz; *Golden Wonder* Nik Naks, 6.6 oz; *Walker's* BBQ crisps, 6.2 oz; *Walker's* prawn cocktail crisps, 6.2 oz; *Waitrose* caramel surprise, 5.3 oz; *Waitrose* chocolate surprise, 5.3 oz; *Onken* chocolate hazelnut mousse, 4.4 oz; strawberry laces, 3.5 oz; *Waitrose* mini jelly babies, 3.5 oz; *Dairylea* Double Dunker nachos, 1.8 oz; Flying Saucers candy, 1.8 oz.

Prepared Food: $26.01

New Covent Garden Food Co vegetable and lentil soup, 1.3 lb; *Waitrose* five-cheese & pepperoni pizza, 1.3 lb; *Loyd Grossman* four-cheese pasta sauce, 15.9 oz; *Heinz* cream of tomato soup, canned, 14.1 oz; *Waitrose* cheese & onion flan, 14.1 oz; *Waitrose* chicken & mushroom flan, 14.1 oz; *Dairylea* ham Lunchables, 7.8 oz; *Bisto* granules gravy mix, roast vegetable flavored, 7.1 oz; *Waitrose* carbonara sauce 5.3 oz.

Homemade Food:

Savory pancakes, *made with flour, milk, and eggs, listed above.*

Beverages: $38.51

Capri Sun fruit juice, 12 6.8-fl-oz pkgs; *Somerfield Pennine Valley* water, 1.6 qt; *Wadworth* beer, 12 16.9-fl-oz cans; *Waitrose* pineapple juice 1.1 qt; *Waitrose* press apple juice, 1.1 qt; *Waitrose* pure orange juice, 1.1 qt; *Tesco* mountain spring water, 16.9 fl oz; *Cadbury* drinking chocolate, 1.1 lb; *James Herrick* red wine, 12.7 fl oz; *Douwe Egberts* Continental Gold coffee, 6.2 oz; *PG Tips* tea, 40 teabags; tap water, for drinking and cooking.

Miscellaneous: $27.60

Waitrose variety cat food, 5.4 lb; *Bakers* dog food, rabbit & vegetable, dry 3.3 lb; *Pedigree* dog food, chicken & game, canned, 1.8 lb; *Friskies Go-Cat* cat food, dry, 13.2 oz; *Golden Virginia* hand-rolling tobacco, 3.5 oz; *Rizla* cigarette papers, 4 pks.

* Homegrown; ‡ Not in Photo

Food Expenditure for One Week:
155.54 British pounds/$253.15

D EB BAINTON CALLS HER SON Josh an "almost vegetarian." She says, half-jokingly that any day now the pendulum will swing fully in that direction and a hearty lentil soup will replace the traditional British Sunday roast. "But I do like a roast," says her husband Mark, with comic wistfulness. There is actually no danger that he might miss out on this. "We're often eating different meals at the same table," says Deb.

Conversations at the Bainton house—they call themselves the Bees—often seem ever so slightly Monty-Pythonesque. Deb: "He's the breakfast cooker." Mark: "I am not the breakfast cooker." Deb: "Yes, you are. If you cook the breakfast then you are the breakfast cooker." Josh, 14, and Tadd, 12, focus on Saturday morning cartoons while they wait for the results of said breakfast cookery. "We're having a proper English cooked breakfast this morning—eggs, bacon, mushrooms, and stewed tomato," says Deb, although who will actually cook seems still to be in question. Eventually, it is Mark at the skillet, with Deb as assistant. "Roughage," Deb says amiably, when both egg and eggshell land in the sputtering grease. As she picks out the eggshell, Josh decides to have cold cereal instead.

This weekend, the Bees and some of Josh's friends will celebrate his 14th birthday at the local pub, with dinner, a cake, a spray can of whipped cream, and a game of pool. But first, it's time for the weekly food-shopping—no one's favorite chore. They hop in the car and drive through their quaint little village, Collingbourne Ducis, named in part for a long-dead duke. They take pastoral byways, past quaint thatched cottages, cow crossings, and military tank crossing signs, through half a dozen other equally quaint little villages in Wiltshire—home of the enigmatic Stonehenge and Avebury monoliths—until the modern world swings briskly into view in the form of Waitrose, the upscale U.K. grocery chain in the town of Marlborough. Mark grabs a shopping cart and they head inside.

"I push the trolley," says Mark, "but I'm banned from shopping." "All sorts of strange foods end up in our cupboards when Mark does the food shop," says Deb, "and he buys lots of sweets." The boys, and Deb, too, are no strangers to sweet things, although Josh's favorite item to sneak into the trolley is very expensive prawns. They stock up on convenience foods like frozen pizza and juice-boxes to get them through the week.

141

I was excited about going to the Baintons' house in southwest England because they live near Stonehenge, which I had never seen before. Because it is open only from 9:30 a.m. until 4:00 p.m., and is surrounded by fences, you can't get anywhere near it for photographs at dawn or sunset, when the light is best. Getting up at 4:00 a.m., I drove through the swirling mist in the dark past Stonehenge, pulled into a pasture, and left Faith in the car as I crept through the fields toward the site. The police were onto me within a hundred yards. I flashed my press card but they were in no mood to make post-9/11 exceptions. Actually, they were pretty nice not to arrest me, especially when I told them that the real mystery of Stonehenge is why it is not open at interesting hours. Back in the car, I was not upset about missing good light, because, true to form, the English dawn broke like a brain in a blender: swirling gray matter that was hard to make sense of in the colorless early hours. — *Peter*

FAMILY RECIPE

Mark Bainton's Cheese and Potato Pie

12 oz mashed potatoes per person

9 leaves basil, finely torn (save 1 leaf for garnish)

3 sprigs parsley, finely chopped (save 1 leaf for garnish)

8–12 oz Cheddar cheese

- Preheat oven to 350° F.
- Combine mashed potatoes, basil, and parsley (or other herbs of your choice).
- Cover bottom of an ovenproof casserole about 1" thick in mashed potatoes; cover with sliced cheese. Repeat, finishing with slices of cheese, so that all the mashed potatoes are covered.
- Bake until golden brown, 20–25 minutes. Serve with garnish.

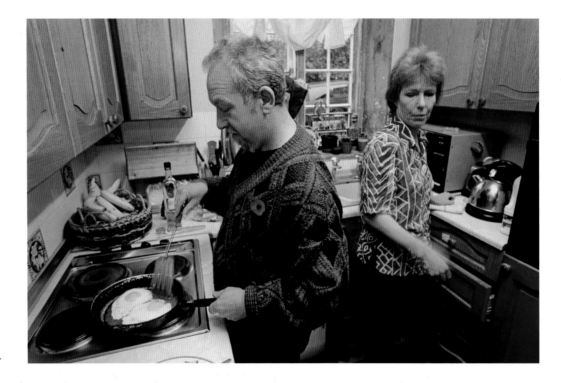

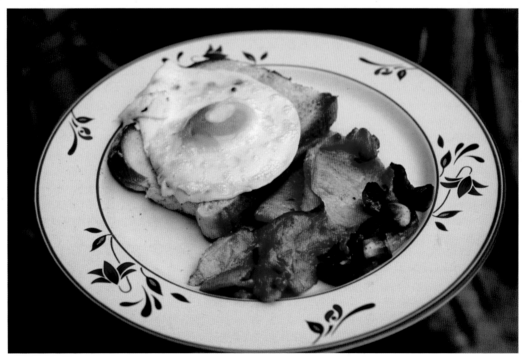

- Population: **60,270,708**
- Population of Collingbourne Ducis: **880**
- Area in square miles: **94,500 (slightly smaller than Oregon)**
- Population density per square mile: **638**
- Urban population: **89%**
- Life expectancy, male/female: **76/81 years**
- Fertility rate (births per woman): **1.6**
- Caloric intake available daily per person: **3,412 calories**
- Annual alcohol consumption per person (alcohol content only): **10.3 quarts**
- GDP per person in PPP $ (Purchasing Power Parity: an adjustment for what equivalent local goods would cost in the U.S.): **$26,150**
- Total annual health expenditure per person in $ and as a percent of GDP: **$1,835/7.6**
- Overweight population, male/female: **63/59%**
- Obese population, male/female: **19/21%**
- Population age 20 and older with diabetes: **3.9%**
- Meat consumption per person per year: **175 pounds**
- McDonald's restaurants: **1,110**
- Big Mac price: **$3.61**
- Fish and chips restaurants: **8,600**
- Fish served in fish and chips restaurants per year: **110,208,000 pounds**
- Cigarette consumption per person per year: **1,748**

On the weekends, there's cooked breakfast *(at left),* but during the week, cold cereal for breakfast is routine—Weetabix, scrub-pad-size squares of toasted wheat—although Tadd prefers a can of tomato soup. Deb, a teaching assistant for children with special needs, has tea and a bite of toast most mornings. She leaves the house when the boys do. Mark, a welder who works the late shift, is on an entirely different schedule during the week, and catches up with the rest of the family only on weekends.

Friends and family celebrate Josh Bainton's 14th birthday party on Saturday night at The Crown, the neighborhood pub. The next morning, Mark *(above left)* cooks breakfast—a task he performs every weekend morning, unless, of course, he can persuade his wife Deb to do it. Today's menu: fried eggs with toast, ham, and mushrooms *(bottom left)*.

The Madsen family in their living room in Cap Hope village, Greenland, with a week's worth of food. Standing by the TV are Emil Madsen, 40, and Erika Madsen, 26, with their children (left to right) Martin, 9, Belissa, 6, and Abraham, 12. Cooking method: gas stove. Food preservation: refrigerator-freezer. Favorite foods—Emil: polar bear. Erika: narwhal skin. Abraham and Belissa: Greenlandic food. Martin: Danish food.

Hunting for the Past

The Madsens could be a family anywhere preparing for a winter camping trip, except for the dead seabirds in their entryway and the 26 dogs yowling outside, 275 miles north of the Arctic Circle.

FEWER THAN 700 PEOPLE LIVE on the central east coast of Greenland, and most live in the town of Ittoqqortoormiit, overlooking Scoresby Sound and the Greenland Sea. There are no roads to Ittoqqortoormiit—Ittoq, as the locals call it—and the nearest settlement, Ammassalik, is 500 miles away. Provisions come to Ittoq by boat during the summer and by air or snowmobile, over frozen Scoresby Sound, during the rest of the year. We first meet Greenlandic hunter Emil Madsen in Ittoq, where he is stopping briefly after a five-day hunting trip. Because his tiny village of Cap Hope has no market—only a small government shop that sells nonperishables, and is managed by Emil's wife, Erika—he does the grocery shopping in Ittoq's government-owned market. Afterward, we pile onto his dog sled for the long drive to his home.

Emil barks commands in Greenlandic to the 14 dogs in his team, starting their trek west, along the Sound, past towering icebergs, frosted mountains, and endless snow. It's easy for a first-time visitor to get lost in the distant views, but what's happening up close is just as riveting. None of the lyrical descriptions I've read about the experience of gliding over the ice on a dogsled quite prepares me for the sight of a large pack of dogs relieving themselves on the run. And it's hard to imagine a more anachronistic sight than our parka-clad hunter, perched at the front of the sled, Prince cigarette between two fingers, thumbing through the messages on his mobile phone (which, unsurprisingly, has very little signal strength). We skim across the snow for well over two hours, bumping over old sled tracks and dog poop—a trip that would take eight or ten minutes in a car, if there were a road.

Emil's youngest child, Belissa, a round-faced girl with an ear-to-ear smile, greets her father with a hug at the door of their modern clapboard house in Cap Hope. Although Emil and Erika are quite reserved—a trait common in Inuit (Kalaallit) adults—their three children and visiting nephew Julian are decidedly not—a common trait of Inuit childhood. Their normal level of excitement is enhanced by the prospect of tomorrow's camping trip to an inland

ONE WEEK'S FOOD IN MAY

Grains & Other Starchy Foods: $34.07

Brown bread, 2 loaves; *High Class* white rice, 2.2 lb; *Ota* sol gryn (mueslilike cereal), 2.1 lb; *Finax* fruit muesli, 1.7 lb; hard biscuits, 1.5 lb, *tucked into pockets for quick snacks;* hard bread, 1 loaf; *Bellaroma* farfalle, 1.1 lb; *Bellaroma* fusilli, 1.1 lb; *Foodline* rice, 1.1 lb; *Quaker Oats* Guldkorn (corn cereal), 1.1 lb; *Foodline* mashed potato mix, 15.5 oz; *Dagens* white bread rolls, frozen, 12.

Dairy: $4.87

Arinco milk, powdered, 4.4 lb, *makes 1.9 gal; Lurpak* butter, 13.2 oz.

Meat, Fish & Eggs: $53.97**

Musk ox,* 26.5 lb; walrus,* frozen, 9.9 lb; arctic geese,* 8.8 lb meat, *after cleaning;* polar bear,* 3.3 lb; *Tulip* hot dogs, 3 lb; little auk (also called dovekie),* 5 birds, 1.9 lb; ground beef, frozen, 1.7 lb; *Danish Prime* meatballs, frozen, 14.1 oz; ham, 1.1 lb; cod, dried, 12.4 oz, *eaten with narwhal oil;* breakfast meat and 4 slices of egg, 10.6 oz, *egg product is purchased in tube form and is called "long egg"; Danish Prime* Danish meatballs, frozen, 8.5 oz; capelin (fish), 7.8 oz; *Tulip* bacon, 5.3 oz.

Fruits, Vegetables & Nuts: $8.67

Nycol oranges, canned, 1.4 lb; *Sunsiesta* fruit cocktail, canned, 11 oz; yellow onions, 1.3 lb; *Bellaroma* tomato sauce, chili pepper flavored, 14.1 oz; *Frontline* champignon mushrooms, preserved, 9.9 oz.

Condiments: $25.66

Heinz tomato ketchup, 3.2 lb; *Jozo* salt 2.2 lb; *Dan Sukker* sugar, 1.1 lb; narwhal oil, approx. 16 fl oz, *they have varying amounts depending on whether anyone has shot one recently; HP* sauce, 15 oz; marmalade, 14.1 oz; *Foodline* chocolate cream, 12.4 oz; coffee creamer, powdered, 10.6 oz; *Lea & Perrins* Worcestershire sauce, 8.5 fl oz; *K* mayonnaise, 7.1 oz; *K* remoulade, 7.1 oz; *Foodline* onions, dried, 1.8 oz; black pepper, 1.1 oz.

Snacks & Desserts: $54.25

Candy, assorted, 3.3 lb; *Haribo Maoam* mini fruit candies, 11.6 oz; *Marabou* chocolate bar, 10.2 oz; *KiMs* X-tra potato crisps, 8.8 oz; *Pringles* Original potato chips, 8.8 oz; raisins, 8.8 oz; *LU* ritz crackers, 7.1 oz; *Goteborgs* ballerina cookies, 6.4 oz; *LU* mini TUC (crackers), 5.3 oz; *Milky Way* candy bars, 4.1 oz; *Bisca* Chocolate Marie cookies, 3.5 oz; bubble mix chewing gum, 3.5 oz; *Mamba* candy, 2.7 oz; *Bounty* candy bar, 2 oz; *Stimorol* chewing gum, 1 pk.

Prepared Food: $35.66

Knorr chicken bouillon 2.5 lb; *Nissin* cup noodles, instant, 2.3 lb; *Daloon* spring rolls, frozen, 1.9 lb; *Danish Prime* sausage mix (sausage and potato), frozen, 1.3 lb; *Knorr* Mexican dried soup base, 10.6 oz; *Knorr* minestrone dried soup base, 10.6 oz; liver paste, 7.1 oz.

Beverages: $36.40

Mixed fruit drink concentrate, 3.2 qt; orange drink concentrate, 3.2 qt; *Rynkeby* apple juice, 2.1 qt; *Rynkeby* orange juice, 1.1 qt; *Coca-Cola*, 12 fl oz; *Faxe Kondi* (carbonated drink), 12 fl oz; *Nikoline* lemon (carbonated drink), 12 fl oz; *Nikoline* orange (carbonated drink), 12 fl oz; *7UP*, 12 fl oz; *Nescafe* instant coffee, 10.6 oz; *Pickwick* lemon tea, 20 teabags; *Pickwick* tropical fruit tea, 20 teabags; spring water, *in milk cans, used for drinking and cooking.*

Miscellaneous: $23.49

Prince cigarettes, 3 pks.

* Hunted

Food Expenditure for One Week: 1,928.80 Danish krone/$277.12

**Local value of hunted meat: $221.26

glacier lake. Throughout the evening, the four children horse around, dividing their attention between MTV and Emil's conversations with his fellow hunters who trickle in for midnight musk ox stew. Only four families live in Cap Hope, but the Madsens' home is a rest stop for anyone traveling between the airstrip at Constable Point and Ittoq.

Breakfast time: there's lots of tea, juice from a sugary fruit concentrate, and muesli in reconstituted powdered milk, accompanied by Danish dance videos and more MTV. Meals are prepared in the family's small, modern kitchen, which has all the usual amenities except running water, and are eaten in front of the television—whether or not there are guests. No one is in a hurry to get going because it never gets dark at this time of year. There's continuous daylight from early spring through late summer. After breakfast, Erika passes provisions through an open window to her sons Abraham and Martin: a hunk of frozen musk ox meat in a plastic bag; a weather-tight bin full of packaged noodles, cookies, and muesli; a soup pot; ice pikes for fishing; and a portable kerosene cook stove. The boys pile everything onto one of the two dogsleds. Nine-year-old Martin is learning to drive Emil's second team. Although Abraham is three years older, he wants little to do with the dogs. He was attacked and almost killed by another hunter's dogs three years earlier.

When Emil appears outside, bundled against the cold, most of his dogs begin a cacophonous group howl—they know there's going to be a run today—but some just curl up tighter on the packed snow for a few more minutes of sleep. These are not pets—they're working dogs and live out their lives tied to one another, pulling loads of 1,000 pounds or more. Emil straps down bedrolls and a tent, and sets his rifle and shotgun into a rack at the back of the sled. He covers the sled with skins for warmth, then spends the next 15 minutes laying out nylon ropes for the dogs and leading them one by one to their spots. Inside, Belissa tries to pull on her boots over one too many pairs of socks. Her mother helps—extra socks off, boots on, hair tied back. Coat on. Hat, mittens, dark sunglasses on. Doll slipped into purple Spice Girls backpack for playtime during the hours-long ride. Finally ready, Belissa steps over the seabirds to the outdoors and shrieks into the cold wind.

SETTING OUT

Mushing along the icy coastline, first one team of dogs leads, then the other. At the front of our sled, Erika and Emil chain-smoke, Belissa sprawls in the middle, playing with her doll, and Peter stands behind me at the back with his camera. After the first 15 minutes, every second of the trip is breathtakingly beautiful but freezing cold, even after we cover up with polar bear pelts. In May, a comparatively warm month, the temperature hovers around freezing. Erika says she doesn't feel the cold; she grew up with it. She's a tiny but solidly built woman only 14 years older than their oldest son, Abraham. On the second sled, the two boys keep warm by jumping on and off the sled and racing next to it. The children spend the entire day singing "Oh happy day," the gospel classic by Edwin Hawkins, which they learned on TV. But they know only those three words.

Emil tells the dogs to veer left or right and keeps an eye on the other sled, as the boys aren't too attentive. Belissa snuggles into her mother for a snooze. Peter runs to the boys' sled, and this delights them. Soon they're all jumping from one sled to the other. Who's guiding the second sled? The dogs, well trained by Emil. As we grind along, I often have to ask Emil whether we are over water or on terra firma; much of our course goes over frozen fjords and there's little visible difference between iced-over water and iced-over land. Emil says he uses the distant icebergs as landmarks. He calls the place where the ice meets the water "the ice edge." At first I think he's calling it "the ice age," but actually neither seems far from the truth. The ice edge is invisible in the whiteness—not dangerous in the winter but perilous when the weather starts to warm up, and cracks begin to develop. No one wants to be stuck on the big chunk that breaks off and floats out to sea.

We head inland, or so Emil says. Surrounded by 360 degrees of white, it's hard for me to tell. Our sleds course over a hill and suddenly there is a palatial glacier, and towering frosted mountains meet a shimmering frozen lake. Surprisingly, the ground above the lake is lichen-covered. Emil stakes out the dogs and then feeds them packaged dog chow and seal innards. Exhausted, they collapse in their tracks after eating and fall asleep instantly. Emil and Erika make a campsite above

A wooden cross stands guard over the village cemetery in Cap Hope. Now home to just ten people, Cap Hope is where both Emil and Erika Madsen grew up. Emil's father is buried in this cemetery. Sparkling in the distance, a huge iceberg catches the 10:00 p.m. light. During the summer at Cap Hope, the sun never actually disappears below the horizon, though it does dip briefly behind the high hills that surround the village.

To break the monotony of dogsled travel, 9-year-old Martin runs alongside. When the snow crust is hard enough to ensure that the dogs won't break through, they can pull the half-ton weight of the sled for hours on end. On level ground, the animals pull at about the pace of a running human, but the sleds can whip down hills so fast that drivers must step on the brake at the rear of the sled to avoid running over their dogs. Belissa sleeps through part of the journey behind her father on his sled.

After a five-hour sled ride from Cap Hope, the Madsens arrive at their destination, a frozen lake below a glacier. Tired and hungry, everyone wolfs down Emil's musk ox stew with pasta *(above right)* in the canvas tent. The next day, Emil, Erika, and the children head out to fish for arctic char. After chopping holes in the ice with a pike, family members lower down hooks baited with seal fat. When the char bite, Erika yanks them out of the hole *(above left)* with a practiced motion. Later, Emil, an accomplished camp cook, serves the fish in a mildly spicy curry.

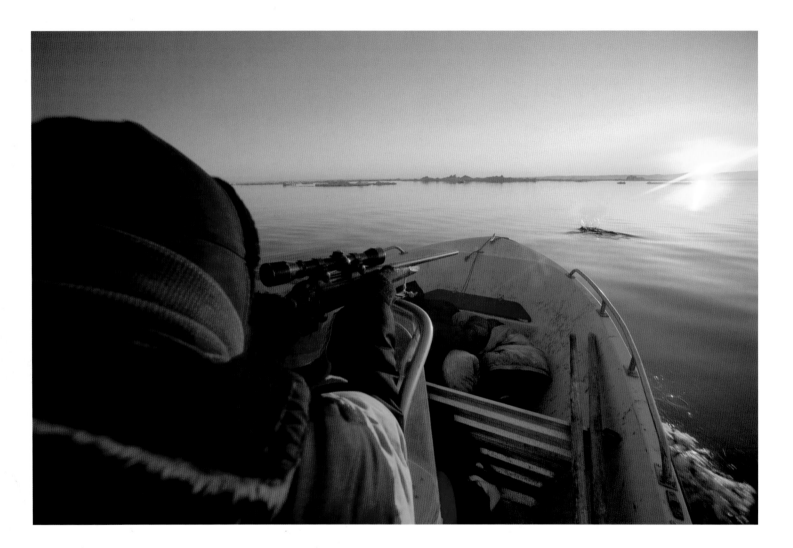

With a single expert rifle shot, Emil kills a seal *(above)* just after midnight in Scoresby Sound, the enormous fjord on Greenland's eastern side. At the bullet's point of impact, a crown of water rises from the sea. The sound does not disturb Emil's son Abraham or his nephew Julian, who have fallen asleep under some old jackets in the bow. After quickly motoring over to the seal to haul its body out before it sinks, the tired hunter heads back home *(at right)*.

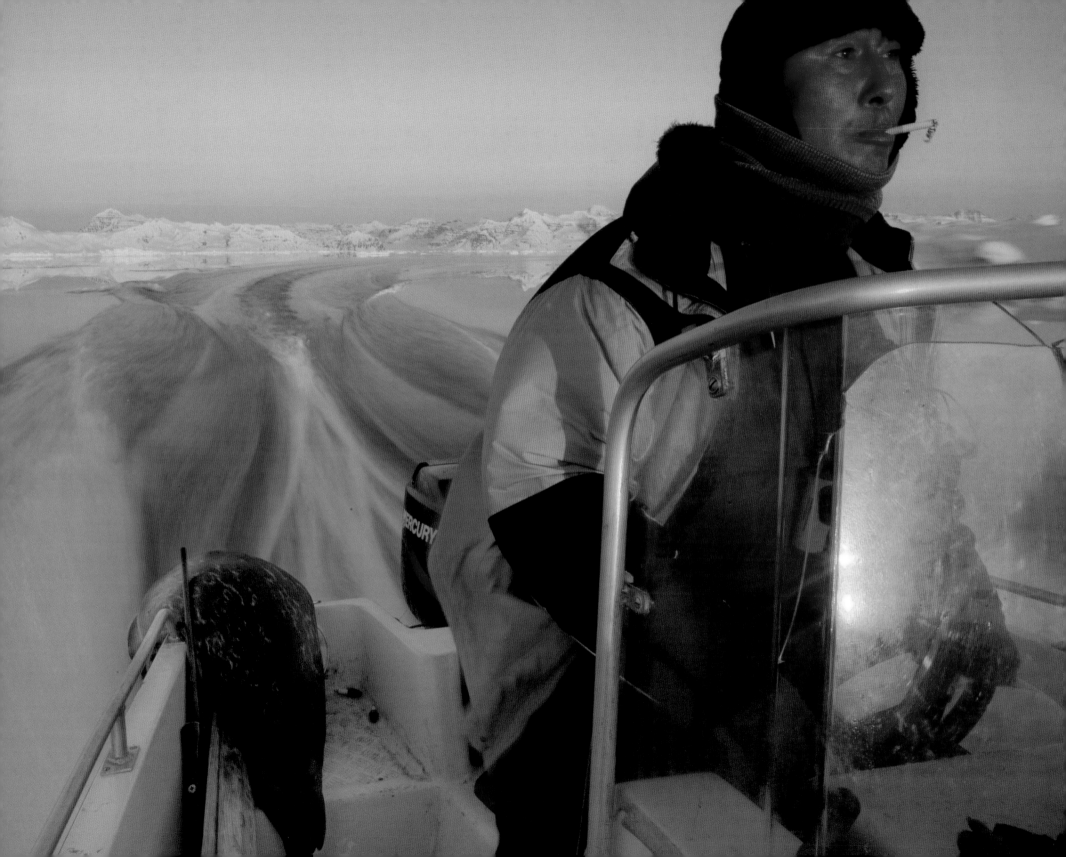

While Emil stows away the gear and winches the boat ashore, Julian and Abraham drag the freshly killed seal up to the house, followed by inquisitive dogs licking up the trail of blood. Although the boys are almost staggering with tiredness—it is 1:30 in the morning—they haul the animal inside, leaving it in the hallway by the bathroom overnight.

- Population: **56,384**
- Population of Cap Hope: **10**
- Native Inuit population: **88%**
- Area in square miles: **836,109 (slightly three times the size of Texas)**
- Population density per square mile: **0.1**
- Urban population: **83%**
- GDP per person in PPP $ (Purchasing Power Parity: an adjustment for what equivalent local goods would cost in the U.S.): **$20,000**
- Aid from Denmark per person per year: **$6,786**
- Land not covered in ice: **19%**
- Rate Arctic Sea ice is melting per decade: **9%**
- Life expectancy, male/female: **64/70 years**
- Fertility rate (births per woman): **2.45**
- Annual alcohol consumption per person (alcohol content only): **13 quarts**
- Percent of population born after 1960 that states they experienced alcohol-related problems in their parental home: **50**
- Total annual health expenditure per person: **$2,622**
- Percent of population, age 18 and older, that smokes: **>60**
- Average number of days each year that temperature is below freezing: **279**
- Obese population, male/female: **16/22%**
- Population age 35 and older with diabetes: **10%**
- Sugar consumption per person per year: **81 pounds**
- Meat consumption per person per year: **250 pounds**
- Percent of population that eats seal 4 times a week: **20**
- McDonald's restaurants: **0**
- Age at which most sled dogs outlive their usefulness and are shot: **6 to 8 years**
- Year that a Greenlandic iceberg sank the Titanic: **1912**

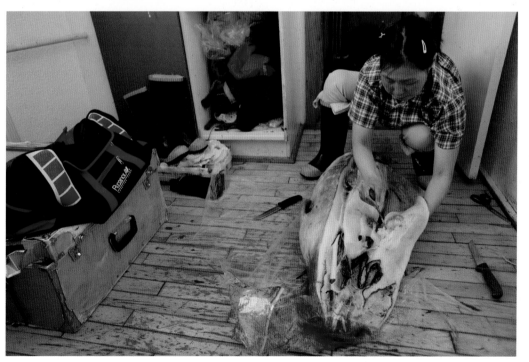

Greenlandic Seal Stew

2 lb seal meat, chunked

2 oz rice

salt

1 onion, sliced

- Put meat and rice in a pot, add water to cover, and bring to a boil.
- When mixture starts to boil, add salt (to taste) and onion.
- Boil for 45 minutes to 1 hour.

As the main supply center for 500 miles in any direction, the general store in Ittoqqortoormiit *(above left)*, the bigger village (pop. 550) across the bay from Cap Hope, sells everything from guns to butter. Although such stores sell seal, musk ox, and other Arctic meats, most Greenlander families still obtain their meat from hunting. Hunting to feed the family is Emil Madsen's lifelong pursuit—taught to him by his father. Too fill his family's larder, Emil is often gone for a week or more. Not surprisingly, prices in the general store are high, but the Danish government heavily subsidizes Greenlanders' incomes—to the tune of $6,786 per person in 1999, the latest year for which statistics are available. Geopolitically, Greenland is part of Denmark, hence the close ties of the people and the cross-immigration. Erika Madsen *(bottom left),* cleaning the seal her son and nephew left in the hall, will cook the best meat for her family, feed the remains to the sled dogs, then dry and sell the sealskin.

the lake while the boys and Peter spend the next hour punching fishing holes through its four-foot-thick ice with long, spearlike pikes. Martin scoops slush from the holes with his bare hands from time to time, and they break through just in time for dinner. Emil and Erika have made musk ox stew with noodles. Bowlfuls are quickly wolfed down amid the balmy heat of the kerosene stoves. Scrumptious.

Snow-white hares bound across the ice in the distance as Erika, Emil, and the children fish companionably until 2 a.m., and then drop the catch in the snow outside the tent in the bright light of bedtime. The dogs are sleeping on the snow, curled up in little balls, as the humans traipse off to bed. At 3 a.m., my portable thermometer shows it's 23 degrees Fahrenheit. Peter would say "nice sleeping temperature." If he were awake. Next day it's more of the same—although time is beginning to run together. (It's hard for non-Greenlanders to gauge time during endless daylight.) Breakfast is cereal—puffed rice and muesli. Emil pours the milk powder directly onto his cereal, adds water and sugar, and mixes. The fishing continues, with the pile of char growing to at least 100. Erika cleans the fish, and Emil steams a bunch of them in a pot of melted snow. Delectable. Then it's off again on the sleds: Emil is going to hunt for seal.

The dogs begin each run with their rope leads arranged in a fan shape—the pack leaders on the longest ones—but the leads get entwined as they run, until eventually they're rubbing shoulders. After a couple of hours, when their ropes have become totally braided, Emil stops the sled and yanks the now-massive rope backward sharply, until the dogs fall down. As he works out the tangle, he's gentle with them when he's rested, but kicks and beats them when he's tired. Later, other people tell me that he treats his dogs better than most Greenlanders. The reason for the harsh treatment, I'm told, is that in this environment the dogs are sometimes all that stand between life and death for the hunter. They must act as a team, with no mistakes. When one occurs, Emil reminds them who's in charge. When he's in a bad mood, they're sure to find that out, too.

Emil keeps an eye on the boys in the other sled—worried, he says, because the large ice fractures must be crossed perpendicular to the crack. As we cross one such crack, the dog at the rear of the pack slips into it, yelping. The other dogs scramble forward furiously so they won't get dragged in. Emil leaps off the sled to rescue the hapless dog. Suddenly, the sled sticks in the fissure and begins to slide backward

into the water. At the front of the sled Erika tosses Belissa to safety and then quickly jumps off herself. I'm on the part of the sled heading into the water and gravity is keeping me there. As the sled slips down farther, Emil shouts at the dogs to pull and with Peter grabs the back of the sled and hauls it forward. They get it across the break just in time. Sleeping bags are wet, but that's all. I've learned firsthand why Emil is concerned about the boys on the other sled.

As we get close to the ice edge, the family concentrates on the open water, looking for the seal that popped its head up from the sea a moment ago. Everyone is silent as they get off the sleds. Abraham sets down the wooden gun rest and Emil lies on the snow with his rifle. A small shiny head breaks the water's surface briefly, and Emil takes a shot. He hits the seal but can't tell whether he's killed or wounded it. Meanwhile, the rest of the family drags the skiff—there's one on the second sled—into the water. Emil jumps into the boat and rows furiously toward the spot where blood is burbling to the surface; Erika and the boys shovel-cut an angled ramp into the ice edge to pull up the boat when he returns. Everyone watches as Emil stops the skiff by the blood and waits, rifle at the ready, 100 feet offshore. The wounded seal has disappeared. Thwarted, Emil returns and is pulled up the ramp. Such failures don't happen very often. Last year, Emil killed a polar bear, some walrus, musk ox, a few narwhals, many seabirds and hares—and 175 seals. The family and their friends ate the meat, the dogs ate the entrails and bones, and the Madsens either sold the skins or used them themselves.

Although the miss discourages him, Emil doesn't give up. He has a speedboat in Cap Hope (these replaced indigenous kayaks long ago). When we finish the two-hour mush home, we all unpack and he heads out to try again. Erika and Belissa stay home, but the boys, Peter, and I go with him. The heart-stopping thrill caused by speeding around 50-foot-tall icebergs, which visibly extend 150 feet below the surface of the astonishingly clear-blue Arctic water, almost makes up for the 30-mph powerboat cold, which is much harsher than the 5-mph dogsled cold. A V-shaped ripple in the water draws Emil's attention. We see the ripple, but not the seal; Emil sees everything. He slows to a gentle stop then shoots the seal in the eye, killing it with one shot. Julian helps him drag the animal onto the back of the boat, its head dripping blood into the water. They head home, where Erika will butcher the seal in the morning.

FIELD NOTE

Traveling by dogsled along the remote Greenland coast was magnificent. During the last week in May, the weather was warm— just below freezing—and the daylight was constant—the sun just kissed the horizon around 2:00 a.m., then rose again.

We spent the first two days on the edge of a frozen lake below a glacier, about a five-hour run from Emil's village. After we pitched our tents at 8 p.m., we immediately trudged out onto the lake with ice-chopping poles. It took at least half an hour to hack each fishing hole through the four-foot-thick ice. Impervious to the cold, the kids scooped out the chunks with bare hands. Using a spinner and a trident hook baited with seal fat, they were catching shiny arctic char in no time. Julian, nose running faster than his little legs, pounced on the flopping fish as soon as they were yanked out of the ice hole. He delighted in hamming it up for me by delivering a dental coup de gras to each fish, chomping mightily on its head (see page 204). Around 11 p.m., we stopped by Emil's big tent for a supper of musk ox stew with pasta and then went back to fish until 2 a.m.

Emil spent the next day looking for seal, a family favorite. After a luckless, seal-less day, we dogsledded back to his village to get the powerboat, recently dug out of the winter snow. By 11 p.m., we were crossing Scoresby Sound. The almost setting sun bathed the icebergs, glaciers, and mountains with a deceptively warm golden light. Succumbing to the cold, the kids slept under some old coats in the bow while Emil cruised doggedly in and out of the jagged ice. Around 1 a.m., he spotted a seal and bagged it with a single shot.

Back home, the kids awoke in time to help drag the seal inside the house. It lay in front of the bathroom door until Erika butchered it the next day. Unfortunately, we had to sled off to catch the weekly flight out before the family ate the seal, so I never got to taste it.
— Peter

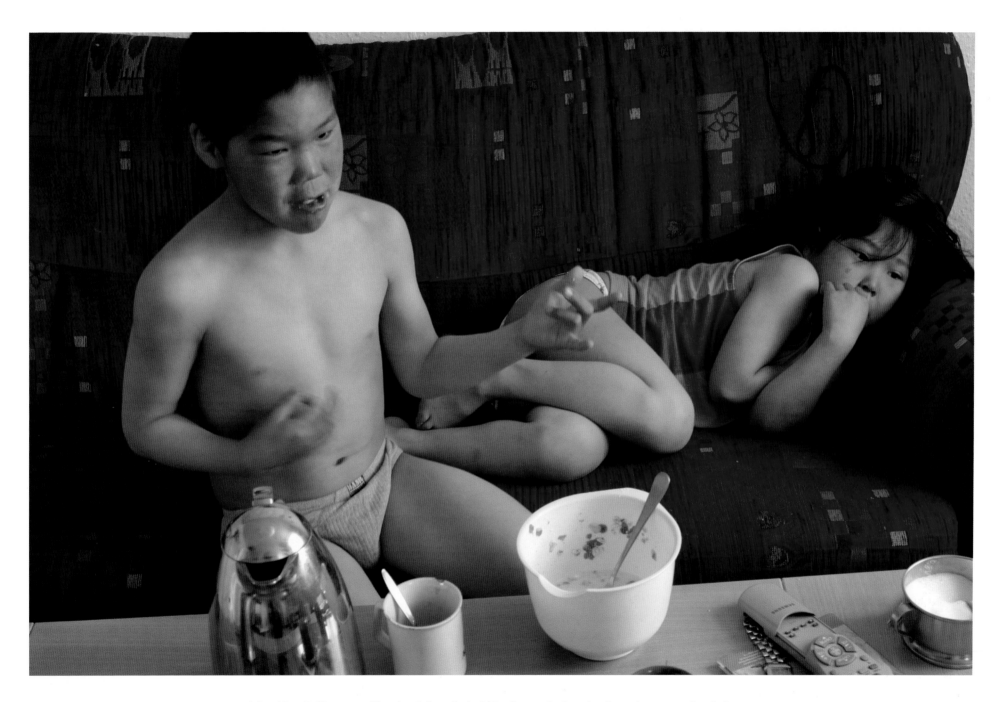

At breakfast, Emil's 10-year-old nephew Julian, who is visiting for a week, plays air guitar and eats sugar-drenched muesli while watching MTV in the Madsens' living room. Sleepily curled on the couch, his cousin Belissa ponders the antics of the rock stars while waiting for her mother to serve breakfast.

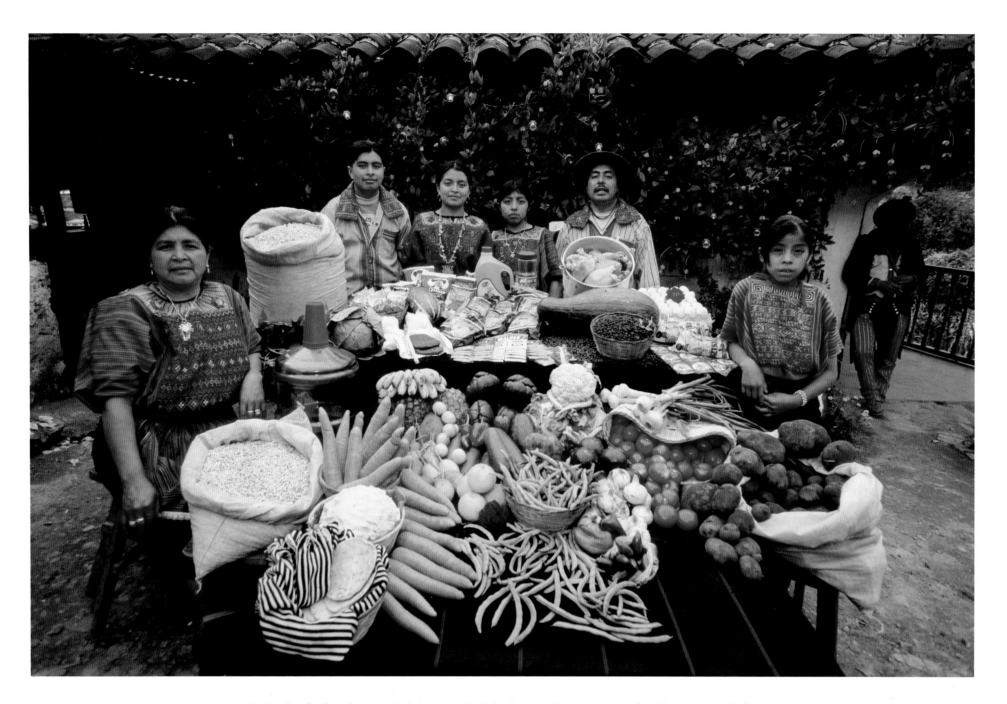

The Mendoza family and a servant in their courtyard in Todos Santos Cuchumatán, Guatemala, with a week's worth of food. Between Fortunato Pablo Mendoza, 50, and Susana Pérez Matias, 47, stand (left to right) Ignacio, 15, Cristolina, 19, and a family friend (standing in for daughter Marcelucia, 9, who ran off to play). Far right: Sandra Ramos, 11, live-in helper. Not present: Xtila, 17, and Juan, 12. Cooking methods: gas stovetop, wood stove. Food preservation: refrigerator.

Indigenous Spirits

ONE WEEK'S FOOD IN NOVEMBER

Grains & Other Starchy Foods: $11.49**

Corn (yellow and white mixed),* 48 lb; potatoes, 20 lb; masa (corn tortilla dough), 8 lb; *Inti* pasta, 4.4 lb; corn tortillas, 4 lb; *Quaker* Avena Mosh (oat breakfast cereal), 1.1 lb; rice,‡ 1 lb.

Dairy: $2.25

Milk, powdered, 14.1 oz.

Meat, Fish & Eggs: $7.93

Chickens, 4.4 lb, *two other chickens in the photograph are for the All Saints Day celebration;* eggs, 30.

Fruits, Vegetables & Nuts: $34.75

Yellow bananas, 7.4 lb; pineapples, 6.4 lb; zapote (brown-colored fruit), 5 lb; passion fruit, 3.9 lb; anona (custard apples), 3.2 lb; oranges, 2.6 lb; lemons, 2.2 lb; black beans, dried, 13.2 lb; green squash, 12 lb; tomatoes, 10 lb; carrots, 7.8 lb; avocados, 5 lb; white onions, 5 lb; cauliflower, 3 heads; green beans, 4.4 lb; cucumbers, 3.5 lb; chayote squash, 3.2 lb; green onions, 3 lb; cabbage, 1 head; red chili peppers, 1.5 lb; green chili peppers, 8.8 oz.

Condiments: $8.85

Oil, 3.2 qt; herbs, assorted, fresh, 1 bunch; white sugar, 5 oz; *Malher* black pepper, 3 oz; *Malher* garlic salt, 3 oz; *Malher* onion salt, 3 oz; *Malher* salt, 3 oz; cinnamon, 2 sticks.

Snacks: $3.96

Chocolate, hand-pressed, 1 lb; *Azteca* tortilla chips, 5 bags.

Prepared Food: $0.79

Malher chicken bouillon, 3 oz.

Beverages: $5.68

Bottled water, 5 gal, *for drinking only;* Corazon de Trigo (wheat drink), 1.1 lb; *Incasa* coffee, 8 oz.

* Homegrown; ‡ Not in Photo

Food Expenditure for One Week: 573 quetzales/$75.70

**Market value of homegrown foods, if purchased locally: $4.12

Except during holidays, most families in Todos Santos eat meat less than once a week. Three times a day they eat rice, beans, potatoes, eggs, and tortillas, in one combination or another. "We don't have fish as we live so far from the sea," says Susana. Her daughter Cristolina, 19, tells us that they don't eat candies and cakes. "If we want a postre [dessert], we have a banana," she says, her smile revealing beautifully white, cavity-free teeth. Although soft drinks are available in the village, and in fact the Mendozas sell them in their new bar, the family drinks only water, a wheat drink, and instant coffee.

The Mendozas eat fruits and vegetables when they are in season—not before or after—because local stores don't have the refrigeration and transportation necessary to stock out-of-season items. Though potatoes are plentiful in the village, when Cristolina was studying in another part of Guatemala, five hours away, she didn't eat potatoes. "The price was incredible," she exclaims, "twice the cost of potatoes here, and very small." Did she miss eating potatoes? "Oh yes," she says.

THE BRIGHTLY DECORATED CEMETERY in the remote mountain town of Todos Santos de Cuchumatán becomes brighter still as an artist from Guatemala City puts the final touches to a cross in polychromatic splendor. Around him, women sweep and scrub their family plots for the celebration of *Dia de Todos Santos*—All Saints Day. Outside the burial ground, slaughtered sheep destined for the dinner table hang from the houses, and family members get together to help with the skinning and cutting, or give advice. This weekend is a double holiday for the Todosanteros, a celebration of both All Saints the Christian holiday, and All Saints the village. Musicians with guitars and marimbas blend in with the villagers on their narrow streets, and delight the hordes of out-of-towners (mostly U.S. and European tourists) who mill about, waiting for one of the world's strangest horse-racing spectacles (p. 158). The alcohol-soaked men of the village celebrate with such astonishing fervor that without the moderating influence of the women the entire village would seem to be in danger of sloshing away. Perhaps it's lucky that this is only a once-a-year event.

On ordinary, nonfestival days, the villagers are a hard-working lot, farmers who grow corn, beans, potatoes, wheat, barley, and sugar cane; many are indigenous Maya and still speak the Maya language known as Mam. As visitors from abroad have become more common, some townspeople have launched a side business, renting rooms in their small adobe houses to students from other countries who attend the little schools that have sprung up to teach Spanish. Women teach visitors intricate backstrap weaving, and others run bars and restaurants. Fortunato Mendoza and his wife Susana engage in several of these occupations to support their six children. Fortunato, a college-educated teacher, musician, renter of rooms, and shaman, is a bit of an anomaly in this rural village; adept at navigating the wider world—he's managed to get his children into good colleges—he remains firmly rooted in his traditional culture. Quiet, unflappable Susana—the love of his life; he says—and their children take on the many jobs that arise from his projects (most recently, a new bar) and tend to the cooking and housekeeping. On any given night, Susana and Fortunato welcome the assortment of friends and relatives who invariably turn up at dinnertime for a good meal and conversations that can ramble long into the night.

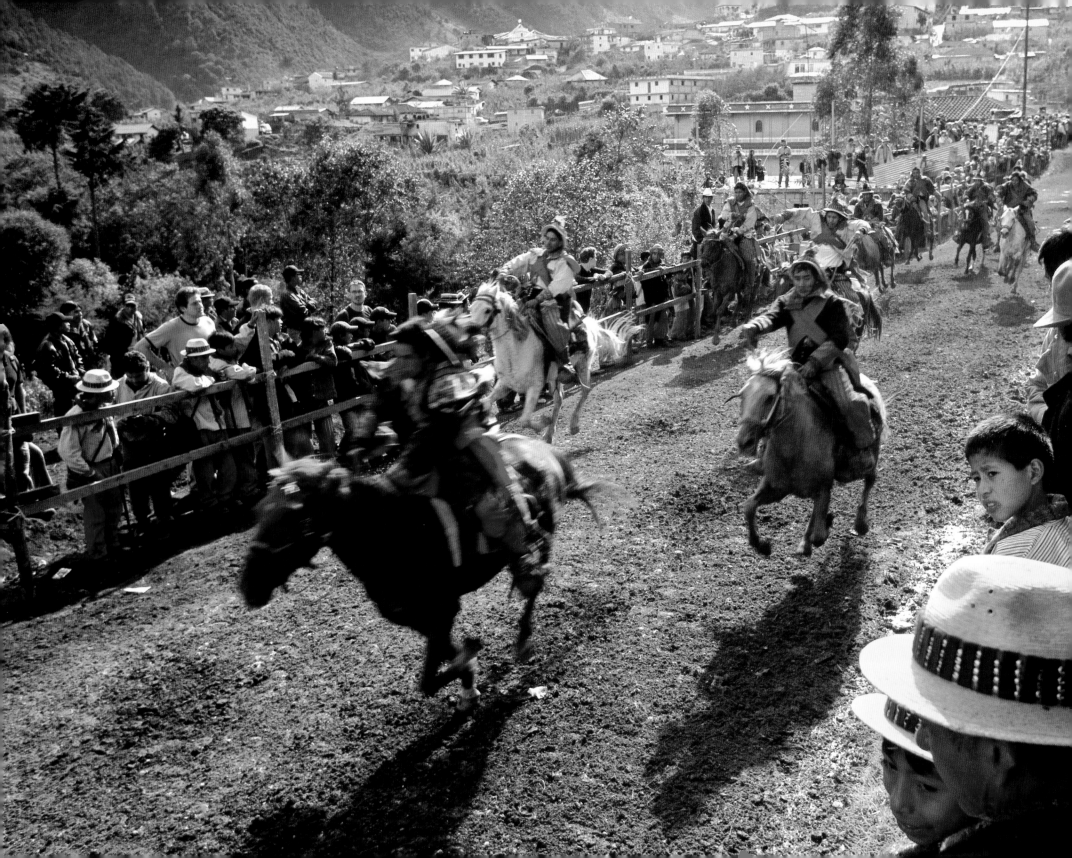

FIELD NOTE

Going to Todos Santos Cuchumatán on November 1 sounded ideal. We could see two overlapping festivals (the village's Patron Saints Day and All Saints Day) and also find a family for our food book. Alcohol consumption begins several days before the first festival proper and culminates with a dangerous drinking game. Dressed in special holiday clothing, a mob of men on horseback race back and forth down the main road into town between throngs of onlookers, stopping at each end of the course to take a pull of hard liquor before galloping at a breakneck pace to the other end *(at left)*. This exciting diversion goes on for hours as new riders enter the festivities and other riders fall off or just drunkenly give up.

After the last jockey passes by, or out *(above right)*, everyone drifts off to the town cemetery to celebrate All Saints Day. The happy throng settles in among the freshly cleaned, painted, and decorated graves for an afternoon and evening of prayer, drink, fireworks, drink, music, drink, food, drink, reminiscence, and drink.

During the festival there seems to be no stigma attached to inebriation. The alcohol-altered state is not for adults only; a surprising number of young boys stagger around, and anyone with the money to buy a drink gets served—no questions asked *(bottom right)*.

Every hostel and guesthouse in the village was full when we arrived, so we felt lucky to find a Mayan family who would rent us a wooden-slat bed in their dirt-floored house. A day later, we were fortunate enough to meet Fortunato, his wife Susana, and their five kids. Because of the village festivals, we had to squeeze our food-family portrait in on the last day. Fortunato, a well-educated, well-respected man in town, prepared himself for the festival in the same way that everybody else did: he got hammered. The next morning, he raced his horse with his friends, drinking all the while. During the photo shoot in the early afternoon, Fortunato, not having slept for several nights, and still pickled, maintained his dignity by sheer willpower, but he seemed slightly out of focus.

— *Peter*

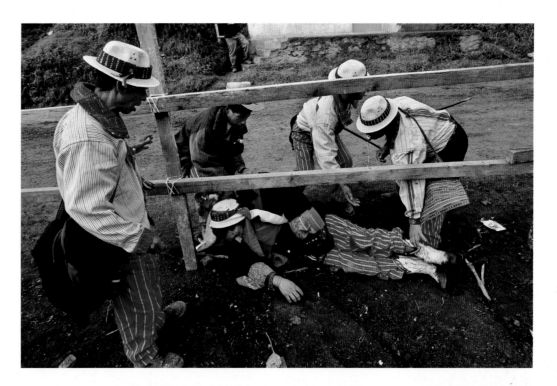

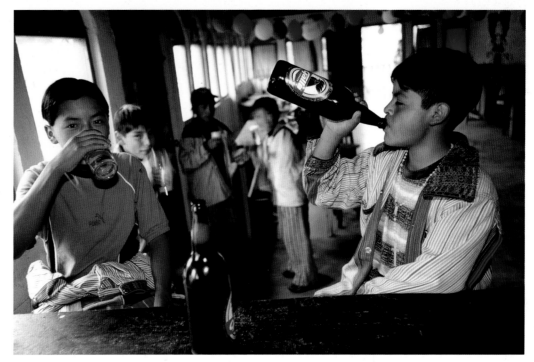

Susana Pérez Matias's Sheep Soup

3 lb mutton, with bones

5 lb potatoes, chunked

1 oz *achote* (seed from annatto tree, native to Latin America)

2 onions, sliced

1 handful (approx. 4 oz) cilantro (coriander leaves), chopped

salt

- Cut meat into medium-size pieces, rinse, and place into heavy kettle with enough water to make soup for 10 people. Add potatoes and simmer until tender.
- Soak *achote* in warm water, strain, and add to broth, along with onion and cilantro. Let boil for 6 minutes.

Turkey Stew

6 lb turkey

5 lb cornmeal

3 2-oz packets pepper, ground

4 chicken or vegetable bouillon cubes

salt

- Kill and dress a 10 lb turkey.
- Cut turkey into medium-size pieces. Rinse, and put in pot large enough to fit meat with enough water to make soup for 20 people. Simmer 2–4 hours, then remove meat.
- In separate bowl, beat cornmeal with cold water to thicken, then add cornmeal mix to broth and bring to boil. Add pepper, bouillon cubes, and salt to taste.
- Add meat back to broth. Let boil for 6 minutes.

The Mendoza kitchen *(bottom left)* is the center of family life, and his wife's cooking unlocks the key to Fortunato's heart. "I am happiest," Fortunato (at right, center) says, "when I'm eating Susana's rice and beans, her homemade tortillas, and her turkey soup."

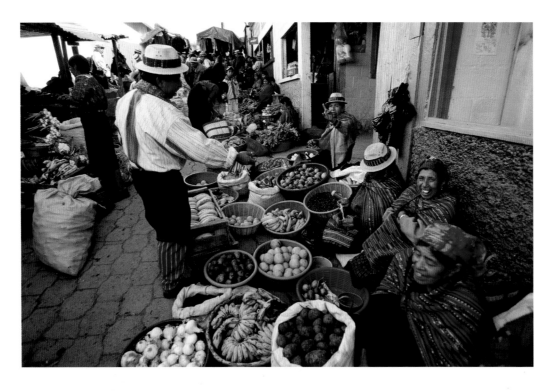

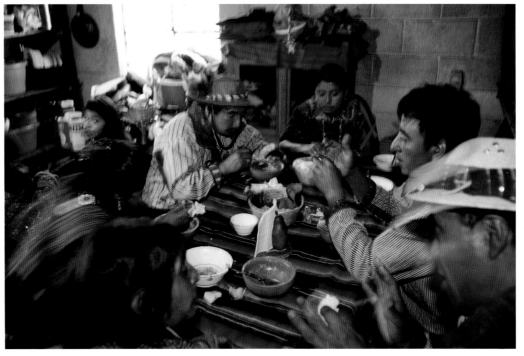

- Population: **14,280,596**
- Population of Todos Santos Cuchumatán: **26,000**
- Area in square miles: **42,032 (slightly smaller than Tennessee)**
- Indigenous population: **66%**
- Population density per square mile: **340**
- Urban population: **47%**
- Rural households with access to electricity: **56%**
- Life expectancy, male/female: **63/69 years**
- Life expectancy gap between indigenous and nonindigenous population: **−13%**
- Fertility rate (births per woman): **4.4**
- Literacy rate, male/female, 15 years and older: **78/63%**
- Caloric intake available daily per person: **2,219 calories**
- Annual alcohol consumption per person (alcohol content only): **2 quarts**
- GDP per person in PPP $ (Purchasing Power Parity: an adjustment for what equivalent local goods would cost in the U.S.): **$4,080**
- Total annual health expenditure per person in $ and as a percent of GDP: **$86/4.8**
- Overweight population, male/female: **53/61%**
- Obese population, male/female: **13/25%**
- Undernourished population: **25%**
- Population age 20 and older with diabetes: **2.7%**
- Meat consumption per person per year: **52 pounds**
- McDonald's restaurants: **38**
- Big Mac price: **$2.01**
- Cigarette consumption per person per year: **609**
- Population living on less than $2 a day: **37%**

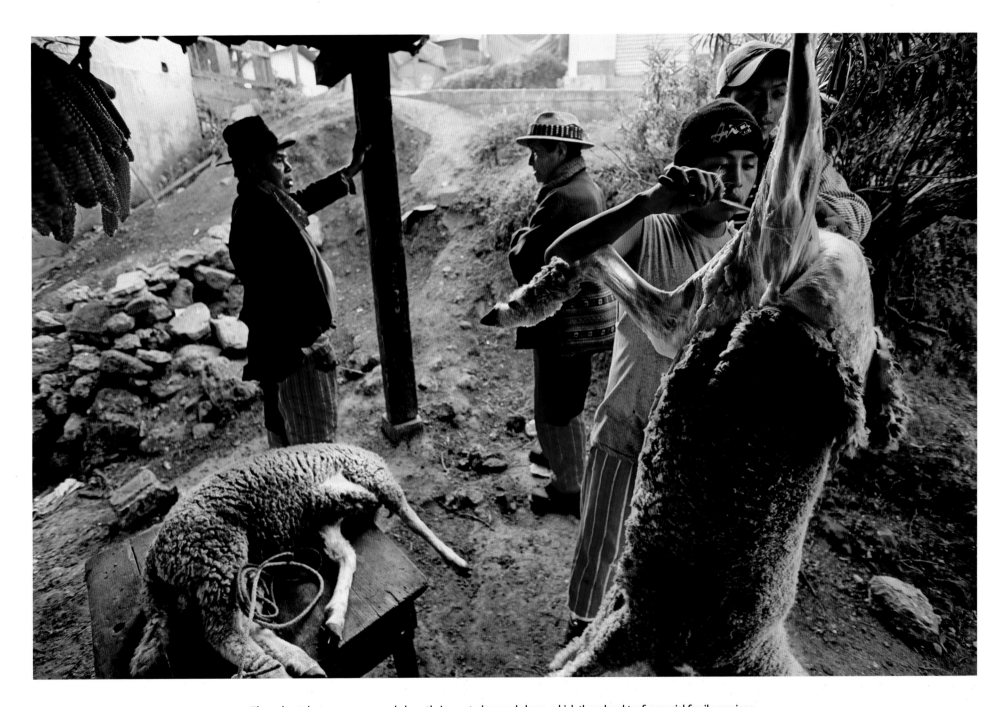

Throughout the town, many people have their own turkeys and sheep, which they slaughter for special family reunions during festival days *(above)*. Especially busy during the days before the holidays, the village market *(above left)* spills out of the big, concrete municipal market and extends down side streets. The Mendoza household gathers with relatives on Sunday in their spacious kitchen for a traditional Mesoamerican meal of turkey soup *(photo and recipe at bottom left)*.

Food with a Face

THERE'S A SCHIZOID QUALITY to our relationship with animals, in which sentiment and brutality exist side by side. Half the dogs in America will receive Christmas presents this year, yet few of us pause to consider the miserable life of the pig—an animal easily as intelligent as a dog—that becomes the Christmas ham.

We tolerate this disconnect because the life of the pig has moved out of view. When's the last time you saw a pig? Except for our pets, real animals—animals living and dying—no longer figure in our everyday lives. Meat comes from the grocery store, where it is cut and packaged to look as little like parts of animals as possible. The disappearance of animals from our lives has opened a space in which there's no reality check, on either the sentiment or the brutality.

Several years ago, the English critic John Berger wrote an essay, "Why Look at Animals?" in which he suggested that the loss of everyday contact between humans and animals—and specifically the loss of eye contact—has left us deeply confused about the terms of our relationship to other species. That eye contact, always slightly uncanny, had provided a vivid daily reminder that animals were at once crucially like and unlike us; in their eyes we glimpsed something unmistakably familiar (pain, fear, tenderness) and something irretrievably alien. Upon this paradox people built a relationship that allowed them to both honor and eat animals without looking away. But that accommodation has pretty much broken down; nowadays, it seems, we either look away or become vegetarians.

Which brings us—reluctantly, necessarily—to the American factory farm, the place where all such distinctions turn to dust. These are places where the subtleties of moral philosophy and animal cognition mean less than nothing, where everything we've learned about animals at least since Darwin has simply been . . . set aside. To visit a modern CAFO (Confined Animal Feeding Operation) is to enter a world that, for all its technological sophistication, is still designed according to Descartes' belief that animals are machines incapable of feeling pain. Since no thinking person can possibly believe this any more, industrial animal agriculture depends on a suspension of disbelief on the part of the people who operate the system and a willingness to avert their eyes on the part of everyone else.

Piglets in confinement operations are weaned from their mothers ten days after birth (compared with 13 weeks in nature) because they gain weight faster on their hormone- and antibiotic-fortified feed. This premature weaning leaves the pigs with a lifelong craving to suck and chew, a desire they gratify in confinement by biting the tail of the animal in front of them. A normal pig would fight off his molester, but a demoralized pig has stopped caring. "Learned helplessness" is the psychological term, and it's not uncommon in confinement operations, where tens of thousands of hogs spend their entire lives ignorant of sunshine or earth or straw, crowded together beneath a metal roof upon metal slats suspended over a manure pit. So it's not surprising that an animal as sensitive and intelligent as a pig would get depressed, and a depressed pig will allow its tail to be chewed on to the point of infection. The U.S.D.A.'s recommended solution to the problem is called "tail docking." Using a pair of pliers (and no anesthetic), most, but not all, of the tail is snipped off. Why the little stump? Because the whole point of the exercise is not to remove the object of tail biting so much as to render it more sensitive. Now, a bite on the tail is so painful that even the most demoralized pig will mount a struggle to avoid it.

More than any other institution, the American industrial animal farm offers a nightmarish glimpse of what Capitalism can look like in

the absence of moral or regulatory constraint. Here, in these places, life itself is redefined—as protein production—and with it suffering. That venerable word becomes "stress," an economic problem in search of a cost-effective solution, like tail docking.

But before you swear off meat entirely, let me describe a very different sort of animal farm. Polyface Farm occupies 550 acres of rolling grassland and forest in the Shenandoah Valley of Virginia. Here, Joel Salatin and his family raise six different food animals—cattle, pigs, chickens, rabbits, turkeys, and sheep—in an intricate dance of symbiosis designed to allow each species, in Salatin's words, "to fully express its physiological distinctiveness."

What this means in practice is that Salatin's chickens live like chickens; his cows, like cows; pigs, pigs. To many animal rightists, even Polyface Farm is a death camp. But to look at these animals is to see this for the sentimental conceit it is. In the same way that we can probably recognize animal suffering when we see it, animal happiness is unmistakable, too, and during my visit to Polyface Farm I saw it in abundance.

Salatin slaughters his chickens and rabbits right on the farm, and would do the cattle, pigs, and sheep there too if only the U.S.D.A. would let him. He showed me the open-air abattoir he built behind the farmhouse—a sort of outdoor kitchen on a concrete slab, with stainless-steel sinks, scalding tanks, a feather-plucking machine, and metal cones to hold the birds upside down while they're being bled. Processing chickens is not a pleasant job, but Salatin insists on doing it himself because he's convinced he can do it more humanely and cleanly than any processing plant. He slaughters every other Saturday throughout the summer. Anyone's welcome to watch.

On Salatin's farm, the eye contact between people and animals whose loss John Berger mourned is still a fact of life—and of death, for neither the lives nor the deaths of these animals have been secreted behind steel walls. "Food with a face," Salatin likes to call what he's selling, a slogan that probably scares off some customers. People see very different things when they look into the eyes of a pig or a chicken or a steer—a being without a soul, a "subject of a life" entitled to rights, a link in a food chain, a vessel for pain and pleasure, a tasty lunch.

Salatin's open-air abattoir is a morally powerful idea. Someone slaughtering a chicken in a place where he can be watched is apt to do it scrupulously, with consideration for the animal as well as for the eater. This is going to sound quixotic, but maybe all we need to do to redeem industrial animal agriculture in this country is to pass a law requiring that the steel and concrete walls of the CAFOs and slaughterhouses be replaced with . . . glass. If there's any new "right" we need to establish, maybe it's this one: the right to look.

The industrialization—and dehumanization—of American animal farming is a relatively new, evitable, and local phenomenon: no other country raises and slaughters its food animals quite as intensively or as brutally as we do. Were the walls of our meat industry to become transparent, literally or even figuratively, we would not long continue to do it this way. Practices like tail docking would disappear overnight, and the days of slaughtering 400 head of cattle an hour would come to an end. For who could stand the sight? Yes, meat would get more expensive. We'd probably eat less of it, too, but maybe when we did eat animals, we'd eat them with the consciousness, ceremony, and respect they deserve.

—excerpted from "An Animal's Place,"
New York Times Magazine, *November 2002 © Michael Pollan 2005*

Michael Pollan teaches journalism at UC Berkeley. His books include Second Nature, A Place of My Own, *and the* New York Times *best seller* The Botany of Desire. *His next book, on the ecology and ethics of eating, is due in 2006.*

"Meat comes from the grocery store, where it is cut and packaged to look as little like parts of animals as possible. The disappearance of animals from our lives has opened a space in which there's no reality check, on either the sentiment or the brutality."

LAMB, WOOLWORTH'S SUPERMARKET • BRISBANE, AUSTRALIA

DUCKS, QINGPING MARKET • GUANGZHOU, CHINA

PORK, DIVISORIA MARKET • MANILA, PHILIPPINES

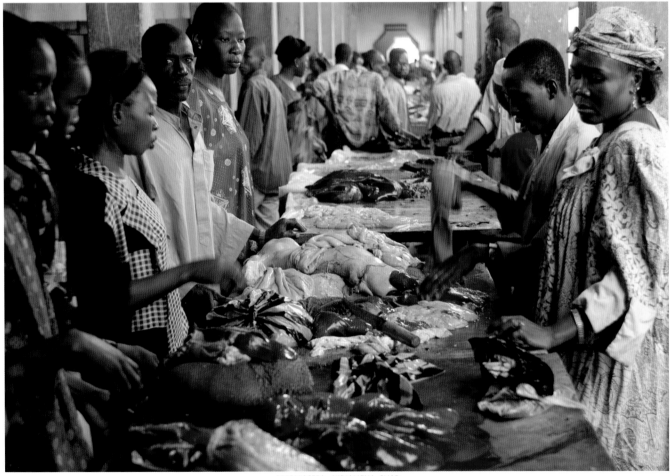

BEEF VISCERA • N'DJAMENA, CHAD

SEAL • CAP HOPE, GREENLAND

PIG PARTS, LARD, MUNICIPAL MARKET • CUERNAVACA, MEXICO

PIG TRANSPORT • BALIEM VALLEY, PAPUA

SHEEP, ZUMBAGUA MARKET SLAUGHTERHOUSE • ZUMBAGUA, ECUADOR

Meat

Although meat in the United States and Europe mainly comes from factory farms and is sold in shrink-wrapped packages, most animal products elsewhere—as these photographs demonstrate—come from small-scale producers and are sold by butchers. As Michael Pollan argues in his accompanying essay, the change to mechanized production has become increasingly controversial. Industrial-scale slaughter reduces costs, but critics charge that it vitiates hunters' time-honored duty to respect their animal prey.

BEEF, MUNICIPAL MARKET • TODOS SANTOS, GUATEMALA

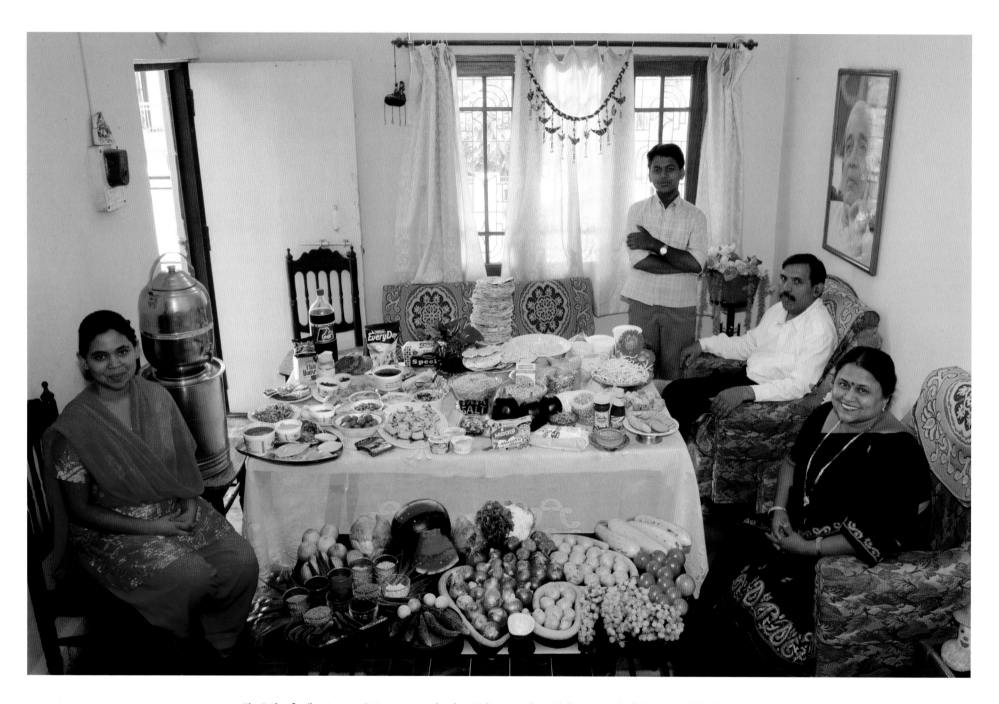

The Patkar family—Jayant, 48, Sangeeta, 42, daughter Neha, 19, and son Akshay, 15—in the living room of their home in Ujjain, Madhya Pradesh, India, with one week's worth of food. Cooking method: gas stove. Food preservation: refrigerator-freezer.

Poha Breakfast

Hindus believe that long ago, during a fierce struggle between gods and demons, four droplets fell to the earth from a pot brimming with the nectar of immortality. Those four drops are said to have been absorbed into the sacred rivers in the cities of Allahabad, Hardwar, Nasik, and Ujjain. Millions of pilgrims, sadhus, and yogis flock to one of these four cities every three years, in a 12-year cycle determined by the celestial clock. Kumbh Mela—the Festival of the Pot of Immortality.

I N HONOR OF THE KUMBH MELA half of the Patkars are on a monthlong break from work and school in their city of Ujjain, in the central Indian state of Madhya Pradesh. But for Jayant Patkar, this is no break. He's a public-works engineer with the city's water department, and the strain on Ujjain's water supply during this time is unparalleled. Many of the millions of Hindu pilgrims who come to the city during the *mela* (festival) stay for the entire month. Jayant's wife Sangeeta, the principal of Oxford Junior College, is having a more relaxing time, as is their 15-year-old son Akshay. Their daughter Neha, 19, has time off from her studies but is cramming for the entrance exam to medical school. She'll race off on her scooter for a tutoring session right after her mother finishes cooking breakfast.

Sangeeta heats a thin film of vegetable oil in a frying pan, then adds mustard seed. When it sizzles, she tosses in thinly sliced potatoes, onions, and chopped chili peppers and stir-fries them until the onions are golden yellow. Previously she has drained a pot of soaking *poha*—rice flakes—and set it aside to rest. Now she adds the *poha* to the frying pan, along with a little sugar and salt, and a pinch of turmeric for color. After stir-frying the mixture a bit more, she covers it and puts the *poha* on the table with condiments—chopped cilantro with grated coconut, and the crisp chickpea-flour noodles called *sev*. The Patkar family's breakfast is ready.

Everyone sits down to breakfast under a poster-size print of the Patkars' spiritual leader, Shri Parthasarathi Rajagopalachari. Sangeeta serves the *poha*, topping each mound of fluffy vegetables and rice with the coconut and cilantro, and sprinkles on the *sev*. Meat is never served at their table. Like most Hindus, they are vegetarians, although the parameters of vegetarianism are wide. "We are not as strict as in my father's house," says

ONE WEEK'S FOOD IN APRIL

Grains & Other Starchy Foods: $5.35
Chapatis (flat bread), 13.2 lb; wheat flour, 8.8 lb; potatoes, 3.3 lb; white rice, 3.3 lb; poha (flattened white rice), 2.2 lb; *Modern* Special white bread, sliced, 1 loaf; porridge, 1.1 lb; chickpea flour, 1.1 lb.

Dairy: $9.70
Milk,‡ 1.9 gal; yogurt curds, 4.4 lb; *Nestlé* Everyday Dairy Whitener milk powder, 1.1 lb; ice cream, assorted flavors, 15.9 oz; ghee (clarified butter), 8.8 oz.

Meat, Fish & Eggs:
The family is of the Brahmin caste, and does not eat either meat or fish.

Fruits, Vegetables & Nuts: $7.73
Watermelon, 6.6 lb; oranges, 4.4 lb; green grapes, 2.2 lb; limes, 12.8 oz; coconut, one-half; red onions, 5.5 lb; gourd, 3.3 lb; bitter gourd, 2.2 lb; cabbage, 2 heads; cauliflower, 1 head; tomatoes, 2.2 lb; yellow lentils, 2.2 lb; eggplant, 1.7 lb; chickpeas, 1.1 lb; cucumber, 1.1 lb; green lentils, 1.1 lb; okra (also called lady fingers), 1.1 lb; red beans, 1.1 lb; black-eyed beans, 8.8 oz; coriander, 8.8 oz; green bell pepper, 8.8 oz; green chili peppers, 3.5 oz; ground nuts, 1.1 lb.

Condiments: $4.47
Soybean oil, 1.1 qt; salt, 1.1 lb; *Nilon's* pickles, 8.8 oz; white sugar, 8.8 oz; *Maggi* tomato ketchup, 7.1 oz; cumin seed, 3.5 oz; fenugreek seeds, 3.5 oz; mint, 3.5 oz; mustard seed, 3.5 oz; black pepper, 1.8 oz; garlic chutney, 1.8 oz; mango, dried and powdered, 1.8 oz; parsley, 1.8 oz; red chili powder, 1.8 oz; aniseed, 0.9 oz; turmeric powder, 0.9 oz; asafetida (powdered gum resin), 0.4 oz; cloves, 0.4 oz.

Snacks & Desserts: $2.33
Gulab jamoon (deep-fried dumplings), 1.1 lb, *served soaked in cardamom-flavored syrup*; upma rawa (savory semolina dish), 1.1 lb; papad (thin, crisp, sun-dried wafers of dal flour) 8.8 oz, eaten as a snack or served sprinkled on soup; biscuits, 3.5 oz; corn-flour crackers, 3.5 oz; extruded noodle, 3.5 oz; rice-flour crackers, 1.8 oz; wheat-starch crackers, 1.8 oz.

Prepared Food: $1.94
Khaman (sweet, steam-baked chickpea cakes), 1.1 lb; *Maggi* 2-minute noodles, 7 oz; *Everest* chhole masala (chickpea masala), 3.3 oz; poori (fried wheat-flour flat breads), 3 pieces.

Street Food: $3.07
Chhole bhature (spicy chickpea curry with flat bread); idli (steamed rice cakes); pav bhaji (bread rolls with spicy mashed vegetables); pizza, 1 small; uttapam (thick and crispy flat bread made with coconut milk), *served with spicy vegetables*; dosa, (crispy savory pancake), 5, *served with chutney or other spicy relishes*; bhel poori (savory puffed rice with chutney); tomato, cucumber, and onion sandwich, 1 small.

Restaurants: $2.88
Shree Ganga Restaurant: dinner for four, including Malai kofta (mashed potato dumplings in vegetable gravy); navratan korma (fruits and vegetables cooked in a creamy sauce and flavored with herbs, spices, and cashews); jeera fried rice (fried with cumin seeds); tandoori roti (flat bread), *cooked in a tandoor, or clay oven*; fried dahl (lentil-flour flat bread); papad; green salad; pickles; dessert.

Beverages: $1.80
Thumbs Up cola, 2.1 qt; *Godrej* chai house tea, 5.3 oz; *Nescafe* Sunrise instant coffee, 0.5 oz; well water, for drinking and cooking.

‡ Not in Photo

Food Expenditure for One Week:
1,636.25 rupees/$39.27

Sangeeta, whose family is of the Brahmin caste—the social class associated with priests and scholars. Fifteen-year-old Akshay is an unlikely vegetarian. He doesn't like many vegetables, especially the gourds and squashes common in India, but because his family eats this way, he does as well. He has eaten chicken, he admits, and likes it.

Dietary restrictions notwithstanding, what all of India loves is a snack—the nation has thousands of street vendors. *Chhole bhature* (spicy chickpea curry with flat bread), steamed rice cakes, *pav bhaji* (spicy mashed vegetables in a bread roll), *uttapam* (thick and crispy flat bread made with coconut milk) with spicy vegetables, *dosa* (a crisp savory pancake) with chutney or other spicy relishes, *bhel poori* (savory puffed rice with chutney), curries of all types, *lassi* yogurt drinks), fruit juices, and, of course, chai (Indian tea). Although every region of this vast, ancient country has its own unique foods, to some extent the lines dividing the regions have become smudged due to India's increasingly mobile society. The Patkars themselves have relocated a few times to accommodate Jayant's career.

Kumbh Mela
This spiritual festival transforms the four sacred cities into celebration sites without equal. Millions of Hindu pilgrims come to commune with swamis, gurus, and yogis, offer prayers to Lord Shiva, and take a spiritually cleansing dip or two, called a *snan*, in Ujjain's sacred Shipra River. Tent encampments housing the pilgrims and the holy stretch for miles, and ashrams (spiritual communities) feed the thousands of pilgrims who arrive at their compounds every day during this month. The local government is stretched to the breaking point, but manages to create an instant city that works, generally. Hordes of people of all ages shuffle shoulder-to-shoulder along both banks of the river, on the ghats (steps leading into the water), and across the bridges spanning the river, at all hours of the day and night. The Patkars too will visit the Shipra several times during the month, and join the other pilgrims for a *snan*.

There are as many different sects and branches of Hinduism as there are leaves on a tree, and all are here on parade. Hinduism en-

compasses many movements and schools and is largely inclusive; its followers keep the basic tenets of Hinduisim, then cherry-pick from the various schools of thought to create a personalized version of belief. The most successful of these gain followers.

Ascetic holy men emerge from their solitude and meditation. Some—the sadhus—wear saffron-colored dhotis (long loin cloths). They have given up everything in the material world in the pursuit of enlightenment and are revered throughout the country. Other sadhus, called *nagas* (the naked), a more bellicose group, are virtually naked and cover themselves with a thin film of ash. The scent of hashish permeates the tented areas of the holy. A *naga* in a contorted pose loses his balance and rolls down a little hill. Nobody laughs. In fact, nobody seems to notice. Some of these holy men either claim, or are said by others to have, special qualities or capabilities, such as consuming no sustenance other than milk in the last 50 years.

Without the programs undertaken by local ashrams to feed the pilgrims, many would go hungry. Many of the city's ashrams may feed 3,000 people a day throughout the month. Well-to-do followers in audience with the guru of the ashram give donations that help pay for the meals. All manner of sadhus, gurus, and yogis ride in the royal parade on decorated pickups, tractors, and painted elephants, and smile at the throngs of people jamming the sides of the road to see them.

From above, the riversides look like slashes of color, slowly moving from the ghats, to the encampments, to the ashrams. The water too is a mass of color during the tightly scheduled bathing periods. On one of the main bathing days—*shahi snan* (royal dip)—we see a man being guided in purification by his own personal guru as another man nearby performs his own simple ministrations. The water is a great equalizer.

With the police in boats caterwauling commands over portable microphones to the bathers on the ghats, safety officials in towers blowing whistles and issuing commands, music blaring from loudspeakers, and ascetics parading, the effect is cacophonous, and incredible—like daily life in India, with the volume turned up a notch.

The Shipra River flows through the holy city of Ujjain, in the central Indian state of Madhya Pradesh. Every 12 years, millions of devout Hindus celebrate the month-long festival of Kumbh Mela by bathing in the Shipra's holy waters. Hundreds of ashrams set up dusty, sprawling camps that stretch for miles. Under the watchful eye of police and lifeguards, the Patkars join the faithful throng in the cool of the evening and bathe in the river, too.

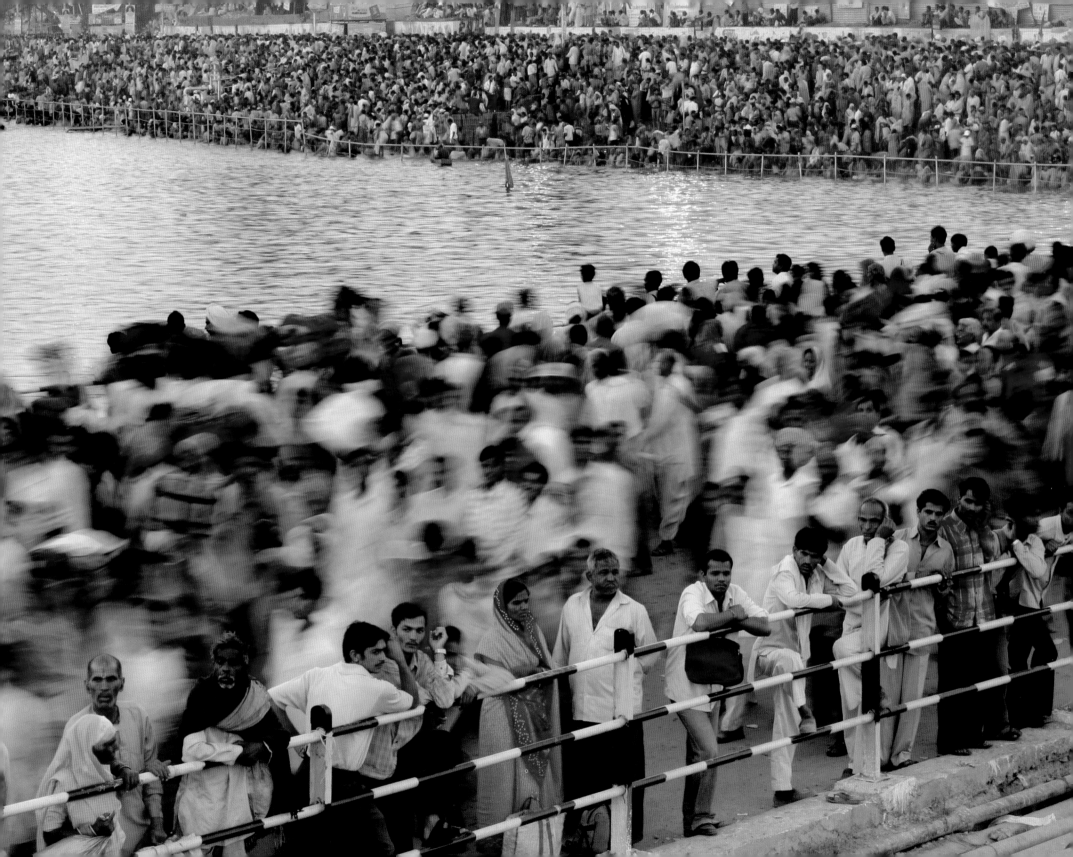

All my senses are usually maxed out while I'm working in India—I love the country for its intensity. With a population of more than a billion, perhaps 40 percent of whom are terribly poor, India does have huge problems. Yet it also has a rapidly growing middle class, 300 million strong, among them Sangeeta and Jayant Patkar.

Sangeeta keeps their small cement house and tiny yard spotlessly clean, a difficult task in a climate that alternates between hot and dry (perfect for dust) and hot and humid (perfect for mold). Their maid—in India, most middle-class families have a servant—is constantly scrubbing pots and pans in the little cleaning area outside. And they have an indoor toilet, also kept clean.

This last point is more important and unusual than it may sound. When I first visited India 20 years ago, toilets were literally few and far between. Even today, nearly three-quarters of the populace have no access to one. Of India's towns and villages, maybe one in ten has a fully functioning sewage system. Most people have to relieve themselves in the open or use communal toilets, which are usually little more than cesspools.

The entirely predictable result is a raft of diseases. With all those people defecating in the open, the amount of fecal matter in the air and water is staggering. So are the bacterial and viral counts. (Whenever I go to India, I always catch something from breathing the air.) India and Indians are impatient to join the developed world. The proliferation of cell phones, color TVs, and personal computers there is amazing. But the country will only truly enter the ranks of the prosperous and healthy nations when it emulates the Patkars, and there are toilets in every home.
— *Peter*

The Patkars shop for vegetables and fruit at Ujjain's sprawling main market *(above right, buying okra and tomatoes)*. **For treats, they frequent a downtown shop** *(bottom right)* **that makes** *khova* **(partially caramelized condensed milk), a key ingredient in Indian sweets.**

- Population: **1,065,070,607**
- Population of Ujjain: **430,669**
- Area in square miles: **1,269,010 (slightly more than one-third the size of the US)**
- Population density per square mile: **839**
- Urban population: **28%**
- Life expectancy, male/female: **60/62 years**
- Fertility rate (births per woman): **3**
- Literacy rate, male/female, 15 years and older: **70/48%**
- Caloric intake available daily per person: **2,459 calories**
- Annual alcohol consumption per person (alcohol content only): **1 quart**
- GDP per person in PPP $ (Purchasing Power Parity: an adjustment for what equivalent local goods would cost in the U.S.): **$2,670**
- Total annual health expenditure per person in $ and as a percent of GDP: **$24/5.1**
- Physicians per 100,000 population: **51**
- Overweight population, male/female: **15/14**
- Obese population, male/female: **0.9/1.1**
- Meat consumption per person per year: **11 pounds**
- McDonald's restaurants: **46**
- Big Mac (Chicken Maharaja Mac) price: **$1.12**
- Percent of beef in a Big Mac in India: **0**
- Number of vegetarian Pizza Huts in the world and in India: **1/1**
- Cigarette consumption per person per year: **129**
- Population living on less than $2 a day: **80%**
- Undernourished population: **21%**
- Population with access to safe sanitation: **28%**
- Number of nuclear weapons tests India conducted in 1998: **5**
- Number of people in India killed by the Indian Ocean tsunami in 2004: **11,000**

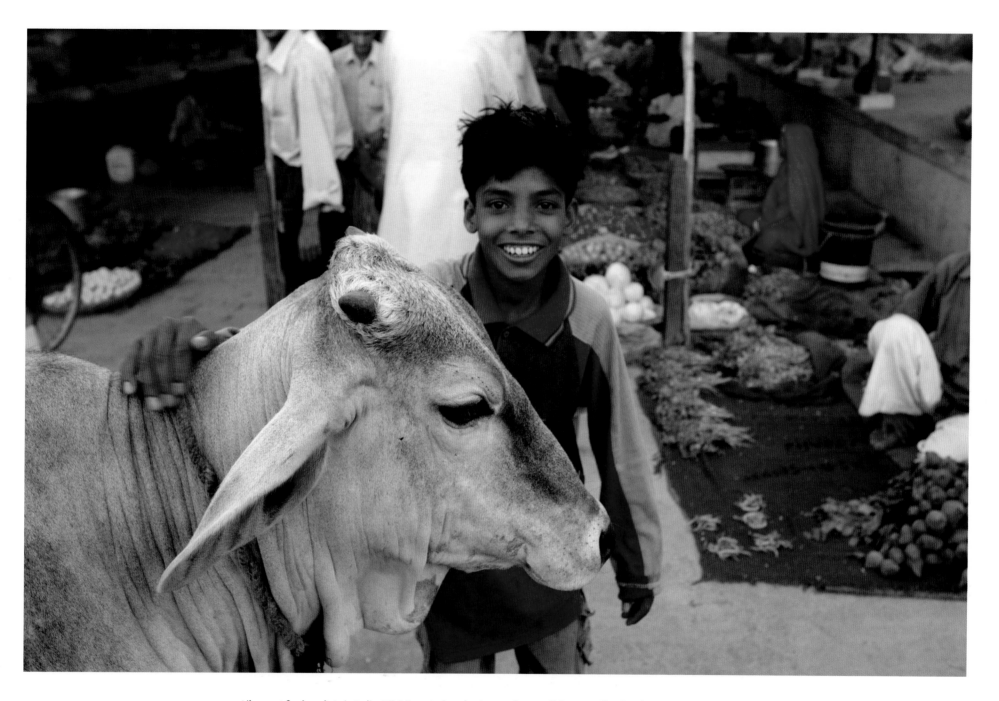

Like most food markets in India, Ujjain's central market is a maelstrom of shoppers elbowing their way around hundreds of vendors sitting on tarpaulins with piles of produce. Cows, revered by Hindus, wander with them, though salespeople and shoppers alike push them out of the way if they get too inquisitive. The Patkars, habituated to the tumult, move with the crowd, calmly picking out what they need.

Sangeeta Patkar's *Poha* (Rice Flakes)

1 lb *poha* (rice flakes—roasted and polished rice that has been beaten into thin flakes)

1 T vegetable oil

1 t mustard seed

2 large onions, sliced thin

1 large potato, sliced

3 large green chilies, chopped

1 t sugar

1 pinch turmeric powder

salt

5–6 stalks cilantro, chopped

1/2 lb *sev* (crispy chickpea-flour noodles)

2 oz coconut, grated

- Soak *poha* in a wide-mouthed container, then drain and let sit for 5 minutes.
- As *poha* rests, heat oil in large frying pan. When hot, add mustard seed. After it begins to sizzle, add onion, potato, and chilies to pan. Sauté this mixture, stirring occasionally, until it becomes golden yellow.
- Add soaked *poha,* sugar, turmeric powder, and salt to taste. Stir-fry for 2 minutes, then cover pan and remove from heat.
- To serve, boil water in a large open-mouthed container and put covered pan on top, like a double boiler, to keep it warm.
- Serve and garnish each plate with cilantro, *sev,* and coconut.

Sangeeta prepares a breakfast of *poha* (rice flakes, see recipe above) in her small, carefully organized kitchen *(at right)*. An hour later, the family has consumed breakfast, and Sangeeta's kitchen helper *(at left)* is outside the kitchen door, sweeping and rinsing the alley beside the house after washing the breakfast dishes.

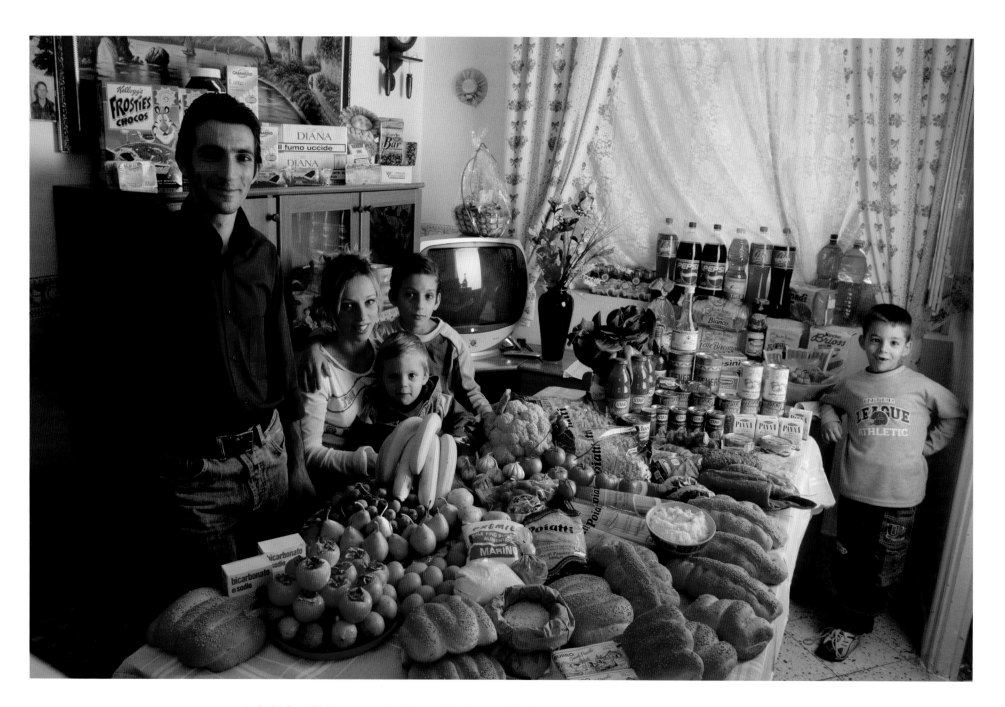

In the kitchen of their apartment in Palermo, Sicily, the Manzo family—Giuseppe, 31, Piera Marretta, 30, and their sons (left to right) Maurizio, 2, Pietro, 9, and Domenico, 7—stand and sit around a week's worth of food. Cooking methods: gas stove, microwave. Food preservation: refrigerator-freezer. Favorite foods—Giuseppe (who is a fishmonger): fish. Piera and Domenico: pasta with *ragú* (meat sauce). Pietro: hot dogs. Maurizio: frozen fish sticks.

Fish Tales

The finned fruits of the sea are a popular repast for many Sicilians but found infrequently on the Manzos' dinner table. Although Piera's husband is a fishmonger, the seafood dinners at her house lean more toward frozen fish sticks than fresh tuna.

GIUSEPPE MANZO'S WEEKDAY MORNINGS begin in a third-floor apartment above the street in which his father worked as an ice vendor, in Palermo's Capo Market. He smokes his first cigarette and drinks a coffee as his wife, Piera Marretta, and their three boys begin to wake up. From his apartment window he can see the fish and seafood shop where he works, and when his bosses' truckload of fish arrives, he heads downstairs. Competitors' trucks rumble in and the rush is on to set up open-air displays and tables before the customers come. Fruit and vegetable sellers, butchers, grocers, tobacconists, fishmongers, and bakers are open for business here every day but Sunday. Some mornings, Giuseppe makes the early run to the dock to choose from among the day's catch, but today he's shoveling crushed ice into bins, wetting down tables full of cod, grouper, and *pesce azzurro*—the collective name for sardines, anchovies, and mackerel—and scooping freshly made calamari salad into containers. The fish shop, tucked into the ground floor of an old Catholic church that still holds Mass, is sparkling clean and decorated with hand-painted tiles. From its depths, Giuseppe and another fishmonger haul a giant weighing scale into the street, along with cutting and wrapping tables and sharp knives. A man-size swordfish is sliced up and positioned with sword pointed skyward for maximum visual effect.

As Giuseppe begins his workday, the school day, too, is beginning in the upstairs apartment, with Kelloggs Frosties Chocos and milk for Pietro, 9, and Domenico, 7. Piera tells the boys she will bring lunch—*pasta al forno* (oven-baked pasta)—to them at school today. With 2-year-old Maurizio perched on one hip, and a cigarette perched between two fingers that is alternately puffed on and cocked toward the window as she talks, Piera calls to mind those smoldering Italian actresses of the '60s.

The boys strap on their heavy backpacks, kiss their mother good-bye, and race to the fish store to ask Giuseppe for their daily snack money, three euros ($3.90 USD) to share. Money secured, they race to a nearby shop for candy and juice-boxes. The boys tuck the purchases

ONE WEEK'S FOOD IN OCTOBER

Grains & Other Starchy Foods: $25.97

Poiatti spaghetti, rotini, orzo, margherite, macaroni, 17.6 lb; bread, 4.4 lb; bread crumbs, 2.2 lb; white potatoes, 2.2 lb; *Kellogg's* Frosties Chocos cereal, 1.7 lb; *Mulino Bianco* fette biscottate, 1 loaf; *Mulino Bianco* white bread, sliced, 1 loaf; white flour, 1.1 lb.

Dairy: $18.38

Granarolo whole milk, 1.1 gal; *Da Cucina* cooking cream, 1.8 lb; *Galbi* yogurts, 1.7 lb; *Grandi Pascoli* butter, 1.1 lb; parmesan cheese, grated, 7.1 oz.

Meat, Fish & Eggs: $36.64

Fish sticks, frozen, 2.2 lb, *sometimes they get a fresh fish or a fresh seafood salad from the owner of Guiseppe's business, but not often. The last fishmonger he worked for let him take one fish home almost every day;* eggs, 12; beef, 1.1 lb; beef, ground, 1.1 lb; sausage, 1.1 lb; veal involtini (meat rolls), 1.1 lb; clams, 12 oz; tuna, 11.3 oz; wurstel (German hot dog), 10.6 oz; ham & cheese, sliced, 3.5 oz; anchovies, 2.8 oz.

Fruits, Vegetables & Nuts: $25.12

Red grapes, 2.8 lb; yellow bananas, 2.2 lb; lemons, 2.2 lb; pears, 2.2 lb; persimmons, 2.2 lb; *Vitale* crushed tomatoes, canned, 5.3 lb; *Star* tomato sauce, bottled, 4.6 lb; broccoflower (hybrid of broccoli and cauliflower), 1 head; chard, 2.2 lb; peas, frozen, 2.2 lb; tomatoes, 2.2 lb; *Comal* olives, 1.1 lb; corn, canned, 11.5 oz; garlic, 8.8 oz.

Condiments: $18.70

Tevere vegetable oil, 2.1 qt; olive oil, 1.1 qt; white wine, 1.1 qt, *used only for cooking; Bonanno* white vinegar, 16.9 fl oz;

mayonnaise, 16.9 fl oz; cherry jam, 14.1 oz; pine nuts and raisins, 10.6 oz; *Italia* white sugar, 8.8 oz; salt, 8.8 oz; tomato paste, 1 4.6-oz tube; bicarbonate of soda (baking soda), 3.5 oz; pepper, 1.8 oz.

Snacks & Desserts: $38.83

Kinder milk chocolate, 3.1 lb; biscotti, 2.2 lbs; *Nutella* chocolate spread, 1.7 lb; *Kinder* paradiso chocolate, 1 lb; *Buondì* (packaged cream cakes), 13 oz; baby biscuits, 12.7 oz; *Kinder Brioss* (packaged cream cakes), 10.6 oz; *Mulino Bianco* flauti (packaged cream cakes with chocolate), 9.3 oz; *Pavesini* biscuits, 7.1 oz; candies, assorted, 3.5 oz.

Prepared Food: $22.33

Star Gran ragú sauce, 1.6 lb; *Star* vegetable bouillon cubes, 7.8 oz; school lunch, lasagna or pasta and juice, *6 days for two children.*

Beverages: $13.47

Pepsi, 2 1.1-qt bottles; ginger soda, 1.6 qt; peach juice, 12 4.2-fl-oz mini bottles; *San Benedetto* iced tea, 1.6 qt; *Spuma* (light cola drink), 1.6 qt; *Top* cola, 1.6 qt; *Espresso Bar* coffee, 1.1 lb; tap water for drinking and cooking.

Miscellaneous: $60.67

Diana cigarettes, 20 pks.

Food Expenditure for One Week: 214.36 euros/$260.11

into their backpacks, run back to kiss their dad good-bye, then take the one-minute walk to their school as Piera watches from the window.

"It's strange to share all this about ourselves," says Piera, when I ask about her daily routine, but she warms to the task quickly. Though he works across the street, Giuseppe doesn't always come home for lunch, she says. He has coffee there, and for lunch eats seafood salad between customers. If he comes home, she might make pasta or a meat dish. The boys get lunch at their school cafeteria, but if it's closed, she and the other mothers walk to the school at lunchtime and drop off hot food in satchels labeled with their children's names.

Piera tells me she doesn't like fish. Does she mind cooking it? "I sometimes prepare it," she says. "Mainly *frittura* [mixed fried fish]. I do like *frittura*." And she likes shellfish, octopus and squid. What she dislikes are the classic finned fish like sole, tuna, swordfish, and *merluzzo* (the generic Italian name for such codlike fish as whiting, hake, and pout), especially their fishy smell. She wrests my video camera from the hands of the charming but insistent Maurizio for the first of many times this morning as she tells me that she does however serve frozen fish sticks. "They're easy to prepare for the children," she says, "and I can keep some in the freezer." And they don't smell. Giuseppe is noncommittal when I ask if the fish sticks are anathema to a fishmonger.

Today, most of the grocery shops and markets in Palermo are still the same small, privately owned businesses that she grew up with. She shops every day for their food, she says—one of the perks of living just above the market. The Manzos can't afford a car or a motorcycle, but the streets of Palermo are so choked with vehicles that it seems as though everyone in the city must own at least one.

We sit at the dining table with a second coffee and Piera's cigarette: "Do you cook anything different for the boys when they're home from school?" I ask. "No, not really," she says, "but of course we have pasta. Every day we have pasta—with beans, or potatoes, or tomatoes, or clams—a thousand different ways. Sometimes with *ragú* [meat sauce]." Another cigarette, and we talk about dinner: "At 7 p.m. I go down to see Giuseppi, to ask him, 'What do you want to eat?' and he always says, 'I don't know, make the decision by yourself.' And I say 'Oh, that's very helpful, thank you,' and then I come back home and prepare pasta—especially if we didn't eat pasta at midday. I make *frittura*, or sausage with potatoes, or some other meat, or chicken. If I don't have anything,

I buy some calamari *fritti*." And what about dessert? The cakes here are fabulous, and Sicily is one of the best places on earth to eat ice cream, but November is coming, and with it the *pupi di zucchero* (sugar puppets) to honor the Day of the Dead. Traditionally, these were chunks of solid sugar, formed and decorated to look like marionettes and dancers. Now, there's every chance that a *pupi* will be hollow sugar shells and look like Spiderman, a dinosaur, or the Japanese anime character Dragonball Z. They are fashioned months in advance in small shops around the city. They can be expensive, but Piera always buys them for the children, just as her mother did for her when she was young.

FUSION

Romans, Arabs, Normans, Greeks, Spaniards, and a host of others—last among them, the Italians—all had a hand in creating what Sicily is today: a strange tangle of the medieval and the modern. All those cultures have contributed to an interesting, sometimes colliding, cuisine. Sicilian pizza has as much in common with Middle Eastern savory-topped breads as with Italian pizza. Pasta reigns supreme, but just behind it is couscous—a staple food in Tunisia, which lies to the south, in Africa. In Sicily, surrounded by water, and with most of the population living on the coasts, fishing is an important part of the economy, and though commercial overfishing is decimating fish populations, it doesn't seem to be putting a damper on anyone's appetite for it. A single large bluefin tuna from Sicily, at auction at Tokyo's famed Tsukiji fish market, can bring in tens of thousands of dollars.

BUYER'S REMORSE

Hypermarkets haven't yet overrun Sicily, the way they have the rest of western Europe. The island is still too poor—there needs to be a certain amount of purchasing power before the multinationals will stick their toe into an economic pool. This means that Sicily will have the time to try to preserve its traditional shopping areas, if Sicilians want to. Piera says she would like to have the opportunity to spend less money for good-quality food, though she is also vaguely aware that if the hypermarkets move in, the cultural complexion of the city would change. Some of the small shops she grew up with will surely find themselves priced right out of business, or unable to compete with the multinational grocery operations. I tell her I'm hoping that someone is thinking about this part of Sicily's future.

ITALY

- Population: **58,057,477**
- Population of Palermo: **686,722**
- Area in square miles: **116,275 (slightly larger than Arizona)**
- Population density per square mile: **499**
- Urban population: **67%**
- Life expectancy, male/female: **77/83 years**
- Fertility rate (births per woman): **1.2**
- Caloric intake available daily per person: **3,671 calories**
- Annual alcohol consumption per person (alcohol content only): **9.7 quarts**
- GDP per person in PPP $ (Purchasing Power Parity: an adjustment for what equivalent local goods would cost in the U.S.): **$26, 430**
- Total annual health expenditure per person in $ and as a percent of GDP: **$1,584/8.4**
- Cigarette consumption per person per year: **1,901**
- Overweight population, male/female: **52/38%**
- Obese population, male/female: **12/12%**
- Population age 20 and older with diabetes: **9.2%**
- Pasta consumption per person per year: **62 pounds**
- Meat consumption per person per year: **199 pounds**
- McDonald's restaurants: **329**
- Pizzerias: **40,000+**
- Number of articles and subclauses in an Agriculture Ministry regulation (2004) defining Neapolitan pizzas: **8/6**
- Percent of "Guaranteed Traditional Specialty" pizzas approved by Agriculture Ministry that are topped with pineapple: **0**

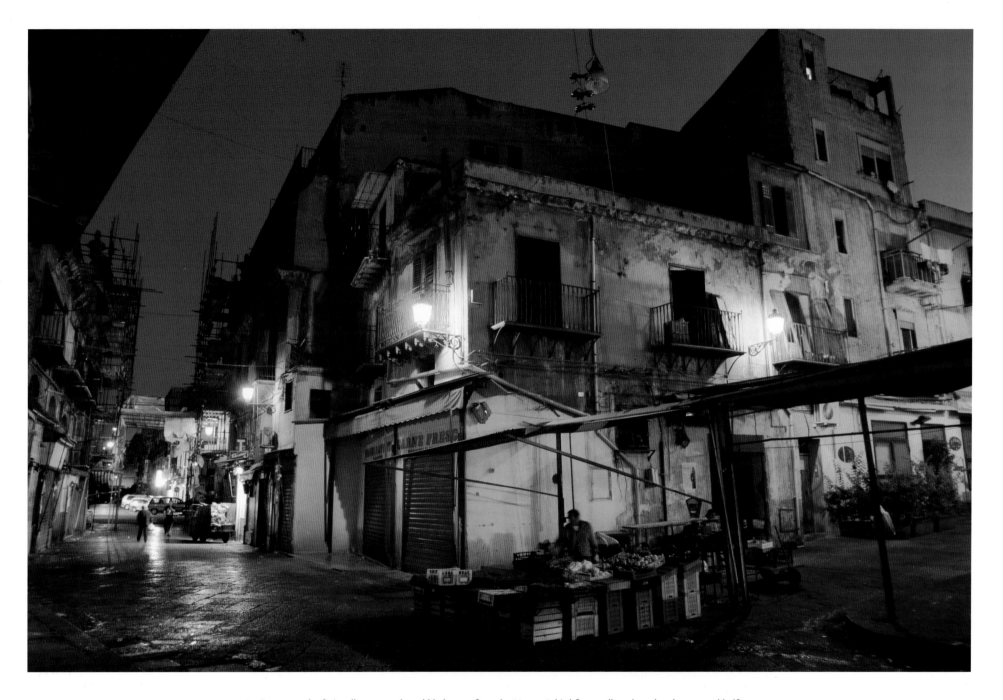

By 6:00 a.m., the fruit seller across the cobbled street from the Manzos' third-floor walk-up has already arranged half of his display. Living in the heart of Palermo's ancient Capo Market, the family is constantly enveloped in the cry and clamor of commerce—and, recently, the clatter of restoration work (scaffolding at the end of street around market gates). To Giuseppe, who grew up in this same neighborhood, the hubbub is the sound of home.

Every time we saw Giuseppe—at home, on the street, or at work in the fish store—he was smoking Diana cigarettes, the ones in the gold packs with the huge black warning label: IL FUMO UCCIDE (smoking kills). He told us he started smoking at age eleven. All the guys he works with smoke. His wife smokes, her sisters smoke, all their relatives smoke, our translator Bartolo smokes. Sicily is one huge ashtray.

Giuseppe's wife Piera sat at her kitchen table one night and opened a cardboard box of photographs. There were pictures of the older boys at school, Piera in a black bikini, a younger Giuseppe on the beach, and Christmas cards with the kids dressed as Superman or Santa Claus. She drank red ginger soda and smoked Dianas, becoming morose as she told us her story—early marriage; three kids; working at home, cooking and cleaning; taking the bus to the beach on weekends with the kids and a lunch bag because they couldn't afford a car or restaurants. Cleaning, cooking, cleaning, cooking, smoking. Oh, if only she could do it all over again....

The day we shopped for the week's worth of food, Piera and Giuseppe were stumped trying to figure how many cigarettes to buy. It took a while to figure out the weekly total because they buy packs of cigarettes one by one, several times a day. They were startled to realize they smoke two cartons a week—50 euros' worth of tobacco ($65 USD). I did some quick math in my head and with my trademark lack of tact blurted out that they must spend 2,500 euros on cigarettes a year ($3,250 USD). That seemed to depress them—but not enough to make them quit.
— Peter

Piera Marretta's *Pasta C'anciuova* (Pasta with Anchovies)

4 cloves garlic, minced

2 T olive oil

1 oz anchovies

1/2 lb tomato puree

1 cup water

2 oz golden raisins

6 T pine nuts

2 T salt

2 T pepper

2 T sugar

7 oz bread crumbs

1-1/4 lb spaghetti

- Sauté garlic in 1 T olive oil over medium heat for about 5 minutes, until garlic is golden brown but not burned. Add anchovies and sauté until they begin to soften and break apart. Add tomato puree, water, raisins, pine nuts, salt, pepper, and sugar.

- In a separate pan, brown bread crumbs with remaining olive oil. Add more oil while cooking if necessary to prevent burning, but mix well and don't soak crumbs in oil.

- Bring salted water to a boil in a large pot. Add pasta and boil until cooked *al dente*.

- Drain pasta and mix with sauce. Sprinkle with bread crumbs and serve.

- Buon appetito!

Pushing the week's worth of food in Maurizio's stroller, Giuseppe and Piera *(above left)* walk through the Capo Market to their apartment. Normally, Piera, who shops every day, would purchase this much only on special occasions. Pietro and Domenico *(bottom left)* also shop every day, loading up on snacks from the grocery next door on their way to school. Backpacks bulging, they cross the street to their father's store to kiss him good-bye before heading off.

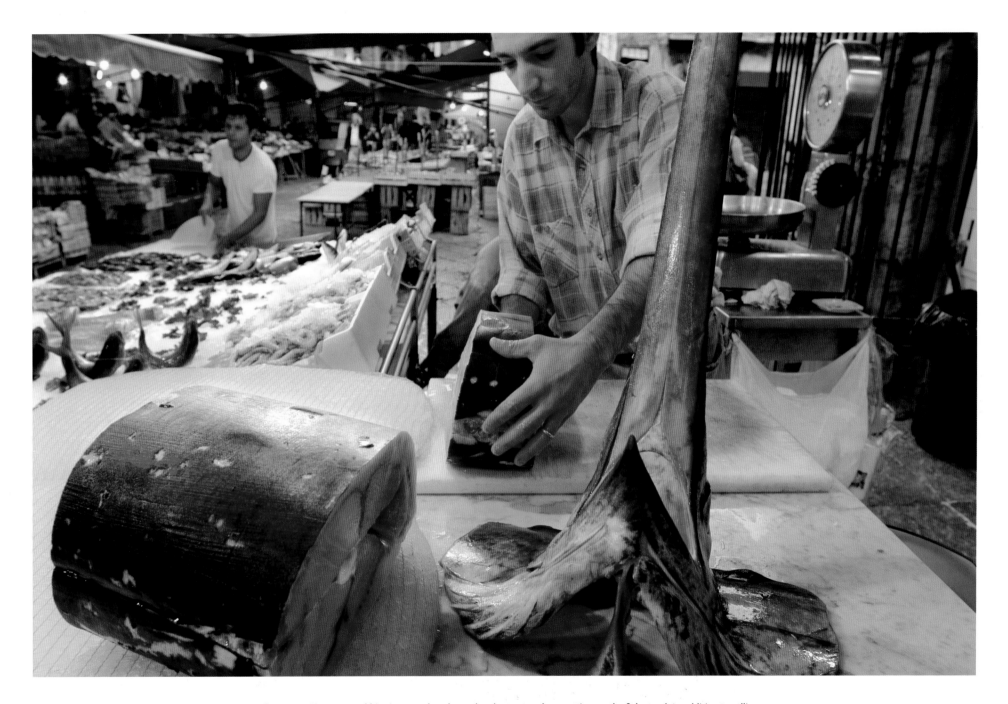

By 8:00 a.m. Giuseppe and his six co-workers have already spent an hour setting up the fish stand. In addition to rolling out the red tarps and unfolding the display tables, they must cut and ice the fish, devoting special attention to Sicily's beloved—and increasingly endangered—*pesce spada* (swordfish), freshly cut chunks of which he arranges around its severed head. Ten hours later, the crew will reverse the process, storing everything for the night.

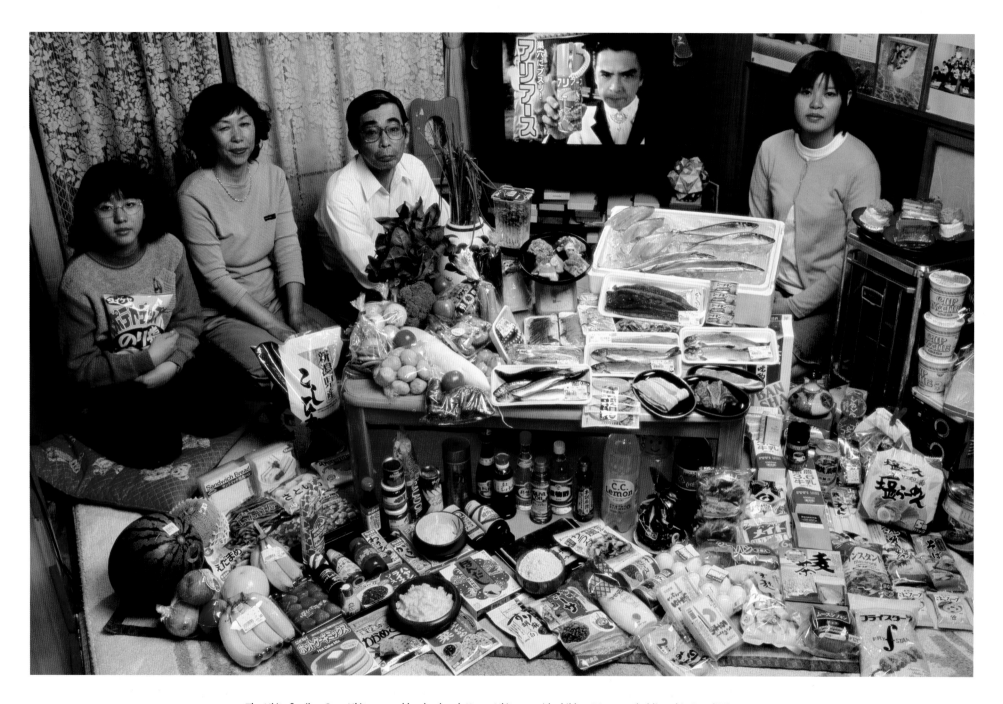

The Ukita family—Sayo Ukita, 51, and her husband, Kazuo Ukita, 53, with children Maya, 14 (holding chips) and Mio, 17—in their dining room in Kodaira city, Japan, with one week's worth of food. Cooking methods: gas stove, rice cooker. Food preservation: small refrigerator-freezer. Favorite foods—Kazuo: sashimi. Sayo: fruit. Mio: cake. Maya: potato chips.

Vitamin Sea

ONE WEEK'S FOOD IN MAY

Grains & Other Starchy Foods: $31.55

Koshihikari rice, 5.5 lb; potatoes, 5.3 lb; Danish white bread, sliced, 1 loaf; white flour, 1.3 lb; sato imo (Japanese yam), peeled, 1.1 lb; udon noodles, 1.1 lb; sômen noodles, 14.1 oz; white sandwich bread, 12.4 oz; *Nippn* macaroni, 10.6 oz; soba noodles, 10.6 oz; *FryStar7* bread crumbs, 8.1 oz.

Dairy: $2.26

Whole milk, 25.4 fl oz; *Haruna* yogurt, 12 oz; butter,‡ 8.8 oz.

Meat, Fish & Eggs: $99.80

Rainbow trout, 2.6 lb; ham, 2.2 lb; eggs, 10; sardines, large, 1.3 lb; clams, 1.1 lb; octopus, 1.1 lb; Spanish mackerel, 1.1 lb; pork loin, 1 lb; tuna, sashimi, 15.5 oz; horse mackerel, 14.8 oz; saury (fish), 13.5 oz; Japanese smelt (fish), 13.1 oz; eel, 12.7 oz; albacore, sashimi, 11.9 oz; *Hagoromo* tuna, canned, 11.3 oz; pork, cubed, 11.3 oz; beef, 10.8 oz; pork, minced, 10.6 oz; pork, sliced, 10.6 oz; pork, thin sliced, 10.3 oz; bacon, 7.8 oz; beef korokke (beef and potato patties), frozen, 7.4 oz, *used for children's lunch;* sea bream, sashimi, 3.6 oz; *Nozaki's* new corned beef (mix of horse and beef meat), canned, 3.5 oz.

Fruits, Vegetables & Nuts: $81.43

Watermelon, 9.9 lb; cantaloupe, 4.4 lb; yellow bananas, 2.8 lb; red apples, 2.4 lb; white grapefruit, 2.2 lb; strawberries, 1.7 lb; cherries, canned, 7 oz; yellow onions, 4.8 lb; green peppers, 4 lb; cucumbers, 3.5 lb; daikon, 3.3 lb; bitter gourd,‡ 2.8 lb; soft tofu, 2.2 lb; tomatoes, 2 lb; carrots, 1.2 lb; green peas, in pods, 1.1 lb; broccoli, 1 lb; lettuce, 1 head; spinach, fresh, 1 lb; edamame, frozen, 14.1 oz; asparagus, 10.6 oz; green beans, frozen, 10.6 oz; mixed vegetables, frozen, 10.6 oz; bamboo shoots, 8.8 oz; white asparagus, canned, 8.8 oz; scallions, 8 oz; daikon sprouts, 6 oz; shitake mushrooms, 6 oz; wakame (seaweed), fresh, 5.6 oz; bean curd, fried, 1.8 oz; nori (seaweed), dried, 1.8 oz; wakame,‡ dried, 1.8 oz.

Condiments: $28.28

White sugar, 15.6 oz; *Ebara* BBQ sauce, 9.9 oz; white miso, 9.9 oz; margarine,‡ 8.8 oz; *Honen* salad oil, 8.5 fl oz; sesame oil, 7.1 oz; bean sauce, 6 fl oz; ginger, 6 oz; *Tea Time Mate* sugar, 28 .2-oz pks; *Kyupi* mayonnaise, 5.6 oz; *Hinode* cooking sake 4.7 fl oz; *Hinode* mirin (low-alcohol rice wine for cooking), 4.7 fl oz; soy sauce, 4.7 fl oz; *Sudo* orange marmalade, 4.7 fl oz; *Sudo* strawberry jam, 4.7 fl oz; vinegar, 4.7 fl oz; *Fuji* oyster sauce, 4.2 oz; *Bull Dog* tonkatsu sauce, 3.4 fl oz; *Captain Cook* coffee creamers, 20 .2-fl-oz pks; salt, 3.5 oz; Chinese spicy sauce, 2.9 oz, *used on tofu; Kagome* ketchup, 2.7 fl oz; sesame seeds,‡ whole, 2.6 oz; honey, 2.5 oz; *Pokka Shokutaku* lemon juice, 2.4 fl oz; *Momoya* kimchi paste, 2.2 fl oz; soy sauce salad dressing, 2 fl oz; *Ajinomoto* olive oil 1.8 oz; *S&B* hot mustard, 1.5 oz; *S&B* wasabi, 1.5 oz; white sesame, ground, 1.4 oz; black pepper,‡ 0.7 oz.

Snacks & Desserts: $15.33

Small cakes, 4; coffee break cookies, 1 lb; cream buns, 10 oz; *Koikeya* potato chips, 8.8 oz; *Pasco* cream rings, 8.8 oz; chiffon chocolate cake, 5.3 oz.

Prepared Food: $21.78

Nissin cup of noodles, instant, 1.5 lb; *Sapporo Ichiban* noodles, instant, 1.1 lb; *Showa* pancake mix, 12.4 oz; *Mama* pasta meat sauce, canned, 10.4 oz; *Oh My* pasta meat sauce, canned, 10.4 oz; seaweed salad, dehydrated, 8.8 oz, *add water to reconstitute; S&B* golden hayashi sauce mix (Japanese style beef bouillon cubes), 8.8 oz; Chinese dumplings,‡ frozen, 8.5 oz, *used for the children's lunches; Ajinomoto* hondashi soup base, bonito (fish) flavor, 5.3 oz; soup, instant, 2.7 oz; yaki fu (baked rolls of wheat gluten, wheat powder, and rice powder), 2.7 oz, *eaten in soup;* vegetable and seaweed rice ball mix, 1.3 oz; *Riken* seaweed rice ball mix, 1.2 oz; *Kyowa* egg drop soup, instant, 0.9 oz.

Beverages: $28.40

Kirin beer, 6 12-fl-oz cans; *Coca-Cola,* 2.1 qt; *Nacchan* orange soda, 2.1 qt; *Suntory* C.C. lemon joyful vitamin C soda, 2.1 qt; *Ban Shaku* sake, 1.8 qt; *Coffee Break* instant coffee, 2.5 oz; green tea, 2.1 oz; *Alpha* wheat tea, 2 oz; *Afternoon Tea* darjeeling black tea, 1.8 oz; tap water for drinking and cooking.

Miscellaneous: $8.42

Mild Seven super-light cigarettes, 4 pks, *smoked by Kazuo.*

‡ Not in Photo

Food Expenditure for One Week: 37,699 yen/$317.25

The purchase of a single powdered chocolate truffle at a Japanese department store can cause an amazing flurry of activity. Behold the spectacle of a wrapping experience: with graceful precision, the clerk gently folds the chocolate into a square of tissue paper, tucks it into a tiny box, and ties it up with an elegant snippet of ribbon—exquisite entertainment for the price of a piece of candy. But this is no mere show. The belief that the presentation is as important as the food itself extends from the finest department store to the humblest home in Japan.

SAYO UKITA IS UP EARLY, SCRAMBLING EGGS and preparing small breakfast salads of artfully placed tomato, cucumber, and lettuce for her daughters Mio, 17, and Maya, 14. Ignoring the elegant array, her husband Kazuo grabs a cup of coffee and a cigarette, turns on the television, and immerses himself in the baseball scores and the weather report before walking to the train station. Though Kodaira City is a Tokyo suburb, Kazuo will have an hour-long commute into central Tokyo, and the book warehouse where he works. The Ukitas own a car, but it's impractical to drive into the city.

Both girls slouch over the low table in the living room, sipping cups of tea, as Sayo serves their breakfast and kneels to eat her own. She has already prepared Maya's two school-lunch bento boxes with food she cooked along with last night's dinner. In one, pieces of grilled fish and lightly steamed green beans flank a portion of white rice, all arranged with perfect symmetry. The second box holds four whole strawberries, two red cherries, and thin slices of Fuji apple spread out like a fan. Sayo covers the two bento boxes and slips them into Maya's backpack, along with her chopsticks. Mio will eat lunch with her friends at one of the many fast-food restaurants near her school—McDonald's, Mos Burger, Lotteria, KFC, DomDom, Wendy's, or Yoshinoya. Neither daughter is expected to pick up her breakfast dishes. "Their responsibility is to do well in school," says Sayo as she cleans up after them. The girls head to the train station for trips in opposite directions, and Sayo will soon follow to do the day's shopping. Japanese train stations serve as the nucleus of Tokyo's suburban cities, and are surrounded by shops and restaurants.

The streets are quiet. Sayo and the other housewives in her neighborhood silently ride their bikes toward the train station to buy the freshest food they can find.

Japan is one of my favorite places to eat. Even the cheap udon and soba noodle places are terrific. And the revolving sushi bars and all-you-can-eat-in-45-minutes sushi restaurants are my idea of great fast food.

During my first stay with the Ukita family, Sayo spent an hour or more making each dinner, and that didn't count the shopping. Every day, she rode her bicycle to the neighborhood shopping street near the train station, where there was every type of fruit, fish, and vegetable known to Eastern man. All of it was incredibly fresh, incredibly elegantly displayed, and incredibly expensive. The drawbacks to eating with the Ukitas were the low table, which was hard on my knees (sitting cross-legged), the omnipresent blaring wide-screen TV, and Kazuo's habit, which he shares with millions of other Japanese salarymen, of quietly downing prodigious amounts of Jack Daniels, beer, and sake.

Nearly a decade later, when I visited them again, Kazuo was still at the Jack Daniels, despite a recent kidney operation. Their daughters had grown up: Mio was in college, majoring in biology, and shy Maya was finishing high school. Sayo still rode her bike to the shopping street (even if she wanted to drive, parking is impossible). She works so hard in the kitchen that this time we wanted to give her a break. So we took her out for sushi at a little place down the street, where we sat at little tables and were served by the little lady that owned the little business that featured completely ordinary—which is to say, extremely good—sushi. — *Peter*

Unlike the western fast-food companies where the food generally stays the same year-round, menus at Japanese chains change with the season. Eating seasonally is a longstanding Japanese tradition, both to get foods at their most flavorful and because foods that are out of season are even more expensive than the normally high prices in this island nation.

Sayo Ukita's *Sukiyaki*

Approx. 3 cups *dashi* (Japanese fish broth)

2–3 T vegetable oil

1–2 lb beef, thinly sliced on the diagonal

3–5 T sugar

3 fl oz sake

1/4 head of baby bok choy (Chinese white cabbage), cut into 2" pieces

11 oz *konnyaku* (yam cake) cut in 1 x 4" pieces

2 *negi* (leeks), cut into 2–3" pieces

4–6 shiitake mushrooms, halved lengthwise

1 big bunch spinach (approx. 1–2 lb)

11 oz tofu, cut in 1" cubes

- Prepare a portable cooking facility, such as a fondue pot or an electric frying pan or wok, and place on dining table.

- Make *dashi*; either 1) simmer *dashi* "teabag" in 3 cups water for 10 minutes or 2) simmer 1 x 2" piece of *konbu* (dried kelp) in 3 cups of water for 10 minutes, remove from heat, add 1/2 cup bonito flakes, let mixture steep for 1 minute, then strain out *konbu* and bonito flakes.

- Set pan to medium-high and add vegetable oil. Heat until oil is hot.

- Add beef (lay flat, so pieces do not overlap), then add sugar and sake and cook for about 2–3 minutes.

- Add half the *dashi* and a portion of vegetables and tofu (fill pan, but do not overcrowd). Keep different items in their own part of pot. Simmer until meat and vegetables are cooked through. Adjust taste by adding soup stock, sugar, and/or soy sauce.

- Pluck out cooked vegetables and meat, adding new pieces at the same time, cooking as in previous step until all ingredients are used up.

- Note: Sukiyaki usually mixes soy sauce, sugar, sake, and *dashi* to create its sweet and salty taste. The Ukitas use less soy sauce and sugar than most Japanese families, although they use *dashi*.

As might be expected in an island nation, Japanese families eat a wide variety of seafood: fish, shellfish, and seaweed of all kinds. In any given week, the Ukitas *(above, Sayo at the supermarket)* will eat at least a dozen different kinds of fish and shellfish, and three varieties of seaweed. Like most people in this heavily urban country, the Ukitas also eat out often, usually at restaurants that follow the Japanese custom of displaying plastic models of the food served within *(far left)*.

JAPAN

- Population: **127,333,002**
- Population of Metro Tokyo: **33,750,000**
- Population of Kodaira City: **175,585**
- Area in square miles: **145,844 (slightly smaller than California)**
- Population density per square mile: **873**
- Urban population: **66%**
- Life expectancy, male/female: **78/85 years**
- Fertility rate (births per woman): **1.3**
- Caloric intake available daily per person: **2,761 calories**
- Annual alcohol consumption per person (alcohol content only): **6.6 quarts**
- Year in which beer-vending machines were voluntarily banned: **2000**
- GDP per person in PPP $ (Purchasing Power Parity: an adjustment for what equivalent local goods would cost in the U.S.): **$26,940**
- Total annual health expenditure per person in $ and as a percent of GDP: **$2,627/8**
- Overweight population, male/female: **25/19%**
- Obese population, male/female: **2/2%**
- Percent of population age 20 and older with diabetes: **6.7%**
- Meat consumption per person per year: **97 pounds**
- Fish consumption per person per year: **146 pounds**
- McDonald's restaurants: **3,891**
- Big Mac price: **$2.50**
- Cigarette consumption per person per year: **3,023**

Exemplifying Japan's lively and adventurous food culture, Osaka's Dotomburi Street *(above left)* offers an all-squid eatery, an all-crab place, and a restaurant specializing in *fugu* (poisonous blowfish). In a more traditional setting, a couple shares a snack *(right)* in a teahouse at a Kyoto temple. Walking in Tokyo's hip Harajuku area, a girl *(bottom left)* clutches a *kurepu*—a crepe.

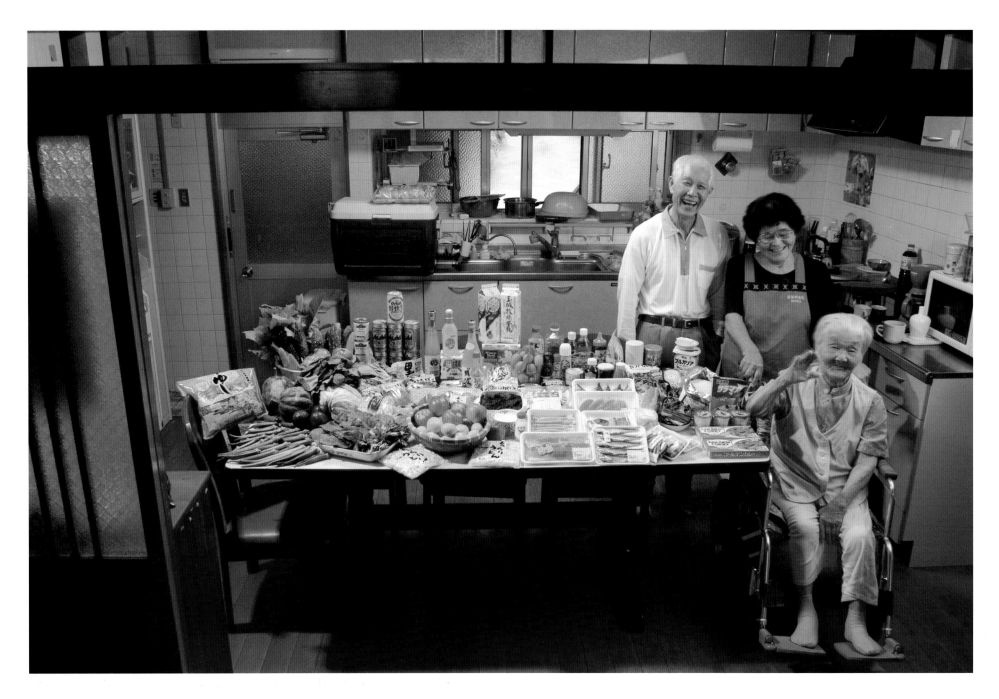

The Matsuda family in the kitchen of their home in Yomitan Village, Okinawa, with a week's worth of food. Takeo Matsuda, 75, and his wife Keiko, 75, stand behind Takeo's mother, Kama, 100. The couple's three grown children live a few miles away. Cooking methods: gas stove, microwave. Food preservation: small refrigerator-freezer.

Hara Hachi Bu

ONE WEEK'S FOOD IN OCTOBER

Grains & Other Starchy Foods: $22.72

White rice, 6.6 lb; bread, 12.4 oz; macaroni salad, 3.5 oz; udon noodles, 2.8 oz.

Dairy: $8.09

Milk, 1.1 qt; *Meiji* Bulgarian Style yogurt, 1.1 lb; *Yukijirushi* cheese, sliced, 5.4 oz; *Yukijirushi* cheese wheel, 5.3 oz; butter, 2.5 oz.

Meat, Fish & Eggs: $32.32

Eggs, 20; *Spam*, 1.5 lb; fish paste, boiled, 1.2 lb; tuna, canned, 14.1 oz; red sea bream, sliced, 13.3 oz; bacon, sliced, 9.2 oz; mackerel, fresh, 8.8 oz; salmon, fresh, boneless, 8.4 oz; pork, sliced, 8 oz; round herring, dried, 6 oz.

Fruits, Vegetables & Nuts: $67.99**

Apples, 2.2 lb; oranges, 2.2 lb; persimmons, seedless, 14 oz; hackberries, 7.1 oz; pumpkin, 5.3 lb; goya (bitter gourd), 4 lb, *often homegrown*; yellow onion, 2.6 lb; cabbage, 1 head; tomato, 1.8 lb; avocados, 3; okra, 1.3 lb; bok choy, 1 lb; carrots, 1 lb; corn, canned, 15.2 oz; salad greens, 9.6 oz; taro, cooked, 8.1 oz; red kidney beans, 7.1 oz; oshiro natto (fermented bean curd), 7.1 oz; soybeans, 7.1 oz; yam leaf, 7 oz; Super Sweet corn, canned, 5.5 oz; bean sprouts, 5.3 oz; enoki mushrooms, fresh, shrink-wrapped, 3.5 oz; konbu (kelp) stock, 3.5 oz; wheat gluten, 3.9 oz; chili peppers, 2.8 oz; konbu (kelp), 2.1 oz; *Asa* wakame (seaweed), .5 oz. *Purchased or picked wild:* nigana (bitter greens),* 13.1 oz; yomogi (mugwort),* 9.6 oz; tsuru murasaki (Malabar spinach),* 2 oz.

Condiments: $44.28

Red miso, 1.3 lb; Okinawan honey, 1.1 lb; salt 1.1 lb; *S&B* golden curry, 1.1 lb; *Mitsukan* apple vinegar, 16.9 fl oz; soy sauce, 12.2 fl oz; bonito shavings (dried fish), 10.6 oz; bitter orange juice, 10.2 fl oz; ketchup, 10.2 fl oz; *Topvalu* BBQ sauce, 10.2 fl oz; *Econa* salad oil, 8.8 oz; purple potato powder, 7.1 oz; jam, 4.9 oz; sesame dressing, 4.1 fl oz; pepper, 0.7 oz.

Snacks & Desserts: $7.88

Werther's candy, 11 oz; *Meiji* pudding, 10.6 oz; ginger candy, 6.4 oz.

Prepared Food: $3.15

May Fair beef stew, canned, 12 oz; gyoza (meat dumplings), 7.4 oz.

Beverages: $27.83

Asahi beer, 6 12-fl-oz cans; *Minute Maid* fruity vegetable juice, 6 12-fl-oz cans; *Seakuwasar* citron juice, 1.6 qt; amawori (Okiwanan rice liquor), 24 fl oz; *Orion* beer, 12 fl oz; *UCC* Mocha Blend coffee, 3.5 oz; tea bags, 50; tap water, for drinking and cooking.

* Homegrown

Food Expenditure for One Week: 22,958 yen/$214.26

**Total value of homegrown foods, if purchased locally: $7.25

Takeo Matsuda's mother Kama danced at her own 100th birthday party six months ago, surrounded by her children, grandchildren, and great-grandchildren, in the home she shares with her son and his wife Keiko. Kama's whole family lives within a 15-minute drive of the home on Okinawa's main island, where she has lived since World War II. It doesn't require a celebration to bring the family together. A surefire draw for even the youngest grandchildren is the traditional Okinawan food that Keiko, 75, cooks every weekend. "They crave the taste of their childhood," she says to us, as she rinses a special favorite—*tsuru murasaki* (Malabar spinach), which grows freely on the island. "Healthful grass," she calls it, though it's not really a grass at all. Although its leaves taste spinachy, the plant is actually a relative of the sweet potato.

She chops the *tsuru murasaki*, then mixes in fresh Okinawan tofu, which is firmer than mainland Japanese tofu, and a little citrus-flavored vinegar. The uncooked greens have a slightly bitter flavor that blends deliciously with the vinegar and the creaminess of the tofu. She sets the mixture aside and assembles a dish of two other wild greens—*yomogi* (mugwort) and *nigana*, a long-leafed bitter lettuce. Next, she washes *goya* (bitter gourd), "another long-life food we eat," she says. She'll stir-fry the *goya* with tofu, a little bit of pork, and egg. She has made us a healthful lunch—lots and lots of vegetables and very little fat.

During the rest of the week, the younger Matsudas, who live on their own, eat a wider variety of foods, including Western fast food. This troubles Keiko. Okinawan cities are teeming with McDonald's, KFCs, and A&Ws, and though she has never eaten at any of them, she's sure she doesn't want to: "I think it isn't very nutritious," she says. What exactly does she think Western food consists of? "A lot of bread, I think. We only see bread as a dessert or snack—not a main food." Her husband, Takeo, is quick to temper her comments with his own, and speaks fervently about the food that the Americans sent to Okinawans after World War II. "We weren't able to grow much at that time," he says. "America gave us many vegetables." America has given the Okinawans canned food as well: Spam and canned tuna are Matsuda grocery staples.

Okinawa, the main island of Japan's Okinawa Prefecture, was part of an archipelago that was the Ryukyu Kingdom before it was annexed by Japan in the late 1800s. The island, a curious mix of Ryukyuan, Japanese, Chinese, and American culture, has become a beachhead for Western fast food, largely because it has been the site of a large U.S. military contingent since the end of World War II. But fast food is an unlikely partner to the local cuisine, which is based on fresh local produce, and to a traditional culture in which moderation is the mantra.

Hara hachi bu—"eat only until 80 percent full"—say older Okinawans. The island has been the focus in recent years of researchers trying to discover why a disproportionately large number of Okinawans are living to age 100 or more. Some scientists attribute this longevity to the island's unique, unbeatable combination of healthy eating habits, exercise, and low stress, as well as a community commitment to ensuring the quality of its older citizens' lives.

At almost 101, Kama spends her days in a wheelchair, but still goes off several times a week to the senior daycare center to see friends. Okinawan nursing homes and daycare centers, both public and private, seem wondrous places—vibrant and lively—where friends gather for a foot massage, water volleyball, a haircut, or lunch. Indeed, the centers are an integral part of the community, and celebrations abound for its people's different stages of life. It's not nirvana for the elderly, but certainly accords dignity to the aging. Keiko takes in stride the age-related changes in her mother-in-law's health and disposition: "After [age] 97, it's like having a big friendly child to be with every day," she concludes.

Though she has always lived with her mother-in-law, Keiko wonders whether any of her children will live with her when she's too old to care for herself. "Life has changed," she says. "When I was in my twenties, people were still willing to [live] with their parents, but that's happening less now. I don't know what will happen when I'm older."

THE (REAL) SIMPLE LIFE

Not all of Okinawa is overrun by the modern world. Roughly half the island is rustic, traditional, and downright lush—especially in the north, after the four-lane toll road ends and the breathtaking ocean views begin. It is here that we happen upon 90-year-old Haruko Maeda, sprawled comfortably in the front yard of her home in Ogimi Village, cutting the grass with a pair of hand shears. "I'm getting this done before it gets too hot," she explains, as she quickly straightens up to greet us. Her son arrives from his home in Naha city and heads into her house, waving hello, and obviously not finding it unusual to see his mother on her knees in the yard with a pair of clippers. "That's my oldest son," says Haruko, who has six children, half of whom live on Japan's main island. "Do they visit often?" I ask. "They always come back," says Haruko. "Every summer, they all come to swim in the ocean." Do you swim with them? "I'm the coach," she says, grinning. She's also the lifeguard—keeping tabs on the youngest great-grandchildren as they splash around in the surf.

We spy bitter gourd in her garden; the cucumber-like, knobby green vegetable with its plump leafy vine is tied to a trellis. "How do you prepare your *goya*?" I ask. "I cut it thin," she says, "then sprinkle it with vinegar, and add tofu, and sometimes octopus." Do your children like it? "Oh yes," she says. "They took some of my seeds with them to the mainland and grow it in their gardens." She saves her own seeds and replants them from year to year. "They grow well, unless I lose them, during typhoon season." A friend walking by the gate stops to ask Haruko if she wants to go with her to pray at the nearby Shinto shrine. "Not now," she says, pointing at her house. "My son has come. I'll see you there later." We say our good-byes to Haruko, as we're late for lunch.

A MEAL WITH MATSU

We're heading for a small restaurant in Ogimi Village called Emi's Shop, where visitors can try traditional healthful food cooked in the Okinawan manner. The set menu is based on foods that promote longevity. A hand-worked sign points out that different foods are prepared daily, depending on what's in season. We've asked the owner, nutritionist Emiko Kinjo, to invite a friend to lunch with us, and she has—96-year-old Matsu Taira shows up and parks her walker by the door. Emiko invites her to take a seat. The meal, served in bento boxes, features fresh green seaweed "tofu" (no soybeans in this particular tofu—just seaweed), along with purple Okinawan sweet potatoes and local lime, bitter gourd with fresh soybean tofu,

- Population: **1,318,220**
- Population of Yomitan Village: **36,000**
- Area in square miles of Okinawa, main island and total prefecture: **454/871 (the main island is slightly less than one-third the size of Rhode Island)**
- American military forces killed in The Battle of Okinawa during WWII: **12,000**
- Japanese military forces killed in The Battle of Okinawa during WWII: **107,500**
- Okinawan civilians killed in The Battle of Okinawa during WWII: **142,000**
- American military forces now stationed on Okinawa: **25,000**
- Land on the main island covered by U.S. military bases: **20%**
- Urban population: **71%**
- Life expectancy, male/female: **77/86 years**
- Rank in the world of life expectancy on Okinawa: **No. 1**
- Number of centenarians per 100,000 people on Okinawa: **33.6**
- Number of centenarians per 100,000 people in most industrialized countries: **10**
- Percent of centenarians that are female on Okinawa: **85.7%**
- In all of Japan, rank of Okinawans under 50 for levels of obesity and risk of liver disease, cardiovascular disease, and premature death: **No. 1**

A few miles down the coast from Yomitan Village, in the town of Chatan, construction workers building Okinawa's biggest hotel, a 24-story complex, begin their day with compulsory exercises—until recently, a method of instilling esprit de corps that was common throughout corporate Japan. Unlike most other developed nations, Japan does not depend on foreign workers to perform hard physical labor. The overwhelming majority, if not all, of these men are Japanese.

イラブチャー
300 円
100g

Brilliantly colored parrotfish *(above)* dominate a stall in the Makishi public market in the Okinawan town of Naha. Meticulously clean, Japanese markets are a testament to the affluence of this island nation. In the Makishi market, a vendor at one typical stall *(at right)* offers a potential customer a free sample of daikon (giant white radish). Other choices include bitter melon, prunes, pickled baby cucumber, cabbage, *rakkyo* (a root in the lily family), and many other delights.

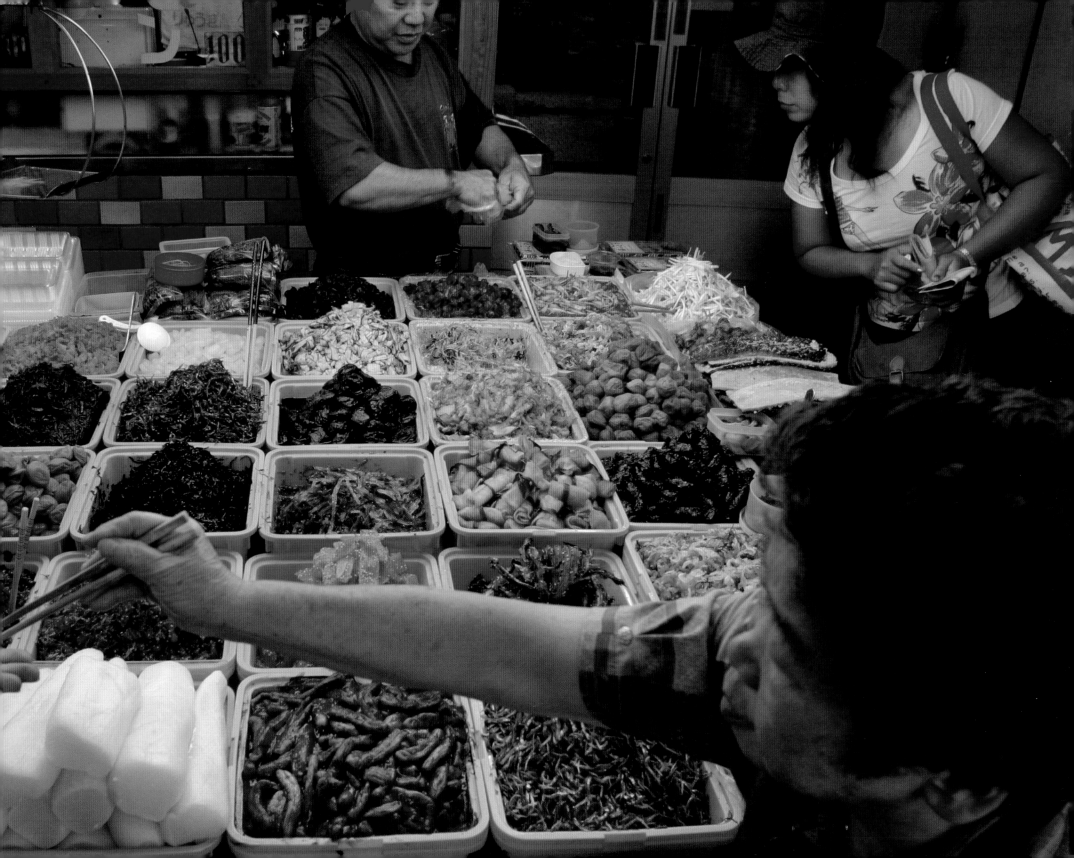

I work better with fuel in my tank and because we started early each morning I was dismayed to find the only restaurant open in our part of Okinawa before 10:00 a.m. was Mister Donut, a Japanese chain. Thinking that doughnuts would be better than nothing, we slinked in and were confronted by a display case that would have made any U.S. cop think he had died and gone to heaven. What was the least unhealthy thing we could order? Pondering our choices, I noticed a sign showing Mister Donut was on the same wavelength. "Pon de Ring" was the name of a soy-flour doughnut shaped like a ring of pop beads. Inside was a layer of either poppy seed or orange cream. They were incredibly good: slightly chewy, not too sweet, and theoretically good for you.

Another unexpected treat on this tropical island came from the sea. To a dedicated fish-lover like myself, the iced-down displays of rainbow-colored seafood in Naha city's largest traditional market looked like candy. After we learned that the top floor of the market consisted of restaurants that cook fish to order, we picked out half a dozen interesting-looking fish and took them up. The cooks cut up half of them and served them raw as sashimi; they steamed the others whole with ginger. Dipped in soy sauce that we had spiced up with a liberal amount of *wasabi*, the strips of raw fish were delicious. Disappointingly, the brilliant colors of the fish disappeared in the steam. In my opinion, when you cook a fish something invariably gets lost in translation. But the cooked fish in the top-floor market restaurant was bone-sucking good, too. — *Peter*

At a "longevity restaurant"—an eatery claiming to serve food that will make patrons live longer—in Ogimi, Okinawa, 96-year-old Matsu Taira *(above right)* finishes the long-life lunch with a jellied fruit dessert made from bright-red acerola berries. Among the treats in the menu are *(bottom right)* silver sprat fish, bitter grass with creamy tofu, daikon, seaweed, tapioca with purple potato and potato leaves, and pork cooked in the juice of tiny Okinawan limes.

Keiko Matsuda's *Hijiki Jyushi* (Rice Cooked with Brown Seaweed)

18 oz Japanese rice

1 oz dried *hijiki* (brown seaweed)

21 fl oz *dashi* (Japanese fish broth)

1 small carrot, julienned

6 oz pork, cut into thin strips

3 T soy sauce

salt

1 small leek, cut into slivers

- Wash rice and drain in sieve or colander.

- Wash *hijiki* and remoisturize in abundant water for 20 minutes. Drain in sieve or colander.

- Make *dashi;* either 1) simmer *dashi* "teabag" in 3 cups water for 10 minutes or 2) simmer 1 x 2" piece of *konbu* (dried kelp) in 3 cups of water for 10 minutes, remove from heat, add 1/2 cup bonito flakes, let mixture steep for 1 minute, then strain out *konbu* and bonito flakes.

- Place *hijiki,* carrot, and pork into electric rice cooker. Add enough *dashi* to cook rice (exact amount will vary by type of rice cooker). When that mixture comes to a boil, add rice, soy sauce, and salt to taste; continue cooking until rice is done.

- When rice is cooked, let it steam for 10 minutes; do not remove lid. Then stir ingredients together. Serve immediately, garnishing individual portions with leek.

- Variations: Almost limitless. Almost any leftovers can be chopped up and added into the rice.

At a senior center in the small city of Nago, Okinawa, elderly Japanese can spend the day in a setting reminiscent of a spa, taking foot baths, enjoying deep-water massage, and lunching with friends. With their caring, community-based nursing and assistance staff, Okinawan nursing homes and senior daycare centers, both public and private, seem wondrous places—vibrant and lively—where friends gather for foot massages, water volleyball, haircuts, or simple meals.

pork with lime juice, pickled vegetables, and copious amounts of green tea. We're fortunate that Matsu can join us on short notice. Since the weather wasn't too steamy today, she might have been working in her field. She's happy to be here because she enjoys any opportunity to socialize: "It keeps me young," she says. "But," she adds, looking around, "it would be better if everyone here were old—the stories would be better." Laughter all around, even from passersby, as Matsu sips her tea. She picks up her chopsticks and tries the seaweed tofu. "You made this? It's good," she tells Emiko.

The seaweed sparks a memory of her youth: "You know, there used to be a lot of seaweed in the ocean, right out there," she says, pointing west toward the back of the restaurant. "When we were small, we used to pick it up from the shore and dry it. Maybe the breakwater killed it, or pollution," she guesses as she tries a piece of Emiko's bitter gourd—a food she prepares for herself every day when it's in season. "Do you ever dry it to have in the winter?" I ask. "No, we don't do that," she says, frowning. "We dry daikon and other vegetables, but not *goya*."

Matsu does not shop in a supermarket; there isn't one in Ogimi Village. She grows her own vegetables and gets everything else she needs from the local food cooperative. She has trouble comprehending that there are people who don't grow any of their own food, and she can't imagine actually buying vegetables herself. She's fascinated to learn that there are people who don't know anything about agriculture. She returns to that fact throughout lunch, and it worries her. "They don't know anything at all?" she asks several times.

Has Matsu ever had fast food? Everyone at the table, in fact everyone with any fast food experience at all, tries to explain the concept of fast food to her. A few moments later, she recollects eating some bread one time that had a kind of Japanese brown jam on it. "Was that fast food?" She asks. She never does truly understand the concept of a hamburger, and it's probably just as well.

Matsu takes a bite of ripe yellow papaya and says she likes the flavor very much. It's also served green, but she prefers the yellow. "Our ancestors said it was good for the heart," she says as she takes another bite. "You know," she says, "we didn't have doctors or medicine long ago, so we looked at all these vegetables that we had and tried to figure out what was good for this or that. There is a bitter grass we have that if you pull it up and eat the roots, it's good for an upset stomach.

This [knowledge] was handed down from generation to generation."

Matsu's husband was a fisherman after World War II. "Every man was," she says. "They would come in from the ocean and we [women] would gather on the beach, collect the fish, and take them to the market. We would sell them, and then buy rice and vegetables. At that time, we weren't able to farm much." What was her favorite fish? "Any fish," she says. "Sometimes, my husband would catch a big shark, and we would sell part of it and keep some to dry."

She recalls that potatoes were the principal food when she was young—*beni imo*, the purple sweet potatoes that Emi is serving today. "I still love them. I eat slices of it every day. It's very healthy," she says. "Tell people they should plant their potatoes after the rain, when the ground is soft," she advises us, still hopeful that everyone, everywhere will suddenly decide to plant a garden. We don't burst her bubble.

Bitter Pill

Though many of Okinawa's grandparents and great-grandparents live into their late nineties and beyond, some in the next generation may not. According to Okinawa Prefecture statistics, Okinawans under the age of 50 now have higher rates of obesity, and a greater risk of cardiovascular disease, liver disease, and premature death, than the overall Japanese population.

A decrease in physical and mental stimulation, along with the loss of the age-old human desire to be needed, could also be a factor. Many Okinawans used to work into their nineties, farming, and weaving *bashofu*, a fine fabric made from a local banana fiber. *Bashofu* weaving was a home-based craft, and highly valued, but there are few, if any, weavers producing the fabric at home anymore. The workshop of Toshiko Taira, 87, and her daughter, in the northern Okinawa village of Kijoka, is virtually all that is left of the art.

But perhaps the finest legacy of Okinawan longevity is that it's a sharing culture. There's even a word for it—*kari*. "When I was small," says Takeo Matsuda, "and the nation wasn't yet wealthy, it was just common sense that everyone shared. If a family grew more potatoes than they needed, they would share them. It was a very cooperative system." Though life has changed a lot in Okinawa since he was a boy, he's happy to see that quality in his children—whatever they're eating.

In 1976, medical researcher Makoto Suzuki was fascinated to learn that Okinawa had the world's highest life expectancy and the highest percentage of centenarians in the world. Reports of big centenarian populations in the Caucasus Mountains, in Pakistan's Hunza Valley, and in Ecuador's Vilcabamba have proven to be exaggerated. But in Okinawa, Suzuki discovered, the claims were verifiable—the government has maintained birth registers since 1879. In most industrialized countries, just ten out of every 100,000 people make it to 100. In Okinawa, the figure is 33.6—three times as high. Moreover, these very old people have very low rates of dementia, cancer, and cardiovascular disease. How do they do it? Suzuki wondered. Is there a lesson here for the rest of the planet?

The Okinawa Centenarian Study (OCS), begun by Suzuki, has examined 675 centenarians, looking for clues to their longevity and good health. The researchers knew from the beginning that they were unlikely to find definitive answers—war and migration have affected the island's population in ways that are impossible to completely account for. But Suzuki came to believe that the Okinawan miracle is due, at least in part, to the island's combination of a low-paced, stress-free life; regular exercise (mainly martial arts); and a good diet (lots of vegetables, fruits, tofu, and fish—little meat and dairy). In addition, many Okinawans believe in *hara hachi bu*—"eat only until 80 percent full." The body requires a long time to register satiety, so that Okinawans who live by the principle of *hara hachi bu* don't overeat.

These ideas aren't surprising. Yet they seem difficult for humankind to follow. Despite the living example of their parents, younger Okinawans are abandoning their forebears' healthy habits in the world of fast food and couch-potatodom. In consequence, researchers say, they may end up with shorter life expectancies than their parents. A demographic anomaly. —*Charles Mann*

At a nursing home near Ogimi Village, most of the community turns out to honor the birthdays of three residents, including Matsu Zakimi (left), turning 97, and Sumi Matsumoto (right), turning 88. (These are traditional Japanese birthdays, not the actual birth dates—88, for example is celebrated on the eighth day of the eighth month in the lunar calendar.) Musicians, dancers, and comedians perform as well-wishers cheerfully gorge on sushi, fruits, and desserts.

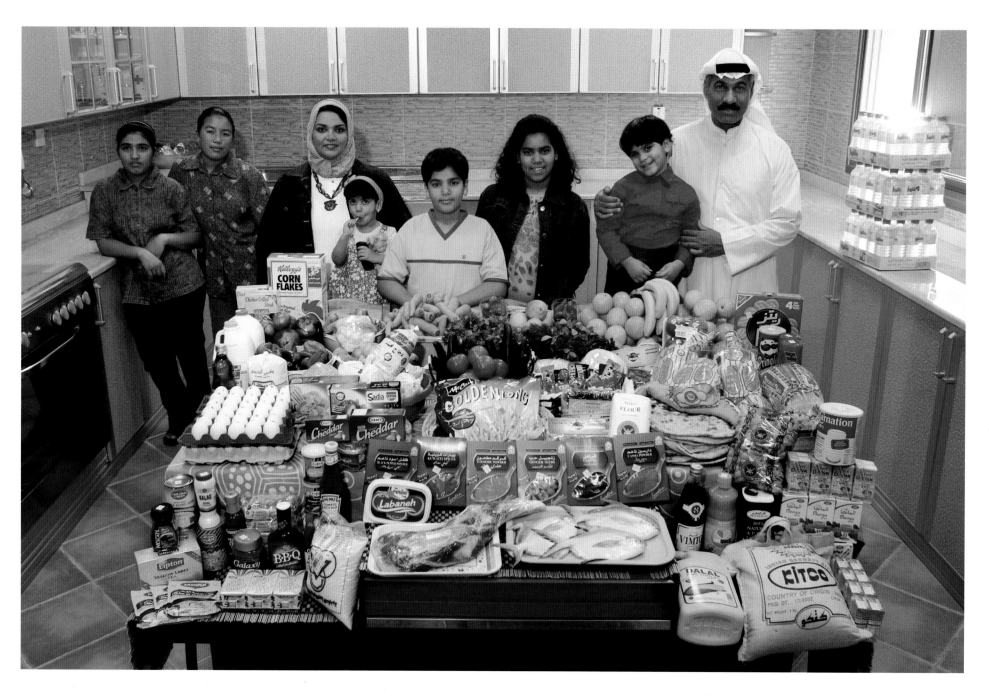

The Al Haggan family and their two Nepali servants in the kitchen of their home in Kuwait City, Kuwait, with one week's worth of food. Standing between Wafaa Abdul Aziz Al Qadini, 37 (beige scarf), and Saleh Hamad Al Haggan, 42, are their children, Rayyan, 2, Hamad, 10, Fatema, 13, and Dana, 4. In the corner are the servants, Andera Bhattrai, 23 (left), and Daki Serba, 27. Cooking methods: gas stoves (2), microwave. Food preservation: refrigerator-freezer.

Oil for Food

ONE WEEK'S FOOD IN APRIL

Grains & Other Starchy Foods: $21.20

Kitco basmati rice, 11 lb; potatoes, 6.6 lb; hot dog rolls, 3.7 lb; Iranian bread, 3.4 lb; *Normal* white toast bread, sliced, 2 loaves; *Patent* all-purpose white flour, 2.2 lb; *Kellogg's* corn flakes, 1.1 lb; macaroni, 1.1 lb.

Dairy: $19.37

Almarai laban (fresh drinkable yogurt), low fat, 2.1 qt; yogurt, 2.3 lb; chocolate milk, 25.4 fl oz; cream, 1.7 lb; *Kraft* Cheddar cheese, 1.7 lb; *Kraft* soft cream cheese spread, 1.1 lb; *Carnation* milk, powdered, 14.1 oz.

Meat, Fish & Eggs: $49.73

Chickens, 5 whole, 11 lb; leg of lamb, 6.6 lb; zobaidy (fish), 5.4 lb; eggs, 30; *Kabir Al Hajim* Americana jumbo hamburger patties, 2.2 lb; *Sadia* chicken nuggets, 13.2 oz; chicken steak, frozen, 13.1 oz.

Fruits, Vegetables & Nuts: $46.59

Oranges, 13.2 lb, *half for juicing, half for eating;* lemons, 4.4 lb; apples, 2.3 lb; dates, 2.2 lb; yellow bananas, 2.2 lb; strawberries, 1.7 lb, *from Egypt;* carrots, 12 lb; cucumbers, 6.6 lb; red onions, 6.6 lb; cabbage, 2 heads, *from Jordan;* zucchini, 3.3 lb; lettuce, 3 heads, *from Egypt;* cauliflower, 1 head; tomatoes, 2.2 lb; green bell peppers, 1.8 lb; *California Garden* Golden Sweet whole-kernel corn, canned, 1 lb; *California Garden* mushrooms, canned, 1 lb; salad greens, 2 bunches.

Condiments: $39.68

White sugar, 4.4 lb; *Dalal* pure corn oil, 2.1 qt; *Vimto* fruit cordial syrup, 24 fl oz, *used for nonalcoholic fruit drinks; Kroger* Hot n' Zesty BBQ sauce, 1.1 lb; *Consul* olive oil 16.9 fl oz; cilantro, 3 bunches; *Heinz* tomato ketchup, 12 oz; *Galaxy* Smooth and Creamy chocolate spread, 10.9 oz; *Fountain* pepper steak sauce, 10.6 fl oz; *Kalas* salt, 8.8 oz; black pepper, 7.1 oz; cassia powder, 7.1 oz; cloves, 7.1 oz; mixed Kuwaiti spices, 7.1 oz; *Taebah* cinnamon, 7.1 oz; *Taebah* garlic powder, 7.1 oz; mint, fresh, 2 bunches; mesquite sauce, 6 fl oz; ginger seed, 5.3 oz; *Taebah* cardamom, 5.3 oz; *Rajah* curry powder, 3.5 oz; *Rajah* ginger, ground, 3.5 oz; turmeric powder, 3.5 oz; dill, fresh, 1 bunch; *Crystal* hot sauce, 3 fl oz.

Snacks & Desserts: $12.51

McCain Golden Long French fries, frozen, 3.3 lb; *Hit* biscuits, 1.1 lb; *Ritz* crackers, 14.1 oz; *Pringles* Original potato chips, 6 oz; *Mars* candy bars, 2.1 oz; *Snickers* candy bars, 2.1 oz; *Twix* candy bars, 2.1 oz; *Bounty* candy bars, 2 oz; *Maltesers* chocolate candies, 1.3 oz; *Kit Kat* candy bars, 0.7 oz.

Prepared Food: $5.97

Maggi chicken noodle soup, 14.1 oz; *Sadia* breaded vegetable nuggets, frozen, 13.2 oz; *Maggi* dry soup, 7.2 oz.

Beverages: $26.40

Bottled water, 7.9 gal; apple and apricot juice, 8 4.2-fl-oz boxes; *Areen* apple juice, 1.1 qt; *Junior Drink* mango and vitamins juice, 8 4.2-fl-oz boxes; mango juice, 6 5.6-fl-oz boxes; *Sunquick* orange juice concentrate, 28.4 fl oz; *Nescafe*, 1.8 oz; *Lipton* yellow label tea, 50 teabags.

Food Expenditure for One Week: 63.63 dinar/$221.45

Because of its vast oil wealth, Kuwait can and does subsidize nearly every part of its people's lives—employment, health, education, housing—and even some grocery stores. The government provides a job to virtually every Kuwaiti citizen, women included. Saleh works for the nationally owned Kuwait Oil Company. Wafaa is a school inspector for the education ministry. Unlike women in Saudi Arabia, who by religious decree are not allowed to drive, Kuwaiti women do drive—a lot. Besides driving to shop and work, Wafaa, the Kuwaiti version of a soccer mom, spends a lot of time carting the kids to club activities and after-school sports. Highways carve up Kuwait City, as they do the sprawling western cities of the United States, connecting one shopping oasis or residential area with another.

T HE OLDEST AL HAGGAN CHILDREN, Hamad and Fatema, eat their usual breakfast of salty olives, tomatoes, cucumber, eggs, feta, Laughing Cow and Kraft cheeses, and fresh, chewy Iranian flat bread, then take the house elevator to their bedrooms in the upper reaches of their newly built home in Kuwait City. As they leave, the Nepali servant Daki Serba watches, amused, as the children's mother, Wafaa Abdul Aziz Al Qadini, tries to tempt her youngest daughter, 2-year-old Rayyan, with forkfuls of tomato omelet. Dana, 4, who is also still at the table, eats with so much enthusiasm that Wafaa is thinking of putting her on a diet. As both little girls drink their milk tea, Daki and Wafaa discuss today's lunch: lamb *biryani*. They speak in Arabic, which Daki has learned since she's come to Kuwait.

Wafaa makes out a shopping list: Egyptian strawberries, Heinz ketchup, Kraft mayonnaise, Carnation powdered milk, Galaxy chocolate spread, Consul olive oil, and Jordanian cabbages. Most of the food in this oil-rich but soil- and water-poor country is imported, as are the laborers who come as service and industry personnel, and as domestic helpers. Guest workers, who outnumber Kuwaiti residents, cannot become citizens. The Al Haggans hired Daki and the family's other Nepali servant, Andera Bhattrai, through an agency, along with Rayyan's nanny, a Filipina woman whose work visa has just expired. "She left last night to return to the Philippines," says Wafaa. "Rayyan will probably cry for her all day."

Wafaa leaves the two girls with Daki and takes the elevator upstairs to put on a new head-scarf (Muslim women in Kuwait must dress modestly, yet they have more personal choice than the women in many other Arab countries). Her tall, trim husband, Saleh Hamad Al Haggan, and the servants are the only ones who use the staircase. She grabs the keys to her late-model American-made minivan for the drive across town to her favorite supermarket.

Today being Friday, the Muslim weekend, 10-year-old Hamad walks to the neighborhood mosque for noon prayer. "The supermarket near the mosque is an added incentive for attendance," says Wafaa, laughing. "I tell him, if he goes to the mosque, he can go to the supermarket afterward and buy anything he wants." What does he want? More often than not, something from the global marketplace—Snickers, Twix, Mars, and Pepsi.

"We never forget" say the signs posted all over Kuwait City, referring to the Iraqi invasion in 1990 and the country's subsequent liberation by a U.S.-led coalition. Just 90 minutes by freeway from the border with impoverished, war-torn Iraq, the affluent Kuwaiti capital is peppered with U.S. fast-food chains and franchised restaurants.

KUWAIT

- Population: **2,257,549**
- Population of Kuwait City: **388,532**
- Area in square miles: **6,879 (slightly smaller than New Jersey)**
- Population density per square mile: **328**
- Urban population: **96%**
- Percentage of population that are non nationals: **57**
- Percentage of citizens that are eligible to vote: **10**
- Land that is barren desert: **91%**
- Water supply from desalinated sea water: **90%**
- Water supply from brackish ground water: **9%**
- Food imported: **98%**
- Oil exported: **96%**
- Life expectancy, male/female: **76/77 years**
- Fertility rate (births per woman): **2.7**
- Literacy rate, male/female, 15 years and older: **85/82%**
- Caloric intake available daily per person: **3,010 calories**
- Annual alcohol consumption per person (alcohol content only): **0.1 quart**
- GDP per person in PPP $ (Purchasing Power Parity: an adjustment for what equivalent local goods would cost in the U.S.): **$16,240**
- Total annual health expenditure per person in $ and as a percent of GDP: **$537/3.9**
- Overweight population, male/female: **70/77%**
- Obese population, male/female: **30/49%**
- Population age 20 and older with diabetes: **9.8%**
- Meat consumption per person per year: **132 pounds**
- McDonald's restaurants: **37**
- Big Mac price: **$7.33**
- Cigarette consumption per person per year: **3,026**

DAILY BREAD

Like most Kuwaitis, Wafaa does most of her grocery shopping in one of the country's many Western-style supermarkets—in her case, a multistory market in a shopping center run by the government-subsidized Shamiya and Shuwaikh Co-operative Society *(bottom left)*. Although Kuwait imports 98 percent of its food, much of it from thousands of miles away, the choice and quality of the goods on display easily match those in European or U.S. markets, and the prices are lower.

Despite the convenience and selection at the Shamiya, though, Wafaa goes to a small shop for one of the most crucial components of her family larder—bread. A plate of *nan-e barbari*, Persian-style flat bread, accompanies every meal in Kuwait, and Wafaa has strong opinions about the skills of the various bakers in the neighborhood.

Unleavened and made with hard wheat, *nan* is cooked in a *tannur*, a traditional Iranian oven. Basically, the *tannur* is a big, round, clay oven; traditionally, its inner walls are hardened with a protective coating of mustard oil, yogurt, ground spinach, and raw sugar. At the bottom is a hinged door that workers reach through to set and light a wood or gas fire.

After punching the air out of the bread dough, the Iranian bakers in Wafaa's neighborhood slap the flattened disks, one at a time, onto the *tannur's* hot inner walls *(above left)* with a tool that resembles an upholstered seat cushion. Meanwhile, other workers extract the cooked loaves with long tongs and flip them onto countertops to cool.

When Wafaa or her servant Andera Bhattrai takes the five-minute walk from home to their favorite bakery, she always tries to buy sesame seed *nan*, a family favorite. The government-subsidized price is 20 fils (17 cents, USD) per loaf. Slipping the bread, still warm and fragrant from the *tannur,* into a zippered pouch keeps it fresh all day.
— *Charles Mann*

During my first trip to Kuwait in 1991, more than 700 of the country's oil wells were set on fire by a neighbor's retreating army. In February and March 2003, I made my fifth trip there, and now the fear was that the neighbor's army would set its own oil wells on fire.

Because unexploded cluster bombs still littered the Iraqi oil fields, the oil-well-fire specialists from Texas, who were waiting in Kuwait with their brand-new, multimillion-dollar equipment, couldn't enter Iraq. Meanwhile, as they were fuming over their inactivity, I went into Iraq with the KWWK (Kuwaiti Wild Well Killers), a special division of the government-owned Kuwait Oil Company. Instead of waiting for U.S. military's explosive ordnance disposal, they used bulldozers to scrape aside the unexploded bombs, which were the size of small juice cans. At the outset, I was skeptical; the Arab stereotype of Kuwaitis is of a people so rich that they never do any physical labor (the work is done by foreign-born guest workers, who make up more than half the population). To tell the truth, I had turned up little evidence to dispel the stereotype during my previous trips to Kuwait. But the KWWK rapidly impressed me with their willingness to get down and dirty in the dangerous work of getting rid of the bombs and then capping and extinguishing the oil-well fires.

Working straight through the day, the devout Muslim crews took double prayer breaks at noon, so they wouldn't have to stop to pray again before sunset. One of my favorite photos of my new friends is taken from behind: all of them in their sweat-and-smoke-stained clothing, prostrating themselves toward the east, toward Mecca, toward the fires they were about to quench, and toward the blue cooler of soft drinks they would consume later, to quench their own thirst.

— Peter

Wafaa Al Haggan's Chicken *Biryani*

4 cups basmati rice

1 t saffron, soaked 10 minutes in warm water

1/2 cup corn oil

2 cups onion, shredded

1 T garlic, crushed

1/2 t fresh ginger, grated

1 whole chicken, cut into 10 pieces

salt

1 T coriander seed, ground

1 t turmeric

3 t allspice

2 T *ghee* (clarified butter)

1 cup yogurt

1 cup fresh tomato, chopped

1 T freshly squeezed lemon juice

Garnish:

1 cup onion, shredded and fried until crispy

1/4 cup pine nuts, toasted

1/4 cup raisins, fried

1/8 cup cashews, fried

- Rinse rice, soak for 30 minutes, drain.
- Preheat oven to 350° F.
- Heat wide, shallow pan until hot; add oil. When oil is hot, add onion, garlic, and ginger; sauté until onion is translucent.
- Add chicken pieces, salt, coriander seed, turmeric, 1 t allspice, yogurt, tomato, and lemon juice. Stir over moderate heat for 7 minutes, taking care to prevent yogurt from boiling. Add water to cover; cook at high simmer for 45 minutes.
- Boil rice with 1 T salt for 5 minutes, drain.
- Put 1 cup rice in a pot, add chicken mixture, then cover with 1/2 of remaining rice. Top with *ghee*, saffron, remaining allspice, and remaining rice.
- Cover pot with aluminum foil and pot lid. Cook in preheated oven for 45 minutes.
- Remove from oven, stir to combine, and serve. Sprinkle on garnish.

Because 98 percent of the food in Kuwait is imported, Wafaa's kitchen *(above left)* is a snapshot of the world's market basket. Yet the diverse breakfast mix of Western (tomato omelet) and Eastern (cucumber salad, olives) is not enough to tempt fussy 2-year-old Rayyan *(above)*. Most of the family's dinners still center around traditional Arab foods like lamb *biryani (bottom left, on the Al Haggans' kitchen table; see recipe for similar dish).*

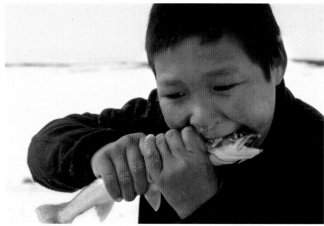

ARCTIC CHAR • EASTERN GREENLAND

SNAPPER • GINOWAN CITY, OKINAWA

HAMSI • ISTANBUL, TURKEY

CRABS • BEIJING, CHINA

PRAWNS IN CORN CAKES • COLOMBO, SRI LANKA

SWORDFISH • PALERMO, ITALY

TILAPIA FROM THE NIGER RIVER • KOUAKOUROU, MALI

DRIED FISH FROM LAKE VICTORIA • KAMPALA, UGANDA

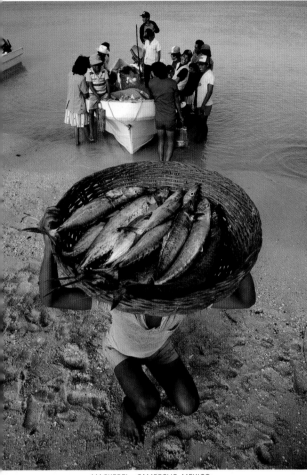

MACKEREL • CAMPECHE, MEXICO

FROZEN TUNA AT TSUJIKI AUCTION • TOKYO, JAPAN

Fish

About a third of humankind lives within 50 miles of a coast, as Carl Safina notes in the accompanying essay. Hundreds of millions more have their homes near rivers and lakes. Is there a large or medium-size city anywhere on earth without a fishmonger? Surely not. Dieticians urge people to eat even more fish—seafood, they believe, is not only uniquely delicious, but uniquely healthy. Unfortunately, *Homo sapiens'* love for the fruits of the sea is imperiling aquatic ecosystems everywhere. The abundance celebrated in these images, ecologists warn, may not survive this century.

COQUILLES ST. JACQUES AND BAR • NEUILLY, FRANCE

KING THREADFIN • AGATS, PAPUA

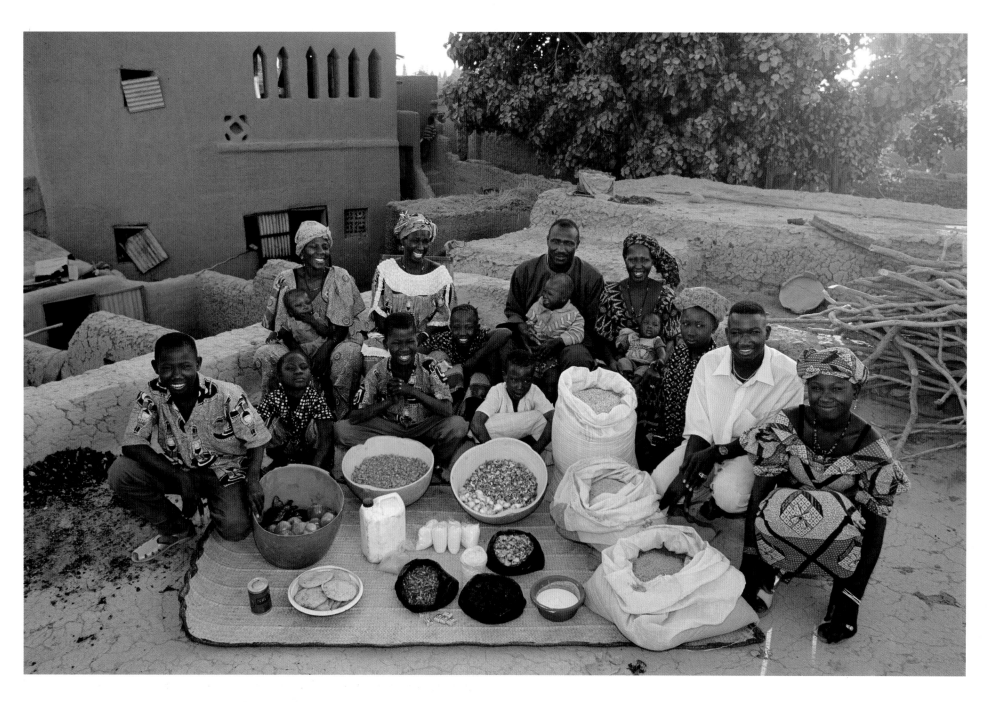

The Natomo family on the roof of their mud-brick home in Kouakourou, Mali, with a week's worth of food. Cooking method: wood fire. Food preservation: natural drying. Favorite foods—the Natomo family doesn't think in terms of "favorites." *(See opposite page for list of family members.)*

Trading Spaces

Grains & Other Starchy Foods: $11.77

Corn, dried, 66.2 lb; millet, 44.1 lb; rice, smoked, 44.1 lb.

Dairy: $0.30

Sour milk, 1.1 gal.

Meat, Fish & Eggs: $1.49

Fish, dried, 4.4 lb, *used in fish and okra soup when the family can afford it, otherwise, they have soup with okra only.*

Fruits, Vegetables & Nuts: $6.50

Tomatoes, 5.5 lb; okra, dried, 4.4 lb; onions, fresh 2.2 lb; onions, dried, 1.1 lb; red peppers, dried, 14.1 oz; *Anna d'Italie* tomato paste, canned, 14 oz; *not a common purchase, although they like to buy it when they can afford it.*

No fruits were in season at the time the photograph was taken. In season, they have mangos from the ten trees planted by Sumana's father. Oranges from the market are also purchased if they can afford them.

Condiments: $6.03

Vegetable oil, 1.1 gal; salt, 5.5 lb; tamarind, 2.2 lb; white sugar, 7.3 oz; sumbala (spice from nere tree pods), 3 lb, *used as a bouillon for soup, mixed with hot pepper and dry onion and cooked with smoked rice.*

Prepared Food: $0.30

Maggi bouillon cubes, 2.1 oz, *the family purchased this, but they normally use the traditional sumbala.*

Homemade Food:

Ngome, approx. 4 lb, *thick fried cake made of millet flour, water, vegetable oil, (and an inadvertent bit of sand).*

Beverages:

Water, drawn from community well for drinking and cooking.

Food Expenditure for One Week: 17,670 francs/$26.39

Family members: Soumana Natomo, 46 (in blue), sits flanked by his two wives, Fatoumata Toure, 33 (on right) and Pama Kondo, 35. Soumana and Fatoumata's children are daughter Tena, 4 months (in Fatoumata's lap), daughter Fourou, 12 (in front of her mother), son Kansy, 4 (in Soumana's lap), and son and daughter Mama, 8, and Fatoumata, 10 (both at their father's feet). Soumana and Pama's children are son Mamadou, 10 (in front of his mother), son Mama, 13 (far left), and son and daughter Kantie, 16, and Pai, 18 (far right). To Pama's left is Kadia Foune, 33, Soumana's sister-in-law, with her children Kantie, 1 (in her lap), and Mariyam, 8 (squatting). They are living with the Natomos while Kadia's husband works in Ivory Coast.

Pama is the methodical partner, the one who has a good head for math and takes the long view of her family's needs. Fatoumata is the contemplative one, who prefers to complete one chore before moving on to another. In any culture, they would make quite a team: in Mali, they're co-wives.

THE VILLAGE OF KOUAKOUROU—north of Mali's capital, Bamako, on the Niger River, between Mopti and Djenne—looks as though it might have risen one day from the depths of the desert. The houses and courtyard walls blend in with the earth around them: desert-colored, sun-dried, mud-bricks, stuck together with mud mortar and plastered—with mud. There is no electricity. Inside the houses, the windowless rooms are cool and austere, containing only a sleeping mat or two, and sometimes a cushion or a stool. A high-walled courtyard—for cooking, mealtimes, and general daily life—surrounds each house, and beyond that is a common area where the women and girls (and sometimes boys, but never men) wrap their practiced hands around a pestle and pound grain in a mortar, singing to pass the time. Women and girls move through skinny high-walled alleyways to the community wells, with pails of water, or dishes, or loads of laundry, balanced on their heads. Those same paths lead to the river, where people wash their clothes, their dishes, and themselves; or catch a *pegasse*, a covered wooden passenger boat, for the several-hour trip downstream to Mopti, a busy trading center.

Between them, Pama and Fatoumata have one husband and nine children to feed and nurture. They are Muslim, and according to their religion's precepts their husband is allowed to have up to four wives, if he can support them and treat them equally. Pama tells me that it's this last part of the Muslim law that tends to escape the average Malian male, but both Pama and Fatoumata say their husband is not one of these men. "In so many families here, the wives and the children don't like each other," says Fatoumata. These co-wives say the husbands are to blame. "What Soumana does for one of us," says Pama, "he does for the other. In so many families this isn't true. We have to share our husband, but that's okay. If you see women fighting, it's usually because their husband is not treating them equally." For Pama, the bottom line is economic: "When you are married to the same man, if the

wives don't get along, it makes too many problems in the family. It can really reduce the earnings." The two women have another relationship as well: Pama is older than Fatoumata by a few years, but Fatoumata is Pama's mother's younger sister, and therefore Pama's aunt.

MILLET TIME

Breakfast at the Natomos begins well before sunrise with the lighting of the morning fire in Pama's courtyard. Although the two co-wives each have their own home, they spend most of their waking hours here. Today, it's Fatoumata's turn to cook. Pama is still asleep inside her house, along with her children. Soumana and most of Fatoumata's children are still sleeping at Fatoumata's house (it was her turn to have him stay overnight). The exceptions are baby Tena, slung on her back, and 4-year-old Kansy, who is running around the courtyard in fuzzy blue pajamas—used clothing sent from France, the country's one-time colonial ruler. Roosters provide the accompaniment to the rhythmic shwooshing of the millet against the basket as Fatoumata rocks it back and forth to winnow out the chaff. She pours water over the grain from a large potbellied cask, discards the debris that floats to the surface, pours off the water, and dumps the millet into the cooking pot, then adds fresh water and stirs. The porridge—called *tô*—is not as thick as other African grain foods, like *aiysh* (p. 57), and is eaten with a soup- or saucelike accompaniment (salt, oil, and tamarind today). Both families eat all their meals at Pama's house, which Fatoumata says is another key to the two women's good relationship. "We make a point of being together," says Fatoumata.

As Fatoumata finishes preparing their food, Soumana returns from the other house and makes the first of the five Muslim daily prayers. The women pray as well, but out of sight, and not with Soumana. Soon afterward, the children all arrive for breakfast, rubbing sleepy eyes. The two families sit together on the ground near the cooking fire and dip their spoons into the communal porridge pot. Some days, a wife might prepare smoked rice porridge with sour milk, and an okra soup with dried red peppers and salt; or a cornmeal porridge, and a smoked fish stew with tomatoes. There is no designated morning or evening food; all

meals center on porridge. The children help as they are asked, and no one seems concerned about whose mother is doing the asking.

PARK IT AT THE MARKET

Early on Saturday mornings, vendors and customers arrive at the water's edge by donkey cart, horse, motorcycle, and truck. Standing in small canoes, boys and men stick poles into the sandy bottom of the shallow inlet bordering the village, and ferry customers across to the Kouakourou side, and the market area that sits at the water's edge. They have to work nimbly to avoid the bigger, brawnier *pegasses* coming in from the Niger River. With no docks—only a best guess for a drop-off point— the *pegasses* hit the shore head-on as deckhands calmly collect empty glasses from captains and crews who have finished drinking sweet tea.

The busy market builds. Early vendors get covered stalls to sell their blankets, dented canned goods, meager household items, clay pots (fired overnight on the sandy shore), and bolts of the thin, cheap, bright-colored, machine-woven cotton that Malian women use for their flowing clothes and head wraps. Vegetable sellers, grain merchants, and meat and fish vendors set up together in rows, spreading their merchandise on the ground and visiting with one another as they work. Looking for a buyer, a boy walks around carrying a pair of live pigeons upside down by their feet. Women ease heavy bundles of goods down from one another's heads as children scamper around the jujube berries, tamarinds, and tomatoes. Babies alternately cry and sleep on their mothers' backs. Two men standing in the Niger inlet scoop the cooling muddy-brown water onto their sweating horses. A medicine man that sets up his traveling display of live scorpions, elixirs, and a tattered stuffed housecat immediately draws a crowd. Holding up a necklace he says, "Wear this and a snake can never bite you. Only 15 francs!" Vendors disembark from boats, dodge the women washing breakfast dishes at the water's edge, and unload their sacks of millet, corn, and rice. The heat intensifies, and the dust level rises. The sand whips up, ensuring that the latest batches of fried *ngome* (salted corn or millet cakes) and *frufru* (fried millet balls) will have that little extra crunch.

By 11:00 a.m. on Saturday, Kouakourou's weekly market has transformed the usually quiet shoreline of this Niger River backwater into a throng of bustling, thatch-shaded stalls and sharp-prowed traders' boats from up the river and down. Soumana (upper left, in blue, arm outstretched in front of his rented storeroom) goes to the market every week to buy and sell grain with his two wives, Pama and Fatoumata.

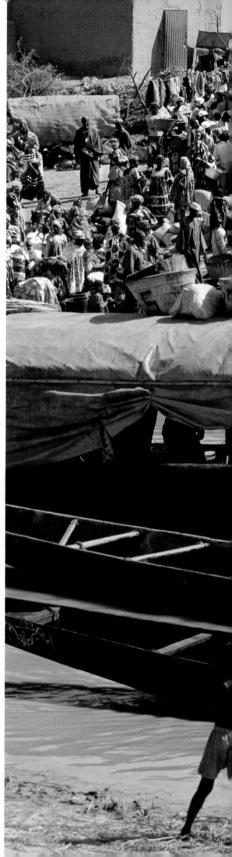

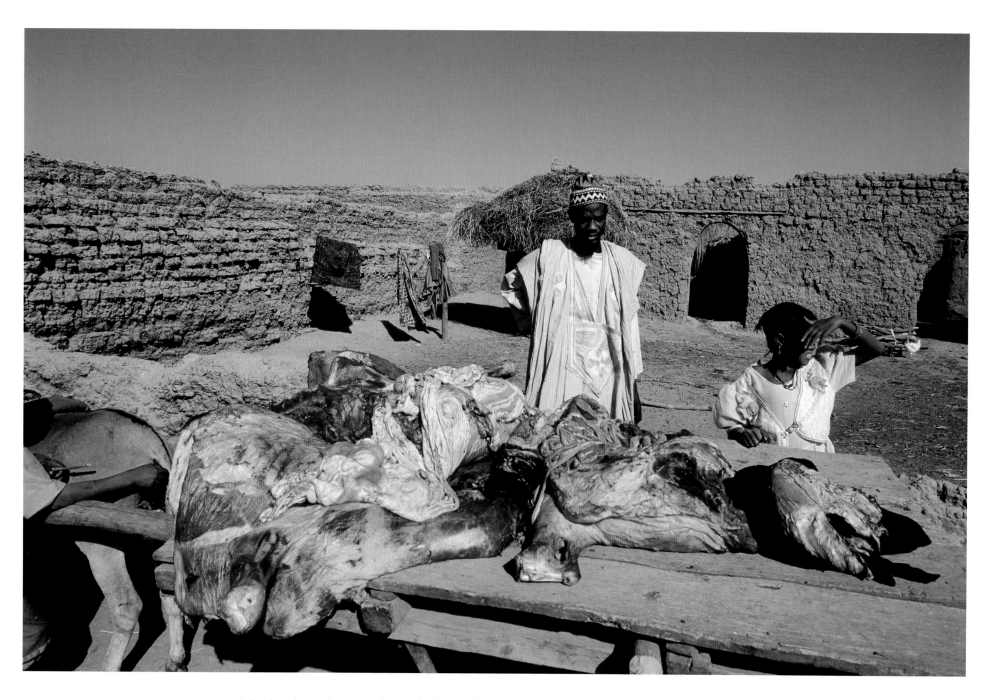

A slaughtered cow rolls on a cart through the dusty mud-brick village of Kouakourou, destined for sale that day at the nearby Saturday market. Because the town has no electricity, and thus no refrigeration, this family will sell all their meat by sunset of the same day that the cow was slaughtered.

MALI

- Population: **11,956,788**
- Population of Kouakourou village: **2,200 (est.)**
- Area in square miles: **478,640 (slightly less than twice the size of Texas)**
- Population density per square mile: **25**
- Urban population: **33%**
- Population living below the poverty line (urban/rural): **30/70%**
- Percent of population that are nomadic: **10**
- Percent of population that are farmers or fishermen: **80**
- Land that is desert or semidesert: **65%**
- Rural households with access to electricity: **1%**
- Life expectancy, male/female: **44/46 years**
- Fertility rate (births per woman): **7**
- Literacy rate, male/female, 15 years and older: **53/40%**
- Caloric intake available daily per person: **2,174 calories**
- Annual alcohol consumption per person (alcohol content only): **0.3 quarts**
- GDP per person in PPP $ (Purchasing Power Parity: an adjustment for what equivalent local goods would cost in the U.S.): **$930**
- Total annual health expenditure per person in $ and as a percent of GDP: **$11/4.3**
- Physicians per 100,000 people: **4**
- Overweight population, male/female: **13/26%**
- Obese population, male/female: **0.4/3%**
- Population age 20 and older with diabetes: **2.9%**
- Meat consumption per person per year: **42 pounds**
- McDonald's restaurants: **0**
- Cigarette consumption per person per year: **233**
- Population living on less than $2 a day: **91%**

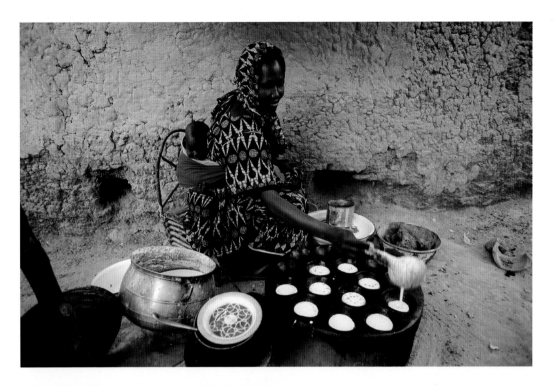

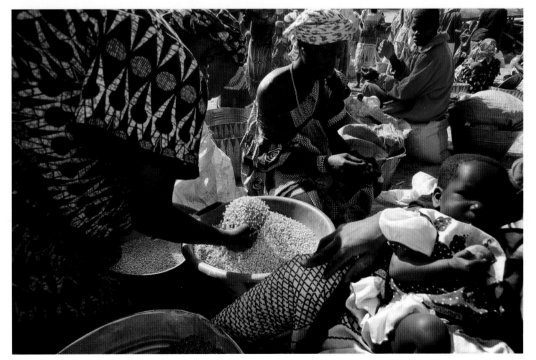

FAMILY RECIPE

Natomo Family Rice Dish

2 oz *Anna d'Italie* tomato paste, or dried tomatoes

1 oz dried red peppers, chopped

9 oz karite butter (shea butter, made from the shea nut) or oil

2 oz *Maggi* boullion cube

9 oz onions, chopped

4-1/2 lb smoked rice

1 oz salt (or to taste)

4 fl oz broth made with *sumbala* (spice made from nere tree pods)

- Combine all ingredients with water to cover and simmer over fire until soft.

In the predawn light, with little Tena bundled onto her back, Fatoumata crouches in the street outside her apartment and lights a fire under the griddle she uses to cook *ngome (above left)*, thick pancakes made from finely pounded corn or millet flour, oil, and salt. Her house is only a minute's walk from the larger home of her co-wife Pama. Fatoumata repeats this streetside routine every day except Saturday, when she sells *ngome* breakfast cakes at the village market. On market days, she stops cooking early, though, to work with her co-wife *(bottom left, Fatoumata bending over and Pama at center)*. They acquire and unload grain in bulk and then sell it in smaller quantities to individuals and families. Soumana spends much of his time overseeing his working wives. Occasionally, he makes a trip to their single-room storehouse to replenish the grain his wives are selling.

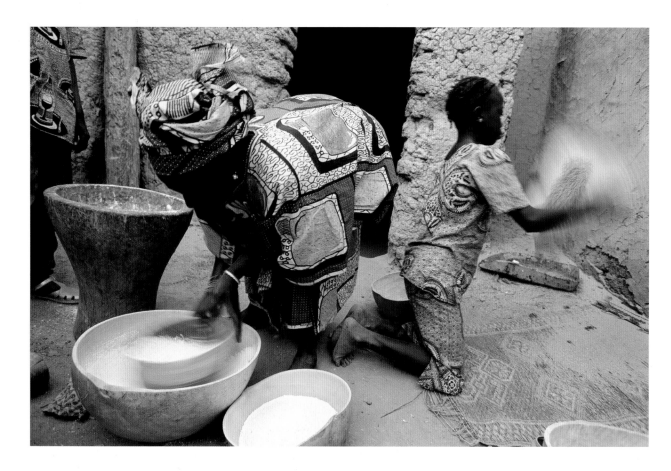

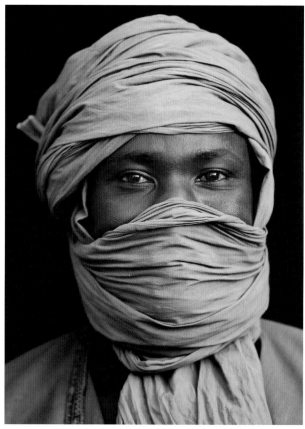

After pounding rice into flour in a large wooden mortar, Pama Kondo *(above)* sifts it to get rid of any remaining hulls. Behind her, 10-year-old Fatoumata (daughter of Fatoumata, Pama's co-wife) does much the same with some sorghum. Can she foresee a day when she will no longer have to pound grain? "That's what children are for," she replies seriously. Although the afternoon is brilliantly hot, the nights can grow surprisingly cool *(above right, Soumana wraps his head and face for protection against many different elements—the morning chill, blowing sand, and the sun).*

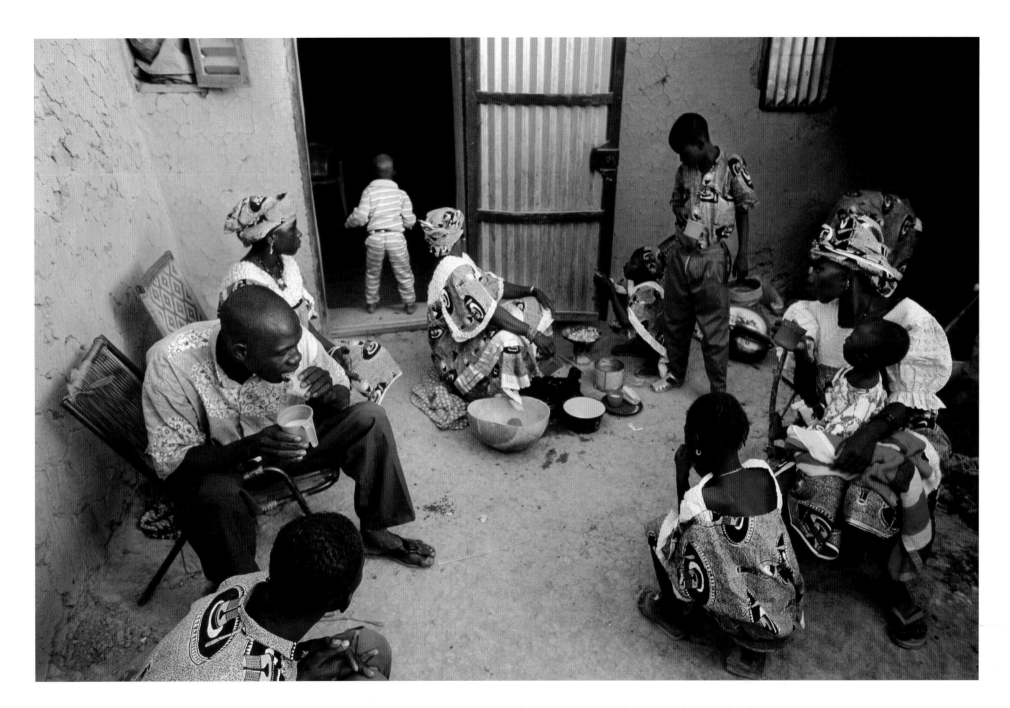

The morning that the family broke the news to Pai (seated, top left) that she was to marry her cousin, Baba (eating bread), they all had breakfast together in the courtyard of Soumana's house. According to custom, the couple then spent the day apart, Pai weeping openly over the loss of her childhood. The next day at the wedding party, Pai's mother Pama was dry-eyed while Fatoumata wept. She said that Pai had always been there to help with the babies and that she would be missed.

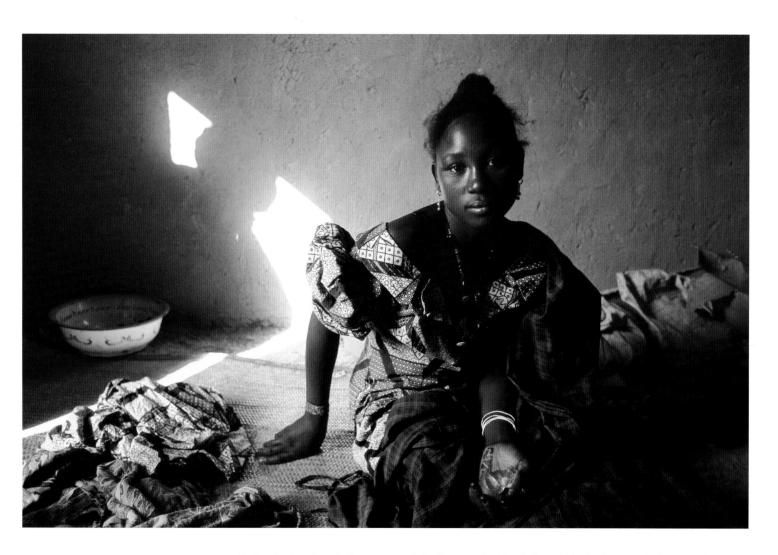

On Sunday, ignoring a half-eaten tomato in her henna-stained hand, 18-year-old Pai *(above)* somberly contemplates what she has just learned: later today she will formally wed her first cousin, Baba Nientao, and then move to his home in Ivory Coast. None of the parents attend the ceremony. Instead, Pai's girlfriends lead her raucously *(at right, hidden under the shawl)* to the Town Hall, where she and Baba sign their marriage license alone with the mayor.

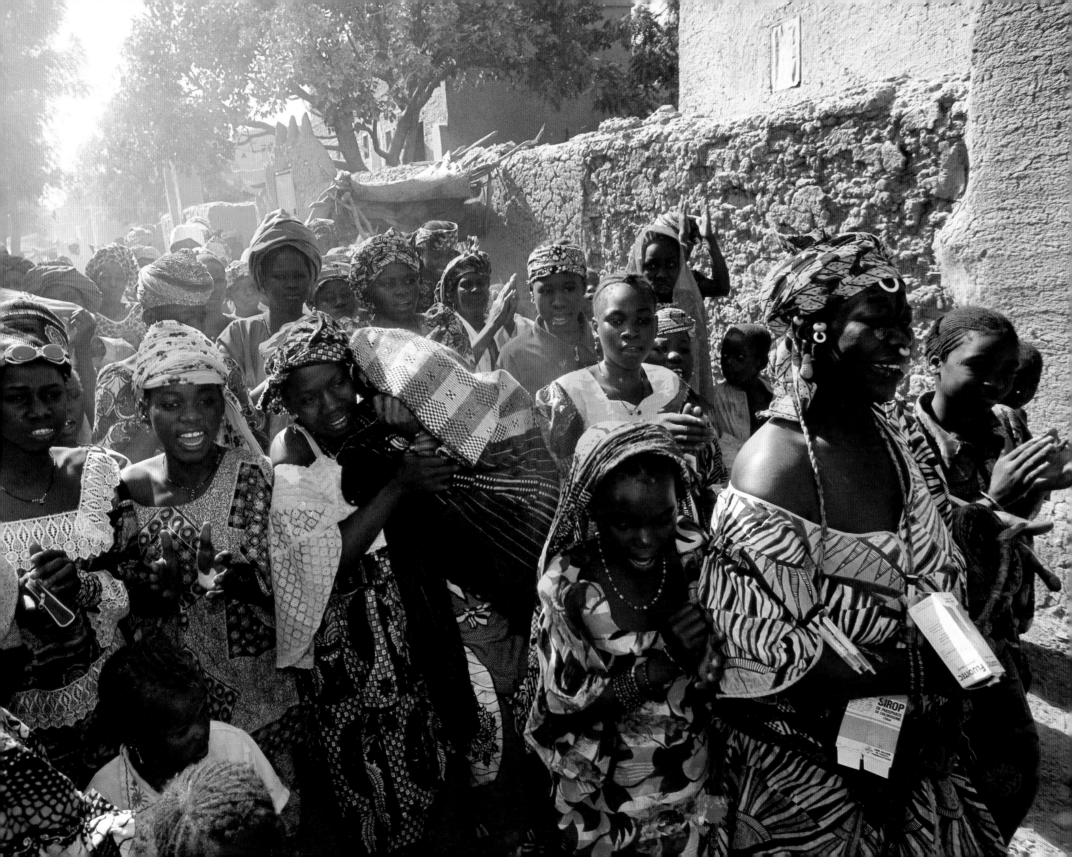

Soumana and Pama are grain traders, and at an early hour Pama is already measuring grain on a tarp stretched out on the ground at the market; Soumana is standing by for the volume sales. Fatoumata sometimes helps, but today she's buying the provisions for the family food portrait: a lot of smoked rice, dried corn, and millet, and a little dried fish. She purchases the millet from Pama, joking, "Give me a good price or I'll buy it from someone else." Pama fires back a comment in Bozo, the language of their ethnic group, and both laugh. (With outsiders, they use a more widespread language called Bambara.) Pama deftly measures out the 44 pounds the family will eat in one week and Fatoumata moves on. She picks through the planks of smoked and dried whole fish but doesn't like what she sees. The seller with the better fish isn't around, and though it pains Fatoumata, she doesn't have time to wait. She mutters about it as she turns over the money. Next she buys corn. "One day we have [corn meal] and another day we have millet," says Fatoumata, moving briskly through the vendors to search out those she trusts. She inspects one seller's smoked rice. "There is an old woman in town who has better smoked rice," says Fatoumata. "I'd rather have hers." But the woman's store isn't open on market day, so we buy what we can find.

Fatoumata sees differences in the grains that I don't see—like the plumpness of one grain of rice compared to another. I explain to her that we usually buy our rice in little bags, and we don't get to examine it—only choose the brand. She finds this unbelievable. There are almost no branded goods here, and the lack of marketing noise is refreshing—like silence after a storm. The market runs throughout the day, but we break for the family portrait, hoping that we're not costing the Natomos too much in lost business. Soumana says "No," we're not, and besides, he has a second, much bigger event to host this weekend—

Hide and Seek Bride

Fatoumata's tears belie her smile this morning, as she tends to baby Tena. Pama's daughter Pai is getting married today and will move from Mali to her new husband's home in Ivory Coast. "Since Pai was young, she has done all that she has been asked to do," says Fatoumata. Tears wet her cheeks and run down over the decorative tattoo that follows her jaw line. "She took care of all our babies. Now someone's carrying her away. I'll miss her," she says. Fatoumata's son Kansy follows Pai around like a puppy. He'll miss her too.

Throughout the day, custom and tradition will prevail. As the mother of the bride, Pama must keep her emotions hidden, and she maintains a stony façade. Pai is marrying her first cousin, Baba Nientao, and by tradition she has been told about the match only this morning—the day of her marriage. "Did Baba know he was to be married before this day?" I ask Soumana. "Of course," he says. I press: "Why is Pai not told?" "This is the custom," he says. After being informed of the marriage, the girl hides herself away—also customary, and as I work to keep my Western prejudices to myself, Fatoumata clarifies its meaning: "She is lamenting the loss of her childhood." Pai and Baba visit the government office to sign the official papers, and then their family elders visit the imam (Muslim prayer leader) to finish the agreement. Afterward, Soumana distributes small candies to the children waiting eagerly for this marriage custom. Tonight, Pai's girlfriends will hide her somewhere in the village, and the groom and his friends will find her. Tomorrow, dozens of girls will dance and sing, accompanied by a band of drummers, to honor the marriage.

"Is it better to be a woman or a man in this culture?" I ask Pama and Fatoumata. "A man," says Pama. She laughs. "Because here in Africa, women suffer much of the time. There is so much work that we do." Both Pama and Fatoumata are totally engaged in this conversation, and for the first time they interrupt one another and talk at once. Fatoumata says, "In our village of over 100 men, you will find only two who can take good care of their families." Pama continues: "Don't you see all our men sitting and sleeping and the women working to feed them? When you go out of this courtyard you should look around. You'll see so many men sitting around doing nothing. We'd like to be men and relax a bit." "Is this something you have discussed with Pai?" I ask. "I don't have to talk to her about such things," her mother says. "She knows."

Pama's work as a grain trader is more interesting to her than some of her household tasks, such as pounding grain for their meals. She laughs when I ask whether she knows how many barrels of grain she has pounded over her 35 years. "A lot," she says. But she expects that there will be less grain pounding in her future. She and other women in the village are taking a literacy class, and when they graduate, an aid organization will give the women a grain mill to share. "Only women will be allowed to use it," Pama tells me, continuing our conversation about gender. I tell her that I don't expect, after the initial newness wears off, that the men will want to use it anyway.

..
FIELD NOTE
..

There are no convenience stores or fast food in Mali. In this part of Africa, processed food is grain pounded by hand. Water is carried from community wells. Wood for the cooking fires is collected from far away. Dishes are washed in the Niger River. Mali food is slow food.

Resonating off the mud-brick walls of family courtyards, the heavy rhythmic thumping that permeates the dusty village air is not coming from boom boxes. The heart-beat of the village comes from heavy wooden pestles, pounding, pounding, pounding the hand-harvested grain—millet, dried corn, or smoked rice—into a fine flour. At Soumana's house, his two wives take turns doing the cooking. Most meals start when that day's cook makes a fire. Using the previously prepared flour, she then mixes the result with well water and dried okra, and, if they are available, fresh tomatoes to make a kind of vegetable porridge. The big pot is enough to feed Soumana, the other, non-cooking wife, Soumana's sister-in-law (who is living with them while her husband is away), and the children who happen to be around that day (usually there are at least eight).

We were never invited to sit and dine with the family, maybe because they eat most meals with their hands, out of a common pot, and they were afraid that we Westerners wouldn't like it. Or maybe there simply wasn't enough—I never saw any leftovers. While we were visiting, one of Soumana's daughters, Pai, got married in a complicated traditional ceremony that culminated the next day in a crowded, raucous party in the family compound. But no food at all was served to the guests.

I did have more than my share of the *ngome* (breakfast cakes) Fatoumata makes from pounded rice or millet, salt, and oil—they were quite tasty even with the occasional bite of gritty sand. But I could eat them at all only because Fatoumata made *ngome* daily in the street outside the house, selling them to customers (and to me). This was an amazingly friendly and hospitable family and village. But food was not part of their largesse.
— *Peter*

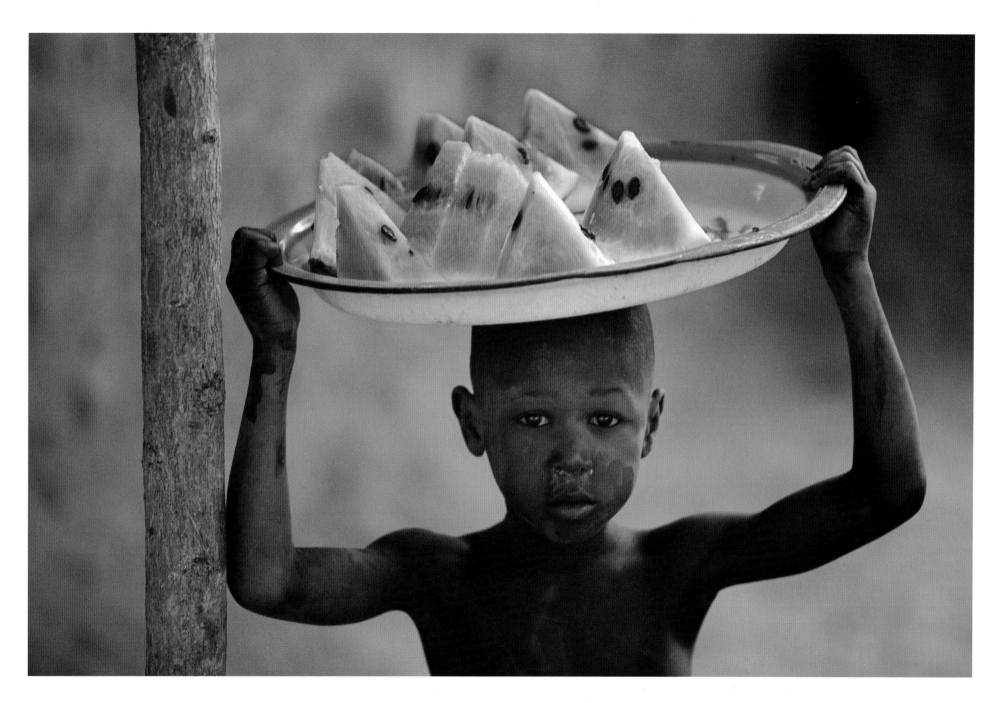

On a warm Saturday afternoon, a young boy with fresh watermelon slices uses the tray for shade as he walks through Kouakourou seeking buyers. He pauses by the outdoor barbershop where Soumana and a group of men are watching a documentary about a Los Angeles SWAT team. Their black-and-white TV is powered by a car battery charged by a solar panel on the roof of the small pharmacy next door.

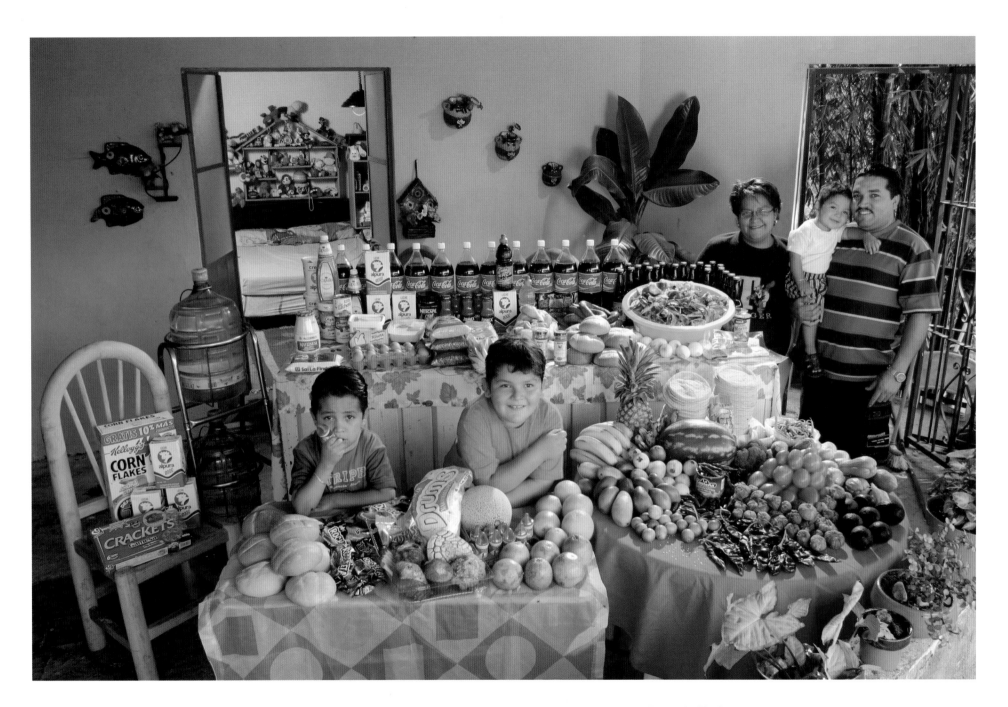

The Casales family in the open-air living room of their home in Cuernavaca, Mexico, with a week's worth of food. Marco Antonio, 29, and Alma Casales Gutierrez, 30, stand with baby Arath, 1, between them. At the table are their older children, Emmanuel, 7, and Bryan, 5. Cooking method: gas stove. Food preservation: refrigerator-freezer. Favorite foods—Marco Antonio: pizza. Alma: crab. Emmanuel: pasta. Bryan: crab and candy. Arath: chicken.

Wanted: Living Wage

Marco Antonio left Mexico for the United States in October of 2004, after agreeing to pay a smuggler $3,000 to get him there. He is now an illegal immigrant, picking fruit for $5 an hour, while his wife raises their three children alone. They never intended to live this way.

WHEN WE FIRST MET MARCO ANTONIO and his wife Alma, a former surgical nurse, they were living in a two-story, cement-block apartment outside Cuernavaca, 50 miles south of Mexico City, and operating a *changarro*—a mini convenience store—on the ground floor. Marco Antonio had been laid off from his job at a brewery a few years earlier and couldn't find another one. Having no savings and no alternative, the couple opened their own little store, which at first carried only 10 or 15 items—pork rinds, sausages, candies, Coca-Cola, and deli foods. With Marco Antonio and Alma splitting the shop keeping, they increased their selection and hung a television from the ceiling of the tiny store to help pass the time between customers. The family ate their meals together behind the counter—a common sight in Mexico's thousands of family-owned shops.

On any given day, the family schedule revolved around their *changarro*. Seven-year-old Emmanuel would tend to his little brother Arath while Marco Antonio tended to his customers—mostly neighbors and friends—through the shop window over a glass-fronted case. It wasn't uncommon for Marco Antonio to scoop up Arath and hold him while working in the shop. If he left to run errands, Alma would take over, because the key to making ends meet was keeping the shop open throughout the day and evening. At midday, Alma would cook the family lunch upstairs: usually rice and beans, and then chicken soup with cilantro, or a savory crab soup, or sometimes *tacos de carnitas* (pork tacos). Like most of her neighbors, Alma bought fresh corn tortillas every day from the *tortillería* nearby. When lunch was ready, she would bring it down to Marco Antonio in the shop, and the children would sit on the floor with their bowls in their laps to eat. In the early evening, they would have *merienda*, a light meal served with bread and fruit. Later in the evening, most Mexican families eat supper, although Alma said this is not her family's custom.

ONE WEEK'S FOOD IN MAY

Grains & Other Starchy Foods: $15.76

Corn tortillas, 22.1 lb; bread rolls, 3.1 lb; *Morelos* white rice, 2.2 lb; potatoes, 2.2 lb; *Bimbo* white bread, sliced, 1 loaf; *Kellogg's* Special K cereal, 1.1 lb; *Morelos* pasta, 1.1 lb; *La Moderna* pasta, 14.1 oz; pan dulces (sweet bread), assorted, 8.8 oz; bread sticks,‡ 3.5 oz.

Dairy: $26.81

Alpura 2000 whole milk, 1.9 gal; *Alpura* sour cream, 2.1 qt; *Muecas* ice cream pops, 1.1 qt; *Yoplait* yogurt, 1.1 qt; cheese, handmade, 1.1 lb; *La Lechera* condensed milk, canned, 14 oz; cottage cheese, 13.6 oz; *Carnation* evaporated milk, 12 oz; Manchego cheese, 8.8 oz; cream cheese, 6.7 oz; butter, 3.5 oz.

Meat, Fish & Eggs: $42.81

Chicken, pieces, 15.4 lb; crab, 2.7 lb; eggs, 18; tilapia (fish), 2.3 lb; catfish, 2.2 lb; sausage, 6.6 oz, *one month's worth shown in photo; FUD* ham, 5.6 oz.

Fruits, Vegetables & Nuts: $44.21

Mangos, 13.2 lb; pineapples, 6.6 lb; watermelon, 6.6 lb; oranges, 5.5 lb; cantaloupe, 4.4 lb; guavas, 2.2 lb; quinces, 2.2 lb; yellow bananas, 2.2 lb; roma tomatoes, 6.6 lb; tomatillos, 6.6 lb; corn,‡ 4 ears; avocados, 7; chayote squash, 2.2 lb; *Morelos* beans, 2.2 lb; white onions, 2.2 lb; zucchini, 2.2 lb; *La Costeña* pickled jalapeño peppers, canned, 1.6 lb; green beans, 1.1 lb; jalapeño peppers, fresh, 1.1 lb; broccoli, 12.8 oz; garlic, 8.8 oz; chipotle peppers (smoked jalapeños), 7.1 oz.

Condiments: $9.37

Capullo canola oil 2.1 qt; margarine, 15.9 oz; *McCormack* mayonnaise 13.8 oz; salt 8.8 oz; garlic salt 3.2 oz; *McCormack* black pepper 3.2 oz; cumin , 0.7 oz; bay leaves, dried, 0.5 oz.

Snacks & Desserts: $6.27

Rockaleta chili lollipops, 1.2 lb; *Ricolino* pasitas chocolate candy, 1.1 lb; *Gamesa* crackers, 15.9 oz; *Drums* marshmallows, 12 oz; *Rockaleta* chili candy, 5.7 oz.

Prepared Food: $4.79

Doña Maria mole (savory sauce made from chocolate and chili), 2.1 lb; *Knorr* chicken bouillon, 3.2 oz.

Beverages: $39.07

Coca-Cola, 12 2.1-qt bottles; water, bottled, 5 gal; *Victoria* beer, 20 11.8-fl-oz bottles; *Jumex* juice, 1.3 qt; *Gatorade* Fierce Black Hurricane drink, 1.1 qt; *Gatorade* lime drink, 1.1 qt; *Nescafe*, instant, decaf, 7.1 oz; tap water, for cooking.

‡ Not in Photo

Note: Grocery expenditure for one week, before the Casales famiy closed their shop and Marco Antonio moved to the US to find work.

Food Expenditure for One Week: 1,862.78 Mexican pesos/$189.09

As the children grew, so did their access to snack food—chips, candy, and other packaged and processed treats. Almost without exception, the Casaleses' meals were served with Coca-Cola, the family's beverage of choice. In a week's time, they drank more than 20 quarts of it. When Alma was a child, beans, pasta, rice, and tortillas were the mainstays of her family's diet, and there was no money for sugary or salty treats. "We only ate foods that [my mother] cooked," she says. "If I wanted candies or *refrescos* [soft drinks]" she says, "my mother would tell me, 'If I give you money for snacks, we won't have money for tortillas.'" Even as cash-strapped adults, Alma and Marco Antonio had access to a wider variety of foods, including a substantial amount of processed, high-fat, high-calorie snacks.

Traditional Mexican cooking—tamales, *huevos rancheros* with fresh corn tortillas, cheese enchiladas, quesadillas, beans and rice heavy with lard—is great fuel for the physically active, which the Mexican population, increasingly, is not. The population has been growing alarmingly heavy. According to statistics released by the World Health Organization in 2005, 65 percent of Mexico's population is now obese or overweight—a tremendously high number (though, still, 5 percent less than the equivalent U.S. population).

Like the United States, Mexico is overeating and underexercising. Alma and Marco Antonio's family are no exception: "My mother, and my mother- and father-in-law are overweight," Alma said. "And they all have diabetes." Alma, Marco Antonio, and their eldest son are also overweight. She worries that they, too, will become diabetic, but that worry hasn't yet been translated into action. Asked whether he got any physical exercise, Marco Antonio said no: "I used to play football and run around, but when the boys were born there wasn't any time for sports." Did he ever go out and run around with his children? "Not really," he said. Sitting behind the *changarro* counter for long hours each day waiting on customers surely wasn't burning any calories. Going to a health club—the solution to inactivity in postagricultural, post-industrial countries—wasn't an economic or logistical possibility for him.

Over time, more and more small stores opened up in Alma and Marco Antonio's neighborhood, taking a significant bite out of their profits. Big supermarkets, too, were moving into the community and drawing customers away. The couple wasn't getting enough business to justify staying open, but Marco Antonio had no other job options. After our visit, Alma's father, an undocumented worker who picks fruit in the U.S., suggested he join him. The couple decided this might be the only way to win financial security. They made arrangement with a *coyote*—a smuggler—to sneak Marco Antonio across the border in exchange for a $3,000 fee. They didn't have to pay it all at once—they gave the *coyote* a down payment and promised to pay the rest later. Both fearful and hopeful, Marco Antonio left his family behind.

Risky Business

So far, the risk has not paid off. Marco Antonio works only 20 or 30 hours a week, at $5 an hour. He sends his meager paychecks to Mexico, where Alma makes the monthly payment to the *coyote* and uses the little that remains to buy food and pay expenses. "We don't eat the way we used to," says Alma, but they aren't eating any healthier either. They eat fewer fresh fruits and vegetables, but the snack foods and soft drinks to which they've grown accustomed have become a permanent part of their diet—though they're down to four quarts of Coke a week. Despite the financial belt-tightening, the children still manage to eat many snacks, even when Alma doesn't pay for them. "They do little jobs and favors for people," she says, "and spend the money [they earn] on candies and [chips]. And if I give them money for lunch at school, sometimes they spend it on snacks." Alma has moved the children into her mother's house. Her sister Estella, who owns a tiny lunch counter nearby, takes care of the boys while Alma works part-time at a nearby market. Is Alma concerned about Marco Antonio? "Yes, I worry," she says, "but he worries too—that he's not making enough money for us." Might he try to find a different job? He's afraid, she says. "As he gets more familiar with the system [in the U.S.] I think he will move on, but it's difficult because he doesn't know the language." They talk on the phone once a month, and hang on to their hopes and dreams.

In Cuernavaca's Colonial-era central square—the *zócalo* found in every Mexican town—city dwellers and visitors take their traditional late-afternoon weekend stroll among the balloon vendors while a band plays on the bandstand. Similar scenes have been replicated in Mexican towns for more than a century. But here, as elsewhere in the nation, is a sign of sweeping change: a banner protesting the imminent arrival of Costco, a U.S. big-box store *(at right)*.

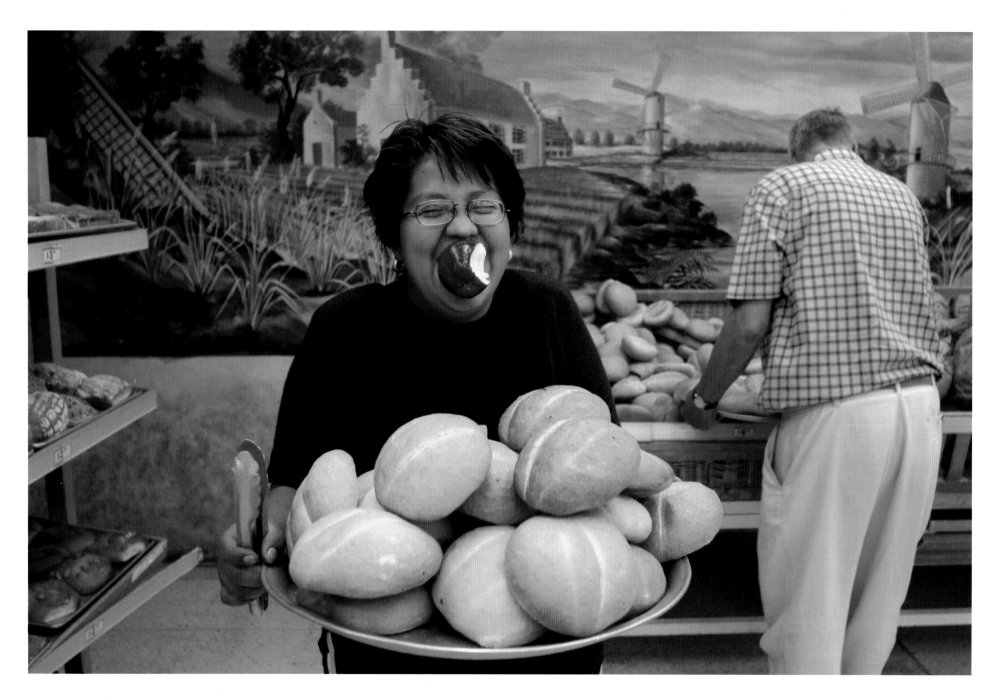

Shopping for the week's worth of food at a big supermarket, Alma marches to the cash register, chomping on an apple and laughing at the absurdity of buying so much bread at once. Her order of tortillas at the *tortillería* across the street from her convenience store *(above right)* is just as irrational—she never buys tortillas, which don't keep well, in bulk. Afterward, she cooks crab soup at her sister's restaurant *(bottom right)* for both the patrons and her family.

MEXICO

- Population: **104,959,594**
- Population of Cuernavaca: **705,405**
- Area in square miles: **761,404 (slightly less than three times the size of Texas)**
- Population density per square mile: **138**
- Urban population: **76%**
- Indigenous population: **14%**
- Life expectancy, male/female: **72/77 years**
- Life expectancy gap between indigenous and non indigenous population: **–6%**
- Fertility rate (births per woman): **2.5**
- Literacy rate, male/female, 15 years and older: **94/91%**
- Caloric intake available daily per person: **3,145 calories**
- Annual alcohol consumption per person (alcohol content only): **4.2 quarts**
- GDP per person in PPP $ (Purchasing Power Parity: an adjustment for what equivalent local goods would cost in the U.S.): **$8,970**
- Total annual health expenditure per person in $ and as a percent of GDP: **$370/6.1**
- Overweight population, male/female: **65/66%**
- Obese population, male/female: **20/32%**
- Population age 20 and older with diabetes: **3.9%**
- Tortilla consumption per person per year: **228 pounds**
- Meat consumption per person per year: **129 pounds**
- McDonald's restaurants: **261**
- Big Mac price: **$2.12**
- Number of restaurants/retail stores run by Walmex (Walmart Mexico, SA): **285/411**
- Cigarette consumption per person per year: **754**
- World rank for per-person consumption of Coca-Cola: **No. 1**
- Population living on less than $2 a day: **26%**

FAMILY RECIPE

Alma Casales' *Sopa de Jaiba* **(Crab Soup)**

2 oz margarine

2 lb red tomatoes, chopped

1/2 lb white onions, sliced

5 cloves garlic

5 olive leaves

5 T salt

4-1/2 lb crab pieces, thoroughly rinsed

1-1/2 lb *La Costeño* chipotle peppers

1 lb carrot, sliced

10 qt water

- In a large pan, melt margarine. Add tomatoes, onions, garlic, olive leaves, and salt. Fry until onions soften.
- Add crab and all other ingredients to pot.
- Pour in water, cover, and simmer for 80 minutes.
- Enjoy with Mexican white bread.

In what may be a disappearing custom, shoppers throng Cuernavaca's daily public market, inspecting the alarmingly fresh meat *(above, hogs' heads, signaling the presence of a butcher)* and picking up snacks at the many small restaurants inside *(at right)*. The crowds are large, but not as large as they used to be. Increasingly, Mexicans are choosing to shop at big chain supermarkets; indeed, Walmex, a Walmart subsidiary, is already Mexico's biggest private employer.

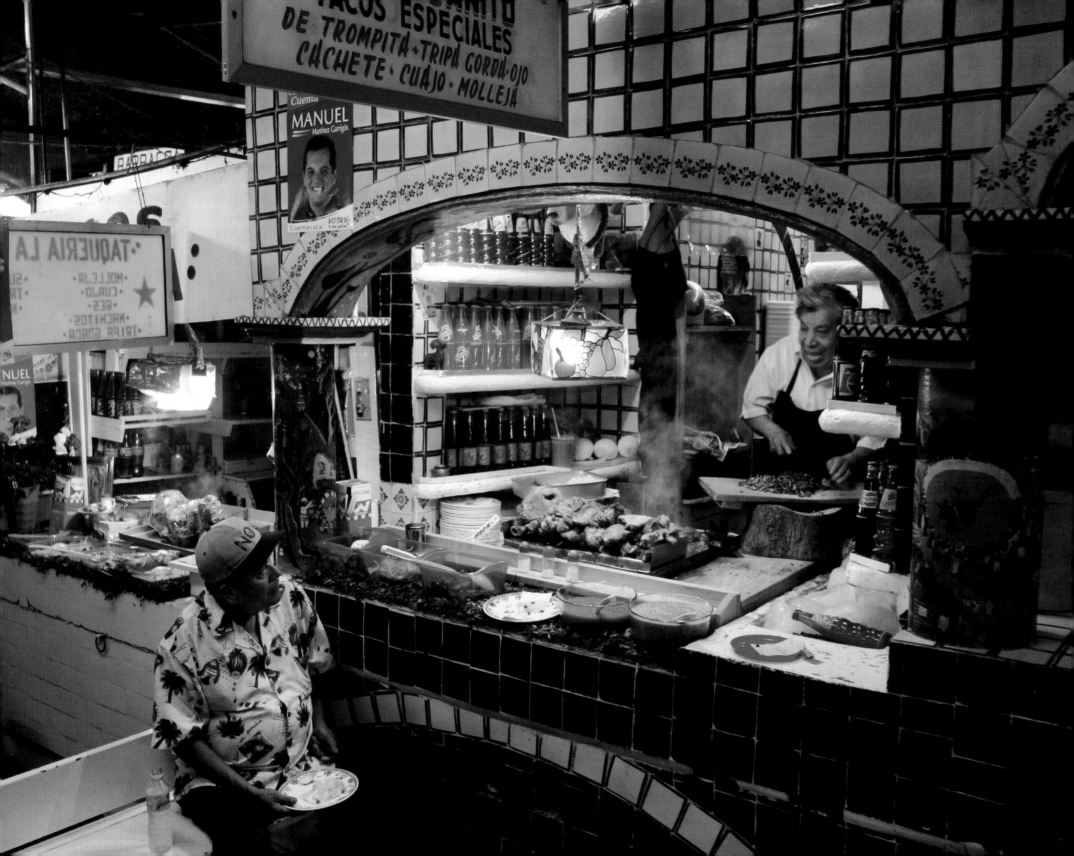

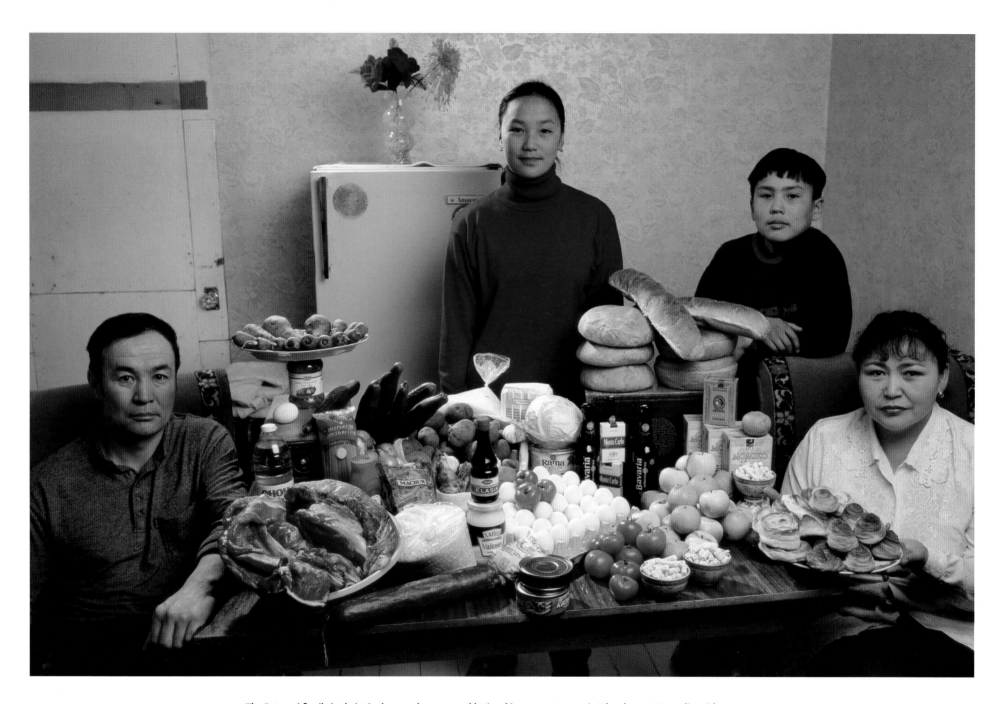

The Batsuuri family in their single-room home—a sublet in a bigger apartment—in Ulaanbaatar, Mongolia, with a week's worth of food. Standing behind Regzen Batsuuri, 44 (left), and Oyuntsetseg (Oyuna) Lhakamsuren, 38, are their children, Khorloo, 17, and Batbileg, 13. Cooking methods: electric stove, coal stove. Food preservation: refrigerator-freezer (shared, like the stoves, with two other families).

Hungry for Change

Grains & Other Starchy Foods: $5.41
Bread, 15.4 lb; potatoes, 11 lb; white rice, 4.4 lb; *Macbur* pasta, spirals, 2.2 lb; spaghetti, 2.2 lb; white flour, 2.2 lb.

Dairy: $6.19
Apta milk, 3.2 qt; *Rama* butter, 2.2 lb; Holland cheese,‡ 1.1 lb, *not a common purchase, as it is expensive and considered a luxury item.*

Meat, Fish & Eggs: $13.51
Beef, 6.8 lb; mutton, 4.4 lb; eggs, 30; sausage, dried, 1.6 lb, *she didn't find the kind she wanted so she bought less than usual;* kilka (an anchovy-like fish), canned, 7.1 oz; sprat (a herring-like fish), canned, 5.3 oz.

Fruits, Vegetables & Nuts: $8.35
Green apples, 4.4 lb; tangerines, 2.2 lb; cucumbers, 5.3 lb; cabbage, 1 head; carrots, 2.2 lb; tomatoes, 2.2 lb; turnips, 2.2 lb; yellow onions, 1.1 lb; *Urbanek* vegetables, preserved, 17.6 fl oz; garlic, 1.9 oz.

Condiments: $1.58
White sugar, 2.2 lb; vegetable oil, 16.9 fl oz; salt, 8.8 oz; ketchup, 4.4 oz; mayonnaise, 3.7 oz; *Vitana* soy sauce, 0.9 fl oz.

Snacks & Desserts: $2.38
Pastries, 6.6 lb; dried milk treat, 1.1 lb, *extruded sweetened and dried milk, eaten as a sweet.*

Beverages: $1.74
Bavaria Millennium Brew beer, 3 14-fl-oz bottles, *Batsuur doesn't drink alcohol at home, but does with his friends; Gita* Indian black tea, 4.4 oz; tap water, for drinking and cooking.

Miscellaneous: $0.86
Monte Carlo cigarettes, 2 pks.

‡ Not in Photo

Food Expenditure for One Week:
41,985.85 togrogs/$40.02

MOUNTAINS OF FLOUR AND IMPORTED SUGAR ring the big central market in Ulaanbaatar where Oyuntsetseg Lhakamsuren shops for her family's food. On spring mornings, she walks to the cavernous covered marketplace through a silvery mist of airborne flour that envelops the outdoor grain wholesalers. Inside, rows and rows of individual vendors sell their wares from tabletops and stalls. Oyuna, as she is called, shops briskly. She chooses papery-skinned yellow onions and garlic cloves at one kiosk and a jar of Chinese-style preserved vegetables at another. Red meat is an integral part of the diet in Mongolia—as it is in most cold climates—and Oyuna is choosy, visiting four vendors before deciding on her mutton purchase. She counts out her *togrogs* (Mongolian currency) and stuffs the package into her oversized shopping bag. Before returning home, she takes a detour—to the local Buddhist temple. "We need help with many problems," she says, as she offers a coin with her prayer.

Since Mongolia emerged from Soviet-style Communism in 1990, many Mongols have found the country's new market economy difficult to negotiate; Oyuna's family is among them. After stockpiling materials for years, her husband, Regzen Batsuuri, hand-built a house on squatter's land next to their traditional family *ger* (a round, portable tent structure) on the outskirts of the city. Meanwhile, Oyuna opened a small private pharmacy with former colleagues; they had worked together at a state pharmacy before the government began allowing private enterprise. It was a heady time for the family, but more financially perilous than they knew. Oyuna's next wish—to have running water—came true, albeit unhappily. She and her friends secured a private loan to support their pharmacy, but didn't understand the concept of compound interest. The debt built up, and Oyuna's family lost everything, including their *ger* and their house. The family of four now lives in a modern apartment with running water. But it belongs to Tanya, an 83-year-old Russian immigrant, who rents them a single room and gives them kitchen privileges. Oyuna has opened a new, much smaller dispensary. Regzen, now an electrician, longs for their old homestead, but the children and Oyuna are happy to have an indoor bathroom and an electric stove, even if it means that they're all shoe-horned into the same small room. Best of all, the children say, they don't have to haul buckets of water home up a steep hill anymore.

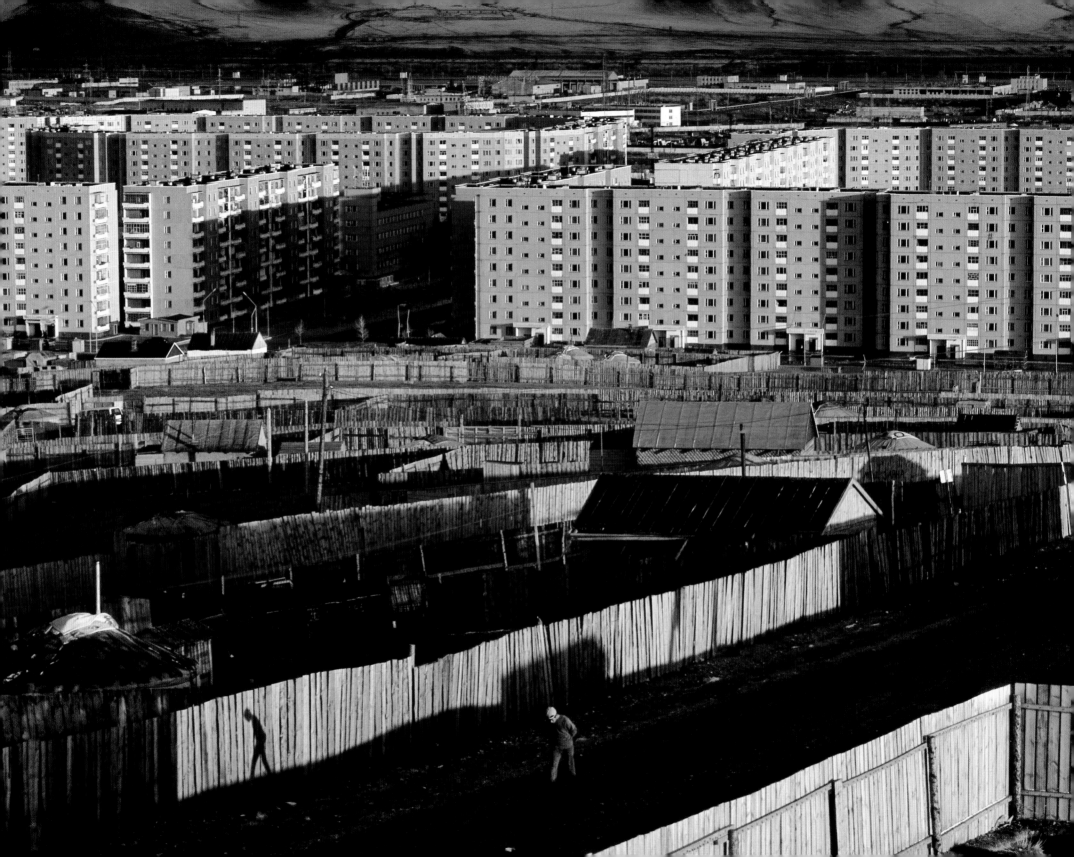

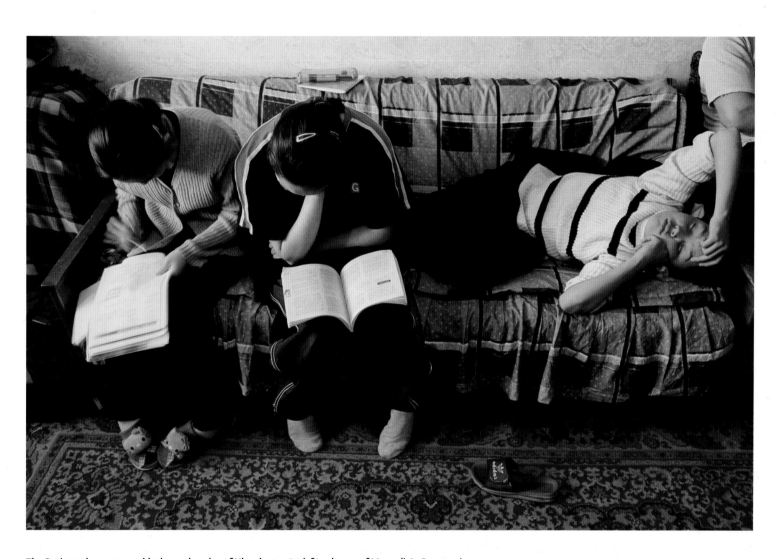

The Soviet-style apartment blocks on the edge of Ulaanbaatar *(at left)*, a legacy of Mongolia's Communist past, are now surrounded by squatters—more accurately, urban homesteaders. Former nomads, they have precisely parceled out the land and staked out their neat *gers*. The *gers* lack indoor plumbing, but in other ways are more comfortable than the city's crowded apartments. Above, Khorloo (center), Batbileg (reclining), and their cousin Suvd Erdene do their homework.

In Ulaanbaatar I played basketball—wildly popular in Mongolia—with Batbileg and some of his neighbors in the dirt parking lot in front of the Batsuuris' building. During the game, three cows ambled though the littered, completely barren area. Begging out of the game, I grabbed my cameras and followed the cows around the corner, watching them forage in a dumpster overflowing with household garbage, mangled plastic jugs and jars, and discarded auto and animal parts (hooves, heads, skulls). It was late in the day and the omnipresent broken glass was now brightly reflecting the sun, which had fallen below the gray cloud cover, changing the mood from apocalypse cow to sparkling urban home on the range, road-warrior style.

On our last night in Ulaanbaatar, we succumbed to a tourist brochure's glowing recommendation and attended a private dinner theater in a *ger* (traditional round tent, covered in felt and canvas). Unfortunately, dinner turned out to be a cold, mediocre version of the delicious *buuz* (meat dumplings) Regzen had served us the night before in his apartment. Halfway through this undistinguished repast, in came the musicians: a throat singer and his backup band. The sound filled the *ger*—a low, guttural droning punctuated by flutelike harmonics, all coming from one man's throat. Unbelievably beautiful songs—I did not understand the words but the sounds made my whole being resonate. Half an hour later, two waiflike teenagers in sequined leotards entered the now crowded space. While the throat singer and his band filled the air on one side of the *ger*, the two girls spidered through a flawless contortionist routine on the other. Transfixed by the amazing music, awestruck by the girls' movements, and buzzed by the warm beer and cold *buuz*, I floated away in bliss. What can I say? For once, a tourist brochure was right on.　　　　　— *Peter*

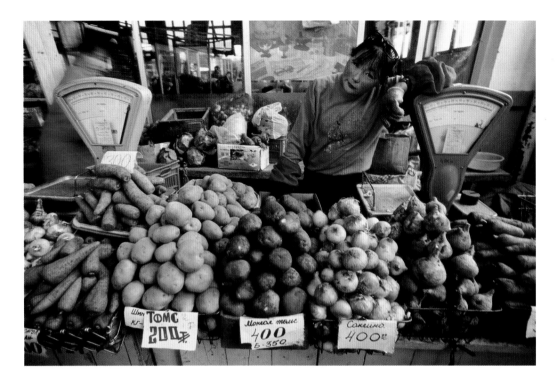

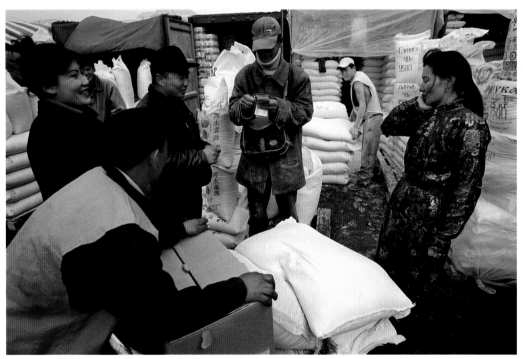

- Population: **2,751,314**
- Population of Ulaanbaatar: **760,077**
- Livestock population (cattle, horses, sheep, goats, camels): **25,000,000**
- Number of livestock deaths from drought and *zud* (brutal winter) between summer of 1999 and winter of 2002: **7,000,000**
- Area in square miles: **603,749 (slightly smaller than Alaska)**
- Land used for grazing (grassland and arid grazing): **80.7%**
- Population density per square mile: **5**
- Urban population: **57%**
- Population living in *gers*: **45%**
- Rank of Ulaanbaatar among the world's coldest capital cities: **No. 1**
- Life expectancy, male/female: **60/66 years**
- Fertility rate (births per woman): **2.4**
- Literacy rate, male/female, 15 years and older: **98/98%**
- Caloric intake available daily per person: **2,249 calories**
- Annual alcohol consumption per person (alcohol content only): **2.4 quarts**
- GDP per person in PPP $ (Purchasing Power Parity: an adjustment for what equivalent local goods would cost in the U.S.): **$1,710**
- Year in which Soviet economic aid stopped: **1991**
- Total annual health expenditure per person in $ and as a percent of GDP: **$25/6.4**
- Overweight population, male/female: **46/66%**
- Obese population, male/female: **5/25%**
- Population age 20 and older with diabetes: **3%**
- Meat consumption per person per year: **239 pounds**
- McDonald's restaurants: **0**
- Population living on less than $2 a day: **50%**

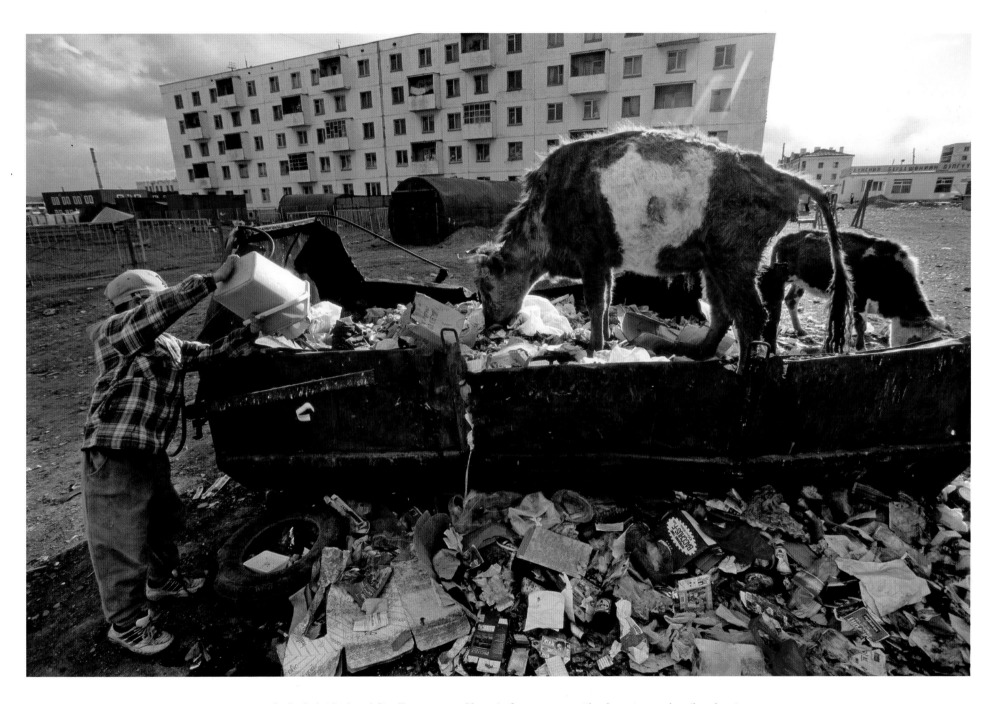

An apple-cheeked girl *(above left)* selling root vegetables waits for customers at Ulaanbaatar's central retail market. On winter days, the unheated market is cold, but the flour wholesalers *(bottom left)*, who work from trucks and sheds outside the market, are even colder. Life in the city is tough but slowly improving. Indeed, the free-range cows dumpster-diving *(above)* in this parking lot are a perverse sign of affluence—Mongolians now have enough food to throw some away.

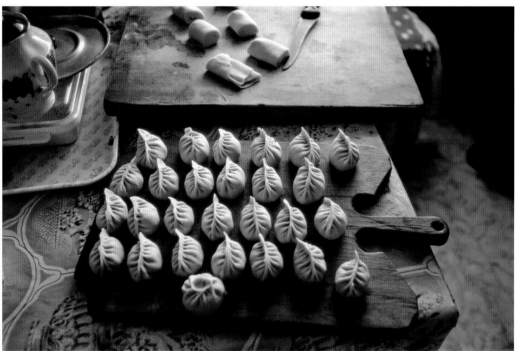

Oyuntsetseg Lhakamsuren's *Buuz* (Steamed Dumplings)

2 lb mutton (beef can be substituted)

7 oz mutton-tail fat

salt

pepper

1 large onion, minced

2 lb flour

3–4 cups water

..

- Mince or grind meat (cutting it with knife into very small pieces is best as it preserves juices). Combine with fat, which makes meat juicy and soft. Add salt, pepper, and onion to taste.

- Combine flour with 3 cups warm water and knead for about 5 minutes, until dough is smooth and elastic and easily gathers into a ball. Add more water, if necessary. Let rest for 10–15 minutes, covered with cloth.

- When the dough is rested, roll into cucumber-size cylinders, and then cut into small slices. Flatten the rounds with a small rolling pin into perfect circles. The edges should be as thin as possible, with the middle a little thicker.

- Place about 1 T meat in the middle of each round and seal the meat in by tightly pinching the dough over it into a semicircle-shaped dumpling. Sealing the dumpling is delicate work; the trick is to match the ends perfectly.

- Lay dumplings carefully into steamer (a Chinese-style bamboo steamer will do, if bottom is oiled) and steam over boiling water for 20 minutes.

Regzen Batsuuri *(above left)* **slices up squash, carrots, and cabbage in the small kitchen his family shares with two other families. He has already prepared the** *buuz* **(mutton-stuffed dumplings,** *bottom left)* **with the help of his daughter, Khorloo. Because Oyuntsetseg is working at her pharmacy tonight, Batbileg walks the meal over to her and then the three of them and a niece sit down to dinner** *(at right).*

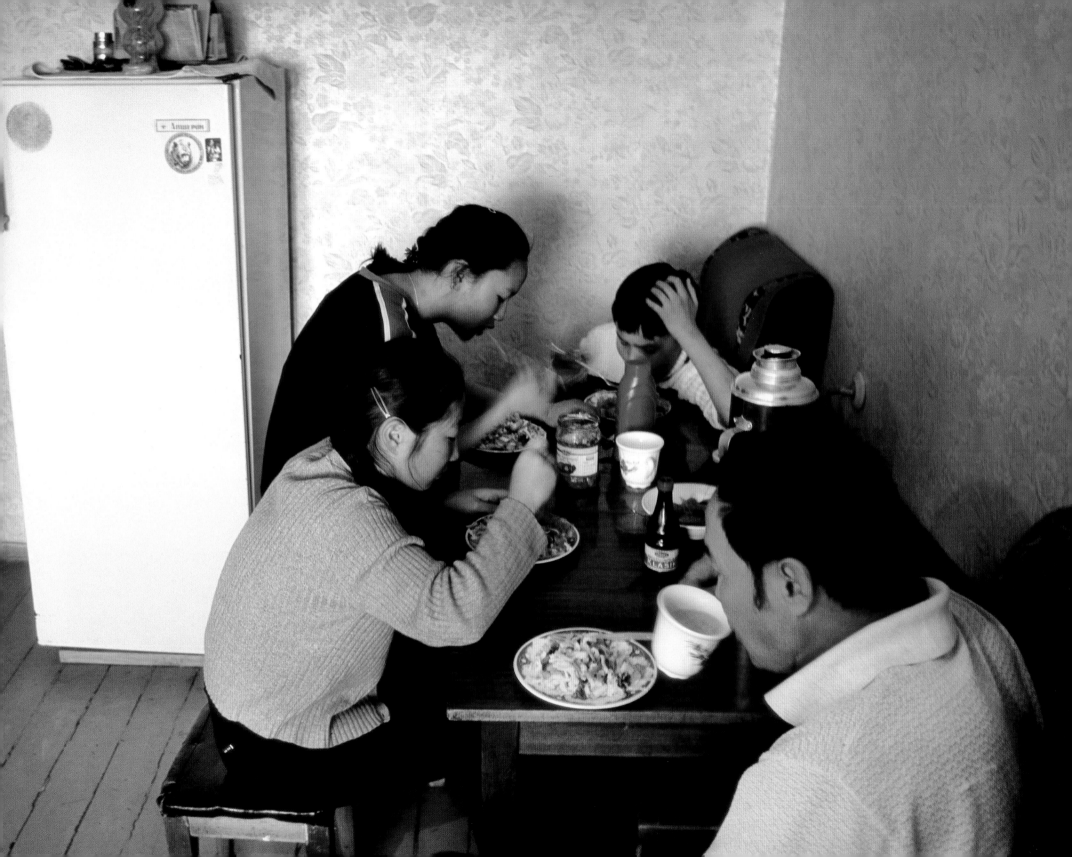

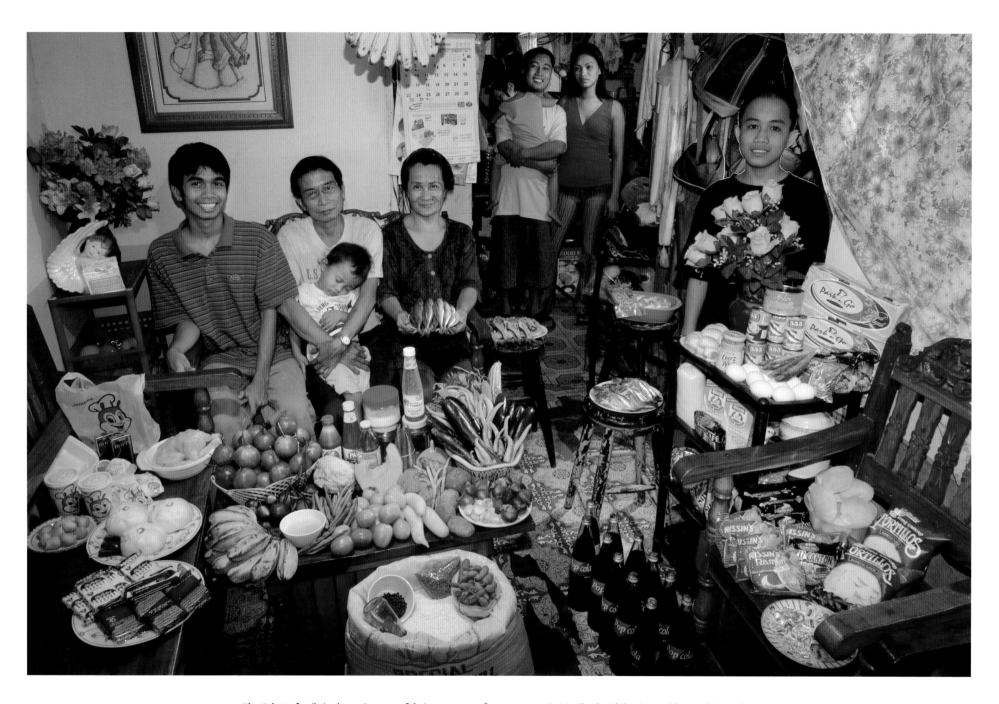

The Cabaña family in the main room of their 200-square-foot apartment in Manila, the Philippines, with a week's worth of food. Seated are Angelita Cabaña, 51, her husband, Eduardo Cabaña, 56 (holding sleeping grandson Dave, 2), and their son Charles, 20. Eduardo, Jr., 22 (called Nyok), his wife Abigail, 22, and their daughter Alexandra, 3, stand in the kitchen. Behind the flowers is the youngest son, Christian, 13 (called Ian). Cooking method: gas stove. Food preservation: none.

Freshly Squeezed

While any traveler with a modicum of curiosity finds Metro Manila fascinating, it's a testament to the resilience of hardworking Filipinos that they can live there. Rampant unemployment, pollution, crime, cronyism, corruption, nepotism, overcrowding, and traffic congestion all plague the Philippine capital. In fact, Manila's best single attribute—all that may be holding the city together—is the cohesive nature and inventiveness of the Filipino family.

IN BRIGHT SUNSHINE, WE STEP from a central Manila city street, past a rooster tied by its leg to a log, into the total darkness of a narrow alleyway leading to Angelita Cabaña's house. Her sons Nyok and Charles say she's not home, but is expected back shortly. She's away demonstrating her line of Tupperware to prospective buyers. This is just one of the many jobs she does to help keep the family fed, in school, and financially afloat. She learned massage therapy, and serves a small clientele of women who can afford the luxury of paying $4 or $5 an hour for the personal attention. Angelita is also the landlady for the half of the house she's given over to renters, squeezing her eight family members into three small rooms to do so. In a pinch she can also repair watches. She inherited a watch repair business when her father died, and it's the work her husband Eduardo does as well—in her father's phonebooth-size shop bolted to the sidewalk on a nearby street. On a good day, Eduardo earns about $18.

The Cabañas' neighborhood in the Malate District houses the working poor, who provide the tourist hotels nearby with waiters, tour guides, and bartenders. Street vendors who live here move around the city selling boxes of candies or small kitchen tools. Food-cart entrepreneurs cook crispy, deep-fried sweet potatoes, skewers of barbecued chicken, and *kwek-kwek*—hard-boiled quail eggs coated in orange-colored flour. Mom-and-pop convenience shops called *sari-saris* open early and close late. Aside from the ubiquitous Coca-Cola, Nestlé, and Kraft products, they sell other items in the small sizes that Filipino families can afford.

The streetlamps in the Cabañas' neighborhood, installed by their local municipal mayor, are lauded by the Cabañas. Like many in Metro Manila—which consists of not one city but four, and thirteen municipalities—the Cabañas live around drug addicts

ONE WEEK'S FOOD IN JANUARY

Grains & Other Starchy Foods: $7.09

White rice, 30.9 lb; *Park n' Go* white bread, sliced, 3 loaves; pan de sal (salty bread), 2.2 lb; cheese bread, 1.3 lb; potatoes, 11.6 oz; *V.C.* original breading mix, 3.5 oz.

Dairy: $2.01

Nestlé Bear Brand milk, powdered, 12.7 oz; *Kraft* Cheez Whiz, 8.8 oz.

Meat, Fish & Eggs: $19.72

Pork, 7.7 lb; chicken, whole, 4.4 lb; milk fish, fresh, 4.4 lb; galunggong (fish), fresh, 2.2 lb; tilapia (fish), fresh, 2.2 lb; eggs, 12; foot-long hot dogs, 1.1 lb; *Ma Ling's* luncheon meat, canned, 14.1 oz; *555 Brand* sardines, in hot tomato sauce, canned, 5.8 oz; *555 Brand* sardines, in tomato sauce, canned 5.8 oz; tuyo (assorted dried fish, like tamban), 2.5 oz.

Fruits, Vegetables & Nuts: $7.17

Green mandarin oranges, 8.8 lb; yellow bananas, 4.4 lb; saba plantains, 2.9 lb; limes, 8.8 oz; kalabasang tagalog (squash), 2.9 lb; eggplants, 2.4 lb; green tomatoes, 2.2 lb; daikon, 2.2 lb; squash, 1.7 lb; kangkong (water spinach), 1.3 lb; bitter gourd, 1.1 lb; red onions, 1.1 lb; cabbage, 1 small head; okra, 12.4 oz; carrots, 8.8 oz; mongo beans, 8.8 oz; snap beans, 8.8 oz; sweet potato, 6.5 oz; hot green peppers, 5.3 oz; garlic, 3.7 oz.

Condiments: $2.01

White sugar, 2.2 lb; cooking oil, 1.1 lb; *Silver Swan* soy sauce, 11.8 fl oz; tamarind, 8.8 oz; *Lorins Patis* hot fish sauce, 5.9 fl oz; ketchup, 5.6 oz; vinegar, 5.1 fl oz; salt, 4.4 oz; *Mang Tomas* all around sauce (made from ground liver mixed with seasonings), 2.9 fl oz; black pepper, 0.5 oz; bay leaves, 8.

Snacks & Desserts: $1.92

Granny Goose stone ground tortilla chips, 8.5 oz; graham crackers, 3.5 oz; *Sky Flakes* crackers, 3.5 oz; *Hello* chocolate mini bars, 2.1 oz; chocolate candies, 1.1 oz; *Halls* cough drops, 1 oz.

Prepared Food: $1.13

Lucky Me instant pancit canton noodles, 1.3 lb; *Nissin* instant ramen noodles, 1.3 lb.

Fast Food: $1.86

Jollibee burger and French fries; fried chicken and rice; *Coca-Cola*, 2.

Street Food: $1.30

Siopao (steamed pork buns), 1.1 lb; quek quek (quail eggs covered in flour and egg mixture and deep-fried), 5.3 oz.

Beverages: $4.46

Pop Cola, 11 27-fl-oz bottles, *produced by the Coca-Cola brand*; *Sunkist* orange juice drinks, 4 8.5-fl-oz pks; *Nescafe* instant coffee, 1.9 oz; tap water for drinking and cooking from indoor faucet only from 2 to 6 a.m. Very weak water pressure.

Miscellaneous: $0.75

HOPE cigarettes, 2 pks.

Food Expenditure for One Week: 2,629.50 pesos/$49.42

and loiterers, and illumination helps make their area safer. But the overflowing trash, the randomness of basic city services, and the lingering pervasiveness of crime are visible reminders that providing a safe, clean environment for a crowded, overwhelmingly poor population is an enormous challenge. Inside the Cabañas' home, although a giant step and a half will get you from one side of the living room to the other, everything is orderly and clean, if threadbare.

CHEF DE CUISINE

The cartoon on the Cabañas' TV holds Nyok's 3-year-old daughter Alexandra in thrall in much the same way that we are mesmerized by the large statue of Santo Niño—the child Jesus—in the corner. Many Filipinos in this predominantly Catholic population have similar statues, which they parade through the streets once a year. The tourism department of the Philippines calls Metro Manila's Santo Niño Festival "a grand procession of over 200 well-dressed images of the child Jesus." (The number we saw was considerably more than 200, and, yes, they were very well-dressed.)

Two-year-old Dave, Alexandra's brother, perks up when his grandmother Angelita—Lita, as she is called—walks in the door. This is the woman of his dreams—the chef de cuisine of the noodles and eggs, the keeper of the Cheez Whiz. Breakfast a la Lita sometimes includes Cheez Whiz, usually includes rice and chicken eggs, and always includes *pan de sal*—the salty bread sold on the street by the "pot pot," vendors named for the sound of their horns.

Relieved of child-care duty by the arrival of his mother, Nyok, a graduate student in business administration, escapes to study in the small room he shares with the two children and Abigail, his wife, who works as a cigarette vendor in a local market. Like many young couples who live with extended family to share expenses, Nyok's family lives with Lita. In addition, they benefit from Lita's remarkable skill at the Manila game of making every peso count at the market, a game with many angles, the most important of which is having *sukis*.

THE ART OF THE *Suki*

Crowded to unsafe levels, the splendidly garish, squat-bodied busses called jeepneys barrel along every road in Metro Manila, including the one near Divisoria Market that Lita and 50 other people are now attempting to cross. Taking advantage of their numbers, they swarm the road and force the jeepneys and trucks to stop and let them pass—a mode of traffic negotiation that is routine throughout Metro Manila. Lita does the food shopping for the entire family between her massage appointments and Tupperware sales. Because her refrigerator recently died an untimely death, she has resigned herself to shopping almost daily again. The problem is that the cheapest places are also the farthest away, so she must weigh the pluses—better prices—against the minuses—the time and money it takes to get there and back. Today at Divisoria Market, 30 minutes by jeepney from her home, she hopes to buy from some of her *sukis*.

Suki is the term used for both buyers and sellers and refers to people who do repeat business with one another. Over time, the relationship—like a sort of noncorporate loyalty card—can garner deep discounts for the buyer and ensures the seller a steady customer. To Lita, the discount might mean the difference between buying a snack-size or a meal-size portion of some item. "I can get up to a 20 percent discount from my *sukis*," she says.

Lita likes to survey the crowd of fruit and vegetable vendors before settling for the freshest produce that's within the budget. She buys onions and tomatoes from her *suki*, choosing only green tomatoes because "it takes longer for the green ones to spoil."

When no *suki* has what she needs, her strategy is to pick a vendor with no other customers, hoping that she will be able to negotiate a better price. She searches vainly for affordable eggplant—"Really expensive," Lita says, shocked, at one table where the price is 30 pesos a kilo (55 cents, USD for 2.2 lbs) rather than the usual 20. Finally, she finds a seller who has no other buyers, and thus is willing to bargain. "Pick out the good ones," Lita tells her, after they agree on a price. To me she explains, "I grill the eggplant, remove the skin, and then cook it with egg." Lita squeezes her finger tightly as the seller makes change. "Did you hurt yourself?" I ask. "I got bitten by a rat last night while I was sleeping," she says, and shows me. Sure enough, there are tiny bite marks on her fingertip and the skin is broken. Will she have a doctor look at it? "Maybe," she says as she accepts her change. Nonfood expenses must be weighed carefully. In the end, she doesn't go.

Lita tries to shop early, not just to get the freshest foods, but also in the hope of being a vendor's *buena mano*—the first sale of the day, which promises the seller many more sales to follow. The *buena mano* gets the biggest discount of the day. Does she have any other

- Population: **86,241,697**
- Filipinos living or working overseas: **7,500,000 (est.)**
- Population of Metro Manila: **14,000,000 (est.)**
- Area in square miles: **115,800 (slightly larger than Arizona)**
- Population density per square mile: **745**
- Urban population: **62%**
- Life expectancy, male/female: **72/65 years**
- Fertility rate (births per woman): **3.2**
- Literacy rate, male/female, 15 years and older: **93/93%**
- Caloric intake available daily per person: **2,379 calories**
- Annual alcohol consumption per person (alcohol content only): **3.5 quarts**
- GDP per person in PPP $ (Purchasing Power Parity: an adjustment for what equivalent local goods would cost in the U.S.): **$4,170**
- Total annual health expenditure per person in $ and as a percent of GDP: **$30/3.3**
- Overweight population, male/female: **22/25%**
- Obese population, male/female: **1/3%**
- Population age 20 and older with diabetes: **7.1%**
- Meat consumption per person per year: **68 pounds**
- Number of McDonald's restaurants/ Jollibee restaurants: **236/400+**
- Big Mac price: **$1.42**
- Cigarette consumption per person per year: **1,849**
- Population living on less than $2 a day: **46%**

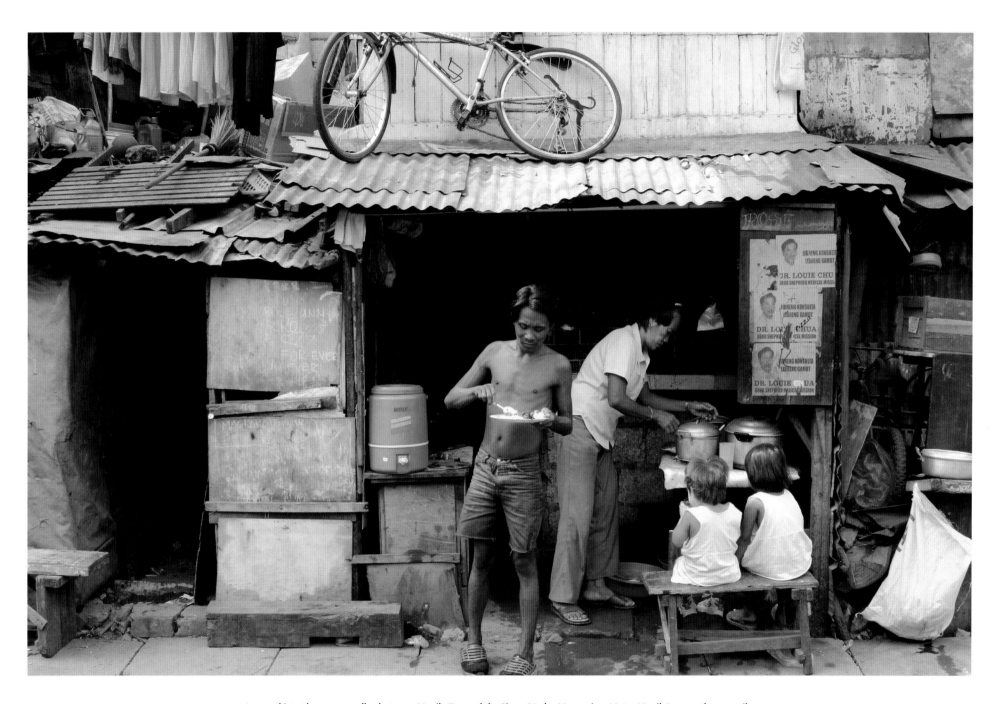

Jammed into the narrow valley between Manila Bay and the Sierra Madre Mountains, Metro Manila's more than 14 million people, many of them very poor, use every square foot of available space. Makeshift shanties jostle high-rise apartments—neighborhoods built on stilts spill into tidal flats, rivers, and the sea. Backed up against a set of railroad tracks, this street-food vendor squeezes her modest business into a space hardly bigger than a U.S. walk-in closet.

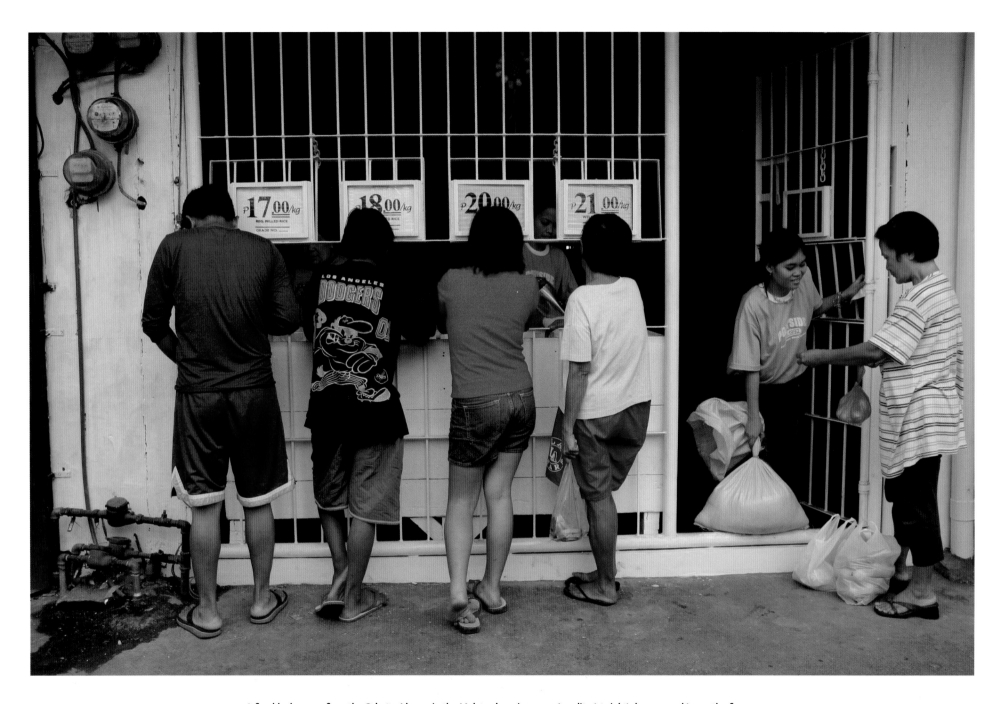

A few blocks away from the Cabañas' home in the Malate shopping area, Angelita (at right), buys a week's worth of rice—30 lbs.—for the photo shoot. Fortified storefronts are not unusual: most small *sari-saris* (variety/convenience shops, often just a window on the street) have similar rails, or bars, for security. Angelita's purchase is unusual: most people in this working-class area buy smaller amounts, handing in their money then getting their rice beneath the bars.

The Philippines must have more street food per capita than China, which is saying something. We found it everywhere—even in the poorest slums—hole-in-the-wall kitchens, street vendors' carts, poor entrepreneurs grilling mystery meat on skewers over a piece of glowing charcoal in a tin can, you name it. Most of it was quite delicious but some of the Filipino dishes I tried—like *dunguan* (pig entrails over rice in a stew of pig blood and pig liver)—were viscerally challenging.

One evening, we happened upon a tent pitched outside a house where a funeral was taking place. Standing next to her mother's glass-topped casket, the bereaved daughter was cooking up eggplant and dried fish on a small fire. She was serving the results to the friends and neighbors at the funeral, many of whom were taking advantage of a quirk in Filipino law that permits wagering on games, but only at funerals. Part of the gaming proceeds went to help the daughter bury her mother.

Near the service desk of a large supermarket I found a small take-out restaurant called Kiss, King of Balls. With a name like that, and an attractive young girl doling out the balls, I couldn't resist. Since I didn't know what *kikiam* balls (ground pork and vegetables wrapped in bean curd sheets) or *gulaman* balls (sea weed gelatin) were at the time, I ordered the squid balls, which were like meatballs of squid (not bad, actually). Because I liked the name so much, I joked later about franchising the chain. I wanted a business card announcing myself as CEO of Kiss, King of Balls. I was later disappointed to learn that a Manila businessman, Melchor Flores, already operates more than 250 Kiss, King of Balls nationwide and has even opened a few in the Middle East. — *Peter*

Sinigang na Baboy ni Ka Lita (Ka Lita's Pork in Sour Soup)

2 lb pork, sliced into 1" cubes

4 cups water (preferably from rice washing)

1/2 t salt

2 oz tomatoes, cut into wedges

2 oz onion, cut into wedges

1 cup eggplant, chopped into cubes

1 cup okra

4 oz daikon, cut diagonally

12 oz tamarind

1/2 t fish sauce (or to taste)

11 oz water spinach

1/2 oz hot green pepper

- Boil pork in water with salt, tomatoes, and onions.
- When pork is almost tender, add eggplant, okra, and daikon.
- Meanwhile, boil tamarind with 1 cup water in a separate pot.
- Using a fork, grind on tamarind to release juice. Pour freshly made tamarind extract and fish sauce into pot.
- Simmer for 5 minutes and then add water spinach and hot green pepper just before turning off heat.
- Serve hot with rice and fish sauce.

Outside the Quiapo Market, people pick through the trash *(bottom left)* discarded from the early-morning wholesale market. Inside, the covered market is a tumult of activity and offers an extraordinary variety of goods, ranging from food, clothing, consumer electronics, and patent medicines to religious images and even prayers (busy people can outsource their prayers to the Quiapo Church's "prayer ladies"). In such hypercompetitive circumstances, fish vendors *(above left)* don't sell their wares by the pound or kilo. Instead, they charge by the *tumpok* (pile). The size of the *tumpok* varies moment by moment, according to demand.

pointers? Buy in bulk. It gets you discounts—if you can afford it. She can't always follow her own advice, but tries to with items that keep well, like onions. If she buys milkfish—a common purchase used in *sinigang* and many other Filipino dishes, she'll marinate it in vinegar and garlic, so it will keep longer. How does she choose a good milkfish? "It's fresh, its eyes are not red, it doesn't smell bad, and it's not too hard or too soft." Another tip: for staples like sugar, soap, and canned goods, go to shops in the more affluent areas. Why? "They have the same prices, but with air-conditioning," Lita says. Luckily, one of her massage clients lives near such a shop. Lita stops there on her way home.

For some items, even Lita can't find a cheaper alternative: "I buy meat at the market close to our house because the price is the same everywhere." But her budget doesn't always stretch enough to afford meat. "I try to serve nutritious food that is not too expensive, like vegetables and fish," she says, "but there are times when I can only serve them dried fish, or sardines. Every now and then we have extra money, and I get to buy roast chicken from a restaurant. We get by, and though our food may not be as expensive as what the rich people eat, it is just as delicious."

JOLLIBEE GOOD

Though McDonald's, KFC, and other global food purveyors have made their way to Metro Manila, street food is a mainstay of the culture and an important part of its underground economy. Across town, in the Quiapo District, Julius and Remy Galimay (p. 131) have cooked barbecue, served with a seasoned vinegar dip, on the street near the Quinta Market for over ten years. "Profits aren't stable," says Remy of their family business, but they make enough skewers of barbecued *isaw, taba, dugo,* and *adidas* to support themselves and their four children. *Isaw*—pig and chicken small-intestine barbecue—is a national favorite, as is *taba*—pieces of pork fat skewered onto a stick and deep-fried. *Dugo* is curdled and congealed pig blood, cut into chunks, skewered, and then grilled. Cow blood is too strong tasting, say the street vendors. *Adidas*, named after the running shoe, is

barbecued chicken feet. Remy sells her skewers for anywhere from one to 40 pesos—*dugo* is the cheapest. While vendors also offer chicken heads, day-old baby birds, fish balls, and floured quail eggs (*kwek-kwek*), the street menu is generally offal.

Like Lita's youngest son, Ian, who lunches on the street each day, spending about 100 pesos a week ($1.80 USD), her middle son, Charles, eats *kwek-kwek* street-side, but prefers to eat at McDonald's, or Jollibee—a local fast-food chain that is going global and has hundreds of outlets. It serves both typical Western fast food like burgers and fries and local Filipino cuisine. Charles is a Manila merit scholar, which means the government pays for his university education. This allows him to study without having to cram work into his schedule, as many Manilenos (Manila residents) do. "It is normal for me to eat lunch every day in McDonald's or Jollibee," says Charles. "I prefer this to street food because it is air-conditioned. And although the products that these restaurants serve in their country of origin might be far from what we are used to in the Philippines, they are slowly incorporating Filipino food into their menus." He says street food "will always remain a step ahead though, because of the affordability, accessibility, and of course the distinct flavor that is truly Pinoy [Filipino]." Even Lita treats herself to McDonald's or Jollibee once or twice a month, after giving a massage, but her favorite fast food is from Ramon Lee, a noodle house that she and her husband have frequented since before they were married. Its single location is 45 minutes from their home.

Though the Cabaña family has spread out across the city during the day, everyone returns home to eat dinner together. Lita's children generally clamor for her *sinigang,* a sour, tamarind-flavored broth with fish, shellfish, pork, or beef. Charles claims it is the best in all the Philippines, and Ian calls it his favorite meal. "We have a very humble home," says Lita, "but we are proud to say that it is filled with love and respect. We try to bring up our children in the best way possible. We share with them the values that we learned from our parents. Education is our main priority—we tell our children this is all that they can inherit from us."

Working just a few feet away from her mother's casket, a Manila woman fries up eggplant and *tuyo* (dried fish) for her family's dinner. She also serves coffee, biscuits, and peanuts to help keep the visitors awake. Many of the mourners are taking advantage of a quirk in Filipino law that permits gambling only at funerals. The loss of decorum does not upset the bereaved woman. She receives a percentage of the take from the gambling and uses the cash to help pay for the burial.

Diabesity

HUMAN BEINGS ARE OMNIVORES, and there is an extraordinary variety of fruits, vegetables, grains, and meats for people to eat. Food preferences may have varied across the globe, but they have also conformed to some universal patterns. In almost every country, diets have traditionally been low in simple carbohydrates, especially processed sugars, and low in trans fats and saturated fats, like palm and coconut oil. Now, though, the world is changing. Everywhere people are eating more and more simple carbohydrates and saturated and trans fats. From place to place, meals still look different, but they are increasingly likely to be the packaged products of a large company—and decreasingly likely to be good for you.

The result is that we are beginning to experience a global epidemic of what has been called "diabesity," a potent mixture of diabetes and obesity. Its epicenter is the United States, where nearly 60 percent of adults—and 30 percent of children—are overweight or obese. Because obesity is tightly linked to diabetes, the Centers for Disease Control and Prevention estimates that one in every three children born in the United States in the year 2000 will have diabetes some time in their life. As a result of diabesity, this generation of American children will likely live less long than their parents.

Diabetes is a disease characterized by abnormally high sugar levels in the blood. It occurs because a key hormone, insulin, is either absent or unable to work normally in some of the body's cells. There are two main forms of diabetes, type 1 and type 2. Type 1 diabetes, which used to be called juvenile-onset diabetes, occurs when the immune system malfunctions and destroys the cells in the pancreas that produce the body's insulin. Typically appearing in childhood and progressing rapidly, type 1 diabetes is relatively rare. Nine out of ten people with diabetes have type 2, which used to be called adult-onset diabetes. In type 2, the pancreas continues to make insulin, but the body doesn't respond to it. Either way, the insulin deficiency or resistance prevents the body's cells from obtaining the sugars they use as fuel. As the body's cells starve, unused sugar accumulates in the blood and spills out into the urine, creating the symptoms of diabetes, including excessive urination, thirst, fatigue, blurred vision, and sores that do not heal normally.

Diabetes, already the sixth leading cause of death in the United States, is responsible for almost 200,000 deaths in the United States each year, most of them from diabetes-linked cardiovascular disease. Diabetes increases the risk of heart disease sixfold and multiplies the risk of stroke by four. It is the leading cause of acquired blindness, kidney failure, and nontraumatic amputation (limb loss that is not due to accidents or violence). In 2002, diabetes cost the United States $132 billion in direct medical costs, lost wages, and lost work productivity.

Type 2 diabetes occurs in those who are genetically susceptible when they overconsume calories, particularly from saturated fats and simple sugars; physical inactivity also plays a role. It usually comes on gradually, with such subtle symptoms that almost a third of those with the disease—more than 5 million people in the United States—do not know they have it. In the past, it typically made its appearance in the fifth or sixth decade of life (hence the previous name adult-onset diabetes), but that is no longer true. Today, younger adults and even children are developing type 2 diabetes.

Type 1 diabetes is incurable and unpreventable, though it can be treated. Type 2 is different. Many people can prevent it simply by maintaining a healthy weight. And even if they develop diabetes, losing weight

can help many people cure the disease, if it is still in its early stages.

Unfortunately, ever-larger numbers of people live in families, attend schools, and inhabit neighborhoods where it is extremely difficult to maintain a healthy diet. They are the victims of a society that does not seem to care, of an economic structure that makes it cheaper to eat fries than fruit, of the food industry and the mass media luring them to consume what they shouldn't. Schools are becoming one of the worst environments of all, selling sugar-containing soft drinks, candy, and fast food to children.

In my work at the Obesity Center of Childrens Hospital Los Angeles, I see children every day who have been made sick by their environment. One of my patients, 16-year-old Max, who weighed close to 300 pounds, told me that he drank a six-pack of sweetened soda every day. I was appalled: he was consuming more than a thousand empty calories every day just in soda. And I was puzzled, too. Max was on his high school's junior varsity football team, which meant he arrived at school early in the morning and left late in the afternoon, after practice. How, I asked, did he manage to drink six cans of soda in the remaining hours of the day?

The answer floored me: Max explained that he bought five cans of sugared soda from school vending machines every day, one each before his first class, his second class, and lunch. Before football practice he downed a fourth can, and he topped it off with a fifth can of soda when practice was over. That left one for home. I asked why he didn't drink water. He told me the water that came out of the fountains was brown and smelly and the vending machines didn't sell it. The rest of his diet was equally bad. In the mid-morning he bought a candy bar at the student store, at lunch he had the high-calorie, high-fat burrito and fries or cheese nachos, and after football prac-

tice there were boxes of doughnuts. I asked about fruits and vegetables. Max told me they were usually soft and brown, or covered in butter or sauce. There was literally nothing in his daily environment that was both nutritious and appealing.

Max is but one of a growing number of children at risk. In 2001, the *Lancet* published a study of sixth- and seventh-grade children in Boston that found the odds of becoming obese increased by 60 percent for each 12-ounce can of sweetened soda consumed daily. Given such figures, which have been shown to be accurate in study after study, schools must no longer sell candy, sugar-containing drinks, and fast foods loaded with calories and fat.

We must begin putting children's health and welfare above the financial benefits of selling junk food, fast food, and sodas in school. A year after the *Lancet* study, I joined a coalition working to ban the sale of soda in the Los Angeles Unified School District, the second biggest in the United States. Ultimately, the district banned the sale of sodas and then vending-machine junk food to students. I hope this move is just the beginning.

We stand at a crossroads, now in the United States and soon in the rest of the world. People must change schools, communities, health-care systems, workplaces, governments, and their own families. Only then can we return to living our lives with appropriate nutrition and physical activity. In this way we can live and grow old with a normal weight, a normal blood sugar, and the chance to be healthy.

Francine R. Kaufman, M.D., is the author of Diabesity, *a call to action against the dangers of diabetes and obesity. A professor at USC, she also heads the Center for Diabetes and Endocrinology at Childrens Hospital Los Angeles.*

"They are the victims of a society that does not seem to care, of an economic structure that makes it cheaper to eat fries than fruit, of the food industry and the mass media luring them to consume what they shouldn't."

CHICKEN, PIGS' FEET, BEEF, TOFU, EGG-WHITE CUSTARD • WEITAIWU VILLAGE, CHINA

CINNAMON BREAKFAST ROLL, CHEESE, MEAT • BARGTEHEIDE, GERMANY

POTATO CURRY, DAL, CHAPATIS AT KUMBH MELA • UJJAIN, INDIA

SERRANO HAM, GRILLED VEGETABLES, FRUIT • PARIS, FRANCE

BBQ PORK • WARSAW, POLAND

PORK AND ONIONS • BRISBANE, AUSTRALIA

CHUGCHUCARAS (PORK, BANANAS, CORN, EMPANADAS) • LATACUNGA, ECUADOR

KARAOKE LUNCH (CHICKEN, CRABS, SOUP, SPRING ROLLS) • MANILA, PHILIPPINES

POHA BREAKFAST (RICE FLAKES, CHICKPEA-FLOUR NOODLES) • UJJAIN, INDIA

FRIED EGGS • SARAJEVO, BOSNIA AND HERZEGOVINA

CHICKEN AND RICE • DUBAI, UNITED ARAB EMIRATES

PLASTIC FOOD, RESTAURANT WINDOW • KOBE, JAPAN

WHATABURGER FRIED CHICKEN AND FRENCH FRIES • SAN ANTONIO, USA

Meals

As every traveler learns, human beings eat an extraordinary variety of foods, all prepared in stunningly diverse ways. Yet, as Francine Kaufman points out in her accompanying essay, these pictures of meals around the world, apparently so dissimilar, illustrate a trend. As societies around the world grow more affluent, their members eat more sugar, more refined carbohydrates, more dietary fat. Nutritionists disagree on the effects of each one, but most believe that the collective impact of this transition is disastrous—producing a global onslaught of obesity, diabetes, and cardiovascular disease.

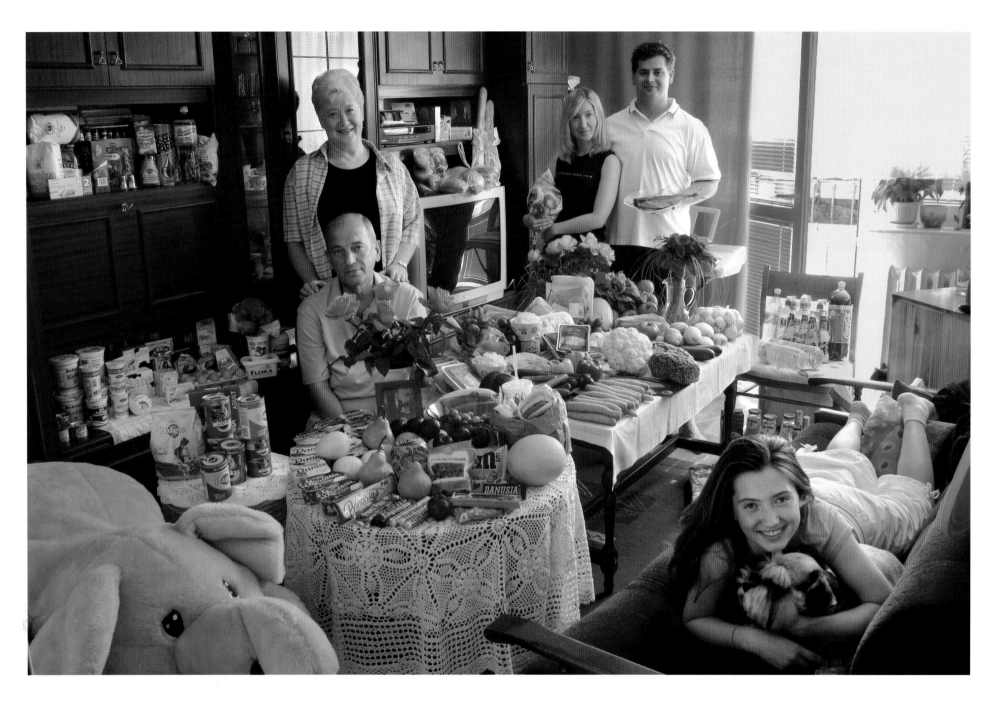

The Sobczynscy family in the main room of their apartment in Konstancin-Jeziorna, Poland, outside Warsaw, with a week's worth of food. Marzena Sobczynska, 32, and Hubert Sobczynski, 31, stand in the rear, with Marzena's parents, Jan Boimski, 59, and Anna Boimska, 56, to their right and their daughter Klaudia, 13, on the couch. Cooking method: gas stove. Food preservation: refrigerator-freezer. (Polish surnames are gender-based and can change when speaking of the family as a whole. "Sobsczynscy" is plural).

Shock of the Shoku

Grains & Other Starchy Foods: $11.02

Mature potatoes, 6.6 lb, *used for grilling;* new potatoes, 4.4 lb; onion bread, 2.2 lb; *Szymanowska* flour, 2.2 lb; six-grain bread, 1.8 lb; bread rolls, 1.3 lb; sesame bread,‡ 1.3 lb; Polish bread, 1.3 lb; *Agnesi* spaghetti, 1.1 lb; baguettes, 1.1 lb; white rice, 1.1 lb; *Sonko* buckwheat, 14.1 oz; ciabatta bread, 10.6 oz; *Wasa* crispbread, 7.1 oz.

Dairy: $19.50

Bakoma kefir (type of light sour cream), 1.6 qt; milk, 1.1 qt; feta cheese, 1.2 lb; cottage cheese, low fat, 15.9 oz; cottage cheese, minced, 15.9 oz; *Danone Danio* Straciatela cream cheese (contains vanilla cream and chocolate flakes), 15.9 oz; cream, 15.2 fl oz; *Bakoma* plum yogurt, 10.6 oz; *Danone* Fantasia cream cheese, 10.6 oz; gouda cheese, 8.8 oz; mozzarella cheese, 7 oz; soignon cheese, 7 oz; *Danone Danio* vanilla cream cheese, low fat, 5.3 oz; *Danone Danio* strawberry cream cheese, 5.3 oz; *Bakoma* Kremowy coconut yogurt, 5.3 oz; *Bakoma* Kremowy coffee yogurt, 5.3 oz.

Meat, Fish & Eggs: $50.50

Auchan (store brand) pork, knuckle, 4.3 lb; *Auchan* chicken, whole, 3.3 lb; *Auchan* pork, loin with bone, 2.3 lb; *Auchan* chicken, fillet, 2.2 lb; *Auchan* pork, minced, 2.2 lb; *Auchan* pork, shoulder, 2.2 lb; *Auchan* ribs, 2.2 lb; sausage, 2.2 lb; *Auchan* ham, 1.7 lb; eggs, 12; *Lisner* herring, 1.7 lb; head cheese, 1.5 lb; *Koral* Norwegian salmon, 1.1 lb; chicken paté, 13.8 oz; *Losos* sprat with tomato sauce, canned, 12 oz; smoked pork sausage, 11.6 oz; *Auchan* pork, loin, 10.6 oz; mackerel, 10.6 oz; *Morliny* hot dogs, 8.8 oz.

Fruits, Vegetables & Nuts: $22.59

Pears, 4.4 lb; lemons, 2.2; red cherries, 2.2 lb; *Dole* yellow bananas, 2 lb; green apples, 1.1 lb; honey melon, 1.1 lb; plums, 1.1 lb; oranges, 1 lb; tomatoes, 11 oz; carrots, 3.3 lb; white onions, 2.2 lb; cucumbers, 2.1 lb; bell peppers, red, orange, yellow, 1.4 lb; butter lettuce, 2 heads; cauliflower, 1 head; pickles, 17.6 fl oz; mixed vegetables for soup stock (leek, parsley, carrots, celeriac), 1.1 lb; red onions,‡ 1.1 lb; radishes, 10.6 oz; tomato puree, 7.4 oz; chives, 3.5 oz; walnuts, 7.1 oz; hazelnuts, 5.3 oz.

Condiments: $11.70

Sauerkraut, 4.4 lb; vegetable oil, 1.1 qt; white sugar, 2.2 lb; *Winiary* mayonnaise, 24 fl oz; margarine, 14.1 oz; olive oil, 12.7 fl oz; salt, 8.8 oz; basil, fresh, 1 bunch; mustard, 4.4 oz; *Vegeta* (mix of various herbs and salt), 4.4 oz; chili powder, 1.9 oz; cumin powder, 1.9 oz; rosemary, dried, 1.9 oz; sweet paprika, 1.4 oz; marjoram, 0.5 oz; bay leaf, dried, 0.2 oz.

Snacks & Desserts: $4.49

M&M's chocolate candy, 14 oz; *Princessa Maxi* chocolate bar, 6.4 oz; *Milka* chocolate candies, with nuts, 5.3 oz; *Mentos* grapefruit candies, 4.3 oz; *Alpen* gold nussbeisser chocolate hazelnut bar, 3.5 oz; *Mentos* mints, 2.2 oz; *Twix* candy bar, 2.1 oz; *Snickers* candy bar, 2 oz; *Danusia* chocolate bar, 1.8 oz; *Olza* Prince Polo chocolate wafer, 1.8 oz.

Prepared Foods: $0.88

Knorr chicken bouillon cubes, 8.7 oz.

Fast Food: $2.60

McDonald's: hamburger, french fries, drink.

Beverages: $21.28

Mineral water, 1.2 gal; *Dr. Witt* carrot juice, 3 1.1-qt bottles; *Zwiec Zdroj* mineral water, 3.2 qt; *Coca-Cola*, 2.1 qt; *Garden* apple juice, 2 1.1-qt boxes; orange juice, 2 1.1-qt boxes; *Miller* beer, 4 12-fl-oz bottles; *Sprite*, 1.1 qt; coffee, 7.1 oz; *Lipton* tea, 50 teabags; tap water, for drinking and cooking.

Miscellaneous: $6.71

Pedigree dog food, dry, 3 lb; *Pedigree* dog food, canned, 2.8 lb; *Wiskas* cat food, canned, 2.8 lb; *Wiskas* cat food, dry, 1 lb.

‡ Not in Photo

**Food Expenditure for One Week:
582.48 zlotys/$151.27**

BEETROOT SOUP WITH DUMPLINGS AND HERBS, potatoes, sauerkraut, meat stews simmered for days: Hubert Sobczynski grew up on this hearty Polish fare in a small village outside Warsaw, and if it seems like quite the cultural leap to go from eating the rib-sticking foods of his youth to loving all things sushi—well, it is. There is nothing in Polish cooking that even remotely resembles Japanese cuisine, but both the taste of sushi and the art of its preparation attracted him. After he apprenticed with a visiting Japanese sushi chef in Warsaw's first Japanese restaurant, he and his wife Marzena opened Shoku-Yoku, their own sushi eatery. To support the new restaurant, and save for their own house, they moved with their 13-year-old daughter Klaudia, into Marzena's parents' tiny three-room apartment. When Hubert isn't making sushi at his restaurant, he cooks Polish dishes at home for the five of them.

In the mornings, the three pack their bedclothes into cupboards and tuck the beds back into the living room sofa. Then it's time for breakfast in the narrow kitchen. The morning meal consists of a variety of foods—sweet buns, fruit, yogurt, cereal and milk, eggs, sausage, and tea or coffee. Although the family, like most Poles, eats mostly traditional Polish fare at home, Marzena's mother Anna has developed a taste for Hubert's sushi. "When we are in the restaurant, we have to take something away for her. Otherwise, she is disappointed," says Marzena. "She likes everything: shrimps, eel, *uni.*" Marzena's father Jan was hesitant—he is much more conservative about food than his wife. "It took us almost a year to convince him to try sushi," says Marzena. "We suspect that he finally felt jealous because of Mum's pleasure in it, and that was the reason he finally tried it. Now, when we ask him if it is tasty, he says it is nothing special, but when we bring some home for Mum, it disappears in strange circumstances."

Sushi is just one of many international cuisines to come to this formerly Communist Eastern European country now that disposable income is increasing, and people are beginning to eat outside their homes. Before 1989, state-run restaurants called *bar mleczny*—milk bars—were virtually the only places to go out for dinner. At first, they served mostly milk-based soups, hence the name, and didn't serve alcohol or meat. Some remain in operation today, serving low-priced traditional food. They are still subsidized by the state, but

are privately owned. The competition from other restaurants and fast-food emporia is now fierce. Along with post-Communist Capitalism, American-style fast food has come to roost in Poland and with it something that Marzena herself never experienced growing up—the media-fueled fear that teenage girls have of getting fat. It seems odd to Marzena that just as high-calorie fast food has been introduced in the culture, so has the desire to avoid its effects at all costs. "All of Klaudia's friends are on a diet," Marzena says. She worries that the struggle is not winnable. Do Marzena and Hubert ever eat fast food? "We laugh and say that the hamburgers are made of the dog minced together with its kennel," she says. "But from time to time we feel like eating something of that kind. Later, we feel guilty, and we promise each other that it was the last time." Today, Poland is home to a cast of the usual multinational supermarkets and food is also readily available from small groceries, green markets, butcher shops, and bakeries, but what a difference a couple of decades make—

DECEMBER, 1981. THE CRISIS
Marzena remembers holding her father's place in a long line of people queued up at a butcher shop to buy meat. Her father would walk her there and then go wait in another queue at another shop. "I was nine years old and frightened," she says, "surrounded by strange and tired people, and thinking, What will I do when I get to the counter if *Tata* [Father] does not get back in time? What will I say? Should I allow a few people to buy first and wait for him?" And there was always the possibility that the meat would run out before he came back—a stressful situation for such a little girl.

Throughout its history, Poland has repeatedly been subjugated by its neighbors. Twenty percent of its population died during World War II, and then the Soviet Union, which drove out the Nazi occupation, became Poland's master, ruling through a puppet government.

The Poles' most recent trial was the period of martial law declared in 1981 by the country's then-Communist government. It was enacted to thwart the momentum of democratic movements like the independent trade-union group Solidarity. With its borders closed, the country ground to a halt. Martial law ended in 1983, but food remained scarce throughout the decade. And even when food could be found, there was little money to buy it. "Sometimes, my father would leave in the morning when it was still dark, to see what he could find," Marzena

says. "He might not come back until late in the evening, but how happy he was and proud of himself when he came back home with food." There was always the chance that only the day's tasteless remainders would be available. Says Marzena: "I remember in one shop, the only food was a huge, orange block of cheese, salty and not tasty at all." With scarcity, likes and dislikes come to the fore. "My grandmother would buy sausage all speckled with caraway seeds," Marzena says. "I tried to take the seeds out, but it didn't improve the taste. I hated this sausage with all my heart, but Grandma still bought it because at least it was available, and probably the price was good."

In the early days of martial law, people could still find chocolate, Marzena's favorite. Later, there wasn't chocolate anymore but a product that was sort of like it. "It was strange," says Marzena, "but it tasted good and I liked it." When there were no longer any sweets to be found, Marzena's mother Anna would make the children little balls of oat flakes with cocoa mixed in. One time, Marzena remembers that the Catholic Church gave each child in her community a gift of two pounds of milk powder and a jar of Gerber baby food. "We ate the milk powder dry, but I discovered that the jar contained nothing tasty."

Hubert and Marzena attended the same school and grew up in the same circle of friends. Everyone in the school knew that Hubert's grandmother had immigrated to the United States before "the crisis" and would send boxes of food to his family. "We were all jealous about that grandma from America," says Marzena. Hubert has fond memories of receiving huge bars of chocolate that they would cut with a knife, and Nutella, which was not available in Poland at that time. "Once, Hubert brought some oranges to school," says Marzena. "Every fruit was wrapped in thin paper. Luckily, Hubert was in love with me, so he offered them to me especially. They tasted delicious, and the paper served me as a bookmark for a long time."

Because of the hardships, the smallest pleasures brought happiness, "even the smallest bar of chocolate, or a mint candy," says Marzena. She has vivid memories of small pleasures: she and her friends would put powdered lemonade on their tongues. "It frothed brilliantly," she says. In these more affluent times, she worries that her daughter doesn't appreciate how well off she is. "So few things make Klaudia happy," she laments. "Candies are merely candies— nothing is special. Bananas, oranges—they are normal to have. For us, they were something incredibly special, and they still are."

- Population: **38,626,349**
- Poles killed during World War II: **6,800,000**
- Population of Konstancin-Jeziorna: **22,000**
- Number of years since 1795 that Poland did not exist as a country: **129**
- Number of years Poland existed as a country under Soviet domination: **45**
- Area in square miles: **120,696 (slightly smaller than New Mexico)**
- Population density per square mile: **320**
- Urban population: **62%**
- Life expectancy, male/female: **71/79 years**
- Fertility rate (births per woman): **1.3**
- Literacy rate, male/female, 15 years and older: **100/100%**
- Caloric intake available daily per person: **3,374 calories**
- Annual alcohol consumption per person (alcohol content only): **8.8 quarts**
- GDP per person in PPP $ (Purchasing Power Parity: an adjustment for what equivalent local goods would cost in the U.S.): **$10,560**
- Total annual health expenditure per person in $ and as a percent of GDP: **$289/6.1%**
- Overweight population, male/female: **51/44%**
- Obese population, male/female: **13/18%**
- Population age 20 and older with diabetes: **4.1%**
- Meat consumption per person per year: **172 pounds**
- McDonald's, restaurants: **200**
- Big Mac price: **$2.06**
- Cigarette consumption per person per year: **2,061**

Scooping out sauerkraut, Marzena leads Hubert and Klaudia through the family's grocery shopping at the Auchan hypermarket. The huge new supermarket, ten minutes' drive from their home, is near a big intersection that serves four or five other bedroom communities. Crowded with weekend shoppers, the store is a sign of the rapid economic development of the Polish countryside, which two decades ago was dominated by Communist-era collective farms.

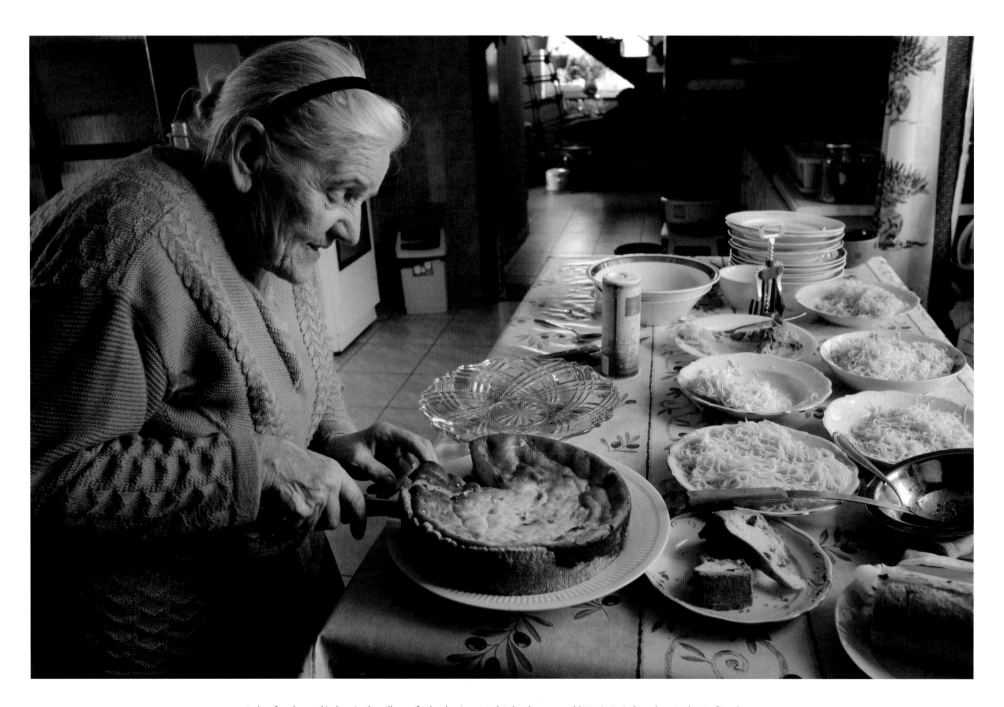

In her farmhouse kitchen in the village of Adamka, in central Poland, 93-year-old Maria Kwiatkowska—Hubert's friend Borys's grandmother—slices the cheesecake she baked for the traditional family gathering on All Saints Day. After visiting the graves of their relatives in the local cemetery, her children and grandchildren descend on her for a splendid lunch of noodle soup with cabbage and carrots, pork roast stuffed with prunes, pickled pumpkin, a fruit-nut roll, and cheesecake.

Hubert's Knuckle

6 qt water

6 pimento berries, dried

6 T salt

6 bay leaves

4 pig's knuckles

2 onions, chopped

soup vegetables (carrots, celery, parsnips, turnips)

1–2 bouillon cubes (optional)

salt

pepper

- Add pimento, salt, and 3 bay leaves to 3 qt water to make a brine.
- Rinse knuckles well and place in brine, making sure they do not stick out of liquid. Refrigerate for 3 days.
- After that time, remove knuckles and rinse.
- Fry onions on a dry pan until they are deep brown, almost black on both sides (this adds taste and aroma).
- Add soup vegetables, optional bouillon, knuckles, salt to taste, and pepper to taste in 3 qt water. Cook for about 3 hours, until knuckles are tender.
- Serve with bread and either horseradish or mustard.

Hubert's account of his ascension of the culinary ladder in Poland, from an assistant cook to a master sushi chef, was impressive, but so far as I was concerned, the proof would be in the sushi. Eight of us ate at a long table one night at his new restaurant. I was slightly apprehensive. A few months earlier, we had looked for a meal at a suburban mall in Knoxville, Tennessee. Seeking solace after scouting a few all-you-can-eat buffet restaurants (deep-fried everything in steam trays), we settled into a booth at a newly opened Japanese place and ordered the sushi lunch special. The *ebi* (freshwater shrimp) and *maguro* (tuna) were not the freshest I have ever eaten, but weren't bad. But when I bit into the "California roll"—their version was a concoction made with sweet mayonnaise and cream cheese that has never been seen in California, let alone Japan—my head spun completely around as I was possessed by the Demon of Southern Cuisine. Taste buds still reeling after paying the check, I sought out the Japanese owner. He explained that he had adapted his food to local tastes. I didn't ask him about grits or deep-fried sushi because I didn't want to give him any ideas. I needn't have worried about Hubert's sushi, which was much closer to the authentic article, although Poland is just as far from Japan as Tennessee is. What a pleasant surprise to feast on magnificently traditional sushi, fresh and delicious, in central Warsaw, prepared by two young Poles who had never been to Japan. — *Peter*

Although Hubert Sobczynski is a professional sushi chef, he cooks and serves European fare for family and guests *(above left, coffee and pastries at the Sobczynscy apartment)*. And when his neighbor and friend Borys invites the three Sobczynscy for dinner *(bottom left)*, Hubert willingly steps into the kitchen to prepare salad and stuffed potatoes—even though Borys in the living room is serving cocktails of absinthe, a legendarily strong green liqueur flavored with wormwood and anise.

The Çelik family in the main room of their three-room apartment in Istanbul, Turkey, with a week's worth of food. Mêhmêt Çelik, 40, stands between his wife Melahat, 33 (in black), and her mother, Habibe Fatma Kose, 51. Sitting on the couch are their children (back to front) Mêtin, 16, Semra, 15, and Aykut, 8. Cooking method: gas stove. Food preservation: refrigerator-freezer.

Fabulous Food

ONE WEEK'S FOOD IN JANUARY

Grains & Other Starchy Foods: $10.46

Bread, 32 loaves, 49.4 lb, *2 loaves missing—the family ate them while waiting for the photograph to be taken*; potatoes, 11 lb; rice, 6.6 lb; yufka (thin pastry sheets), 2.2 lb, *purchased from a street vendor*; *Filiz* pasta, 1.1 lb.

Dairy: $12.16

Yogurt, 2.1 qt; feta cheese, in water, 2.2 lb; *Dost* milk, 1.1 qt; drinkable yogurt (Bandirma style), 1.1 qt; *Sana* butter, 8.8 oz.

Meat, Fish & Eggs: $11.50

Eggs, 24; hamsi (anchovy-like fish), 1.1 lb, *generally eaten twice a month*; beef, 13.2 oz, *eaten one or two times a month only. The meat shown in the picture is enough for one month.*

Fruits, Vegetables & Nuts: $56.53

Oranges, 6.6 lb; tangerines, 6.6 lb; dates,‡ 2.2 lb; yellow bananas, 2.2 lb; pomegranates, 2.1 lb; zucchini, 7.9 lb; tomatoes, 4.4 lb; black olives, 3.3 lb; chickpeas, dried, 3.3 lb; cabbage, 1 head; carrots, 2.2 lb; eggplant, 2.2 lb; leeks, 2.2 lb; lentils 2.2 lb; lettuce, 2 heads; peppers,‡ 2.2 lb; spinach, 2.2 lb; yellow onions, 2.2 lb; cucumber, 1.7 lb; arugula, 1 lb; *Avsarlar* nuts, mixed, 2.2 lb.

Condiments: $9.60

Sunflower oil,‡ 1.1 qt; *Bal Küpü* white sugar, cubed, 1.1 lb; jam, 10.6 oz; honey, 10.1 fl oz; mint, dried, 8.8 oz; salt, 8 oz; cinnamon, 7.1 oz; pepper, 7.1 oz.

Snacks & Desserts: $0.51

Seyidoglu helva (sesame seed paste cookie), 1.1 lb.

Prepared Food: $1.36

Knorr Gunun Corbasa dry soup, powdered, 11.2 oz.

Homemade Food:

Stuffed pastries, approx. 4.4 lb, *sheets of yufka (unleavened pastry dough) formed then filled with arugula and feta, listed above*; dolmas, approx. 2.2 lb, *grape leaves stuffed with spices, rice, vegetables, and meat, listed above.*

Beverages: $29.66

Efes beer, 8 17-fl-oz bottles; *Coca-Cola*, 8 12-fl-oz cans; *Fanta* orange soda, 2.1 qt; *Hediyelik* tea, 3.3 lb; *Pepsi*, 3 12-fl-oz cans; *Coca-Cola* light, 12 fl oz; *Nescafe VIP* instant coffee, 3.5 oz; bottled water, *purchased for cooking and drinking.*

Miscellaneous: $14.10

Tekel cigarettes, 7 pks; *Simarik* bird food, 20 oz.

Food Expenditure for One Week:
198.48 New Turkish liras/$145.88

MELAHAT ÇELIK ISN'T HOME FROM WORK when we arrive at the Istanbul apartment she shares with her family and her mother Habibe Fatma Kose. Habibe and Melahat's 8-year-old son Aykut greet us, along with the members of their extended family who live in the same building. A loud voice in the hall causes Melahat's aunt to return home abruptly. We later hear her husband described as "an angry man." A green songbird twitters in its cage in the corner of the room, and the afternoon call to prayer from a nearby mosque wafts through the open balcony window. Habibe offers us sweet Turkish coffee in the customary tiny cups. When Melahat arrives, we are ensconced on a comfortable sofa that doubles as a bed at night and are getting to know her 16-year-old son Mêtin and her 15-year-old daughter Semra, who have just arrived home from school.

Melahat, whose husband Mêhmêt is a factory worker, has cleaned other people's homes since the couple got married in the Anatolian city of Kastamonu, in Turkey's Black Sea region, where they both grew up. As is customary, the marriage was arranged. They moved to Istanbul almost immediately to find work and Melahat's widowed mother Habibe followed shortly thereafter. She has lived with them for their entire married life.

The Çeliks' small one-bedroom apartment is a tight fit for the family of five, plus a grandmother, Melahat says, assembling the ingredients for *sigara boregi*, a favorite family dish. She seats herself on the living room floor behind her *sofra*, a low, round food-preparation table used in many Turkish homes, which she brought to Istanbul from her hometown. She combines fresh arugula and Feta cheese, and then sets the mixture aside to unfold the package of fresh *yufka* (phyllo pastry dough), purchased from a nearby street vendor. "I always buy it," she says. "It's too difficult to make, and it takes too much time to prepare at home." Laying a sheet of the dough across her little table, she rolls it out with a practiced motion, slices it, and plops a bit of the filling onto the dough. Using the palm of her hand, she folds the pastry around the filling to make a cigar shape, dips the pastry edge in a water bowl, and lightly presses dough against dough to glue it closed. She keeps rolling out more dough, and dropping in more dollops of the arugula and cheese mixture, until she has a pile of pastries ready for the frying pan. I'm impressed that

her dough never sticks to the table. "Good *yufka* shouldn't stick," she says. The preparation of this meal has taken the better part of two hours. I ask her whether she always goes to such lengths to make dinner after she's had a long day at work. "Whether I'm tired or not, I cook these same foods," she says. The list includes homemade lentil or tomato soup, rice soup, *dolma* (chopped spiced meat wrapped in grape leaves—Mêhmêt's favorite), spinach, eggplant, zucchini, rice, black cabbage, and occasionally a fish or meat dish like *yahni* (lamb with onions and potato). "My sister Döne sometimes takes care of the children when I'm late at work," says Melahat, "but I do most of the cooking."

Melahat cooks and cleans for six different families during the week. If any of them have dinner guests, she may not come home until two o'clock in the morning. Sometimes, too, she travels with the families on the weekends to cook for them and clean their country homes. When Melahat is away, Habibe, who has a chronic stomach ailment, cannot take on much responsibility for the household. But she does cook simple meals, Melahat says: "Vegetables prepared with olive oil—*zeytinyagli*, or other meals that are easy to cook." Mêhmêt helps out, but Melahat mainly relies on Döne, who has only one child, to step in and take her place. And the children have learned to take care of themselves as they've grown older. Melahat says she couldn't survive without her sister's help. I ask how Melahat compares her life to the lives of the people she works for. "They are well-educated and have money from their families," she says. "Their lives, their clothes, and their food are of high quality. When they are having guests for dinner, they consume more meat in one night than I could afford in a month." She doesn't begrudge them their comfort, she says, but is grateful that they share their castoff clothes with her family.

Melahat's goal is to see that her three children get enough education so they can avoid the physical labor that she and her husband, both uneducated, must do for a living. "It is okay for me to go hungry, as long as I can afford a good education for [them]," she says. "My children shouldn't live the way I do. It can be a burden to serve or clean up after someone else. I do the cooking, the ironing, I clean the bathrooms, the toilets, wash the windows and floors. It is very hard—exhausting. I don't want my kids to clean up after other people like I am doing now. I want them to become teachers, secretaries. I want them to make a good living using their minds, not

their bodies. I want them to be respectable people in their jobs."

Already her children's lives are quite different from her life in Kastamonu. Mêtin and Semra attend high school and are doing well; Melahat believes they will be able to find good employment. But she is perplexed by her children's attraction to fast food, especially McDonald's. She hears from the people she works for that it isn't healthy to eat such food, but she has trouble telling the children that they can't have it on the few occasions in a year when there might be extra money for a treat. "Aykut likes to have the hamburgers and French fries, to get the little toy gifts they give with the kid's menu," she says. "If I had more money, I'd rather buy chicken and meat every day for my children." But four or five times a year, when she does have the money, she takes them to the McDonald's at the local mall.

The interest in McDonald's is surprising given that Istanbul's streets are full of traditional take-away foods like Turkish *döner kebab*, a spicy meat—usually lamb—sliced thinly from a rotating vertical spit, and served with chili sauce, or other condiment on pita bread. Sometimes the meat is minced, then pressed together with a binding agent onto a vertical spit, and barbecued. This less expensive version is sliced and served as above. In addition, some Turkish foods mimic the look of Western hamburgers but add distinctly Turkish spices and herbs. But even this is generally too pricy for Melahat, so the children settle for the next best thing—homemade French fries with mayonnaise, and spaghetti with ketchup and Feta cheese. Recalling Vanessa Stanton's efforts at homemade French fries in Australia (p. 28), I think the two women would enjoy comparing notes.

A couple of companionable hours later, Melahat is ready to fry the *sigara boregi* in the narrow kitchen by the bedroom and the living room, where her children and her mother sleep. The best part of the whole house may be the half-enclosed balcony where the extra water is stored (Istanbul's tap water is not drinkable), and where sweet-smelling laundry flutters on a clothesline. Unfortunately, the spot holds a terrible memory for Melahat—she fell from this third-floor balcony while beating a mattress. She says she doesn't like to think of how her children's future might have turned out had she died. Though she broke her arm badly and lost consciousness, she survived. Aykut nestles close to his mother as she tells us the story. He would have missed more than an education.

- Population: **68,893,918**
- Population of Istanbul: **8,803,468**
- Area in square miles: **301,304 (slightly larger than Texas)**
- Population density per square mile: **229**
- Urban population: **67%**
- Number of years Turkey, which is 99% Muslim, has been a secular state: **81**
- Life expectancy, male/female: **68/72 years**
- Fertility rate (births per woman): **2.4**
- Literacy rate, male/female, 15 years and older: **94/79%**
- Caloric intake available daily per person: **3,357 calories**
- Annual alcohol consumption per person (alcohol content only): **1.7 quarts**
- GDP per person in PPP $ (Purchasing Power Parity: an adjustment for what equivalent local goods would cost in the U.S.): **$6,390**
- Total annual health expenditure per person in $ and as a percent of GDP: **$109/5.0**
- Overweight population, male/female: **48/65%**
- Obese population, male/female: **11/32%**
- Population age 20 and older with diabetes: **7.3%**
- Meat consumption per person per year: **42 pounds**
- McDonald's restaurants: **81**
- Big Mac price: **$2.80**
- Cigarette consumption per person per year: **2,394**
- Population living on less than $2 a day: **10%**

Fishermen catching *istavrit* (horse mackerel) line the Galata Bridge over the Bosphorus, the strait between the Black and Aegean seas. Located on a narrow isthmus between two bodies of water, Istanbul (formerly known as Constantinople and, before that, Byzantium) long dominated the trade between Europe and Asia. The Galata District in the background, a hub for both entertainment and finance, is on the European side of the Bosphorus, both geographically and culturally.

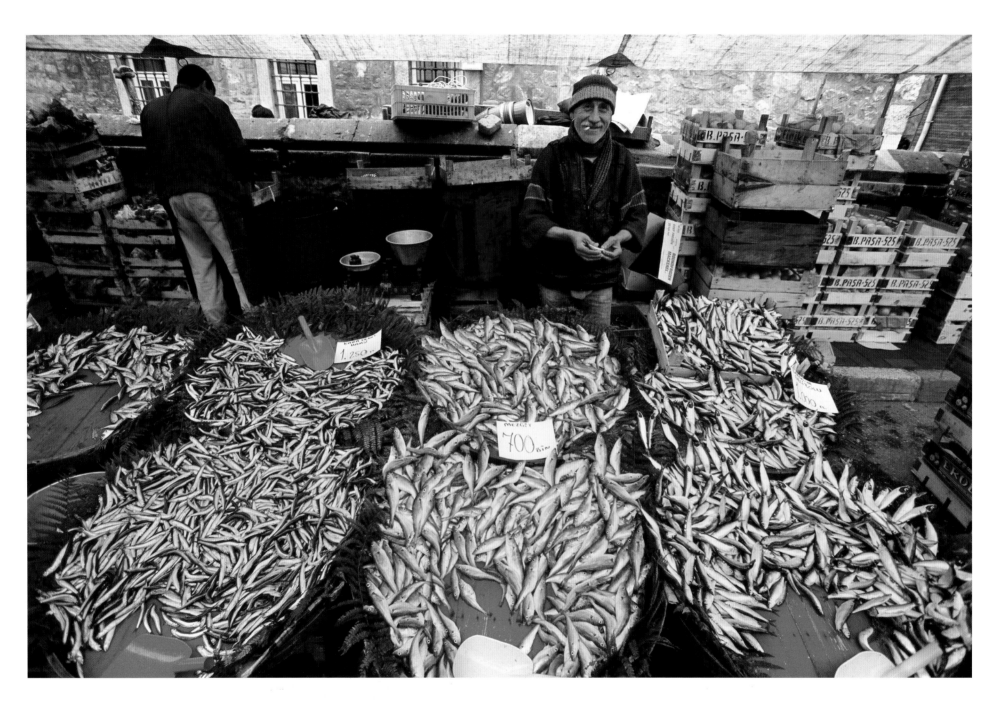

Grinning around his cigarette, a fishmonger in an Istanbul market offers a Turkish favorite—the anchovy-like fish *hamsi*, which can be cooked, according to a Black Sea legend, in 40 different ways. In his canvas-covered stall, the vendor moves from neighborhood market to neighborhood market, each open a different day in the week. Generally, no two neighboring markets operate on the same day—they don't want the competition.

My first-ever visit to Istanbul came after a punishing overnight flight from California. Despite the ferocious jet lag, I performed a ritual that I do in every city: check out the view from the hotel roof. I had wanted to see Istanbul for years and the city did not disappoint. Looking west, the Bosphorus Strait and a crimson sky were separated by a hillside of ancient buildings punctuated by dozens of minarets. And then, in true Islamic surround sound, the loudspeakers on Istanbul's 1,000 mosques cried out the evening call to prayer. I stopped taking photos and just listened until it was over.

Eight days of hard shooting later, I wanted a break. Urged on by Faith, I went with our Turkish friend Ferit to Tarihi Galatasaray Hamami, a *hamam* (traditional Turkish bath) built in 1481. The steamy old marble interior was really steamy and really old. I thought: bath, scrub, sweat, massage, sweat, rinse, *ahhhhh*. The central attractions, as far as I was concerned, were the big marble slabs in a domed marble room that was gray with steam. I was quietly melting down on my slab, totally relaxed in my own ancient cloud, when in walked a hairy, tough-looking man who was as wide as I am tall. This monster proceeded to scrub and massage me into a painful pool of protoplasm. The scrubbing was done with a washcloth that could easily be confused with a wire brush; the massage was like being strapped to a jackhammer. Too proud to beg for mercy, I endured this brutal cleansing and meat-tenderizing routine for a full half hour. Afterward, Ferit, who had experienced this national torture numerous times before, couldn't understand what I was complaining about. He did confess, though, to being paired with a smaller sadist.

— *Peter*

Melahat's *Puf Böreği* (Puffed Pastries)

1/2 lb flour

3/4 coffee cup (6 fl oz) water

1 egg

1 T extra-virgin olive oil

3 oz butter, melted

1/2 lb feta cheese, grated

1 to 1-1/2 cups vegetable oil

- Make dough by combining flour, water, egg, and olive oil. Rest dough for 15 minutes before cutting it into 5 equal pieces.

- Roll those 5 pieces flat with a rolling pin; then spread melted butter on both sides and stack them on top of each other. Let stand for half an hour.

- Roll out dough as thin as possible into a large disk. On half the disk, place small portions of feta cheese. The portions should be about 5" apart.

- Fold empty half of disk over filled half, creating a big semicircle of dough. Around each lump of filling cut out a 4" semicircle in dough with an aluminum saucer or something similar. Press around edges with fingers to seal tightly in half-moon shapes.

- Fry dumplings in oil and serve.

- Variation: prepare as above, substituting 1/2 lb ground meat mixed with minced onion (to taste) for feta cheese.

At a neighborhood open-air market, near one of Melahat's housekeeping jobs, she and her son Aykut *(above left)* buy eggs. In another market, near the Golden Horn, a butcher displays *(bottom left)* cow stomachs, hearts, livers, feet, and a head.

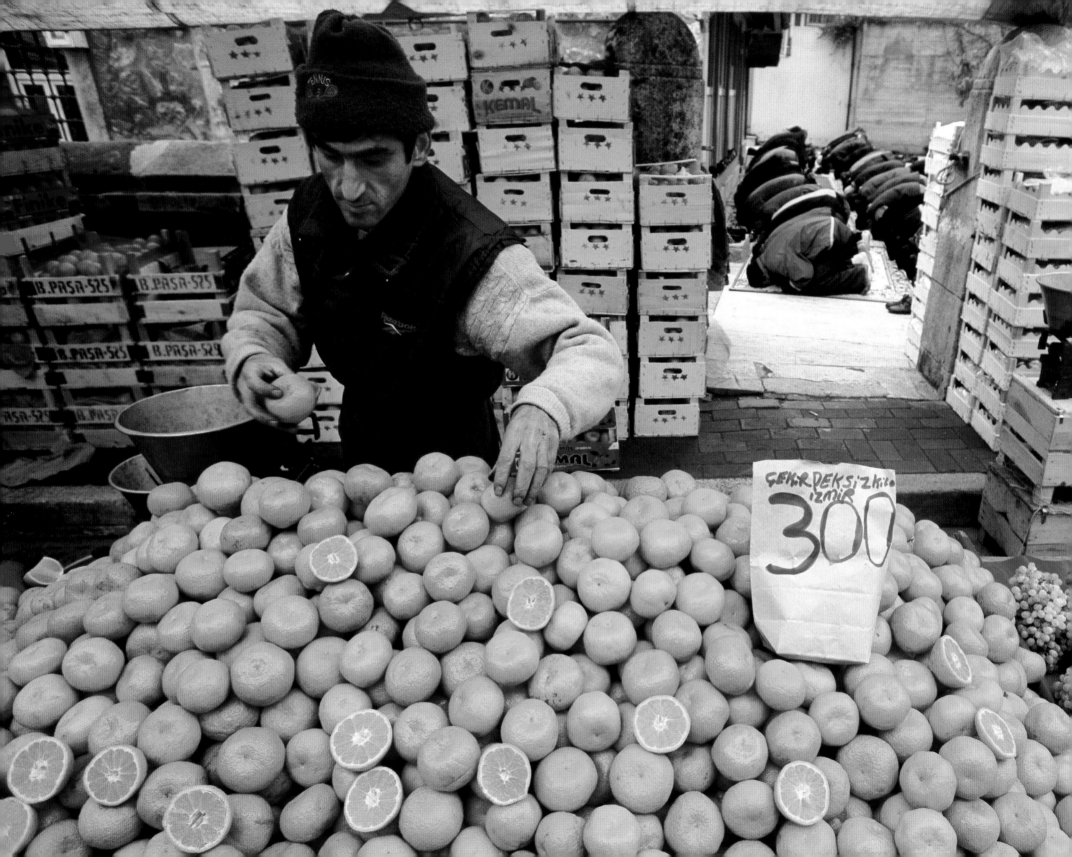

After Melahat Çelik mixes the arugula-feta filling for a savory Turkish pastry in her apartment kitchen, she sits on the living room floor *(above)* and rolls paper-thin pastry called *yufka* around the filling to create an eggroll-style pastry her family loves. On Friday, the noon prayers have begun and a vendor arranges his oranges while behind him men pray at a small mosque.

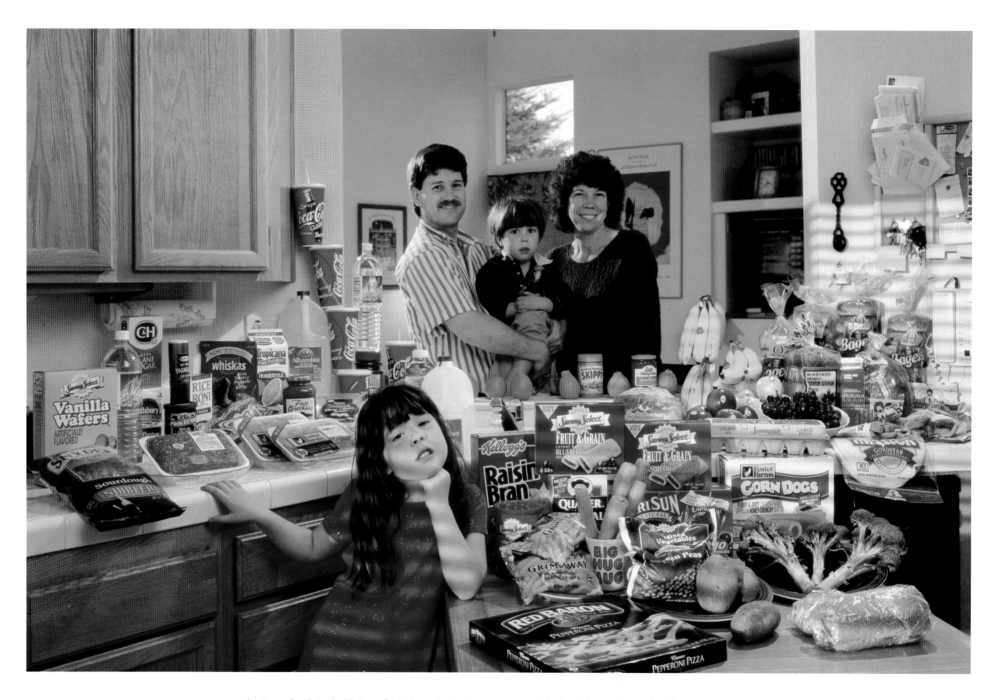

The Caven family in the kitchen of their home in American Canyon, California, with a week's worth of food. Craig Caven, 38, and Regan Ronayne, 42 (holding Ryan, 3), stand behind the kitchen island; in the foreground is Andrea, 5. Cooking methods: electric stove, microwave, outdoor BBQ. Food preservation: refrigerator-freezer, freezer. Favorite foods—Craig: beef stew. Regan: berry yogurt sundae (from Costco). Andrea: clam chowder. Ryan: ice cream.

Kick the Can

Grains & Other Starchy Foods: $30.11

San Luis sourdough bread, sliced, 2 loaves; *Oroweat* cinnamon raisin bagels, 2.5 lb; *Oroweat* onion bagels, 2.5 lb; potatoes, 2 lb; *Kellogg's* raisin bran cereal, 1 lb; *Quaker* oatmeal, instant, 1 lb; *Bohemian Hearth* seven-grain bread, sliced, half loaf; *No Yolk* egg noodles, 12 oz; *Mission* Gorditas flour tortillas, 10 oz; *Buitoni* five-cheese tortellini, 8 oz; *Pillsbury* Best all-purpose flour, 8 oz; *Progresso* bread crumbs, 4 oz.

Dairy: $6.22

Sunny Select (store brand) milk,‡ 1 gal; cheese,‡ shredded, 8 oz; *Kraft* parmesan cheese, grated, 3 oz.

Meat, Fish & Eggs: $22.87

Foster Farms chicken breast tenders, 4 lb; *Sunnyside* eggs, 12; beef, ground, 1.5 lb; tuna fish,‡ canned, 1 lb.

Fruits, Vegetables & Nuts: $21.30

Del Monte yellow bananas, 5 lb; Braeburn variety apples, 2.5 lb; Golden Delicious variety apples, 2.5 lb; tangerines, 2 lb; red grapes, 1.5 lb; baby carrots, 2 lb; broccoli, 1 lb; carrots, 1 lb; *Sunny Select* mixed vegetables, frozen, 8 oz; *Sunny Select* peas, frozen, 8 oz.

Condiments: $9.43

Skippy Roasted Honey Nut peanut butter, 1.1 lb; *C&H* white cane sugar, 8 oz; *Mary Ellen* apricot jam, 4 oz; *Best Foods* mayonnaise,‡ 2 oz; *French's* yellow mustard,‡ 2 oz; *Heinz* ketchup,‡ 2 oz; salt, 1.6 oz.

Snacks & Desserts: $11.54

Snyders sourdough nibbler pretzels, 1 lb; *Sunny Select* raisins, 12 oz; *Sunny Select* vanilla wafers, 12 oz; *Sunny Select* Blueberry Fruit & Grain cereal bars, 10.4 oz; *Sunny Select* Raspberry Fruit & Grain cereal bars, 10.4 oz.

Prepared Food: $19.33

Red Baron pepperoni pizza, 4 lb; ham submarine sandwiches, 2 12-oz, *Craig buys a sandwich at school two times a week*; *Foster Farms* corn dogs, 1.3 lb; *Five Brothers* marinara sauce, 12 oz; *Rice a Roni*, chicken flavor, 6.9 oz.

Fast Food: $7.50

McDonald's: 2 Happy Meals, (each containing 1 6-piece chicken McNuggets, 1 small French fries, 1 low fat milk); chocolate chip cookies, 1 pkg.

Restaurants: $4.50

Fresh Choice Restaurant, *the family eats here once a month, using a coupon to defray the cost. Price shown reflects one-fourth of the cost of one visit per month.*

Beverages: $22.89

Alhambra water, 5 gal; *Coca-Cola,*‡ 2.6 qt; diet *Coca-Cola*, 2.2 qt, *one fountain drink purchased before daily drive to work*; *Capri Sun* juice drink, 10 6.8-fl-oz pkgs; apple juice, 2 qt; *Tropicana* homestyle orange juice, 2 qt; *Sunny Select* instant coffee, 12 oz; tap water for cooking.

Miscellaneous: $3.49

Whiskas Savory Nuggets cat food, 3.3 lb.

‡ Not in Photo

Food Expenditure for One Week: $159.18

"My mother didn't have access to the nutrition information now required by the FDA," says Regan. "She trusted that if the market carried a food item, it must be okay to eat it. So we ate a lot of time-saving food—packaged and canned—rarely anything fresh. I, on the other hand, rarely feed my family canned foods." She prefers serving fresh fruits and vegetables.

THERE ARE MORE SOFT-DRINK MACHINES than water fountains in the Northern California high school where Craig Caven teaches—a fact that angers, but doesn't surprise him. Lucrative contracts with soft-drink companies and snack vendors provide cash-strapped school districts with needed funding. And what better place than a school to find captive consumers with money to burn? "Cafeteria meals have improved," says Craig, "but they're still offering fatty alternatives." He says he still sees many students visiting the vending machines and eating pizza. "What proof do I have?" Craig asks. "All the cans and wrappers on the classroom floor." He believes students are reflecting lessons they're learning at home: "If their parents had taught them good eating habits, then the students would make healthier choices at school."

Craig and his wife Regan, a counselor at the University of California, Berkeley, try to find a balance between what their own two children, Andrea, 5, and Ryan, 3, want and what they actually need. Part of her own balancing act includes Regan's hour-long commute from the city to their home in the grassy suburbs. "I don't mind cooking, but I often get home with no time to think about what to cook," says Regan. Though they have been known to eat a frozen corn dog or two, she doesn't regularly serve convenience food. Despite the time pressure, Regan manages to make a nutritious meal, thanks to her culinary sidekick, the microwave oven. And exercise? Craig says there isn't much time for it. "I've never been on a diet—although some gentle hints have been made in my direction within the past year or so."

Although Regan and Craig have the same nutritional goals at the grocery store, their approach to shopping differs. Regan is a self-proclaimed label reader. "I save my reading for home," says Craig. He tries to get into and out of the grocery store as quickly as possible, and to buy store brands, because "they're generally cheaper than national brands." Regan is looking for "foods low in sodium, low in fat, not too processed, fresh, and organic, if they're not too expensive." They generally eat at home, trying to set a good example—though a few times a month they take the children out for Happy Meals. They've found that doing what's right is not always that easy. "There are just too many chocolate holidays," says Regan, alluding to her own personal vice. "I get through the Christmas candy just in time for Valentine's Day. Next, it's Easter. Then, maybe I can keep away from sweets until Halloween."

Caven Family Beef Stew

2 lb beef stew meat, extra lean, cut into one-inch chunks

1 large onion, peeled and cut into eighths

1–2 T vegetable oil

2 cups water

1 cup canned tomato sauce

1 clove garlic, minced

4 T fresh parsley, chopped

1/4 t basil, dried

1/4 t marjoram, dried

1/4 t oregano, dried

1/4 t freshly ground black pepper

1/4 t rosemary, dried

1/4 t sage, dried

1/4 t salt

1/4 t thyme, dried

3 large potatoes, with skins, cut into eighths

2 carrots, cut into bite-size pieces

2 stalks celery, chopped coarsely

- In a large pot, brown beef and onions in oil.
- Add water, tomato sauce, garlic, parsley, and all spices. Bring to boil, then lower heat, cover, and simmer for 1 hour.
- Add potatoes, carrots, and celery. Simmer covered until tender (30–60 minutes).
- Serve with good, crusty bread.

"As an adult, I'm not as physically active as I was when I was younger," says Craig, "and this has rubbed off on my kids. I don't think they consider the option of going outside to play as much as they ought to. When I was their age I lived on quiet residential streets and my parents felt secure in letting me run around. Nowadays, we live on a street that can be quite busy, so our kids' ability to play in the neighborhood is limited. When I was young I rode my bike to school. Andrea and Ryan have to be driven to their school because it's in the next town, so another opportunity for exercise is lost."

Because Craig had time off from work on Easter week, he did the shopping at Raley's supermarket. Clutching the detailed grocery list that Regan had compiled, he dutifully performed his larder-stocking chore with all the enthusiasm of a man spending his day off in the supermarket. Before beginning, he put Andrea and Ryan into the childcare room at the supermarket. After pushing the overflowing cart through the checkout stand, he picked up the kids, stopping to let them buy gum from one of the kid-enticing vending machines by the door.

Right after that, Craig went to the drive-through window at the McDonald's at the other end of the parking lot and bought the children Happy Meals and little cartons of milk. Sometime between slugging down his milk and tearing into his McNuggets, young Ryan stuck his gum up his nose.

Back at their ranch—well, ranch-style house—Craig put the groceries away while Ryan and Andrea watched cartoons and finished off their Happy Meals. Craig came into the living room when he was done and started to wrestle with Ryan on the floor. Occasionally, when Ryan needed to catch his breath, or got involved in a cartoon, they called a time-out. It seemed to me that Craig, who said that he was just as overactive as Ryan when he was the same age, was enjoying the physical interaction on a purely nostalgic childlike level. It brought back memories of wrestling with own my sons and even a few bouts with my father as well. Maybe these memories are literally sweet, as father-son sparring is probably triggered by fructose as much as by testosterone.

— *Peter*

Momentarily suspending the wrestling match with his son, Craig tilts his head back to share a cartoon moment. They are surrounded by debris from the Happy Meals they purchased at the drive-thru window of a McDonald's *(bottom left)* in Napa, California, on the way home from the weekly shopping expedition to Raley's *(top left)*, a California grocery chain. The high school where Craig teaches is on break this week, so the children are out of daycare and home with Dad.

Jumping for joy, Andrea *(above, second from left)* works through the routines in her ballet class at the American Canyon Community Center. Parents (Regan on right, in UCSD sweatshirt) benevolently supervise from chairs along the wall. The next day, Easter Sunday, both kids *(at left, Andrea, foreground, in pink; Ryan, foreground, holding egg)* join Craig's family in Santa Rosa, 45 minutes away, for their annual Easter egg hunt, complete with a man in an Easter Bunny suit.

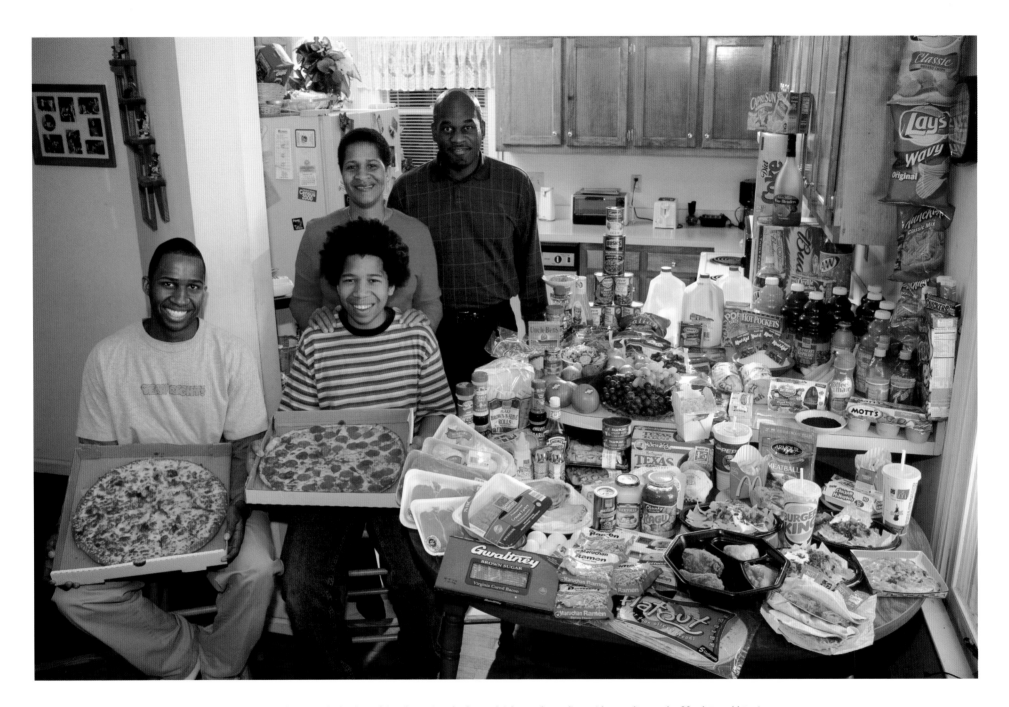

The Revis family in the kitchen of their home in suburban Raleigh, North Carolina, with a week's worth of food. Ronald Revis, 39, and Rosemary Revis, 40, stand behind Rosemary's sons from her first marriage, Brandon Demery, 16 (left), and Tyrone Demery, 14. Cooking methods: electric stove, toaster oven, microwave, outdoor BBQ. Food preservation: refrigerator-freezer. Favorite foods—Ronald and Brandon: spaghetti. Rosemary: "potatoes of any kind." Tyrone: sesame chicken.

Pounding Around

Grains & Other Starchy Foods: $17.92

Red potatoes, 2.3 lb; *Natures Own* bread, sliced, 1 loaf; *Trix* cereal, 1.5 lb; *Mueller* fettuccini, 1 lb; *Mueller* spaghetti, 1 lb; *Uncle Ben's* Original white rice, 1 lb; *Flatout* flatbread wraps, 14 oz; *New York* Original Texas garlic toast, 11.3 oz; *Harris Teeter* (store brand) Flaky Brown-n-Serve dinner rolls, 11 oz.

Dairy: $14.51

Harris Teeter milk, 1 gal; *Kraft* cheese, shredded, 8 oz; *Kraft* sharp Cheddar cheese, sliced, 8 oz; *Kraft* Swiss cheese, sliced, 8 oz; *Kraft* Cheese Singles, 6 oz; *Kraft* Parmesan cheese, grated, 3 oz; *Harris Teeter* butter, 2 oz.

Meat, Fish & Eggs: $54.92

Harris Teeter beef, pot roast, 2.5 lb; *Harris Teeter* pork chops, 1.9 lb; *Harris Teeter* chicken drumsticks, 1.7 lb; eggs, 12; *Harris Teeter* chicken wings, 1.5 lb; *Armour* Italian-style meat balls, 1 lb; *Gwaltney* bacon, Virginia-cured with brown sugar, 1 lb; *Harris Teeter* ground turkey, 1 lb; shrimp,‡ 1 lb; *StarKist* tuna, canned, 12 oz; honey-baked ham, sliced, 9 oz; smoked turkey, sliced, 7.8 oz.

Fruits, Vegetables & Nuts: $41.07

Dole yellow bananas, 2.9 lb; red seedless grapes, 2.4 lb; green seedless grapes, 2.2 lb; *Birds Eye* baby broccoli, frozen, 4 lb; yellow onions, 3 lb; *Green Giant* corn, canned, 1.9 lb; *Green Giant* green beans, canned, 1.8 lb; *Bush's* vegetarian baked beans, canned, 1.8 lb; cucumbers, 1.4 lb; *Harris Teeter* tomatoes, vine-ripened, 1.2 lb; *Del Monte* whole leaf spinach, canned, 13.5 oz; garden salad, packaged, 10 oz; Italian salad mix, packaged, 8.8 oz; pickled mushrooms, 7.3 oz; *Harris Teeter* peanuts, 1 lb.

Condiments: $12.51

White sugar, 1.6 lb; *Ruffles* ranch dip, 11 oz; *Crisco* vegetable oil, 6 fl oz; *Nestle Coffee-Mate*, French vanilla, nonfat, 6 fl oz; *Food Lion* garlic salt, 5.3 oz; *Hellmann's* mayonnaise, 4 oz; *Newman's Own* salad dressing, 4 oz; *Jiffy* peanut butter,‡ 3 oz; black pepper, 2 oz; *Harris Teeter* Original yellow mustard, 2 oz; *Heinz* ketchup, 2 oz; salt, 2 oz; *Colonial Kitchen* meat tenderizer, 1 oz; *Durkee* celery seed, 1 oz; *Encore* garlic powder, 1 oz.

Snacks & Desserts: $21.27

Mott's apple sauce, 1.5 lb; *Munchies* Classic mix, 15.5 oz; *Kellogg's* yogurt-flavored pop tarts,‡ 14.7 oz; *Orville* Redenbacher's popcorn, 9 oz; *Harris Teeter* sunflower seeds, 7.3 oz; *Lays* Classic potato chips, 5.5 oz; *Lays* Wavy potato chips, 5.5 oz; *Del Monte* fruit in cherry gel, 4.5 oz; *Extra* chewing gum, 3 pks; *Snickers* candy bar, 2.1 oz; *M&M's* peanut candy, 1.7 oz.

Prepared Food: $24.27

Bertolli portobello alfredo sauce, 1 lb; *Ragu* spaghetti sauce, chunky mushroom and bell peppers, 1 lb; *Maruchan* shrimp flavored ramen, 15 oz; California sushi rolls, 14 oz; *Campbell's* cream of celery soup, 10.8 oz; *Hot Pockets*, jalapeño, steak & cheese, 9 oz; shrimp sushi rolls, 7 oz.

Fast Food: $71.61

McDonald's: 10-pc chicken McNuggets, large fries, large *Coca-Cola*, Filet-o-Fish meal; *Taco Bell*: 4 nachos Bell Grande, 2 soft tacos, taco supreme, taco pizza, taco, bean burrito, large lemonade; *Burger King*: double cheeseburger, onion rings, large *Coca-Cola*; *KFC*: 2-pc chicken with mashed potatoes, large *Coca-Cola*; *Subway*: 6-inch wheat veggie sub, 6-inch wheat seafood crab sub; *Milano's Pizzeria*: large sausage pizza, large pepperoni pizza; *I Love NY Pizza*: 4 pizza slices.

Restaurants: $6.15

China Market: shrimp fried rice, 2 orders; large fruit punch.

Beverages: $77.75

Budweiser, 24 12-fl-oz cans; bottled water, 2 gal; *Harris Teeter* cranberry-apple juice cocktail, 4 2-qt bottles; diet *Coca-Cola*, 12 12-fl-oz cans; *A&W* cream soda, 2 2.1-qt bottles; *7UP*, 6 16.9-fl-oz bottles; *Harris Teeter* cranberry-raspberry juice cocktail, 2 2-qt bottles; *Harris Teeter* ruby grapefruit juice cocktail, 2 2-qt bottles; *Capri Sun*, 10 6.8-fl-oz pkgs; soda,‡ 5 12-fl-oz cans, *purchased daily by Brandon at school*; *Arbor Mist* strawberry wine blenders, 1.1 qt; *Gatorade*,‡ 16 fl oz; *Powerade*,‡ 16 fl oz; *Snapple*, Go Bananas juice drink, 16 fl oz; *Maxwell House* instant coffee, 1.5 oz; *Kool-Aid*, black cherry, 0.5 oz; breakfast tea, 5 teabags; tap water for drinking and cooking.

‡ Not in Photo

..

Food Expenditure for One Week: $341.98

..

ALTHOUGH IT SEEMS AS THOUGH it should, and many Americans wish it would, an exhausting schedule does not an exercise program make. As a consumer protection specialist for the North Carolina Department of Justice, Rosemary Revis is busy in the office and equally busy at home, caring for her teenage sons Brandon and Tyrone, and her husband, Ron. The physical demands are less challenging than the mental ones—a common condition in modern life. After racing through overscheduled days and constantly nibbling, she says, she found herself 30 pounds overweight. Rosemary tried Weight Watchers and shed the pounds, only to gain them back within six months. "I went back to my old eating habits."

She wasn't the only family member to struggle with food. When Tyrone, now 14, was younger, he was a picky eater. Then his grandmother moved in to help care for the boys. "My mother is a great cook," says Rosemary. "She'd cook things like cube steak with gravy and onions, cabbage, boiled potatoes, and cornbread. She'd fry pork chops and chicken, make collards and fresh salad greens. We'd come home in the evening, and the house would smell delicious. It was a feast." Tyrone became less picky. And as he got older, like most American teens, he was also eating a lot of snacks and fast food. "I would just sit on the couch and watch TV and eat—hot pockets, burritos, fried eggs," he says. He began spending more time on his skateboard, but the call of the potato chip was still mighty and strong. When his mother—determined to lose weight—joined a health club, he joined too. So did Ron and Brandon. Ron, a trim, fit man, works out mainly for the cardio benefits, he says—treadmill in the winter, basketball and walking during the rest of the year. But he eats fast food for lunch five days a week, and at home "he's a big meat eater," says Rosemary. The workouts were great, but there was an unintentional by-product: they had less time for home-cooked meals. "We would pick up fast food. It was the most convenient thing to do," says Rosemary. "That is not the result that we had in mind when we started this exercise program."

Rosemary and Tyrone lost weight because they were more active, but they were eating even more fast food than before. They ditched the health club and now use exercise equipment at home—nearer to the fresh vegetables, leaner meats, and well-planned meals now being served on their dinner table—and they're cutting back on the fast food.

Rosemary Revis's Stuffed Green Peppers

1 lb ground turkey

1 onion, coarsely chopped

6 oz instant rice, uncooked

3/4 cup water

1 14.5-oz can peeled and diced tomatoes with juice

1 14.5-oz can stewed tomatoes, chopped

salt

pepper

1 14.5-oz can corn (optional)

4 large green bell peppers

1 16-oz jar spaghetti sauce, heated

1/2 to 1 lb mozzarella cheese, grated

- Brown ground turkey and onions in a large skillet over medium heat. Drain fat.
- Add rice, water, diced tomatoes, and stewed tomatoes. Season with salt and pepper (to taste) and simmer until rice is tender. Add optional corn.
- Preheat oven to 325° F.
- Cut tops off bell peppers and scrape out seeds and membrane. Fill peppers with meat-rice mixture.
- Arrange peppers vertically in casserole dish and bake for 25 minutes, or until peppers are tender.
- Remove from oven and cover with heated spaghetti sauce.
- Top with mozzarella cheese and return to oven until cheese is melted.

Brandon, who's off from school this week, accompanies Rosemary to shop for their week's worth of food for the food portrait at the Harris Teeter supermarket *(above right)*, **a short drive from their suburban home. Rosemary chooses a lunchtime sandwich at Subway** *(bottom right)* **during the work week, or eats in the State Capital cafeteria.**

The Battle of the Bulge, North Carolina–style, rages on. The enemy is dug in at nearly every major intersection in suburban Raleigh. Using counterintuitive logic to their advantage, the attackers scoff at the need for camouflaged bunkers. Instead, huge neon signs visible from great distances lure bewildered victims to bright dining areas or little windows, where greasy time bombs are loaded into their vehicles in harmless-looking bags. The hapless victims even pay for the time bombs before consuming them.

But not everyone succumbs, and some even fight back.

I documented one family's weekly Wednesday-night battle and I was elated by their courage. When I arrived at the front line—their health and fitness club—the entire Revis clan was already sweating as if in a steam bath. Running hard, Ron and his stepsons were in hot pursuit on treadmills. Rosemary, who walks every day as well, was initiating a steadier, stealthier attack on the same machines. Then the men in her family switched tactics and fought their individual battles on the other high-tech machines (legs, back, torso, arms, etc.)—two hours of nonstop combat.

Because the Revises were constantly waging a weight war, it was impossible to tell if they were winning or losing. But what I did witness was a valiant attempt to keep a few steps ahead of the body snatchers. — Peter

The Revises say they are using their family portrait in this book as a catalyst for change. "Everyone was very unsettled by the sheer amount and kinds of food on the table for the photograph," Rosemary says. When they saw Super Size Me, *the documentary on fast-food overeating, their old diet scared them even more. The Revises' new fare includes more fresh vegetables and leaner cuts of meat, and they police one another's refrigerator habits. "Before Brandon eats something now," says Rosemary, "he'll say to me, 'Mom, how much fat do you think is in that sandwich?' That never happened before."*

Every week, the Revis family (foreground, Brandon curling weights; background, left to right, Rosemary, Tyrone, and Ron) faithfully trekked to the health club in the Wakefield Medical Center, a hospital complex, for two-hour exercise sessions. They enjoyed the workouts, but found them so time-consuming that they wound up eating more fast food than ever. Fearing its potential impact on their health, they ultimately gave up the club in favor of dining and exercising at home.

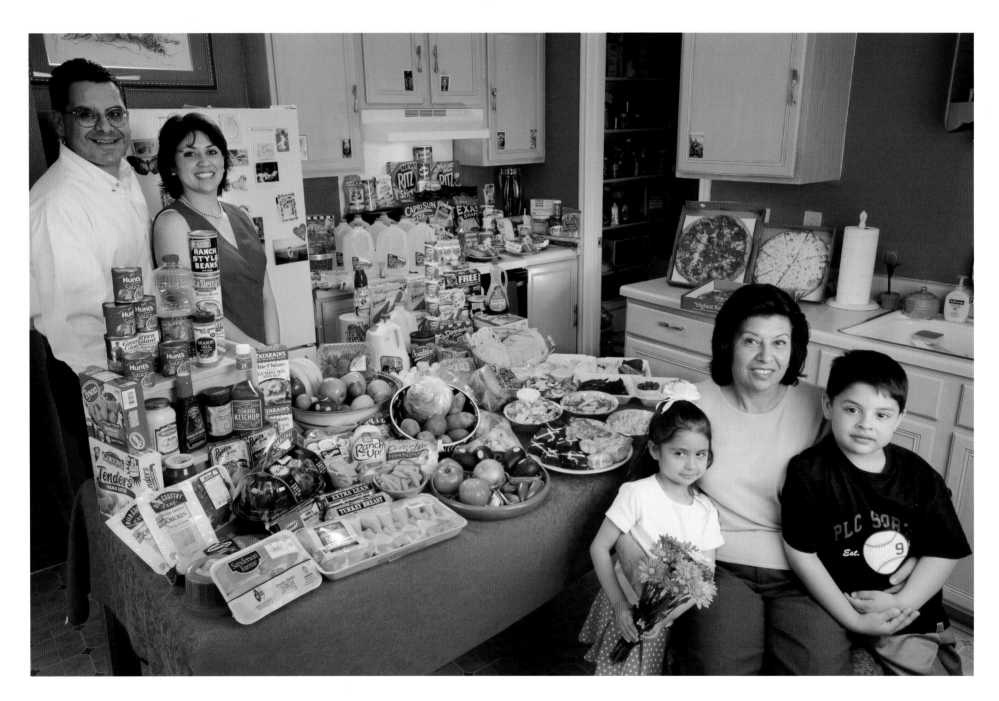

The Fernandez family in the kitchen of their San Antonio, Texas home with a week's worth of food—Lawrence, 31, and wife Diana, 35, standing, and Diana's mother, Alejandrina Cepeda, 58, sitting with her grandchildren Brian, 5, and Brianna, 4. Cooking methods: electric stove, microwave, toaster oven, outdoor BBQ. Food preservation: refrigerator-freezer. Favorite foods—Diana: shrimp with Alfredo sauce. Lawrence: barbecue ribs. Brian and Brianna: pizza. Alejandrina: chicken mole.

Tejas Texas

ONE WEEK'S FOOD IN MARCH

Grains & Other Starchy Foods: $19.28

Potatoes, 5 lb; homemade tortillas, 1.6 lb; *Kellogg's* Special K cereal with red berries, 1.5 lb; *Nature's Own* honey wheat bread, 1 loaf; *Quaker* masa harina, 1.3 lb; *Gold Medal* all-purpose flour, 1 lb; *H-E-B* (store brand) French-style bread, 1 lb; white rice, 1 lb; *Cream of Wheat* cereal, 14 oz; *Quaker* oatmeal, 13.5 oz; dinner rolls, 13 oz; *Post* Cocoa Pebbles cereal, 13 oz; *H-E-B* fettuccine, 5.3 oz; *Q&Q* vermicelli, 5 oz.

Dairy: $17.72

Borden Kid Builder milk, 1% low-fat, high-calcium, 1 gal; *Oak Farms* Skim Deluxe milk, 1 gal; *Blue Bell* ice cream, 1 qt; *Danon* Danimals, Swingin' Strawberry Banana and Rockin' Raspberry drinkable yogurt, 25.2 fl oz; *Yoplait* piña colada yogurt, 1.5 lb; *Yoplait* blueberry yogurt, 12 oz; *Kraft* Colby & Monterey Jack cheese, 8 oz; *Frigo* Cheese Heads string cheese, 6 oz.

Meat, Fish & Eggs: $42.10

Hill Country Fare chicken drumsticks, 3 lb; *Hill Country Fare* jumbo eggs, 18; *H-E-B* rotisserie chicken, original flavor, 2.5 lb; *Sanderson Farms* chicken thigh fillets, boneless & skinless, 1.5 lb; *Gorton's* Original Tenders fish sticks, frozen, 1.1 lb; *H-E-B* extra-lean beef, ground, 1 lb; *H-E-B* turkey breast, ground, 1 lb; *Oscar Mayer* turkey cotto salami, 1 lb; shrimp, frozen, 1 lb; *Butterball* turkey variety pack, sliced, 12 oz; *H-E-B* beef, top round cubes, 12 oz; *Tyson* fun nuggets, frozen chicken, 12 oz; *Hill Country Fare* smoked chicken, sliced, 5 oz.

Fruits, Vegetables & Nuts: $33.05

Grapefruit, 5 lb; *Dole* bananas, 2.5 lb; Granny Smith apples, 1.3 lb; green grapes, 1.3 lb; *Coastal* strawberries, 1 lb; Key limes, 1 lb; red apples, 12.8 oz; Hass avocados, 4; *Hunts* tomato sauce, 2.5 lb; *Green Giant* green beans, canned, 2 lb; *Green Giant* corn, frozen, 1.6 lb; tomatoes, 1.3 lb; *La Sierra* refried pinto beans, 15 oz; iceberg lettuce, 1 head; *Fresh Express* Italian salad mix, 8.8 oz; yellow onions, 8.6 oz; *Fresh Express* coleslaw, 8 oz; mini carrots, 8 oz; mushrooms, sliced, 8 oz; jalapeño peppers, 4 oz; garlic, 2 oz; *Planter's* honey-roasted peanuts, 12 oz.

Condiments: $16.05

Great Value vegetable oil, 2.1 qt; *Hill Country Fare* BBQ sauce, 1.1 lb; *International Delight* coffee creamer, 16 fl oz; *I Can't Believe It's Not Butter* spread, 15.8 oz; *Aunt Jemima* Butter Lite syrup, 12 oz; *Hill Country Fare* ketchup, 9 oz; *Clover Burleson's* honey, 8 oz; *H-E-B* roasted pepper salsa picante, 8 oz; *Season* All seasoned salt, 8 oz; *Wish Bone* Classic Ranch Up! dressing, 6 oz; peanut butter, 4 oz; pepper, ground, 1 oz; salt, 0.5 oz.

Snacks & Desserts: $23.33

H-E-B Texas-shaped corn chips, 1 lb; pretzels, 1 lb; *Dreyers* whole-fruit bar popsicles, 16.5 fl oz; *Oreo* cookies, 9 oz; *Ritz* whole wheat crackers, 7.5 oz; *Pepperidge Farm* Goldfish Colors crackers, 6.6 oz; *Ritz* Sticks crackers, 6.3 oz; *Pringles* potato chips, 6 oz; *General Mills* Fruit Gushers snacks, 5.4 oz; *Kellogg's* Special K blueberry bars, 4.9 oz; *Kellogg's* Special K peaches & berry bars, 4.9 oz; *Orville Redenbacher's* Smart Pop microwave popcorn, 3.7 oz; *Barnum's* animal crackers, 2.1 oz.

Prepared Food: $18.16

Prego spaghetti sauce, 1 lb; *La Sierra* refried beans with cheese, 15 oz; *Ranch Style* beans with jalapeño peppers, 15 oz; *Pioneer Brand* buttermilk pancake mix, 10.7 oz; *Bertolli* creamy alfredo sauce, 8 oz; *Zatarain's* black beans & rice, 7 oz; *Zatarain's* gumbo mix, 7 oz; *Pioneer* brown gravy mix, nonfat, 2.8 oz; *Pioneer* Country gravy mix, nonfat, 2.8 oz; *Knorr Suiza* chicken broth, 2 oz; *Diana at work, 5 cafeteria meals, variety of main courses available. Lawrence grabs a salad or slice of pizza at work.*

Fast Food: $11.81

McDonald's: 3 Happy Meals; 4 Mountain Blast ice cream drinks; 1 vanilla ice cream cone.

Restaurants: $42.11

Fire Mountain Buffet: dinner for 5, assorted items, sold by the pound, 3.8 lb; *Cici's Pizza:* large beef pizza, large white pizza, large meat lover's pizza, 3 salads.

Beverages: $18.87

Hill Country Fare natural spring water, 8 gal; *Tree Top* apple juice, 1 gal; *Capri Sun* Mountain Cooler, 10 6.8-fl-oz pkgs; *Capri Sun* orange drink, 10 6.8-fl-oz pkgs; *Dole* pineapple-orange-banana juice, 8 6-fl-oz cartons; *Hill Country Fare* iced tea mix, 1.7 lb; *Wylers Light* pink lemonade, powdered mix, 1.2 lb; *H-E-B* Café Ole coffee, 3 oz; *Ovaltine* malted instant drink mix, 3 oz; Kool-Aid, sugar-free grape, powdered mix, 1.2 oz.

Food Expenditure for One Week: $242.48

LEJANDRINA CEPEDA WORKS AS A NANNY on the weekdays, but for an hour on Saturday afternoons she transforms the home she shares with her daughter's family into a Mexican *tortillería*. Her grandchildren stand on chairs with their own kid-size tortilla presses and watch her mix masa harina (corn-flour mix) and water with her hands. Brianna, 4, leans over the bowl inquisitively, speaking with her grandmother in English. Alejandrina, who speaks English, answers in her native Spanish. Brian, 5, loudly flings his press open and closed several times. "Remember, Brian," warns his mother, Diana Fernandez, a school librarian, "your grandmother likes you to be serious when you're cooking with her." Brian is more interested in eating the tortillas than making them, but with the just-add-water tortilla mix from the supermarket, the process is quick. Diana—who was raised by Alejandrina in the Mexican city of Nuevo Laredo, on the U.S.-Mexico border—flows between the two languages seamlessly, helping her children understand words they don't know. The conversation is wide-ranging. "What is *limón?*" Brianna asks at one point, as her grandmother hands her a ball of dough. "Lemon," says Diana, as she watches Brian pummel the dough in his press. "Is this pancake okay?" Brianna asks. "*Bueno,*" says Alejandrina, who's expertly pressing most of the tortillas in her own large press. "But it's not a pancake—it's a tortilla," she says in Spanish. Diana translates. Alejandrina will forgo cooking the tortillas on a *comal,* a traditional griddle. She'll cook them on the stove and turn them into the kids' favorite—cheese quesadillas.

The Fernandezes eat from the global dinner table most of the time. "We go from mullet to *menudo* to egg rolls," says Diana's husband Lawrence, an accomplished cook who grew up in Louisiana. He credits his upbringing there with sparking his love of food: "When someone invites you to dinner in Louisiana, you never say no. It's going to be a big deal—a big pot of something," says Lawrence. "Especially if they've got a [Creole name like] Breaux or Mouton." Lawrence, who manages a Cici's Pizzeria, also cooks with the children. On those occasions he, too, helps them prepare balls of dough, though ones that are much bigger than his mother-in-law's. "I'll bring raw dough and sauce home," he says, "and the kids and I will build pizzas. And that's a big treat." Any dessert? "Ice cream at midnight, when the kids are asleep."

After the Saturday soccer game, Diana *(above, far right),* and Alejandrina perform a family ritual: making fresh tortillas (in background) for cheese quesadillas (see recipe). The next day, though, it's back to less less-than-traditional fare: takeout chicken and soda pop *(bottom, far right).* The Fernandezes begin their Sunday grocery trip after lunch. Clutching their spending money, Brianna and Brian *(above)* head for the bakery case, where they settle on giant *pan dulces.*

UNITED STATES

- Population: **293,027,571**
- Urban population: **80%**
- Life expectancy, male/female: **75/80 years**
- Fertility rate (births per woman): **2.1**
- Caloric intake available daily per person: **3,774 calories**
- Caloric intake available from animal products daily per person: **1,047 calories**
- Annual alcohol consumption per person (alcohol content only): **9.6 quarts**
- GDP per person: **$35,750**
- Total annual health expenditure per person in $ and as a percent of GDP: **$4,887/13.9**
- Physicians per 100,000 population: **279**
- Cigarette consumption per person per year: **2,255**
- Sugar and sweeteners available per person per year: **158 pounds**
- Soft-drink consumption/Coca-Cola product consumption per person per year: **54.8 gallons/25.7 gallons**
- Meat consumption per person per year: **275 pounds**
- McDonald's restaurants: **13,491**
- Beef/potatoes purchased annually by McDonald's: **1 billion pounds/1 billion pounds**
- Manure from all intensive animal-farming practices per year: **2 billion tons**
- Human waste per year: **200 million tons**
- Household food waste per year: **48 million tons**
- Cost of household food wasted per year: **$43 billion**
- Household food waste per year as a percent of food purchases: **14**
- Percent of processed foods with some genetically modified ingredients: **75**
- Percent of soy/corn raised that is a genetically modified variety: **80/40**

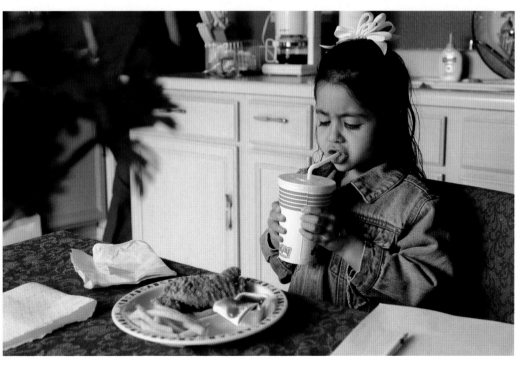

Diana Fernandez's Quesadillas from Fresh Corn Tortillas

2 cups masa harina (dried, lime-treated fine cornmeal)

1-1/2 cups warm water

4 cups Colby Jack cheese (can substitute any kind of Cheddar cheese), coarsely grated

1/4 t salt

- Knead warm water and salt into *masa harina* and combine until dough is warm and only slightly sticky. Cut dough into about 18 little balls, each of which will form one tortilla.
- Flatten the little dough balls with a *tortillera* (tortilla press) until they are very thin. (They can be rolled with a rolling pin, but this is much more difficult.)
- Place flattened dough circle on a seasoned *comal* (a flat cooking pan made specially to cook tortillas) on medium-high heat.
- Once tortilla yellows and becomes harder, put cheese in middle and fold tortilla over. Keep folded tortilla on *comal* just long enough to melt cheese, turning it over when necessary (about 5 minutes).
- Serve immediately.

SUPERSIZED U.S.A.

- Overweight population, male/female: **72/70%**
- Obese population, male/female: **32/38%**
- Population age 20 and older with diabetes: **8.8%**
- Liposuction surgeries per year: **400,000**
- Gastric bypass surgeries per year: **150,000**
- Percent paid by taxpayers for obesity-related medical costs: **50**
- Percent of dieting men/women on any given day: **25/45**
- Annual spending on dieting and diet-related products: **$40 billion**
- Percent of all dieters who will regain their lost weight within 1 to 5 years: **95**

Lawrence Fernandez is a food professional: he has managed several all-you-can-eat cafeterias, including a Luby's, and now runs a Cici's pizza franchise with a $3.99 all-you-can-eat buffet in suburban San Antonio, Texas. The Fernandez family is not supersized, but that is not true of their city. San Antonio went from 13th fattest city in the U.S. to 4th between 2003 and 2004, says *Men's Fitness* magazine. According to the Centers for Disease Control, more than one in four adult Texans is clinically obese.

Texas itself is supersized; it's a huge state with a wide body and a pretty thick neck—also called the panhandle—and judging by the size of the meals and people here, a thick panhandle is necessary to pick up the skillet. I couldn't help noticing restaurants named The Pig Stand, Fat Tuesday, and Fat Boys Fajitas in San Antonio. But besides the wide streets lined with such honestly named eateries, the city does have an incredible gem: the Riverwalk, a beautiful downtown stretch of the San Antonio River lined with restaurants, shops, hotels, and more restaurants. Tour boats entice visitors as they shuffle along the landscaped pedestrian walks flanking the river. Riverwalk visitors don't usually get to walk very far before they succumb to the food. Don't want to walk and eat? Another option is to float and bloat (dining on boats as you watch other people eating along the riverbanks).

There is a widening consensus, though, that being big is natural, normal, and even noble. During our visit, I photographed the Ms Plus America Woman for 2004, Nanette Watts, a truly beautiful woman decked out in a pink top, satin banner, and sparkling crown. She was huge, but against the backdrop of the supersized Alamodome she looked fittingly in scale. — *Peter*

Trying to contain the children in the giant shopping cart, Diana and her mother *(at left)* prowl the local H-E-B supermarket. Brian, who repeatedly self-ejects from the cart, must be constantly reminded that the impulse items hung in every aisle are not on the shopping list. At home, he polishes off a cheeseburger *(at right)* from Whataburger.

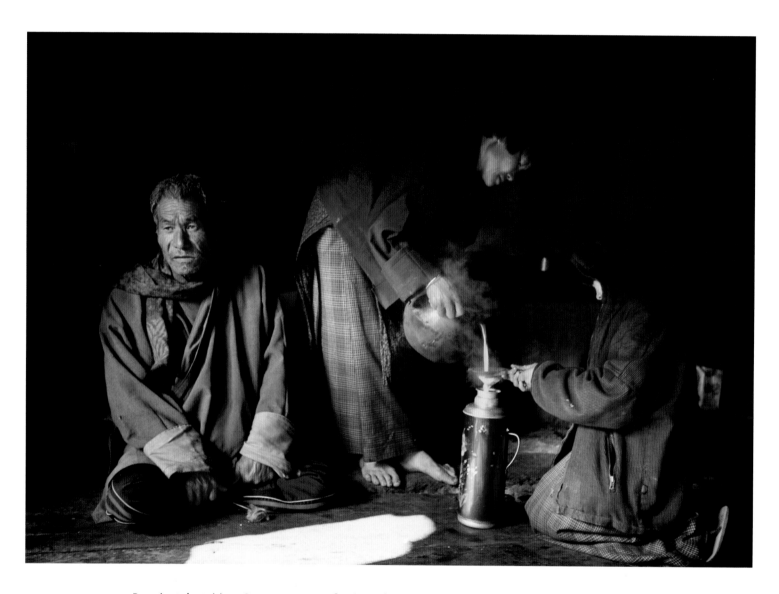

Preparing to host visitors, Sangay pours a pot of tea into a thermos. Her half-sister Bangam holds the sieve. Meanwhile, Namgay, the family patriarch, waits patiently for a cup.

Digestif

Why did you want to do a book on what the world eats? What's the best, worst, and strangest thing you ate? Considering what you learned, have you changed your diet? These are the questions we hear most often about this project.

MORE THAN 20 YEARS after I began criss-crossing the globe on photo assignments, I noticed that the world was shrinking, but that Americans weren't. Then, at the turn of the century, a paper from the environmental organization Worldwatch reported that for the first time in the history of our planet more people were overfed than underfed. Malnutrition—the imbalance from either a deficiency *or an excess* of nutrients and other dietary elements necessary for health—now manifests itself worldwide in obesity as well as emaciation. Even with a cornucopian food supply, the world today has record levels of malnutrition in one form or another. The chance to document this tipping of the global food scale from scarcity to surfeit was too tempting to pass up.

Here in the United States, we spend nearly $5,000 per person per year on health care—much more than any other country in the world, yet we are becoming the fattest and unhealthiest people on the planet. Why? Experts have outlined the many interrelated causes: in our postindustrial society, the decrease in jobs requiring physical, calorie-burning work; the ubiquitousness of the car culture and the ease of personal mobility; the low cost and high availability of sweet, fatty, starchy, and highly processed foods. For that last one, a big fat thank-you to the giant food corporations for making life shorter for our rotund fellow Americans.

Having worked and traveled extensively in Asia and Africa, I could understand why people there aren't battling the bulge like we are, but why are Europeans lagging in the fatty behind? What could we learn about ourselves by examining what and how the rest of the world eats?

Are there secret diets or simple ingredients that can keep the weight off our idle thighs and motionless middles? Yes there are. But the answers are not simple, and they're not secret. The first key is moderation: don't consume more calories than your body needs. Another is movement: keep active—in any number of ways— to keep healthy. And the third is quality: eat whole, unprocessed, or minimally processed food. These nutritional lessons are basically hard work. There isn't a pill for what you want or need.

The best, the wurst, and most bizarre? As we learned during the course of eating scores of species of invertebrates for our book *Man Eating Bugs: The Art and Science of Eating Insects*, food preferences are ingrained at a very early age. For most people, these basic likes and dislikes stick with them for life. I swallowed my fear-food factor many, many bugs ago and will eat anything that anyone else does, as long as it is fresh and in season. Spit-roasted Ecuadorian guinea pig, Okinawan parrotfish sashimi, fresh Greenlandic char pulled right from a glacial lake, and juicy steamed Mongolian lamb dumplings topped my list of favorites for *Hungry Planet*. Deep-fried starfish-on-a-stick in China was the only food in 24 countries that I didn't finish with gusto (p. 287).

Have we changed our diets? Faith and I have always been aficionados of the fresh and in-season. New converts to the many benefits of organic food, we now seek it out in the grocery, but have long had a big vegetable garden and enjoy eating what we grow. When dining out, especially in the U.S., we often order two salads, and then order one main dish to share. I grew up with parents who enforced the clean-plate rule and as I get older I am still trying to heed their advice while at the same time relaxing my own dining regulations to embrace the teachings of long-lived folks in Okinawa. *Hara hachi bu* means "eat only until 80 percent full"—an excellent old concept in new times of overabundance.

How We Did This

Hungry Planet began on the first day of the millennium when we flew to Istanbul as the subjects of a Japanese documentary for NHK TV. During the next four months, we revisited several of the families from our 1994 book, *Material World: A Global Family Portrait.* In that book I had photographed statistically average families with all their possessions outside their homes; now we and the Japanese crew were setting out to see how their lives had changed since our last visit.

Faith had traveled to some of the same countries and visited the same families for our 1996 book, *Women in the Material World.* While working with the Japanese, as well as for *GEO* magazine in Germany, we also visited some new families. Adding a new spin to our original coverage, we shot these families with a week's worth of food, at the suggestion of Ruth Eichhorn, the photo director of *GEO,* who wanted to use the images for a magazine special on nutrition. It was *much* easier to convince families around the world to pose with a week's worth of food (which we paid for) than to persuade them to take everything out of their homes for a photograph.

At the end of 2000, Faith thought we should continue to shoot more families and turn the coverage into a book. At first I was not convinced. Then, while I was in Iraq and Kuwait during the U.S. invasion in 2003, I photographed a family in Kuwait City with a week's worth of food. I felt powerless to do anything about the Bush foreign policy, but wanted to do something useful and necessary. I decided that Faith was correct, and a book that would examine nutrition and food around the world was exactly what the world needed; especially now that the problem of obesity is finally being recognized as a "big" issue.

Why did we choose these countries and not others? In some cases, we covered a country because we were already there working on something else, in others it was because we wanted to see something new. Neither of us had been to Greenland, and I

really wanted to go. Faith thought it was cold. We covered some countries just to round out the list. We wanted a country in South America, so we included Ecuador. We wanted a second country in Africa, and to observe refugee life, so we traveled to Chad.

We found our subjects in a variety of ways: through colleagues, translators, fixers, friends, and taxi drivers, and by just talking to people on the street. We were looking for representative people, but not necessarily statistically average people, as well as proximity to situations and events that might add flavor to the coverage. This was why we went to Ujjain, India, where Kumbh Mela, one of the most bizarrely fascinating cultural events on the planet, was being celebrated.

We rarely do one project at a time—travel is expensive, thanks in part to the weak American dollar. So we work on many projects simultaneously. This makes photography and reporting much more difficult and confusing, but never boring.

Faith and I work together as a coordinated team— sometimes like Siamese twins and at other times like battle-axe-wielding spouses. I'm the photographer. I also find the families and do the logistics, and hire translators, drivers, etc. Faith is the writer. She also does interviews, reporting, food styling, and image processing in the field—and provides the charm offensive—and then finally, the writing and book production. When she is writing at home I do all the cooking, since she is a cranky beast who must stay focused and is even more dangerous when hungry.

The families in the first eight countries were photographed with Canon and Mamiya cameras on Fujichrome transparency film. I switched to Canon digital cameras for shooting in Iraq and Kuwait, and have not shot a single frame of film since then. I use Canon 1Ds and 20D cameras, predominantly in RAW mode. Although the digital cameras and related computers and external memory devices are much more expensive than film cameras, I am very happy

with digital: I carry no film, no filters, and I can get by with carrying less lighting equipment—although 27 of the 30 family food portraits were shot using flash. Sometimes these required several cases of lights, which I made Faith haul around the world at least three times.

Working anywhere on the planet is not that difficult if you lower your expectation level, and raise your tolerance for unfamiliar food and situations. We have been operating this way for decades—a previous book on eating insects in 13 countries taught us a lot about our food preferences and about unexpected tastes and textures (as well as how to eat some small creatures alive). So dining now from uncharted menus is a piece of cake.

—*Peter*

LITTLE BLACK MARKS

Getting space for words in a photography book can be difficult. Luckily, Peter likes to do photography books for people who think, and understands that words can play a role in providing the complete picture. If I feel strongly about needing more room to explain a situation, then generally I get it. Problematically for Peter, I feel strongly about just about everything.

I didn't have a formula in mind when writing about the 30 families we covered. When something seemed interesting, I wrote about it, even when it had only a tenuous connection to the subject of food. Pama and Fatoumata in Mali, with one husband between them fascinated me. I probably included more about it than was absolutely necessary but did so because their mutual relationship contributes to the family's economic viability. They were equally curious about my life with my one husband.

If someone brought up a historical point and it contributed to their family's current food situation, or informed it, then I explored that a bit. Marzena in

Poland spoke so eloquently about her experiences as a child in Communist Poland, and her fear that her daughter doesn't appreciate not having to worry about where her next meal is coming from, that I had to include it.

I wrote the stories of our families after extensive interviews and observation in each of the 24 countries we visited for this book, and often, additional inquiries afterward. This was easier in the "connected world," but it proved not to be as difficult as one might imagine in remote places like Chad, where (though an email or fax can be difficult to arrange, except with aid organizations) mobile phones are becoming common. We can call Khamis Hassan Jouma in Abeche to ask about the current price of Chadian millet, and he can run over to the market and get the answer in just a few minutes.

Connectability is a marvelous tool that Peter and I never take for granted. Sitting at the computer in Quito, Ecuador, I simultaneously "talked" to Ewa Ledochowicz in Warsaw, John Tsui in Okinawa, and our son Josh who was vetting text for me while sitting at home in Taipei. I don't do this "chat room" style—otherwise, I'd never get anything done, but everyone "on the line" is aware that there are others on this bright blue ball of ours handling the same general task at the exact same time. It's energizing.

The grocery lists were exceedingly difficult to produce, right up until the end of book production. Lots of detail means lots of opportunity for error. We worked hard on corrections. Statistics as well are always a minefield.

That the books we do seem to have incredible longevity in people's minds is our most treasured accomplishment; and we couldn't have done it without the sound advice and able skills of our friends and colleagues Charles C. Mann and David Griffin.

—*Faith*

Brownell, Kelly D., Ph.D., and Katherine Battle Horgen, Ph.D., *Food Fight: The Inside Story of the Food Industry, America's Obesity Crisis, and What We Can Do About It*. New York: McGraw-Hill Companies Inc., 2004.

Cahill, Tim. *Pass the Butterworms: Remote Journeys Oddly Rendered*. New York: Villard Books, 1997.

Campbell, T. Colin, Ph.D. *The China Study: Startling Implications for Diet, Weight Loss and Long-term Health*. Dallas: Benbella Books, 2004.

Cherikoff, Vic. *The Bushfood Handbook: How to Gather, Grow, Process & Cook Australian Wild Foods*. Bornoria Park: Cherikoff Pty Ltd, 2000.

Child, Julia. *The Way to Cook*. New York: Alfred A. Knopf, Inc., 1989.

Cook, Christopher D. *Diet for a Dead Planet: How the Food Industry Is Killing Us*. New York: The New Press, 2004.

Cook, Guy. *Genetically Modified Language*. New York: Routledge, 2004.

Crosby, Alfred W., Jr. *The Colombian Exchange: Biological and Cultural Consequences of 1492*. Westport: Praeger Publishers, 2003.

Crosby, Alfred W. *Ecological Imperialism: The Biological Expansion of Europe, 900–1900*, 2nd ed. Cambridge: Cambridge University Press, 2004.

Cummins, Ronnie, and Ben Lilliston. *Genetically Engineered Food: A Self-Defense Guide for Consumers*, 2nd ed. New York: Marlowe & Company, 2004.

Dalby, Andrew. *Dangerous Tastes: The Story of Spices*. London: The British Museum Press, 2000.

Davidson, Alan. *The Oxford Companion to Food*. Oxford: Oxford University Press Inc., 1999.

Easterbrook, Gregg. *The Progress Paradox: How Life Gets Better While People Feel Worse*. New York: Random House, Inc., 2003.

Fisher, M. F. K. *The Art of Eating*. New York: Macmillan, 1990.

Halweil, Brian. *Eat Here: Reclaiming Homegrown Pleasures in a Global Supermarket*. New York: W. W. Norton & Company, Inc., 2004.

Jacobson, Michael F., Ph.D., and Jayne Hurley, RD. *Restaurant Confidential: The Shocking Truth About What You're Really Eating When You're Eating Out*. New York: Workman Publishing Company Inc., 2002.

Kaufman, Francine R., M.D. *Diabesity: The Obesity-Diabetes Epidemic That Threatens America, and What We Must Do to Stop It*. New York: Bantam Dell, 2005.

Kummer, Corby. *The Joy of Coffee: The Essential Guide to Buying,*

Brewing and Enjoying, rev. ed. Boston: Houghton Mifflin, 2003.

Lambrecht, Bill. *Dinner at the New Gene Café: How Genetic Engineering Is Changing What We Eat, How We Live, and the Global Politics of Food*. New York: Thomas Dunne Books, 2001.

Leonard, John. *The New York Times Guide to Essential Knowledge*. New York: St. Martin's Press, 2004.

McGee, Harold. *On Food and Cooking: The Science and Lore of the Kitchen*, rev. ed. New York: Scribner, 2004.

Menzel, Peter, and Faith D'Aluisio. *Man Eating Bugs: The Art and Science of Eating Insects*. Berkeley: Ten Speed Press, 1998.

Nestle, Marion. *Food Politics: How the Food Industry Influences Nutrition and Health*. Berkeley and Los Angeles: University of California Press, 2002.

Nestle, Marion. *Safe Food: Bacteria, Biotechnology, and Bioterrorism*. Berkeley and Los Angeles: University of California Press, 2003.

Pollan, Michael. *Second Nature: A Gardener's Education*. New York: Delta, 1992.

Pollan, Michael. *The Botany of Desire: A Plant's-Eye View of the World*. New York: Random House, Inc., 2002.

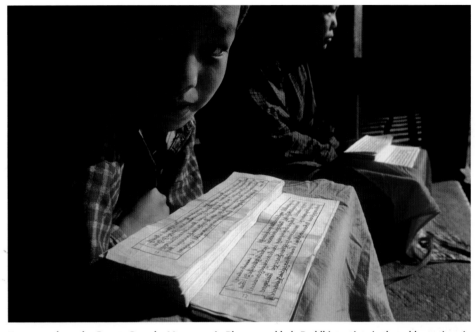

Young monks at the Gangte Goemba Monastery in Bhutan read holy Buddhist scripts in the cold morning air.

Safina, Carl. *Eye of the Albatross: Visions of Hope and Survival*. New York: Owl Books, 2003.

Safina, Carl. *Song for the Blue Ocean: Encounters Along the World's Coasts and Beneath the Seas*. New York: Owl Books, 1999.

Sale, Kirkpatrick. *The Conquest of Paradise: Christopher Columbus and the Columbian Legacy*. New York: The Penguin Group, 1990.

Schell, Ruppel Ellen. *The Hungry Gene: The Science of Fat and the Future of Thin*. New York: Atlantic Monthly Press, 2002.

Schlosser, Eric. *Fast Food Nation: The Dark Side of the All-American Meal*. New York: Houghton Mifflin, 2001.

Schwartz, Barry. *The Paradox of Choice: Why More Is Less*. New York: HarperCollins Publishers Inc, 2004.

Severson, Kim and Cindy Burke. *The Trans Fat Solution: Cooking and Shopping to Eliminate the Deadliest Fat from Your Diet*. Berkeley: Ten Speed Press, 2003.

Simoons, Frederick J. *Eat Not This Flesh: Food Avoidances from Prehistory to the Present*, 2nd ed. Madison: The University of Wisconsin Press, 1994.

Simoons, Frederick J. *Food in China: A Cultural and Historical Inquiry*. Boca Raton: CRC Press Inc., 1991.

Stewart, Jon, and Ben Karlin, and David Javerbaum. *America (The Book): A Citizen's Guide to Democracy Inaction*. New York: Warner Books, Inc., 2004.

Tannahill, Reay. *Food in History*. New York: Crown Trade Paperbacks, 1988.

The Worldwatch Institute. *State of the World 2005: Redefining Global Security*. New York: W. W. Norton & Company, Inc., 2005.

Toussaint-Samat, Maguelonne and Anthea Bell trans. *History of Food*. Cambridge: Blackwell Publishing, Ltd., 1994.

Willcox, Bradley J., M.D., and D. Craig Willcox, Ph.D., and Makoto Suzuki, M.D. *The Okinawa Program*. New York: Three Rivers Press, 2001.

Measuring Table

	Population	Population Density (people per sq. mile)	Total Area (sq. miles)	Population in Urban Areas (percent)	Life Expectancy (male/female)	Fertility Rate (total births per woman)	Literacy (percent, male/female)	Income (annual per capita in USD$/PPP)	Health Care Expenditure (annual per capita in USD$/ % of GDP)	Physicians (per 100,000 people)	Access to Safe Water (percent)	Access to Safe Sanitation (percent)
Australia	19,913,144	7	2,967,124	92	77.9/83.0	1.7	100.0/100.0	$20,822/28,260	$1,741/9.2	247	100	100
Bhutan	2,185,569	121	18,142	9	60.2/62.4	5.0	56.2/28.1	$695/1,300	$9/3.9	5	62	70
Bosnia	4,007,608	203	19,736	45	69.3/76.4	1.3	98.4/91.1	$1,362/6,100	$85/7.5	145	N/A	N/A
Chad	9,538,544	19	495,624	25	46.1/49.3	6.7	56.0/39.3	$240/1,020	$5/2.6	3	27	29
China	1,298,847,624	351	3,704,427	38	69.6/72.7	1.8	95.1/86.5	$989/4,580	$49/5.5	164	75	40
Cuba	11,308,764	264	42,792	76	75.0/79.3	1.6	97.2/96.9	NA/2,900	$185/7.2	596	91	98
Ecuador	13,212,742	121	109,454	62	67.9/73.5	2.8	94.0/91.0	$1,897/3,580	$76/4.5	145	85	86
Egypt	76,117,421	197	386,560	42	65.3/69.0	3.3	68.3/46.9	$1,354/3,810	$46/3.9	218	97	98
France	60,424,213	286	211,154	76	75.9/83.5	1.9	99.0/99.0	$24,061/26,920	$2,109/9.6	330	N/A	N/A
Germany	82,424,609	598	137,810	88	75.6/81.6	1.4	99.0/99.0	$24,051/27,100	$2,412/10.8	363	N/A	N/A
Great Britain	60,270,708	638	94,500	89	75.8/80.5	1.6	99.0/99.0	$26,444/26,150	$1,835/7.6	164	100	100
Greenland	56,384	0.1	836,109	83	64.0/70.0	2.45	N/A	N/A	$2,622	146	100	>90
Guatemala	14,280,596	340	42,032	47	63.1/69.0	4.4	78.0/63.3	$1,941/4,080	$86/4.8	109	92	81
India	1,065,070,607	839	1,269,010	28	60.1/62.0	3.0	70.2/48.3	$487/2,670	$24/5.1	51	84	28
Italy	58,057,477	499	116,275	67	76.8/82.5	1.2	99.0/98.3	$20,528/26,430	$1,584/8.4	607	N/A	N/A
Japan	127,333,002	873	145,844	66	78.4/85.3	1.3	99.0/99.0	$31,407/26,940	$2,627/8.0	202	N/A	N/A
Kuwait	2,257,549*	328	6,879	96	75.8/76.9	2.7	85.1/81.7	$15,193/16,240	$537/3.9	160	N/A	N/A
Mali	11,956,788	25	478,640	33	43.9/45.7	7.0	53.5/39.6	$296/930	$11/4.3	4	65	69
Mexico	104,959,594	138	761,404	76	71.7/77.0	2.5	94.0/90.5	$6,320/8,970	$370/6.1	156	88	74
Mongolia	2,751,314	5	603,749	57	60.1/65.9	2.4	98.0/97.5	$457/1,710	$25/6.4	278	60	30
Philippines	86,241,697	745	115,800	62	65.1/71.7	3.2	92.5/92.7	$975/4,170	$30/3.3	115	86	83
Poland	38,626,349	320	120,696	62	70.6/78.7	1.3	99.8/99.7	$4,894/10,560	$289/6.1	220	N/A	N/A
Turkey	68,893,918	229	301,304	67	67.9/72.2	2.4	94.3/78.7	$2,638/6,390	$109/5.0	123	82	90
USA	293,027,571	79	3,717,727	80	74.6/79.8	2.1	97.0/97.0	$36,006/35,750	$4,887/13.9	279	100	100

* includes 1,291,354 non-nationals † population > 35 years with DM type 2: 10% ‡ on U.S. Navy base ** m/f together: >60%

Caloric Intake (daily, per capita, kcal)	Caloric Supply from Animal Products (daily, per capita, kcal)	Under-nourished (percent, 2001)	Overweight (percent, male/female)	Obese (percent, male/female)	Diabetics (percent, age 20 years and older)	Human Development Report Index	Number of McDonald's	Meat Consumption (annual, per capita, lbs.)	Sugar and Sweetener Supply (annual per capita, lbs.)	Alcohol Consumption (annual per capita total, qts.)	Cigarette Consumption (annual per capita total)	Smokers (precent, age 18 and older, male/female)	
3,054	1,032	N/A	69.7/60.2	21.2/22.5	6.8	94.6	726	207.00	106.04	10.87	1,907	30.7/23.1	Australia
N/A	N/A	N/A	34.0/44.7	5.3/13.1	3.5	53.6	0	6.60	N/A	0.60	N/A	N/A	Bhutan
2,894	391	8	56.6/51.0	13.8/21.5	3.8	78.1	0	47.08	73.04	6.70	N/A	54.6/31.5	Bosnia
2,114	140	34	10.4/17.1	0.3/1.3	2.8	37.9	0	31.46	17.60	0.21	160	19.7/3.1	Chad
2,951	618	11	27.5/22.7	1.0/1.5	2.4	74.5	546	115.28	15.84	5.45	1,791	58.9/3.6	China
3,152	387	11	55.2/57.0	12.3/20.7	6.0	80.9	1‡	70.84	137.06	3.61	1343	48.8/28.5	Cuba
2,754	502	4	40.2/50.9	6.1/15.4	4.8	73.5	10	99.00	105.82	1.73	232	31.9/7.4	Ecuador
3,338	255	3	64.5/69.7	22.0/39.3	7.2	65.3	40	49.50	65.78	0.47	1,275	47.9/1.8	Egypt
3,654	1,357	N/A	44.1/33.4	7.2/6.1	3.9	93.2	973	222.42	88.00	14.07	2,058	42.6/33.9	France
3,496	1,070	N/A	63.7/53.6	19.7/19.2	4.1	92.5	1,211	180.62	97.24	13.17	1,702	39.0/30.9	Germany
3,412	1,043	N/A	62.5/58.8	18.7/21.3	3.9	93.6	1,110	175.12	96.14	10.19	1,748	34.6/34.4	Great Britain
N/A	N/A	N/A	35.0/33.0	16.0/22.0	N/A†	N/A	0	250.36	80.74	12.89	N/A	N/A**	Greenland
2,219	204	25	53.2/61.1	13.1/25.0	2.7	64.9	38	52.36	90.64	2.02	609	24.5/3.7	Guatemala
2,459	189	21	15.0/13.7	0.9/1.1	5.5	59.5	46	11.44	54.34	1.07	129	34.6/3.4	India
3,671	952	N/A	51.9/37.8	12.2/12.2	9.2	92.0	329	198.88	68.64	9.67	1,901	37.9/29.7	Italy
2,761	572	N/A	25.3/18.6	1.5/1.5	6.7	93.8	3,891	96.58	64.68	5.83	3,023	52.5/12.4	Japan
3,010	525	4	69.5/76.6	29.6/49.2	9.8	83.8	37	132.44	77.88	0.11	3,026	35.7/2.7	Kuwait
2,174	208	21	12.8/26.1	0.4/3.4	2.9	32.6	0	41.80	22.44	0.29	233	26.9/4.7	Mali
3,145	611	5	64.6/65.6	20.3/31.6	3.9	80.2	261	128.92	109.12	4.24	754	36.5/14.3	Mexico
2,249	894	38	46.0/65.8	5.2/24.6	2.5	66.8	0	239.36	28.38	2.40	N/A	46.2/7.3	Mongolia
2,379	373	22	21.7/25.4	1.1/2.8	7.1	75.3	236	68.42	61.82	3.50	1,849	59.6/13.8	Philippines
3,374	882	N/A	50.7/44.3	12.9/18.0	4.1	85.0	200	171.82	99.44	8.74	2,061	51.5/27.9	Poland
3,357	318	3	47.9/65.4	10.8/32.1	7.3	75.1	81	42.46	56.76	1.66	2,394	51.1/18.5	Turkey
3,774	1,047	N/A	72.2/69.8	32.0/37.8	8.8	93.9	13,491	274.56	158.18	9.58	2,255	27.8/22.3	USA

Measuring Table

Population: US Census Bureau.

Total area: CIA *World Factbook 2004*.

Percentage of population in urban areas: Statistics Division, UN Department of Economic and Social Affairs; China figure from UNDP *2004 Human Development Report*.

Life expectancy at birth*: World Health Organization.

Total fertility rate*: UNDP *2004 Human Development Report*.

Percentage of population that is literate: CIA *World Factbook 2004*; Bosnia literacy rate from UNDP *2004 Human Development Report*.

Annual per capita income: UNDP *2004 Human Development Report*; Bhutan, Bosnia, and Cuba figures from CIA *World Factbook 2004*.

Per capita total expenditure on health (at average exchange rate)*: World Health Organization.

Physicians per 100,000 people*: UNDP *2004 Human Development Report*.

Percentage of population with sustainable access to an improved water source*: UNDP *2004 Human Development Report*.

Percentage of population with sustainable access to improved sanitation*: UNDP *2004 Human Development Report*.

Total available daily caloric intake per capita: Food and Agriculture Organization of the UN.

Percentage of population that is undernourished: UNDP *2004 Human Development Report*.

Percentage of population that is overweight*: World Health Organization.

Percentage of population that is obese*: World Health Organization.

Percentage of population age 20 and above with diabetes*: World Health Organization.

Human Development Report Index: UNDP *2004 Human Development Report*.

Number of McDonald's: McD Corporation and *www.McDonalds.com*.

Annual meat consumption per capita: World Resources Institute.

Annual available per capita sugar and sweetener supply*: Food and Agriculture Organization of the UN.

Annual per capita alcohol consumption*: World Health Organization.

Annual per capita consumption of cigarettes: World Health Organization.

Percentage of population age 18 and above that smokes*: World Health Organization.

** Greenland figures from correspondence with Greenland Chief Medical Officer.*

Additional Sources for Chapter Statistics

Australia

Population: Metro Brisbane, Australian Bureau of Statistics. Riverview, Queensland Department of Housing

Land that is desert: University of New South Wales School of Biological Science.

Ratio of sheep to people: Meat and Livestock Australia.

Indigenous population: *www.countriesquest.com*.

Indigenous population in 1777: Australian Government Culture and Recreation Portal.

Life expectancy gap between indigenous and nonindigenous population: UNDP *2004 Human Development Report*.

Big Mac price: *The Economist*.

Kangaroos killed under commercial harvest for meat and skins: Australia Department of the Environment and Heritage.

Bhutan

Percent of population that are subsistence farmers: EM Research Organization.

Land that is above 10,000 feet in elevation: Food and Agriculture Organization of the UN.

Population with access to electricity: BBC News.

TV stations in 1998/2005: BBC News.

Government tariff for individual foreign visitors per day: Bhutan Department of Tourism.

Bosnia and Herzegovina

Population of Sarajevo: Bosnia and Herzegovina Federal Office of Statistics.

Deaths during siege of Sarajevo: *users.erols.com/mwhite28/warstat3.htm*.

Unemployment rate: CIA *World Factbook 2004*.

Suicide rate per 100,000 people, prewar and postwar: *Space Daily*.

Chad

Percent of population that are subsistence farmers and cattle herders: CIA *World Factbook 2004*.

Land planted in permanent crops: CIA *World Factbook 2004*.

Years of ethnic warfare endured since gaining independence from France in 1960: *World Factbook 2004*.

Oil reserves in southern Chad: CIA *World Factbook 2004*.

Number of years oil reserves would supply Chad, if used at current rate and not exported: CIA *World Factbook 2004*.

Oil that is exported: CIA *World Factbook 2004*.

Households with access to electricity: *African Energy* newsletter.

Paved highways, percent of total: CIA *World Factbook 2004*.

Darfur Region, Sudan

Population of Darfur Province: International Crisis Group.

Percent of Darfur population that are refugees within Darfur: International Crisis Group.

Sudanese refugee population in Chad: USAID.

Population of Breidjing Refugee Camp: UN High Commission for Refugees.

Refugee camp interviewees who reported witnessing the killing of a family member: Coalition for International Justice.

Death toll from 2004 Indian Ocean tsunami: Center of Excellence in Disaster Management and Humanitarian Assistance.

Death toll from Darfur genocide since 2003: Coalition for International Justice.

US Government aid to Darfur region since 2003: USAID.

US Government aid to tsunami-affected regions: Center of Excellence in Disaster Management and Humanitarian Assistance.

Number of refugee camps in eastern Chad: World Health Organization.

Number of refugee camps in Darfur: USAID.

Camels exported from Sudan to Egypt annually for meat: *Al Ahram Weekly Online*.

China

Population of Metro Beijing: *China Statistical Yearbook 2003*.

Number of KFC restaurants: *Shenzhen Daily*.

Big Mac price: *The Economist*.

Percent of population living on less than $2 a day: UNDP *2004 Human Development Report*.

Number of days of curing, after which a "1,000-year-old egg" is most delectable: *www.kowloontraders.com*.

China, Rural

Rural population (people/households): Program on Energy and Sustainable Development, Stanford.

Percent of laborers in China engaged in agriculture work: Ministry of Agriculture of the People's Republic of China.

Ratio of percentage of rural to urban population that is overweight: Worldwatch Institute.

Ratio of rural to urban electricity use per person: The Chinese Academy of Social Sciences.

Ratio of rural to urban household consumption: *China Statistical Yearbook 2003*.

Ratio of suicide rates in rural to urban areas: *Muzi News*.

Number of casualties in rural China resulting from 420 protests of angry farmers who surrounded local government buildings in the first half of 1998: *Issues & Studies*, Institute of International Relations, National Chengchi University, Taipei, Taiwan,

Average per capita income, rural/urban: *China Statistical Yearbook 2003*.

Number of refrigerators per 100 families: *China and World Economy*.

Percent of rural residential energy consumption that comes from noncommercial sources, i.e., straw, paper, dung: The Chinese Academy of Social Sciences.

Ratio of Internet users in rural/urban areas: Ministry of Science and Technology of the People's Republic of China.

Rank of rat poison as murder weapon of choice in rural areas: *NY Times*.

Cuba

Population of Havana: *www.citypopulation.de*.

Population born after Castro became head of state: www.cubanet.org.

Ecuador

Indigenous population: UNDP *2004 Human Development Report*.

Year in which Ecuador formally adopted the U.S. dollar as legal tender: CIA *World Factbook 2004*.

Number of volcanoes: volcano.und.nodak.edu.

Population living on less than $2 a day: UNDP *2004 Human Development Report*.

Egypt

Population of Cairo: *www.citypopulation.de*.

Population with access to electricity: Africa Energy Forum.

Big Mac price: *The Economist*.

Population living on less than $2 a day: UNDP *2004 Human Development Report*.

Percent of camels imported into Egypt that are used for food: experts.about.com.

France

Population of Metro Paris: Institut National de la Statistique et des Etudes Economiques, France.

Percent of Paris population that is foreign-born: UNDP *2004 Human Development Report*.

Annual per capita consumption of wine/soft drinks: CBC News; www.nutraingredients.com.

Cheese consumption per person per year: Japan Dairy Council.

Big Mac price: *The Economist*.

Germany

Annual consumption of beer/soft drinks per person: *The Guardian*.

Sausage consumption per person per year: Euromonitor Global Information Database.

Big Mac price: *The Economist*.

Great Britain

Big Mac price: *The Economist*.

Fish and chips restaurants: www.plaiceandchips.co.uk.

Fish served in fish and chips restaurants per year: www.plaiceandchips.co.uk.

Greenland

Native Inuit population: *Greenland in Figures 2003*.

Aid from Denmark per person per year: CIA *World Factbook 2003*.

Land not covered in ice: *Greenland in Figures 2003*.

Rate Arctic Sea ice is melting per decade: BBC News.

Percent of population born after 1960 that states they experienced alcohol-related problems in their parental home: Danish Environmental Protection Agency.

Average number of days each year temperature is below freezing: www.weatherbase.com.

Percent of population that eats seal 4 times a week: Danish Environmental Protection Agency.

Year that a Greenlandic iceberg sank the *Titanic*: www.factmonster.com.

Guatemala

Population of Todos Santos Cuchamatán: www.cause.ca.

Indigenous population: UNDP *2004 Human Development Report*.

Rural households with access to electricity: ENCOVI Living Standard Measurement Study.

Life expectancy gap between indigenous and nonindigenous population: UNDP 2004 Human Development Report.

Big Mac price: The Economist.

Population living on less than $2 a day: UNDP 2004 Human Development Report.

India

Population of Ujjain: Office of the Registrar General and Census Commissioner, India.

Big Mac price: The Economist.

Number of vegetarian Pizza Huts in the world and in India: www.rediff.com.

Population living on less than $2 a day: UNDP 2004 Human Development Report.

Number of nuclear weapons tests India conducted in 1998: www.infoplease.com.

Number of people in India killed by the Indian Ocean tsunami in 2004: www.infoplease.com.

Italy

Population of Palermo: Istituto Nazionale di Statistica, Italy.

Pasta consumption per person per year: http://www.personal.psu.edu/users/t/m/tmg203/group_project/index.htm.

Pizzerias: www.arrivenet.com.

Number of articles and sub-clauses in an Agriculture Ministry regulation protecting Neapolitan pizzas: BBC News.

Japan

Population: Metro Tokyo- Stat. Handbook of Japan 2004. Kodaira City- Kodaira City gov.

Year in which beer-vending machines were voluntarily banned: www.jointogether.org.

Fish consumption per person per year: Food and Agriculture Organization of the UN.

Big Mac price: The Economist.

Japan, Okinawa

Population of Yomitan village: Yomitan Village Official Web Site.

American military forces killed in the battle of Okinawa during WWII: www.globalsecurity.org.

Japanese military forces killed in the battle of Okinawa during WWII: www.globalsecurity.org.

Okinawan civilians killed in the battle of Okinawa during WWII: www.globalsecurity.org.

American military forces stationed now on Okinawa: Marine Corps Times.

Land on main island covered by US military bases: Okinawa Peace Network of Los Angeles.

Urban population: Okinawa Prefecture government website.

Life expectancy: Japan Ministry of Health, Labour, and Welfare.

Rank in the world of life expectancy: The Okinawan Centenarian Study.

Number of centenarians per 100,000 people: The Okinawan Centenarian Study.

Number of centenarians per 100,000 people in most industrialized countries: The Okinawan Centenarian Study.

Percent of centenarians that are female in Okinawa: The Okinawan Centenarian Study.

Rank of Okinawans under 50 (for all Japan) for levels of obesity and risk of liver disease, cardiovascular disease, and premature death: Statistics and Information Division, Okinawa Prefecture Government Department of Health and Welfare.

Why So Old? column: Makoto Suzuki, Okinawa Research Center for Longevity Science, Okinawa International University.

Kuwait

Population of Kuwait City: www.citypopulation.de.

Percentage of population that are non nationals: CIA World Factbook 2004.

Percentage of citizens that are eligible to vote: CIA World Factbook 2004.

Land that is barren desert: cp.settlement.org.

Water supply from desalinated sea water: www.gulflink.osd.mil.

Water supply from brackish ground water: www.gulflink.osd.mil.

Food imported: Kuwait Information Office.

Oil exported: Kuwait Information Office.

Big Mac price: The Economist.

Mali

Population living below the poverty line: CIA World Factbook 2004.

Percent of population that are nomadic: CIA World Factbook 2004.

Percent of population that are farmers or fishermen: CIA World Factbook 2004.

Land that is desert or semidesert: CIA World Factbook 2004.

Rural households with access to electricity: Global Environment Facility.

Population living on less than $2 a day: UNDP 2004 Human Development Report.

Mexico

Population of Cuernavaca: Instituto Nacional de Estadistica Geografia e Informatica, Mex.

Indigenous population: UNDP 2004 Human Development Report.

Tortilla consumption per person per year: www.signonsandiego.com.

Big Mac price: The Economist.

Number of restaurants/retail stores run by Walmex: The Christian Science Monitor.

World rank for per person consumption of Coca Cola: Worldwatch Institute.

Population living on less than $2 a day: UNDP 2004 Human Development Report.

Mongolia

Population of Ulaanbaatar: National Statistical Office of Mongolia.

Livestock pop: www.freedomhouse.org.

Number of livestock deaths from drought and zud between summer of 1999 and winter of 2002: www.freedomhouse.org.

Land used for grazing: Food and Agriculture Organization of the UN.

Population living in gers: Mongolia National Statistical Office.

Rank of Ulaanbaatar among the world's coldest capitals: Asian Development Bank.

A market vendor at Galewela, Sri Lanka, relaxes among his grains and spices while waiting for customers.

Year in which Soviet economic aid stopped: CIA World Factbook 2004.

Population living on less than $2 a day: UNDP 2004 Human Development Report.

Philippines

Filipinos living or working overseas: The Occidental Quarterly.

Population of Metro Manila: www.absoluteastronomy.com.

No. of Jollibee restaurants: www.jollibee.com.

Big Mac price: The Economist.

Population living on less than $2 a day: UNDP 2004 Human Development Report.

Poland

Poles killed during World War II: Polonia Global Fund.

Number of years since 1795 that Poland did not exist as a country: freepages.genealogy.rootsweb.com.

Years Poland existed as a country under USSR domination: www.lewrockwell.com.

Population of Konstancin-Jeziorna: www.ville-st-germain-en-laye.fr.

Big Mac price: The Economist.

Turkey

Population of Istanbul: State Institute of Statistics, Republic of Turkey.

Number of years Turkey, which is 99% Muslim, has been a secular state: CIA World Factbook 2004, www.eurasianet.org.

Big Mac price: The Economist.

Population living on less than $2 a day: UNDP 2004 Human Development Report.

USA

Soft-drink consumption/Coca-Cola product consumption per person per year: www.mattonigranddrink.com.

Beef/potatoes purchased annually by McDonald's: NY Times.

Manure from all intensive farming practices per year: Animal Alliance of Canada.

Human waste per year: Animal Alliance of Canada.

Household food waste per year: www.endhunger.org.

Cost of household food waste per year: Medical News Today.

Household food waste per year as a percent of food purchases: Medical News Today.

Percent of processed foods with some genetically modified ingredients: Assoc. Press.

Percent of soy/corn raised that is a genetically modified variety: Associated Press.

Liposuction surgeries per year: Worldwatch Institute.

Gastric bypass surgeries per year: NY Times.

Percent paid by taxpayers for obesity-related medical costs: Center for Disease Control.

Percent of dieting men/women on any given day: National Eating Disorders Association.

Annual spending on dieting and diet-related products: National Eating Disorders Association.

Percent of all dieters who will regain their lost weight within 1 to 5 years: National Eating Disorders Association.

CONTRIBUTORS

Additional reporting and translation by **Fiona Rowe**, in Brisbane, Australia; **Abakar Saleh** in N'Djamena, Chad; **Khamis Hassan Jouma** in Abeche, Chad; **Joshua N. D'Aluisio-Guerrieri** in Beijing, China; **Owaldo Muñoz** in Quito and Simiatug, Ecuador; **Karina Bernlow** in Ittoqqortoormiit, Greenland; **John Tsui** in Naha City, Japan; **Elaine Capili** in Manila, Philippines; **Neha Diddee** in Ujjain, Varanasi, and Mumbai, India; **Tuvshin Mend** in Ulaanbaatar, Mongolia; **Dorota Waśniewska** and **Ewa Ledochowicz** in Warsaw, Poland; **Ferit Kayabal** in Istanbul, Turkey.

Alfred W. Crosby, Ph.D., has retired from the History Department of the University of Texas and is cruising around Nantucket Island on his only form of mechanical transportation, a bike. He has published many articles and seven books, the best-known being *The Columbian Exchange* and *Ecological Imperialism*. He has received the Medical Writers' Association Award and the Phi Beta Kappa Society's Emerson Award, and holds memberships in the Finnish Academy, the American Academy of Arts and Sciences, and the American Philosophical Society. He is completing a book on the history of humanity and energy.

Faith D'Aluisio is the author of the award-winning book *Women in the Material World* and co-author with Peter Menzel of *Man Eating Bugs: The Art and Science of Eating Insects* and *Robo Sapiens: Evolution of a New Species*. She is a former television news producer. Her documentaries and news series pieces have won regional and national awards from the Headliners Foundation, United Press International, Associated Press, and Radio-Television News Directors Association.

Joshua N. D'Aluisio-Guerrieri, a recent graduate of U.C. Berkeley, has spent several years exploring China and has lived in both Beijing and Taipei. He works throughout China as a freelance translator/interpreter and a fixer for major U.S. and international magazines and corporations. He is based in Taipei. www.entim.net.

Francine R. Kaufman's book *Diabesity* takes us to the front lines of the fight against this preventable and deadly disease. Her call to action details the tools for change at every level—from families to school systems to health care to government. Past president of the American Diabetes Association, she is a professor of pediatrics at the Keck School of Medicine at the University of Southern California and the head of the Center for Diabetes and Endocrinology at Childrens Hospital Los Angeles.

Corby Kummer has been a senior editor at the *Atlantic Monthly* since 1981. His work there and at the *New York Times* and *Gourmet* magazine has established him as one of the most authoritative and creative writers on food. He is the author of *The Pleasures of Slow Food: Celebrating Authentic Traditions, Flavors, and Recipes* and *The Joy of Coffee: The Essential Guide to Buying, Brewing, and Enjoying*.

Charles C. Mann's latest book is *1491: New Revelations about the Americas before Columbus*. He is the co-author of four previous books and is a correspondent for the *Atlantic Monthly* and the journal *Science*. His writing has appeared in publications in the U.S., Europe, and Asia, including the *Asahi Shimbun, GEO,* the *New York Times, Panorama, Smithsonian,* and the *Washington Post*. He was an editor of, and contributor to, the *Material World* series.

Peter Menzel is a photographer known for his coverage of international feature stories on science and the environment. His award-winning photographs have been published in *Life, National Geographic, Smithsonian,* the *New York Times Magazine, Time, Stern, GEO,* and *Le Figaro*. He is the creator, executive director, and principal photographer for the book *Material World: A Global Family Portrait* and the creator of *Women in the Material World*. He is co-author with Faith D'Aluisio of *Man Eating Bugs: The Art and Science of Eating Insects* and *Robo Sapiens: Evolution of a New Species*. www.menzelphoto.com.

Marion Nestle, Ph.D., M.P.H., is the Paulette Goddard Professor of Nutrition, Food Studies, and Public Health at New York University and the author of the award-winning book *Food Politics: How the Food Industry Influences Nutrition and Health* and *Safe Food: Bacteria, Biotechnology, and Bioterrorism*. www.foodpolitics.com.

Michael Pollan is the author of *Second Nature, A Place of My Own,* and *The Botany of Desire,* a *New York Times* best seller. His work has won numerous awards and appears in many anthologies, including the *Norton Book of Nature Writing, Best American Essays,* and *Best American Science Writing*. He is a contributing writer at the *New York Times Magazine* and is the Knight Professor of Journalism at UC Berkeley. He is currently completing a book on the ecology and ethics of eating, which will be published in spring 2006.

Carl Safina, Ph.D., grew up loving the ocean. His numerous publications include the books *Song for the Blue Ocean* and *Eye of the Albatross,* and he co-authored the *Seafood Lover's Almanac*. He is a recipient of a Pew Fellowship, a World Wildlife Fund Senior Fellowship, the Lannan Literary Award, the John Burroughs Writer's Medal, and a MacArthur Prize. He is now president of Blue Ocean Institute, which seeks to inspire a closer relationship with the sea. www.blueoceaninstitute.org.

The Itanoni Tortillería in Oaxaca, Mexico, sells handmade tortillas cooked on top of clay ovens. It contracts with local growers to produce increasingly rare native varieties of corn. Oaxaca is the center of diversity for corn—the world headquarters, so to speak, of its gene pool.

ACKNOWLEDGMENTS

A book whose subjects live in more than two dozen countries scattered around the world could not have been done without the help of hundreds of people. We are grateful to them all. Our especial thanks to the families in this book who opened their homes, hearts, and refrigerators.

Editorial and design: David Griffin and Charles C. Mann.

Book production: Liddy Tryon, Joshua N. D'Aluisio-Guerrieri, Hui-ling Sun, Carla Crawford, Susan D'Aluisio, Loren Van Krieken, Adam Guerrieri and Evan Menzel.

Copyediting: Charles C. Mann and Katherine H. Wright.

Special thanks to: Ruth Eichhorn and *GEO* magazine, Germany; Nozomu Makino and NHK TV, Japan; Elizabeth Olson, P&G, USA; Kathleen Strong and Chizuru Nishida, World Health Organization; Sissi Marini, UNDP, New York; Aida Albina and Cedric Bezin, UNHCR, Abeche.

Ten Speed Press: Phil Wood, Lorena Jones, Julie Bennett, Nancy Austin, Hal Hershey, Gonzalo Ferreyra, Erika Bradfield, Lisa Regul.

Copia, the American Center for Wine, Food, and the Arts: Betty Teller, Deborah Gangwer, Neil Harvey.

Pictopia: Mark Liebman, Bryan Bailey, James Cacciatore, Bo Blanton. www.pictopia.com.

Website: Bo Blanton.

Peter Menzel Photography staff, recent past and present: Liddy Tryon, Sheila DS Foraker, Nicole Elwood, Colleen Leyden D'Aluisio.

Australia
Fiona Rowe
Kelly Debono
Val Brown
Bernadette Jeffries
Vic Cherikoff
Beryl Van Oploo
Norma Scott-Molloy

Bhutan
Brent Olson at Geographic Expeditions: www.GeoEx.com
Ugen Rinzen at Yangphel Travels: www.yangphel.com
Karma Lotey
Yangzom
Yosushi Yugi
Jigme Singye
Tshering Phuntsho
Sha Phurba Dorji
Chato Namgay

Bosnia
Mirha Kuljuh
Mr. Oska
Sheila DS Foraker
Nedzad Eminagic
Arina and Nadja Bucalovic
Lokman Demirovic
Alexandra Boulat

Chad
Aida Albina
Cédric Bezin
Willem Botha
Colin Pryce
Guy Levine
Colin Sanders
Jean Charles Dei
Taban Lokonga
Stefano Porotti
Khamis Hassan Jouma
Eduardo Cué

Nancy Palus
Moustapha Abdelkarim
Hassane Mahamat Senoussi
Stefanie Frease
Abakar Saleh

China
Angela Yu
Joshua N. D'Aluisio-Guerrieri
Leong Ka Tai
Juliet Hsu

Cuba
Alberto D. Perez
Oswaldo Hernandez
Georgina Torriente
Kenji Fujita
Emilio Reyes

Ecuador
Oswaldo Muñoz at www.nuevomundotravel.com
David Muñoz
Pablo and Augusto Corral Vega
Cornelia at Simiatug Sinai

Egypt
Mounir and Wagdi Fahmy
Mona Abdel Zaher
Mohamed Bakr of Mitsco Languages and Translation: www.mitsco.com.eg

France
Isabelle and Pierre Gillet
Annie Boulat and Cosmos
Olivier Dumont
Patrice Lanoy
Delphine Le Moine
Edward Arckless
Rémi Blemia

Germany
Ruth Eichhorn
Venita Kaleps
Peter-Matthias Gaede
Christiana Breustedt
Uta Henschel
Nadja Masri
Peter C. Hubschmid
Peter Ginter
Thomas and Susanne Borchert

Great Britain
Philippe Achache
Zute Lightfoot
Michael and Caroline Martin

Greenland
Knud Brinkløv Jensen
Lars Pederson
Karina Bernlow and Marten Munck at Nanu Travel: www.nanu-travel.com
Kathleen Cartwright at Arcturus Expeditions: www.arcturusexpeditions.co.uk

Guatemala
Naomi Robertson
Pablo Perez
Eve Astrid Andersson

Iceland
Björn Thoroddsen
Linda Gunnlaugsdottr

India
Neha Diddee
Susan Welchman
Manoj Davey
William Allard
Kathy Moran

Italy
Fabio Artusi
Bartolo Usticano
Grazia Neri

Japan
Hui-ling Sun
Toyoo Ohta
Lina Wang
John Tsui
Asaka Barsley
Hsiu-lin Wang
Hirofumi Ando

Kuwait
Bill Kalis
Michel Stephenson
Haider Farman
Larry Flak
Brian Krause
Aisa BouYabes
Sara Akbar

Mali
Patricia Minn
Kone Lassine
Albert Gano
Sékou Macalou

Mexico
Juan Espinosa
Agustin Gutierrez
Angélica Pardiñas Romero
Mauricio Casteñeda
Jorge Vasquez Villalón
T. Boone Hallberg
Amada Ramirez Leyva
Lea Gabriela Fernandez Orantes
Irma Ortiz Perez

Mongolia
Tanya Suren
Tuvshin Mend at www.mogultravel.mn

Philippines
Elaine Capili
Peter Ginter

Poland
Ewa, Borys, and Ola Ledochowicz
Dorota and Bartek Waśniewscy
Malgorzata Maruszkin
Albert Krako

Turkey
Ferit Kayabal
Ugurlu Yaltir
Sezgi & Feriye

USA
Ray Kinoshita
Melanie Lawson
John Guess
Dawn D'Aluisio
Karen and Bob Prior
Malena Gonzales-Cid
Lisa Kuny
Ellie Menzel
Linda and Ron Junier
Ruben Perez
Paul Franson
Brian Braff
Nicole David
Miriam Hernandez
Andrew Clarke
Linda Dallas
Billy and Kimberly Campbell
Philip Greenspun
Michael Hawley
JP Caldwell, for taking care of Oscar during our many absences

Faith enjoys a chuckle with Elugundegma, a Yali tribesman, in Papua, Indonesia. On a Beijing street, Peter discovers that the taste and texture of a deep-fried starfish are less than stellar.

Material World Books
199 Kreuzer Lane, Napa, California, USA
www.menzelphoto.com

Ten Speed Press
Box 7123, Berkeley, California, 94707
www.tenspeed.com

Distributed in Australia by Simon and Schuster Australia, in Canada by Ten Speed Press Canada, in New Zealand by Southern Publishers Group, in South Africa by Real Books, and in the United Kingdom and Europe by Publishers Group UK.

Cover design by David Griffin and Chloe Rawlins
Text design by David Griffin

Library of Congress Cataloging-in-Publication Data

Menzel, Peter, 1948-

Hungry planet : what the world eats / photographed by Peter Menzel ; written by Faith D'Aluisio.

p. cm.

Summary: "A photographic collection exploring what the world eats featuring portraits of thirty families from twenty-four countries surrounded by a week's worth of food"--Provided by publisher.

Includes bibliographical references.

ISBN-13: 978-1-58008-681-3
ISBN-10: 1-58008-681-0

1. Food--Pictorial works. 2. Diet--Pictorial works. 3. Food habits--Pictorial works. I. D'Aluisio, Faith, 1957- II. Title.

TX353.M43 2005

641.3--dc22 2005013455

Paperback ISBN-13: 978-1-58008-869-5
Paperback ISBN-10: 1-58008-869-4

Printed in China
3 4 5 6 7 8 9 10 — 11 10 09 08

The last straw. Wangdi Phodrang, Bhutan